培文·电影

电影史
双语读本

游飞 —— 主编

—— 上册 ——

北京大学出版社
PEKING UNIVERSITY PRESS

申漢史
本東橋改

目录

上　册

导　言

第一章　初创时期 1895—1927

第一节	**电影的诞生**	011
	1. 爱迪生和迪克森	011
	2. 卢米埃尔兄弟	013
第二节	**法国电影的主导**	017
	1. 梅里爱：叙事的演进	017
	2. 百代、高蒙和艺术电影公司	020
第三节	**美国电影的兴起**	024
	1. 鲍特和《火车大劫案》	025
	2. 格里菲斯的《一个国家的诞生》和《党同伐异》	030
	3. 电影叙事的成熟	036
	4. 马克·森内特和西席·地密尔	040
第四节	**德国表现主义及北欧**	045
	1.《卡里加里博士的小屋》	049
	2. 德国经典大师：朗格、茂瑙和巴布斯特	052
	3. 乌发电影公司	059
	4. 北欧电影、德莱叶和《圣女贞德》	061
第五节	**苏俄蒙太奇**	065
	1. 苏俄蒙太奇理念和社会主义现实主义	065
	2. 爱森斯坦和《战舰波将金》	069
	3. 普多夫金的《母亲》、维尔托夫和杜甫仁科	074

第六节	欧洲先锋派电影	080
	1. 印象派和冈斯	080
	2. 超现实主义与《一条安达鲁狗》	084
	3. 达达主义、抽象主义和诗意纪录片	087

第二章　经典时期 1927—1945

第一节	好莱坞体制和经典叙事	095
	1. 有声电影的出现	095
	2. 电影技术革新	103
	3. 八大电影公司	110
	4.《海斯法典》与美国电影协会	116
	5. 美国电影艺术与科学学院与奥斯卡奖	121
	6. 奥逊·威尔斯和《公民凯恩》	123
	7. 好莱坞经典叙事系统	127
第二节	美国类型电影和经典大师	132
	1. 西部片和约翰·福特	134
	2. 歌舞片和米内里	139
	3. 喜剧片：卓别林、刘别谦和马克斯兄弟	144
	4. 警匪片（黑帮犯罪片）：霍克斯和休斯顿	155
	5. 黑色电影	162
	6. 恐怖片和悬疑惊悚大师希区柯克	167
	7. 剧情片（家庭情节剧）： 斯特劳亨、斯登堡、顾柯、惠勒和卡普拉	173
第三节	法国电影黄金时代的"五虎将"	182
	1. 诗意现实主义	182
	2. "黄金五虎"费德赫、杜维威赫、 帕尼奥尔、卡尔内和雷诺阿	183

3. 雷诺阿的《游戏规则》和《大幻灭》 188
4. 让·维果和《零分操行》 192

第四节　纪录、宣传与政治　194
1. 弗拉哈迪与《北方的纳努克》 196
2.《意志的胜利》和《奥林匹亚》 199
3. 英国的格里尔逊和詹宁斯 202
4. 美国纪录片和《我们为何而战》 205

第五节　东方电影的出现　209
1. 日本经典时期：沟口健二和小津安二郎 209
2. 20世纪30—40年代中国电影 216

第三章　转型时期 1945—1967

第一节　意大利新现实主义电影　225
1. 罗西里尼和《罗马，不设防的城市》 227
2. 德·西卡与柴伐蒂尼和《偷自行车的人》 229
3. 维斯康蒂和《大地在波动》 232

第二节　意大利电影第二次复兴及其后　235
1. 费里尼 235
2. 安东尼奥尼 238
3. 意大利电影第三代：
奥米、罗西、帕索里尼、贝托鲁奇和莱昂内 241

第三节　美国电影的转型　253
1. 大制片厂衰落与电视的出现 253
2. 类型片的转型与科幻片的兴起 263
3. 好莱坞黑名单 268

4. 转型期的导演们：斯蒂芬斯、怀尔德、津纳曼、
卡赞、普莱明格、富勒、雷伊和西尔克及"方法学派"
的青春偶像　　　　　　　　　　　　　　　271

第四节　　法国"新浪潮"　　　　　　　　　　　　288

1. "新浪潮"之前的法国经典大师：布列松、塔蒂、
奥菲欧斯和麦尔维尔　　　　　　　　　　　288
2. 巴赞、《电影手册》、"电影作者论"和克拉考尔　　300
3. "新浪潮"　　　　　　　　　　　　　　　305
4. 特吕弗和戈达尔及夏布洛尔、侯麦和里维特　　306
5. 左岸的阿兰·雷乃等人　　　　　　　　　　314

第五节　　苏俄"解冻"电影　　　　　　　　　　　　320

1. 繁荣的电影春天　　　　　　　　　　　　　320
2. 塔尔科夫斯基　　　　　　　　　　　　　　324

第六节　　战后各国电影的兴盛　　　　　　　　　　328

1. 欧洲艺术电影的"圣三位一体"：瑞典的伯格曼　328
2. 英国电影：英国自由电影运动和社会现实主义电影　335
3. 日本电影崛起中的黑泽明、
战后第二代、"新浪潮"和大岛渚　　　　　　344
4. 印度电影和雷伊　　　　　　　　　　　　　356
5. 戛纳、威尼斯和柏林国际电影节　　　　　　361

第七节　　新纪录电影　　　　　　　　　　　　　　364

1. 法国真实电影：让·鲁什　　　　　　　　　364
2. 美国直接电影：怀斯曼　　　　　　　　　　368
3. 事实、真相与态度　　　　　　　　　　　　373

导　言

一、电影的概念

"电影"作为一个复合型的概念，在英语中大致有四种译法：

1. 法国人最早使用的 cinéma（英语为 cinema）来自于古希腊语的 kinema，为"运动"之意。现在用以统称电影或电影院，cinema 统称电影时强调电影的美学和艺术内涵；

2. film 原指用于记录活动影像的电影胶片，后来演变为对电影最常见的、最中性的泛指；

3. movie 强调电影的大众流行特质和娱乐价值，有时也会涉及媒介的经济范畴；

4. motion picture 强调电影的制作流程，或者电影跟经济和市场密切相关的电影产业。

二、法兰西作为电影的发源地

作为电影的故乡（虽然美国人未必认同），法国电影对世界电影的发展产生过重大影响，证据之一是电影艺术的一系列核心概念就来自法语，包括蒙太奇（montage）、场面调度（mise-en-scène）、黑色电影（film noir）、作者（auteur）和真实电影（cinéma-vérité）等。

三、中文版的《世界电影史》

《世界电影史》（中国电影出版社，1982年）：作者为闻名世界的电影史大师、法国巴黎高等电影学院（IDHEC）教授乔治·萨杜尔（Georges Sadoul）；

《世界电影史（1960年以来）》（中国电影出版社，1987年）：作者为德国电影资料馆之友学会主席、德国电影电视学院电影史教授乌利希·格雷戈尔（Ulrich Gregor）；

《世界电影史（第二版）》（北京大学出版社，2014年）：作者为美国著名电影学者、威斯康星大学教授克里斯汀·汤普森（Kristin Thompson）和大卫·波德维尔（David Bordwell）；

《世界电影百科全书》（社会科学文献出版社，1993年）：主要根据苏联百科全书出版社1986年出版的《电影百科全书》编译而成。

四、本书选编的权威英文版《世界电影史》

Film History：An Introduction (Kristin Thompson & David Bordwell, Third Edition, McGraw-Hill, 2009)《世界电影史概观》作者为克里斯汀·汤普森博士和大卫·波德维尔博士夫妇：著名电影学者、威斯康星大学（University of Wisconsin Madison）知名教授、波德维尔还是法国电影资料馆（Cinémathèque Française）顾问；

A Short History of the Movies (Abridged Edition) (10th Edition) (Gerald Mast & Bruce Kawin, Pearson Longman, 2009)《世界电影简史》作者为杰拉尔德·梅斯特：芝加哥大学（University of Chicago）博士、电影史教授、系主任，布鲁斯·卡温：科罗拉多大学（University of Colorado）电影学教授；

A History of Film (Jack C. Ellis, 2005, Prentice Hall)《世界电影史》作者为杰克·埃利斯：哥伦比亚大学博士、西北大学（Northwest University）电影学教授、系主任；

A History of Narrative Film (David A. Cook, Fourth Edition, Norton, 2004)《叙事电影史》作者为大卫·库克：埃默里大学（Emory University）电影学教授、系主任；

Film：An International History of the Medium (Robert Sklar, Prentice Hall & Abrams, 2003)《电影：国际媒介史》作者为罗伯特·斯卡拉：哈佛大学博士、纽约大学（NYU）电影学教授；

The Cinema Book (ed. Pam Cook, BFI Publishing, Third Edition, 1996)《电影手册》作者为帕梅·库克：英国南安普顿大学（University of Southampton）

电影学教授、权威电影杂志《视与听》杂志副主编、女性电影理论奠基人之一；

The Oxford History of World Cinema (ed. Geoffrey Nowell-Smith, Oxford University Press, 1996)《牛津世界电影史》作者为杰弗里·诺威尔-史密斯：牛津大学毕业、前英国电影学会（BFI）研究出版部主管、伦敦大学玛丽学院电影史教授；

The Complete Film Dictionary (Ira Konigsberg, A Meridian Book, 1989)《电影大词典》作者为艾拉·康尼斯伯格：斯坦福大学博士、密歇根大学（Michigan University）影视中心主任、教授。

The Film Encyclopedia (Ephraim Katz, Harper Perennial, 1994)《电影百科全书》作者为艾弗瑞蒙·卡兹：这位纽约大学电影系毕业的影评人和电影人耗费毕生精力编纂这部权威的百科全书。

本书选编者愿意借此机会向上述各位作者表达诚挚的敬意和衷心的感谢！

五、几点说明

1. 本书选编自英语世界最权威的《世界电影史》教材、著作和词典；
2. 英语世界不同版本的《世界电影史》各有千秋、相映成辉；
3. 尽管付出了最大的努力，但选编不同版本的英文原稿仍然可能产生某种交叉和重复、甚至个别的矛盾之处，在此敬请读者宽宥；
4. 由于版本和出版时间等缘故，为方便阅读理解，不得已在个别地方作出适当的调整、变更或加注，亦请读者体谅。

最后，本书为财政部和教育部资助出版的国家级双语示范课程专用教材，编著者在此感谢有关部门和北京大学出版社的大力支持！

第一章

初创时期
1895—1927

据说电影的源头可以追溯到人类远古的洞穴壁画、古希腊柏拉图神秘的洞穴壁影理论、西方的魔灯（伯格曼将他的自传命名为《魔灯》）、中国汉代的石像画和皮影戏等，而电影的诞生又离不开静态摄影、"视觉暂留"和动态呈现这三大前提。

第一节　电影的诞生

1. 爱迪生和迪克森

　　1893 年美国大发明家托马斯·爱迪生（Thomas A. Edison）为了给自己发明的留声机配上活动图画，雇用英国工程师威廉·迪克森（William Dickson）发明了第一台定型的摄影机（Kinetograph），用以拍摄室内的运动、舞蹈、拳击、马戏团和名人等奇观性内容，并通过可供单人观看的"西洋镜"（Kinetoscope）进行商业演示。《喷嚏》和《亲吻》就是爱迪生公司电影最早的代表作。

Edison's Program

　　The first presentation of Edison's Vitascope four months later in New York did not have the same impact on spectators, nor has it provided grist for later critical analysis. Edison mostly put on the screen films that looked exactly like those that had been appearing in the Kinetoscope viewing machines for the previous several years—works shot inside the Black Maria against a black background, presenting moving figures in a kind of spatial void. The one widely praised film at the Vitascope debut was a shot of crashing waves at the seaside, and it had been filmed in England by Birt Acres and supplied to Edison by Robert W. Paul.

　　Edison may have gotten a message when most of the acclaim went to the wave film (its original title was A Rough Sea at Dover, but it was changed to Sea

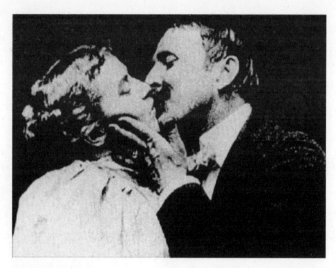

爱迪生公司的《亲吻》

Waves in the United States to make it appear a local product). Shortly after the Koster & Bial screening, Edison began to rely less on the stationary Black Maria camera and sent cameramen with portable cameras out into the world to shoot "actualities" on the model of Acres and the Lumières. During 1896 they filmed Shooting the Chutes at Coney Island, a waterfall, a train, a fire truck pulled by a horse, farmyard scenes, and several short outdoor comedies in the manner of Arroseur et arrosé.

Despite the initial successes of projected motion pictures, the early months were a time of disorder and shakeout in the new medium. Expectation exceeded technology, and technology outran manufacturing capability. Competition intensified—in addition to the primary French, British, German, and American projectors, another important machine came onto the scene: the Biograph, manufactured by the American Mutoscope Company (the firm soon changed its name to American Mutoscope and Biograph Company and eventually shortened it to Biograph Company). Soon another dozen different projecting devices were on the market.

William. K-L. Dickson

Edison's director of the motion picture project was William Kennedy-Laurie Dickson. He was the primary inventor of the Edison cameras and viewers, and with his associate, William Heise, he made the first American films.

From early 1889 to late 1890, Dickson worked on the pinpoint-photo project with his first associate, Charles A. Brown. In October 1889, when Edison returned from the European tour during which he had met Marey, he saw the cylinder movies and agreed that they looked bad. After writing the fourth caveat, Edison told Dickson to invent a camera that used a strip of film. Dickson soon began experimenting with celluloid, but he also kept working on cylinders.

At first, Dickson bought sheets of celluloid film from inventor John Carbutt and cut them to size. (For several years, film was sliced and sometimes perforated by the purchaser.) Late in 1889, Dickson placed his first order with Eastman. He also bought 35mm film from other manufacturers—in 1893, for example, from the Blair Camera Company—but Eastman eventually became Edison's sole supplier.

2. 卢米埃尔兄弟

卢米埃尔兄弟（Louis & Auguste Lumière）拥有坚实的工业技术背景，他们将爱迪生公司笨重的室内摄影设备简化为便携式的、可用于室外拍摄的机器，并称之为"电影"（Cinématographe，源于古希腊语的"运动记录器"或"动态书写"，更直接的来源则是"西洋镜"的法语翻译）。

卢米埃尔兄弟拍摄过大量的户外单镜头短片，包括记录日常生活的《火车进站》《工厂大门》和《婴儿的午餐》等，而著名的《水浇园丁》则呈现了电影叙事和戏剧性冲突的雏形。

1895年12月28日，卢米埃尔兄弟将自己拍摄的上述短片首次以活动影像的方式投射到巴黎大咖啡馆地下室的银幕之上，让观众目瞪口呆，甚至夺路而逃。这一天被全世界公认为电影的诞生日。

The Lumière Brothers

Auguste Marie Louis Nicolas Lumière, the elder, and Louis Jean Lumière, the younger and more important of the brothers, started dabbling with Edison's Kinetoscope and Kinetograph in 1894. They also were familiar with the work of Marey. Their father, all avid photographer, had founded a factory in Lyon for manufacturing photographic plates and, later, celluloid film. Interested in the new motion photography, the brothers—who were excellent mechanics as well as budding industrialists, scientifically curious and brilliantly creative—had developed their own mochine within a year. They called it the Cinématographe

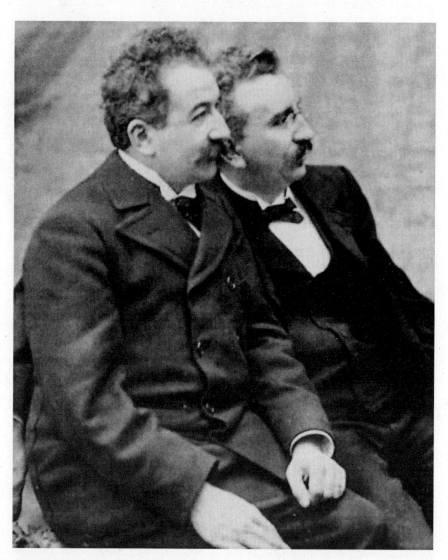

卢米埃尔兄弟

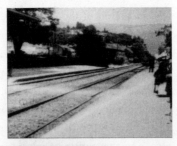

《火车进站》剧照

(from the Greek "motion recorder" or "kinetic writer", but more directly from Kinetograph, which it simply translated into French). It ran perforated 35mm film at 16 fps, and it used a unique claw mechanism to engage and advance the film. Louis always made sure his brother shared full credit, but Louis was the primary inventor of the Cinématographe—the final design came to him in a dream—and he shot the early films. Unlike Edison's bulky indoor camera, the Lumière camera was portable; it could be carried to any location. The operator turned a hand crank rather than pushed an electric button. Most significantly, the same machine that shot the pictures also printed and projected them. While the machine admitted light through its lens during filming, it projected light through its lens during projection. It printed by running raw and processed film through at once; they were in contact in the gate when light exposed the blank film. Intermittent movement and steady alignment were guaranteed for movie photography, printing, and projection.

Early in 1895, the Lumière brothers shot their first film, *Workers Leaving the*

Lumière Factory. Beginning in March of the same year, the Lumières projected this film and several others to private, specially invited audiences of scientists and friends throughout Europe. The first movie theatre opened to the paying public on December 28, 1895, in the basement room of the Grand Café in Paris. This date marks the generally accepted birthday of the movies. The choice of birthdate reflects the importance of the theatre—where the Lumière pictures continued to play for months and where money could be earned on a regular basis—but it also honors the first release to the public of what turned out to be the most comprehensive and influential solution to the problems of exposing and projecting movie film. The date they first presented their work—March 22, 1895—was as significant as December 28, the date their theatrical exhibition defined the business.

The Lumières projected several films, among them a later version of *Workers Leaving the Lumière factory*, a Lumière baby's meal (*Le Repas de bébé*, the first home movie), a comical incident about a gardener's getting his face doused through a boy's prank (*Le Jardinier et le petit espiègle*, the first narrative film, happily a comedy), and a train rushing into a railway station (*L'Arrivée d'un train en gare*). The last film (or one called *The Sea*) provoked the most reaction; the audience is said to have shrieked and ducked when it saw the train or the water moving toward them.

The Lumière discovery of 1895—especially its elegant technical simplicity and public success—established the brothers as the most influential and important men in motion pictures in the world, eclipsing the power of Edison's Kinetograph and Kinetoscope. The Lumières sent the first camera crews all over the globe, recording the most interesting scenes and cities of the earth for the delight and instruction of a public who would never be able to travel to such places on their own. Theirs were the first films to be shown in India, Japan, and other countries, inspiring film industries and film going around the world.

The Lumière brothers adopted and established conventions and practices that have remained standard throughout the history of film. The Lumières stabilized film width at precisely 35mm, still the standard gauge today. (Dickson's had been about 39mm.) They also established the exposure rate of 16 fps, a functional silent speed until the invention of sound required a faster one for better sound reproduction. The slower exposure rate used less film—thus saving money—and allowed their machine to run more quietly and dependably, whether it was shooting, projecting, or printing—for all of which it used intermittent movement. Another Lumière contribution was the name of their invention—the Cinématographe .In many countries today, the movies are the cinema, and shooting is cinematography.

第二节　法国电影的主导

1. 梅里爱：叙事的演进

法国魔术师兼剧院经理乔治·梅里爱（Georges Méliès）从英国人罗伯特·保罗（Robert W. Paul，他仿造爱迪生西洋镜获得英国专利）手中获得摄影机，开始将魔术、幻想、梦境和奇观引入电影当中，拍摄了《消失的女人》《德雷福斯案件》和《月球旅行记》等名作。

据《梅里爱自传》记载，1896年秋天他在巴黎街头拍摄公共马车时摄影机出现故障，排除故障后重新拍摄，镜头中的公共马车竟然变成了灵车，这一偶然事故成为电影镜头切换的发端，而停机再拍（stop-motion photography）也成为梅里爱魔幻电影的核心技巧。1898年，梅里爱更是第一次突破电影单镜头（场景）的限制，拍摄了多镜头（场景）的影片《咫尺月球》。梅里爱首创了多次曝光、手绘画幅、叠化和延时摄影等电影特技，并成为电影"蒙太奇"和"场面调度"概念的最早的先驱。

电影理论大师巴赞和克拉考尔都认为，如果说是卢米埃尔兄弟开创了电影的写实主义传统，那么，梅里爱无疑就是电影幻觉意识的开拓者。梅里爱证明电影不仅能够记录现实，而且更擅长于创造和想象。

Georges Méliès, Magician of the Cinema

Méliès was a performing magician who owned his own theater. After seeing

the Lumière Cinématographe in 1895, he decided to add films to his program, but the Lumière brothers were not yet selling machines. In early 1896, he obtained a projector from English inventor R.W.Paul and by studying it was able to build his own camera. He was soon showing films at his theater.

Although Méliès is remembered mainly for his delightful fantasy movies, replete with camera tricks and painted scenery, he made films in all the genres of the day. His earliest work, most of which is lost, included many Lumière-style scenics and brief comedies, filmed outdoors. During his first year of production, he made seventy-eight films, including his first trick film, *The Vanishing Lady* (1896). In it, Méliès appears as a magician who transforms a woman into a skeleton. The trick was accomplished by stopping the camera and substituting the skeleton for the woman. Later, Méliès used stop-motion and other special effects to create more complex magic and fantasy scenes. These tricks had to be accomplished in the camera, while filming; prior to the mid-1920s, few laboratory manipulations were possible. Méliès also acted in many of his films, recognizable as a dapper and spry figure with a bald head, moustache, and pointed beard.

In order to be able to control the mise-en-scène and cinematography of his films, Méliès built a small glass-enclosed studio. Finished by early 1897, the studio permitted Méliès to design and construct sets painted on canvas flats. Even working in this studio, however, Méliès continued to create various kinds of films. In 1898, for example, he filmed some reconstructed topicals, such as Divers at Work on the Wreck of the "Maine". His 1899 film, *The Dreyfus Affair*, told the story of the Jewish officer convicted of treason in 1894 on the basis of false evidence put forth through anti-Semitic motives. The controversy was still raging when Méliès made his pro-Dreyfus picture. As was customary at the time, he released each of the ten shots as a separate film. When shown together, the shots combined into one of the most complex works of the cinema's early years.(Modern prints of *The Dreyfus Affair* typically combine all the shots in a single reel.) With his next work, *Cinderella* (1899), Méliès began joining multiple shots and selling them as one film.

Méliès's films, and especially his fantasies, were extremely popular in France and abroad, and they were widely imitated. They were also commonly pirated, and Méliès had to open a sales office in the United States in 1903 to protect his interests. Among the most celebrated of his films was *A Trip to the Moon* (1902), a comic science-fiction story of a group of scientists traveling to the moon in a space capsule and escaping after being taken prisoner by a race of subterranean creatures. Méliès often enhanced the beauty of his elaborately designed mise-en-scène by using hand-applied tinting.

Except in Méliès's first years of production, many of his films involved sophisticated stop-motion effects. Devils burst out of a cloud of smoke, pretty

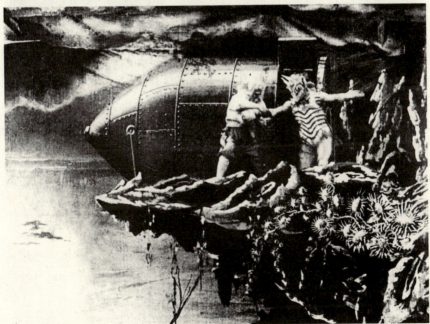

《月球旅行记》剧照

women vanish, and leaping men change into demons in midair. Some historians have criticized Méliès for depending on static theatrical sets instead of editing. Yet recent research has shown that in fact his stop-motion effects also utilized editing. He would cut the film in order to match the movement of one object perfectly with that of the thing into which it was transformed. Such cuts were designed to be unnoticeable, but clearly Méliès was a master of this type of editing.

For a time, Méliès's films continued to be widely successful. After 1905, however, his fortunes slowly declined. His tiny firm was hard put to supply the burgeoning demand for films, especially in the face of competition from bigger companies. He continued to produce quality films, including his late masterpiece *Conquest of the Pole* (1912), but eventually these came to seem old-fashioned as filmmaking conventions changed. In 1912, deep in debt, Méliès stopped producing, having made 510 films (about 40 percent of which survive). He died in 1938, after decades of working in his wife's candy and toy shop.

2. 百代、高蒙和艺术电影公司

查尔斯·百代（Charles Pathé）被法国电影史学家乔治·萨杜尔称为"电影的拿破仑"，这位留声机制造商在1896年创立法国百代电影公司（Pathé），标志就是一只引吭高歌的雄鸡。百代公司取代梅里爱的明星公司，以垂直整合制作、发行和放映及平行扩张至意大利、俄罗斯和美国的方式，从1905年迅速崛起，成为第一次世界大战之前法国电影乃至世界电影的主导力量。（大西洋两岸60%的电影为百代出品，百代也是澳洲、日本、印度和巴西电影业的先驱）。

歌厅艺人出身的费迪南·齐卡（Ferdinand Zecca）出任百代公司万塞纳制片厂总监，执导和监制了数百部影片（包括重新剪辑收购的梅里爱电影），其中1930年的44分钟的《基督受难》为最早的故事长片。麦克斯·林戴（Max Linder）在百代公司编导主演过四百部喜剧电影，其优雅世故的倒霉蛋形象影响了卓别林等一代喜剧大师。

作为百代公司的主要竞争对手，高蒙电影公司（Gaumont）由工程师兼发明家列昂·高蒙（Léon Gaumont）在1895年夏创立（比电影诞生还早五个月）。尽管它的规模只有百代公司的四分之一，却拥有全球最大的制片厂，并在第一次世界大战期间取代百代公司成为法国电影的主角。这主要归功于高蒙公司艺术总监、前百代公司编剧路易·费拉德（Louis Feuillade），他执导的系列侦探片《鬼魂》获得了空前的成功，通过场面调度将悬疑氛围和日常生

百代公司标志

高蒙公司标志

活巧妙地融合在一起,对此后的法国电影和欧美电影产生了深远的影响。

法国艺术电影公司(The Film d'Art Company)成立于1908年,致力于艺术电影的拍摄。著名的《刺杀吉斯公爵》汇集舞台剧明星、著名剧作家和圣桑乐曲讲述一个妇孺皆知的法国历史故事,成为后世艺术电影创作的原始典范。

France: Pathé versus Gaumont

During this period, the French film industry was still the largest, and its movies were the ones most frequently seen around the world. The two main firms, Pathé Frères and Gaumont, continued to expand, and other companies were formed in response to an increased demand from exhibitors. As in many western countries, workers were winning a shorter workweek and thus had more leisure time for inexpensive entertainments. The French firms also courted a wider middle-class audience.

From 1905 to 1908, the French firm industry grew rapidly. Pathé was already a large company, with three separate studios. It was also one of the earliest film companies to become vertically integrated. A vertically integrated firm is one controlling the production, distribution, and exhibition of a film. As we shall see time and again in this book, vertical integration has been a major strategy pursued by film companies and often a measure of their strength. Pathé made its own cameras and projectors, produced films, and around 1911 began manufacturing film stock as well. In 1906, Pathé also began buying theaters. The following year, the firm began to distribute its own films by renting rather than selling them to exhibitors. By then, it was the largest film company in the world. Starting in 1908, it distributed films made by other companies as well.

By 1905, Pathé employed six filmmakers, still overseen by Ferdinand Zecca, each making a film a week. The films encompassed a variety of genres: actualities,

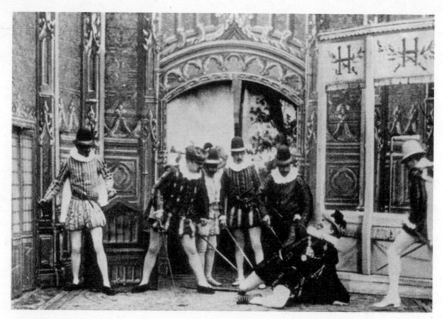

《刺杀吉斯公爵》

historical films, trick films, dramas, vaudeville acts, and chases. During 1903 and 1904, Pathé created an elaborate system for hand-stenciling color onto release prints. Stencils were painstakingly cut from a copy of the film itself, with a different stencil for each color. Assembly lines of women workers then painted the colors frame by frame on each release print. Pathé reserved color for trick films and films displaying flowers or elegantly dressed women. Such hand-coloring continued until the early sound era.

 Among Pathé's most profitable films were series starring popular comics: the "Boireau" series (with André Deed), the "Rigadin" films (with the music-hall star Prince), and, above all, the Max Linder series. Linder's films reflected the industry's growing bid for respectability by being set in a middle-class milieu. Max typically suffered embarrassment in social situations, such as wearing painfully tight shoes to an elegant dinner. He was often thwarted in love; in *Une ruse de mari* ("*The Husband's Ruse*"), he unsuccessfully tries to commit suicide in various ways, calling on his valet to fetch a knife, a gun, and so on. Linder's films were enormously influential. Charles Chaplin once referred to Linder as his "professor" and himself as Linder's "disciple". Linder worked in both the United States and France from 1909 until his death in 1925.

 Aside from being a vertically integrated firm, Pathé also used the strategy of horizontal integration. This term means that a firm expands within one sector

of the firm industry, as when one production firm acquires and absorbs another one. Pathé enlarged its film production by opening studios in such places as Italy, Russia, and the United States. From 1909 to 1911, its Moscow branch made about half the films produced in Russia.

Pathé's main French rival, Gaumont, also expanded rapidly. After finishing its new studio in 1905, the firm took on additional filmmakers. Alice Guy trained this staff and turned to making longer film herself. Among the new filmmakers was scriptwriter and director Louis Feuillade, who took over the supervision of Gaumont's films when Guy left in 1908. He became one of the silent cinema's most important artists, and his career paralleled Gaumont's fortunes until the 1920s. Feuillade was extraordinarily versatile, making comedies, historical films, thrillers, and melodramas.

Following Pathé's lead, other companies and entrepreneurs opened film theaters, aiming at affluent consumers. Such theaters often showed longer and more prestigious films. Prosperity in the French industry and in film exports led to the formation of several smaller firms during this period.

One of these had a significant impact. As its name suggests, the Film d'Art company, founded in 1908, identified itself with elite tastes. One of its first efforts was *The Assassination of the Duc de Guise* (1908, Charles Le Bargy and André Calmettes). Using stage stars, a script by a famous dramatist, and an original score by classical composer Camille Saint-Saëns, the film told the story of a famous incident in French history. It was widely shown and had a successful release in the United States. *The Assassination of the Duc de Guise* and similar works created a model of what art films should be like. The Film d'Art company, however, lost money on most of its productions and was sold in 1911.

On the whole, the French industry prospered. From 1907 on, the rental system encouraged the opening of cinema theaters. By 1910, screenings in cafés and traveling fêtes foraines had dwindled, and large film theaters were the rule. During the same era, however, French firms were facing challenges in the lucrative American market and would soon lose their dominance over world markets.

第三节　美国电影的兴起

占据主导地位的欧洲电影（特别是法国电影）在第一次世界大战期间遭到重创，而美国电影则获得了崛起的天赐良机。电影逐渐发展成为一种成熟的艺术形式：格里菲斯（D. W. Griffith）实现了电影艺术的多重整合、森内特（Mack Sennett）和卓别林（Charles Chaptin）引领着美国喜剧的蓬勃发展，而美国电影的制片厂体制也在此时落地生根。美国电影从最初落后于欧洲（特别是法国）的劣势、逐步转变成分庭抗礼、并最终获得竞争的优势。

Rise of the American Film, 1914-1919

Except for the United States, the major film producing countries—France, Germany, Great Britain, and Italy—were involved in World War I from its outbreak. The U.S. did not enter the war until 1917, and then our participation was far less than total. Since some of the materials required for the manufacture of high explosives are the same as those for photographic film (cotton, and nitric and sulfuric acids), film stock was in short supply abroad. A much more serious effect of war on European film producers was the curtailment of international distribution of completed films. Nations were separated from each other by battle lines; transportation was unavailable for many nonmilitary purposes; and the large American audience lay three thousand miles across a submarine-infested ocean.

Though the French and the Italians had been the first to arrive at feature-length films, the U.S. was now in a position to pursue that development as no

other country could. With its sizeable moviegoing public, an economy stimulated rather than drained by war, a tradition of business expertise, and film makers of considerable inventiveness and occasional genius, America had a crucial advantage at this important stage. The Americans made full use of their resources, and that is to their credit. If there had not been that four-year lead at exactly that historical moment, however, the subsequent domination of the world's screens by the United States might never have occurred, at least not to the extent that it has.

As it happened, during the second half of the teens, the Americans were the ones who expanded the art to a fuller expression, discovered the sorts of ingredients that would make the entertainment universally popular, and devised systems of manufacture, wholesaling, and retailing that could support the new expensiveness of feature production. In the U.S. during those years were three parallel developments that deserve particular attention. First, was the culmination of Griffith's earlier experimentation in film form, his first features. Second, there began the quite special tradition of American screen comedy in the output of Mack Sennett and his co-workers, most notably Charles Chaplin. Finally, the new and prototypical systems of mass production, distribution, and exhibition evolved—with Thomas H. Ince among the leaders in organizing production—laying the groundwork for subsequent economic expansion.

1. 鲍特和《火车大劫案》

爱德温·鲍特（Edwin S. Porter）1900年受雇于爱迪生公司，很快为该公司的电影制作总监。鲍特拍摄的《消防队员的生活》和《火车大劫案》引进因果叙事逻辑、多场景交叉剪辑、时空重构和梦幻心理呈现等元素，代表了电影连续性剪辑核心观念的生成。而《火车大劫案》更被称为西部片、警匪片和动作片等美国类型电影的始祖。

Edwin S. Porter

In most of the early French, German, and American films, one shot equaled one scene; the finished film was a series of scenes—only incidentally a series of shots. Each scene progressed chronologically, following the central character about. There were no leaps in time, no ellipses in the sequence of events. The camera was usually distant enough from the playing to include the full bodies of all the players. It remained for filmmakers to learn to move the camera, to build

scenes out of several shots, and to combine scenes and individual shots into sequences, the work of filmmakers from G. A. Smith in England to D. W. Griffith in America.

One of those crucial filmmakers was Edwin S. Porter (1869-1941). After Porter returned from the Caribbean, he paid a visit to his "father" and asked for a job. Edison hired him as a cameraman in 1900; within a year or two, Porter had become director of production for Edison's film company.

Porter's two most important films were released in 1903. *Life of an American Fireman* (shot late in 1902) begins with the fireman-hero falling asleep, the subject of his reveries appearing in a superimposed white space near his head (a vignette, or "dream balloon")—perhaps the first time an American film had attempted to present a character's thoughts, converting part of the movie screen into a "mindscreen".

As the fireman dreams of a mother and child, then wakes—worried about those who may be in danger from fire at the moment—there is a cut to a close-up of a fire alarm box and a hand setting off the alarm. The scene changes again to the fire station as the men tumble out of their beds— obviously in response to the alarm, which implies causal continuity from shot to shot. The cause-and-effect relationship between these shots is as important in the history of film continuity, in the very logic of film editing, as the cut to the close-up of the faraway alarm box. Before, there had been virtually no way to move a story from one shot or location to another without having the same character in both of them. Now the cut could be seen as the agency of a force exerted by one shot on another, a cinematic act that went beyond juxtaposition into the realm of asserted meaning and effective relationship. Like the British, Porter found that editing had a logic, one that would be explored by filmmakers from Griffith and Eisenstein to Hitchcock and Resnais. That close-up itself was not the first ever made, by the way, but it was the first Porter had cut into an ongoing narrative.

Having leapt out of bed, the firemen slide down the pole in one shot and reach the ground floor in the next shot. Two sets, two shots, apparently one pole, and a cut in the right place, establishing the continuity of action and location from shot to shot—and all at once Porter's audience understood the relative location of both sets, the layout not just of the two-story firehouse but of the cinematically defined landscape.

Then the firemen rush out on their horsedrawn fire engines. The exterior shots of the fire brigade charging out of the station and down the street were bits of stock footage Porter found and cut into the narrative; that was an economical move, saving the cost of shooting a new scene, but it was also a demonstration that the actors and the real firemen would be read by the audience as tile same firemen. At the site of the fire, Porter cut from the stock footage to a new shot—and achieved

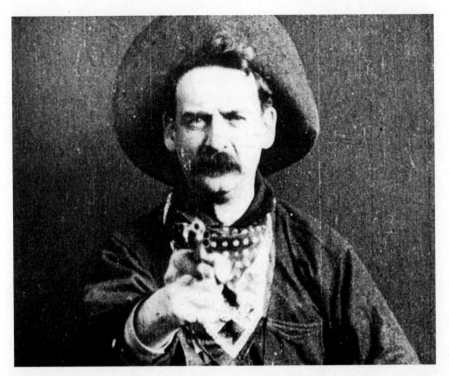

《火车大劫案》

yet an-other breakthrough, for as the fire engines rush up, the camera pans (that is, it pivots horizontally or turns sideways) to follow the engines and reveal a burning house. This was not a simple matter of panning to cover a wide subject, like a city skyline; what it did was discover the logic for the pan, making a camera movement part of the film's dramatic strategy—because it followed a moving object and because it kept the burning house out of the frame until Porter chose to reveal it.

There are two surviving versions of the film, referred to as "the copyright version" and "the cross-cut version"; each does the rescue scene differently.

In the copyright version, the audience sees the entire rescue and the putting out of the fire first from inside the house, then repeated in its entirety from outside the house.

The cross-cut version is more comprehensible and daring. It cuts back and forth between the interior and the exterior of the house—that is, intercuts the two takes into a 13-shot sequence—turning the two place-bound setups into the coherent narration of a single temporal process. The fireman climbs up the ladder (outside), steps into the room and saves the woman (inside), climbs down the ladder with her and then up again when the woman tells him about the baby

(outside), gets the baby (inside), and so on. Porter was thought to have realized and shown here that the basis of film construction was not the scene but the shot.

The question is, Did he edit the film that way? Which of these copies represents the film as it was originally released? The answer, established by film historian Charles Musser, is that the copyright version corresponds to the release version. The cross-cut version was re-edited (not by Porter) in the Griffith era. The fact that to cut back and forth between the interior and exterior views would have been logical does not mean that Porter thought of it in 1902.

Porter seems to have intuited that the cinema's narrative logic creates a unity of place where none exists in nature. As later theorists have demonstrated, we make sense of a narrative, a story, not merely on the basis of the action as presented but on the interplay between those events and our mental ability to connect them into a meaningful sequence. Porter's constructing the rescue process from two distinct views demanded that we mentally connect them into a single process—one event happening at one time—and the interior and exterior shots into views of a single building.

Porter's later film of 1903, *The Great Train Robbery*, makes even greater use of this interplay between filmed event and mental connection, and probably owes to that its terrific success as the single most popular film in America before 1912. The first series of shots in the film shows the same kind of step-by-step, one-shot-one-scene editing of the Méliès films. The outlaws enter the telegraph office and tie up the operator, board the train as it stops for water, rob the mail car and shoot the railroad man, seize the locomotive, unhook it from the rest of the train, rob all the passengers and shoot one who tries to escape, run to the locomotive and chug off, get off the locomotive and run to their horses in the woods. Up to this point in the film any director might have made it, except for the flow and careful detail of the narrative sequences and the beauty and vitality of the outdoor shots. But the cut to the last scene of this sequence reveals a new editing idea. It is clearly an elliptical jump in time (from when the outlaws started their escape in the train to when they stopped the train and got off to find and mount their horses), and it contains a pan shot that follows the outlaws through the woods.

But the next shot identifies the director's cinematic imagination more clearly. He cuts back to the opening scene, the telegraph office, and shows the discovery of the assaulted operator. Although the cut may be a backward leap in time and certainly deserts the spatial focus of the film (the outlaws and their getaway, which we understand to be an action that continues, unshown, while we watch the operator be revived), it makes perfect sense in the story's continuity. Making the mental connection, linking the film's events with our thinking about them, it answers the question the audience naturally asks: How will the outlaws be caught?

In the film's final shoot-out, three of the four bandits meet overacted, hands-

in-the-air, pirouette-and-fall deaths. Apart from these stagey deaths, the film's cinematic showmanship is evident in the final shot—a close shot of a bandit firing at the audience—which was intentionally unrelated to the whole film and could, according to the Edison catalogue, be shown before or after the rest of the movie. Like 3-D of later years, the shot thrilled customers with a direct assault. For the next five years, it became almost obligatory to end a film with a close shot of its major figure.

For all the understandable later attention to the editing of this landmark film, several other sources of its power and popularity cannot be overlooked: its violence, its careful production design, its fluid mixing of scenes shot in the studio and on location, and its detailed demonstration of how to rob a train.

值得一提的是，其后的英国影片《义犬救主》提升了鲍特开创的叙事建构和剪辑节奏，使影片具备强烈的悬念和动态张力。

Apart from Brighton, important work was being done elsewhere in England.

Cecil Hepworth's Rescued by Rover (1904, remade 1905) is one of the most energetically edited pre-Griffith films, a decided advance over Porter in narrative construction and rhythm. In the first expositional shot, a nurse wheeling a baby carriage insults a gypsy woman, who vows revenge. In the second shot, a carefully blocked sequence with a camera pan—a general strategy that would later be described as plan-séquence, the complicated blocking of a lengthy shot—the gypsy steals the baby as the nurse chats with a beau. Then Hepworth makes a huge elliptical jump. Rather than sticking with nurse, watching her discover the loss and run home to tell baby's parents, the film's third shot begins with nurse bursting into the family living room to tell her news. As she recites her tale, Rover, the family collie, listens intently; he jumps out the window in search of the stolen baby.

Then begins the most remarkable sequence in the film: a series of individual shots documenting Rover's finding baby, returning to tell his master, and leading master back to baby. The sequence, most of which is shown in Fig. 3-5, ends with baby, master, mistress, and Rover happily united in their living room; Hepworth has elliptically omitted the process of returning home, knowing that the sequence was not necessary and would weaken the emotional tension of the film. This is a crucial early instance of leaving out what the audience can figure out for itself, a basic lesson of filmmaking.

Hepworth's careful editing of *Rescued by Rover* produced two effects that had not been achieved before, which communicated themselves to the audience by completely cinematic means. His systematic use of the same setups (or camera positions) to mark Rover's progress both toward and away from the baby firmly

implanted in the audience's mind exactly where Rover was. Without any titles or explanations, the audience had a complete understanding of the rescue process and the spatial layout. Second, this documentation produced not only awareness, but also suspense. Because the audience knew where Rover's path was leading, it could participate in the excitement of Rover's finally reaching the end of it. Hepworth increased this excitement with the dynamic fluidity of cuts from one setup to the next.

2. 格里菲斯的《一个国家的诞生》和《党同伐异》

大卫·格里菲斯在鲍特手下短暂学艺后转投迪克森的传记电影公司（Biography Company），五年内拍摄了四百多部短片，在编导、摄影、剪辑和表演等方面积累了丰富的经验。1915年，这位南部邦联军上校的儿子拍摄了反映美国南北战争的史诗性长片《一个国家的诞生》，影片在电影化叙事和商业票房上取得空前的成功，却因其种族主义观念而饱受诟病。格里菲斯其后倾其所有执导了最具野心的《党同伐异》，以四个人类历史和现实故事，倡导人性的宽容精神、反驳对他族主义的指控，但影片却因超前的多线索叙事和超大的制作预算而惨败。而格里菲斯注定要用他的余生拍摄中规中矩的剧情片来还清欠债，涉及华人的《凋谢的花朵》就是其中的佼佼者。

D. W. Griffith

Born in Kentucky on 23 January 1875, the son of Civil War veteran Colonel "Roaring Jake" Griffith, David Wark Griffith left his native state at the age of 20 and spent the next thirteen years in rather unsuccessful pursuit of a theatrical career, for the most part touring with secondrate stock companies. In 1907, after the failure of the Washington, DC, production of his play A Fool and a Girl, Griffith entered the by then flourishing film industry, writing brief scenarios and acting for both the Edison and Biograph companies. In the spring of 1908 the Biograph front office, facing a shortage of directors, offered Griffith the position and launched him, at the age of 33, on the career which most suited him.

Between 1908 and 1913 Griffith personally directed over 400 Biograph films, the first, The Adventures of Dollie, released in 1908 and the last, the four-reel biblical epic Judith of Bethulia, released in 1914, several months after Griffith and Biograph had parted company. The contrast between the earliest and latest

Biograph films is truly astonishing, particularly with regard to the aspects of cinema upon which Griffith seems to have concentrated most attention, editing and performance. In terms of editing, Griffith is perhaps most closely associated with the elaborate deployment of cross-cutting in his famous last-minute rescue scenes, but his films also exerted a major influence upon the codification of other editing devices such as cutting closer to the actors at moments of psychological intensity. With regard to acting, the Biograph films were recognized even at the time as most closely approaching a new, more intimate, more "cinematic" performance style. Several decades after they were made, the Biograph films continue to fascinate not only because of their increasing formal sophistication, but also because of their explorations of the most pressing social issues of their time: changing gender roles; increasing urbanization; racism; and so forth.

Increasingly chafing under the conservative policies of Biograph's front office, particularly the resistance to the feature film, Griffith left Biograph in late 1913 to form his own production company. First experimenting with several multi-reelers, in July 1914 Griffith began shooting the film that would have assured him his place in film history had he directed nothing else. Released in January 1915, the twelve-reel *The Birth of a Nation*, the longest American feature film to date, hastened the American film industry's transition to the feature film, as well as showing cinema's potential for great social impact. *The Birth* also had a profound impact upon its director, for in many ways Griffith spent the rest of his career trying to surpass defend or atone for this film.

His next feature, *Intolerance*, released in 1916, was a direct response to the criticism and censorship of *The Birth of a Nation*, as well as an attempt to exceed the film's spectacular dimensions. Intolerance rather unsuccessfully weaves together four different stories all purporting to deal with intolerance across the ages. The two most prominent sections are "The Mother and the Law", in which Mae Marsh plays a young woman attempting to deal with the vicissitudes of modern urban existence, and "The Fall of Babylon", dealing with the Persian invasion of Mesopotamia in the sixth century and featuring massive, elaborate sets and battle scenes with hundreds of extras. In an editing tour de force, the film's famous ending weaves together last-minute rescue sequences in all four Stories. The third of the important Griffith features, *Broken Blossoms*, is by contrast a relatively smallscale effort focused on three protagonists, an abused teenager, played by Lillian Gish in one of her most impressive performances, her brutal stepfather, Donald Crisp, and the gentle and sympathetic Chinese who befriends her, this role, as enacted by Richard Barthelmess, clearly intended to prove that Mr Griffith was no racist after all.

After the release of *Broken Blossoms* in 1919, Griffith's career began a downward trajectory, both artistically and financially, which he never managed to

reverse. Plagued to the end of his life by the financial difficulties attendant upon an unsuccessful attempt to establish himself as an independent producer-director outside Hollywood, perhaps more importantly Griffith never seemed able to adjust to the changing sensibilities of post-war America, his Victorian sentimentalities rendering him out of sync with the increasingly sophisticated audiences of the Jazz Age. Indeed, the two most important Griffith features of the 1920s. *Way Down East* (1920) and *Orphans of the Storm* (1921), were cinematic adaptations of hoary old theatrical melodramas. While these films have their moments, particularly in the performances of their star Lillian Gish, they none the less look determinedly back to cinema's origins in the nineteenth century rather than demonstrate its potential as the major medium of the twentieth century. Making a series of increasingly less impressive features throughout the rest of the decade. Griffith did survive in the industry long enough to direct two sound films. *Abraham Lincoln* (1930) and *The Struggle* (1931). The latter, a critical and financial failure, doomed Griffith to a marginal existence in a Hollywood where you are only as good as your last picture. He died in 1948, serving occasionally as script-doctor or consultant, but never directing another film.

The Birth of a Nation (1915)

Among those for whom Cabiria made the ground tremble was D. W. Griffith. His ambition was to be recognized as the world's greatest filmmaker; but the Italians were regularly raising the stakes. It was the arrival of Quo Vadis? In New York that prompted him in 1913 to go beyond Biograph's policy of one-reel films and make two-reel films and his own biblical epic, *Judith of Bethulia*. Merely hearing about *Cabiria*, it was reported, led him to begin planning his own big historical film, *The Birth of a Nation* (1915), and actually seeing the Italian work set him to an even more grandiose project, the omni-historical *Intolerance* (1916).

The Birth of Nation came only fifty years—not, as in Cabiria's case, two millennia—after the events it depicted. Still, some background is required to place the film in its historical context. The United States Civil War of 1861-65 between the northern and southern states had numerous causes, but many of them stemmed from the South's attempt to preserve the holding of African-Americans as chattel slaves. Slavery was abolished in the South by President Abraham Lincoln's Emancipation Proclamation during the war, and the victorious North followed a policy of Reconstruction after the war in the defeated southern states, partly in an effort to insure rights of citizenship for freed slaves. The Civil War and Reconstruction were the subjects of Griffith's film. By the early twentieth century, a new tide of racialism in the United States had swept away the gains

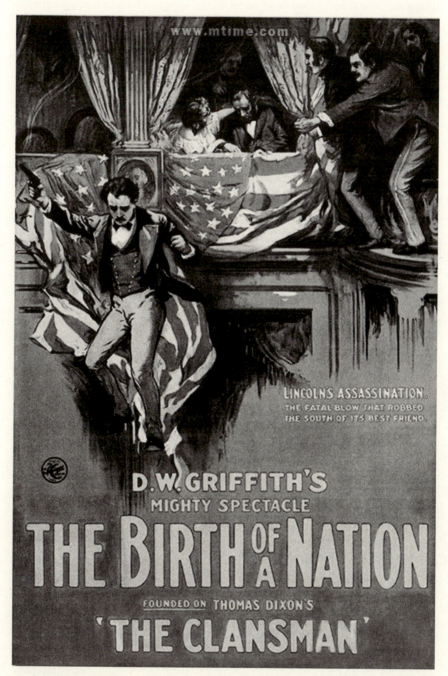

《一个国家的诞生》剧照

of Reconstruction, segregation between whites and blacks had become a way of life in the South, and theorists of racial purity were advocating a reconciliation between northern and southern whites who had formerly been enemies.

As a southerner living and working in the North and seeking national approbation, Griffith chose to emphasize one particular version of the reconciliation theme: that the southern secession from the union deserved to be forgiven because southern whites had demonstrated to northern whites that their true enemies were not each other, but the threat of dilution of their common race. While proclaiming its fidelity to historical accuracy, Griffith's film subsumes the issues of chattel slavery and the southern secession within its larger subject—that racial equality places white women in danger of sexual assault.

Reviewers in the United States were quick to hail *The Birth of a Nation* as superior to *Cabiria*. If the motion picture medium had not yet proven itself a major cultural force, the film's sweeping depiction of significant events in United States history put the matter to rest. The riveting sequence of the Ku Klux Klan's ride to rescue white maidenhood had the forceful power to sweep the spectator up at least temporarily into its racist fantasy of fear and redemption. However disturbing its social implications, the sequence marked the most spectacular instance of analytical editing yet constructed, with its cascade of dozens of separate shots, switching rapidly back and forth between the white woman besieged by the sexual advances of a mulatto man and the gathering of the white-hooded bands who ride to save her.

The Birth of a Nation was controversial from its first screening. The National Association for the Advancement of Colored People (NAACP), a recently formed organization concerned with the rights and development of African-Americans, organized a public campaign against the film and sought unsuccessfully through legal action to have it banned. Even decades later the film often cannot be screened without protests. Its historical importance is undeniable, but as the first great American epic its legacy is more troubling than triumphant.

Intolerance (1916)

Griffith's *Intolerance* seems to have been shaped as much by his resentment against the critics of The Birth of a Nation as by any larger philosophical viewpoint. While he was working on a contemporary story of injustice in an urban ghetto much like the setting of *The Musketeers of Pig Alley* (a humanitarian sensitivity toward immigrants and white ethnic minorities stood in contrast to his racial views), he decided to create an epic on the subject of lack of tolerance toward others' beliefs by adding to the present-day narrative further episodes on

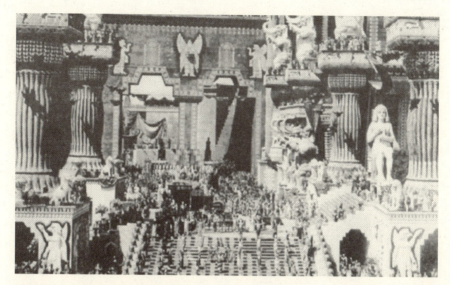

《党同伐异》中壮观的巴比伦盛筵

the persecution of Jesus, the massacre of Protestant Huguenots in sixteenth-century France, and obscure but colorful struggles in ancient Babylon. These four separate narrative strands were intermingled, with the shift from one to another signaled by a repeated shot of a woman rocking a cradle.

Griffith had been spending the winter months since 1910 in the Southern California community of Hollywood, where a number of filmmakers had begun to work year-round; after leaving Biograph he had relocated there for his first feature film work. For the Babylonian sequence of *Intolerance*, he built in an open Hollywood field a set that was his answer to the mammoth Carthage sets of *Cabiria*. His Babylon made Moloch's temple in the Italian film look puny by comparison; he borrowed the motif of elephantine figures, but made them twice the size of Pastrone's devouring god. The spectacle of licentiousness and carnage that he staged on this set was justified, as it were, by association with the more pious and humane themes of the other three episodes. Unlike *The Birth of a Nation* and the Italian epics, *Intolerance* was a commercial failure. One reason audiences did not find it satisfactory, ironically, was that its structure challenged the narrative conventions that Griffith more than anyone else had made the norms of filmmaking practice and spectator expectation.

Cabiria and the Griffith epics profoundly influenced cultural discourse about cinema, though their impact on the way films were made was, at least in the short run, limited. The outbreak of World War I in Europe in August 1914 cut off resources for film-making, curtailing production generally and precluding

any grand projects. In the United States (which did not enter the war until 1917), the development of standard management and production procedures in the film industry discouraged expensive, time-consuming projects. The epics mainly affected how people talked about film: cultural elites who had previously given scant attention to the medium could now appreciate its artistic capabilities in the framework of traditional "high" art forms such as opera, theater, and symphonic music. While there were still holdouts who deplored the movies primarily on moral grounds, with the epics of the mid-teens most educated people throughout the world accepted cinema not only as a sociological phenomenon but as the newest form of art.

3. 电影叙事的成熟

"美国电影之父"格里菲斯是公认的电影语言集大成者。第一，格里菲斯将镜头（shot）作为电影语言的基本单位，并界定了电影语言的基本词汇和语法；第二，他对电影的叙事建构、写实功能和表意潜质作出了深入的探究；第三，对电影剪辑、电影时空和电影节奏进行了创新性的成功尝试；第四，则是以标志性的"最后一分钟营救"（last-minute rescue）确立了好莱坞完美的大团圆结局；最后，格里菲斯的电影创作还为好莱坞的制片厂体制、类型片概念、明星效应和商业产销提供了充实的依据。

The Language of Film

Perhaps Griffith's single most important insight was that the shot rather than the scene should be the basic unit of film language. With that discovery came the possibility of varying the standard, stationary, head-on long shot. Gradually Griffith moved his camera to setups closer to the action or farther away, altered its angle for the most effective view, let it follow a moving subject when appropriate or traverse a stationary scene for certain kinds of kinetic emphasis. These varied shots were then edited together to create the appearance of a continuous scene selectively viewed. Once understood, these options gave the film maker immeasurably greater control over the audience's emotional response, adding powerful connotations to the action itself. Méliès's framing, in unvaried long shot, had been emotionally neutral. Though Porter had begun to break away from fixed convention, the exceptions did not upset established rules even in his own films (and the deliberateness of his intentions is less than certain).

It was Griffith more than anyone who came to understand the separate psychological-aesthetic functions of the long shot, the medium shot, and the closeup, and who used this awareness consistently. In Griffith's work, and in that of his successors, the long shot usually begins a scene, establishing the action and its setting. It might be used to "reestablish," after closer and partial views, so that the parts could be kept related to the whole. Full of information—one could go on and on describing all the things seen in it—it is emotionally cool: We are literally distanced from the action. As the camera is placed closer, or a longer lens is used to achieve much the same effect, there are fewer things included within the frame, but we tend to be more interested in them, are closer to them emotionally as well as perceptually. The medium shot rather than the long shot became the standard framing from which the director departs for special purposes, just as we usually deal with life around us from middle distance. In it we are close enough to see and comprehend what is happening and what it means. Generally the stress of the medium shot is on relationships, on interaction: a person in conversation with another, or petting an animal, or cooking at a stove. When the camera is moved closer still, to a closeup, the visual information becomes quite limited—perhaps to one face, a hand stroking fur, a pot boiling over—but the emotional weight becomes very heavy. Our attention is directed to what we might not have noticed otherwise or might not have been able to discern at a distance. The closeup can also be used to draw us into strong identification with a character, and to suggest through facial expression what is being thought and felt. It is a freed visual statement that permits directors to show us exactly—and only—what they want us to see in the way they want us to perceive it.

Griffith called closeups "inserts", and he shot them after the scene had been filmed in long and medium shots. This frequently shifting point of view, especially to the closeup, offered a means of expression comparable to the use of spoken words in the theater. Though the stage director can block and light action in a way designed to lead our eye, we are still free to regard the whole proscenium— no more, no less—from one fixed position. Broad gestures and conspicuous props and symbolic settings may be employed, but most of what we learn comes from what the characters say to each other. Lacking the power of spoken words, Griffith substituted a kind of visual language with its own conventions and limitations. Though never as intellectually precise as words, the affective use of images can cause us to feel directly and deeply in a manner both unique and compelling.

Alternation of tempo through the editing of detached shots is something that Griffith came to understand from intuition and experiment, and that Porter understood not at all. Though Porter shifted from one scene to another, he did not break up the run of the camera within scenes. The pursuit of the bandits by the posse in *The Great Train Robbery* remains one of the slowest chases in memory

as the first party of horsemen, and then the second, enters and passes through the frame. Griffith might extend screen time beyond actual time, as he would cut back and forth from shots of bandits to shots of a posse, building to a rhythmic climax; yet his chases (honored as "the Griffith last-minute rescue") seem incredibly more tense—and even faster. What he discovered, other film makers have learned and used since: Rapid cutting, or a succession of short shots, can create excitement; slow cutting, or shots held longer on the screen, will aid calm contemplation. Both the shifting spatial framing and the temporal alternation of shots give the film maker artistic resources extending well beyond the bare meaning of the action being recorded.

For transitions between shots, Griffith used a larger range of optical effects than is generally employed today, and gave each effect a consistently specific function. The cut is basic within scenes; virtually unnoticed in itself, it is necessary for the variable ordering and pacing of the action. The dissolve is a more noticeable transition in which one image is gradually superimposed over, and then replaces, the other. As in early Méliès, it is usually used between scenes rather than within them, and signals a change of place and/or of time. When one image fades out to darkness and a new image fades in to full exposure, a different place and lapse in time are usually being signaled also. (Griffith tended to favor fades over dissolves.) As the "heaviest" screen "punctuation", the only one in which we are given nothing to look at for a few seconds, fade-outs frequently indicate a larger break in the dramatic action as well, marking off groups of scenes that are called sequences by some critics. (Other writers and many film makers use shot and scene synonymously and sequence for what is here being called scene, leaving no term for a larger dramatic/narrative unit short of the entire film.)

Griffith also liked irises as connective devices. An iris begins with a black screen containing only a small circle (or square or other shaped portion) of the total image: a girl's bowed head, for example. Then as the iris opens up it reveals the whole action and setting: a family standing over the girl at the dinner table in a farm kitchen. When the scene has run its course, with the girl explaining how she had been orphaned and had come in desperation to these old friends of her parents, the final shot might iris out; within the contracting circle of black we see the girl's smiling, upturned face as she learns that the family will let her stay.

Griffith employed masking in several different ways: the sides of the frame darkened to emphasize the height of a tower in the center; tops and bottoms darkened to form a CinemaScope-proportioned strip across the middle, stressing the horizontal movement and length of a column of galloping cavalry; or a cameo masking of the corners, to enhance the oval loveliness of Lillian Gish's face. He also experimented with superimposition and split screen for special effects—for the longing daydream in *Enoch Arden* (1911), or to make the awareness of burning

Atlanta hang over the foreground of people fleeing in *The Birth of a Nation* (1915).

Griffith did not by any means confine his attention to the "grammatical" elements of screen language. Though of the theater, as Porter was not, Griffith soon began to sense that performance in film required a style quite different from that in fashion on the stage. If spoken words were lacking, the eloquence of body movement and gesture was magnified; in the new medium the camera registered and the projector projected. Actors on the screen appeared large, their every movement easily discernible from the back rows; as the camera came closer to them, its photographic authenticity rendered as false the prevailing theatrical histrionics. Griffith began to confine movement, dress, and makeup to an approximation of life; any exaggeration was kept small in scale and justified by character. Pantomime became more and more expressly tailored for the camera—the sad smile with only the face visible, the upper part of a body with hands plucking and fluttering in nervous excitement, the eyes revealing remorse or anger or frustrated passion. Richer and subtler characterizations began to replace the broad and simple performances of the first dramatic films. Faces and bodies, cut up and reassembled in edited sequence, were made to achieve a new precision of expression. Griffith commanded a thoughtfulness and invention from the actors in his developing stock company; with camera and cutting shears he shaped their performances into a dramatic entity that had existed initially only in his mind.

As for physical background to the action, Griffith's exterior locales were always carefully selected for their appropriateness to the events depicted and for their capacity to reinforce the mood of the story. Constructed sets in his Films strike us as the real thing even when they're not; the style is invariably naturalistic in solidity and detail. What he couldn't find on location he had carefully and fully re-created on the back lot or in the studio. Griffith was able to achieve a scale that had no theatrical precedents: real trains rushing across a wide prairie, enemy hordes encircling a besieged city. His lighting initially advanced along existing stage fines and then, as brighter lights and more sensitive emulsions became available, finally surpassed theatrical possibility. At first he and cameraman G. W. "Billy" Bitzer were content to light scenes with sharp, even clarity, using controlled sunlight for interiors as well as exteriors—standard practice at the time; yet photographically the earliest Griffith/Bitzer films stand out from those of most of their peers, as they somehow manage to look fresh and sharp even today. In addition to exact exposure and focus, this quality must have something to do with choice of emulsion and care in processing. In later work Griffith began to experiment with the effective possibilities of modulated and directional artificial light, breaking some taboos in the process. An interior night scene might be lit as if suffused by the flickering softness of the firelight, underexposed by standards then current, or what is called "low-key lighting" today. In another scene the heroine's

head might be lit from behind by simulated morning light streaming in through a window so that it bounced off her blonde hair to form a halo of overexposure, "halation" in photographic terms. Some of these experiments would be expanded and refined by the Germans in the twenties, just as the Russians would further develop Griffith's editing.

Finally, Griffith was one of the leaders in the movement against the short length of films imposed by the American industry of the day. With few exceptions, the dominant companies were conservative in their adherence to established practice and their unwillingness to risk the capital that longer films would have required. At first Griffith was confined to the one-reel (ten to fifteen minutes) standard that Méliès and Porter had achieved. As film makers became more aware of the potential of the medium, they became increasingly ambitious in terms of subject matter. Larger subjects demanded more running time. In 1910 Griffith made a two-reeler entitled His Trust, which the studio released as two separate one-reel films. The same thing happened to his next two-reeler, Enoch Arden, but Griffith and others persisted until two reels became accepted as standard length. He continued to strive for more time and larger scale, and by the end of this first period of film history, he had reached a length of four reels, with *Judith of Bethulia* (1914). It was his last important film before *The Birth of a Nation*, and in narrative structure and historical spectacle it foreshadowed his even larger feature, Intolerance.

4. 马克·森内特和西席·地密尔

马克·森内特曾是格里菲斯的演员和门生，1912年建立启斯东电影公司（Keystone）拍摄著名的"启斯东喜剧"，发掘出卓别林等一系列喜剧大师，并与格里菲斯和著名制片人托马斯·因斯（Thomas Ince）一起成为好莱坞制片厂体制的奠基人（三人曾组建过短命的"三角电影公司"）。

深谙观众心理的西席·地密尔（Cecil B. DeMille）是早期美国电影最成功的导演兼制片人，他靠拍摄最早的西部片起家，第一次世界大战后改拍涉性的家庭伦理片，1923年又投入创纪录的百万美元、执导了空前成功的圣经故事影片《十诫》，直接开启了长盛不衰的史诗题材电影创作。地密尔还因为在1913年的采景中首先发现那个叫"好莱坞"（Hollywood）的谷场，而被称为"好莱坞的奠基人"。

Mack Sennett

Another architects of the American studio system, and the founder of silent screen comedy, was Ince's and Griffith's partner in the Triangle Films Corporation. Mack Sennett Sennett had worked as an actor in many of Griffith's Biograph films and set himself consciously to study the director's methods. He too began to direct films for Biograph in 1910, but was given very little creative freedom. So in September 1912 Sennett founded the Keystone Film Company in Fort Lee, New Jersey, with the financial backing of Adam Kessel, Jr., and Charles O. Bauman, the owners of the New York Motion Picture Company, and within the month he had moved his company to the old Bison studios in Hollywood. Here, between 1913 and 1935, he produced thousands of one-and two-reel films and hundreds of features which created a new screen genre—the silent slapstick comedy—that was to become the single most vital American mode of the twenties. Influenced by circus, vaudeville, burlesque, pantomime, the comic strip, and the chase films of the French actor Max Linder, Sennett's Keystone comedies posited a surreal and anarchic universe where the logic of narrative and character was subordinated to purely visual humor of a violent but fantastically harmless nature. It is a world of inspired mayhem—of pie-throwing, cliff-hanging, auto-chasing, and, pre-eminently, of blowing things up. The slam-bang comic effect of these films depended upon rapid-fire editing and the "last-minute rescue" as learned from Griffith, and also upon Sennett's own incredibly accurate sense of pace. He had a genius for timing movement, both the frenetic physical activity which filled the frames of his films and the breathless editing rhythms which propelled them forward at breakneck speed. Sennett's films often parodied the conventions of other films, especially those of Griffith (e.g., Teddy at the Throttle, 1916), or satirized contemporary America's worship of the machine (Wife and Auto Trouble, 1916). Just as often, they would develop a single improvised sight gag involving the Keystone Kops or the Sennett Bathing Beauties into a riotous series of visual puns whose only logic was associative editing (*The Masquerader*, 1914; *The Surf Girl*, 1916).

In the first two years at Keystone, Sennett directed most of his films himself, but after 1914 he adopted the Inceville model and began to function exclusively as a production chief in close association with his directors, actors, and writers. Unlike Ince, however, Sennett preferred simple story ideas to detailed shooting scripts, and he always left room in his films for madcap improvisation. The number of great comedians and directors who began their careers at Keystone is quite amazing. Sennett discovered and produced the first films of Charlie Chaplin, Harry Langdon, Fatty Arbuckle, Mabel Normand, Ben Turpin, Gloria Swanson, Carole Lombard, Wallace Beery, Marie Dressier, and W. C. Fields. He also provided the

《十诫》海报

training ground for some of the most distinguished directors of comedy in the American cinema: Chaplin and Keaton, of course, but also Malcolm St. Clair, George Stevens, Roy Del Ruth, and Frank Capra. Furthermore, the enormous international popularity of Sennett's Keystone comedies contributed substantially to America's commercial dominance of world cinema in the years following World War I. Sennett's realization that the cinema was uniquely suited to acrobatic visual humor established a genre which in the twenties would become perhaps the most widely admired and vital in the history of American film. Many serious critics, at least, regard it as such. And yet Sennett's conception of comedy was wed to the silent screen. Purely visual humor loses a great deal to the logic of language and naturalistic sound; and when silence ceased to be an essential component of the cinema experience, the genre that Sennett had founded vanished from the screen.

Sennett himself continued to make films after the conversion to sound, but by 1935 Keystone was bankrupt, and its founder did not produce another film before his death in 1960.

Cecil B. DeMille

The most successful and flamboyant representative of the "new morality" in all of its manifestations was Cecil B. DeMille . A virtual incarnation of the values of Hollywood in the twenties, DeMilie had an uncanny ability to anticipate the tastes of his audiences and give them what they wanted before they knew they wanted it. He began his career by directing *The Squaw Man* (1914), the first feature-length Western ever made in Hollywood, for Jesse Lasky's Feature Play Company. The film was a great popular and critical success, and DeMille followed it with a series of Western features (*The Virginian*, 1914; *Call of the North*, 1914) and stage adaptations (*Carmen*, 1915) that made him famous. Like Griffith, DeMille had apprenticed in the melodramatic theatrical tradition of David Belasco, and these early films were striking for their expressive "Rembrandt" or "Lasky" lighting and vivid mise-en-scène. During the war, DeMille made a group of stirringly patriotic films—*Joan the Woman* (1917); *The Little American* (1917); *Till I Come Back to You* (1918)—and then shifted gears to pursue the postwar obsession with extramarital sex among the leisure class. In a series of sophisticated comedies of manners aimed directly at Hollywood's new middle-class audience—*Old Wives for New* (1918), *Don't Change Your Husband* (1919), *Male and Female* (1919), *Why Change Your Wife?* (1920),*Forbidden Fruit* (1921), *The Affairs of Anatol* (1921), *Fool's Paradise* (1921), *Adam's Rib* (1922), and *Saturday Night* (1922)—DeMille made the bathtub a mystic shrine of beauty and the act of disrobing a fine art, as "modern" marriages collapsed under the pressure of luxuriant hedonism. These films did not simply embody the values of the "new morality"; they also legitimized them and made them fashionable.

When the Hays Office was established, DeMille embraced the "compensating values" formula and made it uniquely his own in *The Ten Commandments* (1923), a sex- and violence-drenched religious spectacle that made him internationally famous. Costing over 1.5 million dollars to produce, with Biblical sequences in two-color Technicolor (generally lost today), this film became one of the most profitable motion pictures of the era, and it offers a good example of the way in which the Hays Office worked to permit the lurid depiction of "sin" so long as it was shown to be ultimately punished. This successful formula for religious spectacle became a DeMille trademark, and he used it time and again throughout his career-in *King of Kings* (1927), *The Sign of the Cross* (1932), *Samson and*

Delilah (1949), and finally in his last film, *The Ten Commandments* (1956), a full-color widescreen remake of the prototype. But DeMille excelled at other forms of spectacle as well: historical (*Cleopatra*, 1934; *The Crusades*, 1935; *The Buccaneer*, 1938), Western (*The Plainsman*, 1938; *Union Pacific*, 1939), and circus (*The Greatest Show on Earth*, 1952). With the exception of a brief venture into independent production between 1925 and 1929, DeMille worked all of his life for some incarnation of Paramount-first the Lasky Feature Play Company, then Famous Players-Lasky, and finally Paramount itself after 1930. A frequent collaborator was the scenarist Jesse Lasky, Jr. (1908—58—*Union Pacific, Samson and Delilah*), son of the studio's cofounder, and in the sound era DeMille became closely identified with the Paramount "style" as described in Chapter 8. A few of his films, such as *Male and Female* (1919) and *Union Pacific* (1939), are classics of their genres, but on the whole DeMille was a great showman, rather than a great director, who incarnated the values of Hollywood in the twenties throughout his career. He was extravagant, flamboyant, and vulgar, but he possessed a remarkable instinct for the dualistic sensibilities (some would simply say "hypocrisy") of his middle-class American audiences, who paid by the millions for over fifty years to sit through his kinetic spectacles of sex, torture, murder, and violence so long as some pious moral could be drawn from them at the end.

第四节　德国表现主义及北欧

第一次世界大战消减了法国电影对于德国、美国、意大利和丹麦等国的影响，并使德国以首创的表现主义电影一举确立了德国电影在国际影坛不可动摇的重要地位。根植于北欧神话传说、哥特式文化氛围和霍夫曼恐怖故事，又结合战败后瘟疫般的精神沮丧、经济危机和社会动荡，德国表现主义电影通过变形的布景和构图、浓重的阴影布光、倾斜和弯曲的线条、非自然的服装和化妆以及主观性的摄影机运动，创造出焦虑不安、令人窒息的梦魇世界。以《卡里加里博士的小屋》为代表的表现主义电影对后来美国的黑色电影和黑帮片等产生过深远影响。

German Expressionism and the German Film Industry

Between about 1919 and 1930, a number of films were made in Germany which have since been constituted as a movement called 'German Expressionism'. The term Expressionism (borrowed from painting and theatre) refers to an extreme stylization of *mise en scène* in which the formal organization of the film is made very obvious. The stylistic features of German Expressionism are fairly specific and include chiaroscuro lighting, surrealistic settings and, frequently, a remarkable fluidity of mobile framing. The "gothic" appearance of these films is often accompanied by similar acting styles and macabre or "low-life" subject matters. The overall effect is to create a self-contained fantasy world quite separate from everyday reality, a world imbued with angst and paranoia in the face of that which

cannot be rationally explained. This "other world" often functions as criticism of bourgeois society, though not always.

Analyses of German Expressionism tend either to assert that the films of a nation reflect its "mentality" in a more direct way than other artistic media or, ignoring the industrial context which marks cinema as different from other artistic media, they elect the director as *auteur*. Historian Siegfried Kracauer prefers the former approach; nevertheless, he begins with the industry itself rather than with either national character or *auteurs*:

"Since in those early days the conviction prevailed that foreign markets could only be conquered by artistic achievements, the German film industry was of course anxious to experiment in the field of aesthetically qualified entertainment. Art ensured export, and export meant Salvation" (Kracauer, 1974).

Although the origins of German cinema can be traced back to the 1890s, the output of the German film industry before World War I was relatively insignificant, and movie theaters showed mostly foreign imported films. The outbreak of war in 1914 resulted in the imposition of import restrictions, and in the absence of American, Italian, French or Danish competition, a number of German production companies were created to exploit the newly expanded domestic market. According to Kracauer, the number of such companies rose from 28 in 1913 to 245 in 1919. During this period of consolidation, the German government, increasingly aware of cinema's propaganda potential for supporting an unpopular war, founded Deulig (1916), an amalgamation of independents involved exclusively in the production of propaganda shorts, and Bufa (1917) an agency concerned with providing frontline troops with a steady supply of films and film theatres.

By the end of the war some industrialists were beginning to recognize the economic advantages of paying close attention to foreign audiences, and accordingly in December 1917 the Universum Film AG (Ufa) was set up to facilitate further unification of the film industry. One third of Ufa's finance came from the State, and the rest from banking interests and big business. Almost at once Ufa became the major production company in Germany, attracting foreign film-makers (like Alfred Hitchcock) and embarking on co-productions with other countries which were to give it considerable control of the post-war international market.

The end of the war, the collapse of the November uprising and massive inflation all contributed to an export boom in the German film industry that began in 1919. Of 250-odd independent production companies in Germany that year DeclaBioscop was second only to Ufa in assets and output. Its chief executive was Erich Pommer, who was convinced that foreign markets could only be conquered by artistic achievements. Perhaps the earliest artistic success among Decla's output was *The Cabinet of Dr. Caligari* (1919), which inaugurated a long series

of entirely studio-made films. Kracauer (1974) suggests that this withdrawal into the studio was part of a general retreat into a shell, but it may also be explained in terms of rationalisation of the film industry in the immediate post-war period. *The Cabinet of Dr. Caligari* is generally regarded as the film which first brought Expressionism to the German cinema. After the war, the German film industry had concentrated on spy and detective serials, sex exploitation films and historical epics in an attempt to control the domestic and foreign markets. *Caligari* started a stylistic movement, borrowed from avant-garde painting, theatre, literature and architecture, which for a few short years became Germany's internationally-respected national cinema, successfully differentiated from, and competing with, those of other countries, particularly America.

In 1921, the year in which *The Cabinet of Dr. Caligari was* finally premiered in New York, and subsequently became an international success, Decla-Bioscop was absorbed by Ufa along with producer Erich Pommer. Two years later Pommer became overall head of Ufa film production. One of the last Decla-Bioscop films to be made before Ufa took over was *Der mude Tad* (*Destiny*, 1921). Shot in a nineweek period and involving three exotic settings - one Arabic, one Venetian and one Chinese - the film illustrated the kind of ingredients that German companies were inserting into their films in order to appeal to the international, and particularly the American, market.

During this period, there was a considerable amount of vertical integration in the German film industry, and Ufa continued to expand throughout the early 1920s, absorbing a number of smaller production companies as well as larger enterprises like Decla-Bioscop. *Dr. Mabuse der Spieler* (1921), for instance, was a co-production of Ullstein-Uco Film and Decla-Bioscop, and released by Ufa. Despite its length of more than three hours, *Dr. Mabuse der Spieler* was successful at the box-office, perhaps because it was easy to market as a thriller. Its plot, concerning a gambler who makes a fortune on the stock exchange, can be related interestingly not only to the economic conditions of contemporary Germany but also to those of the film industry itself.

Another short-lived studio, Prana Film, supplied Ufa with its next bid for international success, *Nosferatu* (1922). In 1922, Ufa's capital stock was increased to 200 million marks, and the company was able to increase its dividend from 30% to 700% thanks mainly to a boom in its export business (inflation notwithstanding). What films like *Nosferatu* lacked in 'stars' was compensated for in its gothic subject matter and atmospheric visual style. By contrast, *Warning Shadows* (*Schatten*) (1922) exemplifies all the stylistic features of German Expressionism, but was unable to capitalise on them, apparently because the film only found a response among 'film aesthetes' and made no impression upon the general public.

Ufa, meanwhile, continued to produce, through its subsidiary Decla-Biosco,

large-budget and ambitious films. *Die Nibelungen* (1923-1924) for example, a two-part project, took a total of 31 weeks to shoot. But Ufa had overestimated the film's likely profitability. In 1924, with the settlement of German reparations under the Dawes plan, the mark was stabilized and Germany was reintroduced to the Gold Standard, leading American firms to invest in the German film industry. The export boom in the film industry collapsed almost as swiftly as it had started, and the market was once again flooded with imports. By the end of the year, 40% of the films being shown in Germany were American. Not surprisingly in the light of the changed situation, *Die Nibelungen* was a catastrophe at the box office.

Ufa's *The Last Laugh* (*Der letzte Mann*) (1924) met much the same fate as *Die Nibelungen*, despite the fact that the film's director, F.W. Murnau, was invited to Fox in Hollywood on the strength of its critical success. Although *The Last Laugh* received laudatory press notices it was a commercial failure. Expressionism as a national movement died out around 1924, though Expressionist tendencies can be found in later German films, and its influence can be seen in Hollywood, particularly in horror films and film noirs.

From 1926 until 1930, income from German film exports fell to less than 50% of total takings, and soon even Ufa was in difficulties. As Julian Petley has pointed out, enormously costly films aimed partly at an export art-house market clamouring for 'Expressionism' simply couldn't cover heir production costs.

Released in 1926, *Metropolis* was the most expensive German film to date: budgeted at 1,900,000 marks, production costs eventually exceeded 5 million marks.

"At one point the Ufa governing board had considered halting the production because of the enormous expense, but decided to complete the picture in the hope lat its distribution abroad, particularly in the United States, would recoup the losses. *Metropolis* proved to be a financial failure and in April 1927, Ufa, which controlled 75% of German film production, was organised by a new board of directors".

In producing such a failure Fritz Lang had employed some 800 actors, 30,000 extras and taken 310 days and 60 nights of filming. He was never permitted such an extravagant experiment again.

In order to stabilise a dangerous economic situation, the major German film companies made a series of agreements, disadvantageous to themselves, with the large American companies. In 1927 Paramount and MGM formed Parufamet with Ufa. The agreement was that Ufa would exhibit 20 of each of the American companies' releases in exchange for a total of 10 films to be distributed by MGM and Paramount, and a loan of 17 million marks. Other German companies made similar agreements: Terra with Universal, Rex with United Artists, Phoebus with MGM.

"The Government responded to the flood of imports with a quota law which decreed that for every foreign film released in Germany, a German film should be produced, but this resulted merely in a flood of ... cheap films often ... made solely to acquire a quota certificate ... Since the Americans wanted as many quota certificates as possible they even produced their own quota films in Germany".

The Parufamet deal and others like it offered the industry only temporary respite from receding receipts. These deals also represented the culmination of American attempts to bring the German film industry to rely on American financial support and thus to weaken its strongest foreign competitor. In 1927, however, Alfred Hugenberg, a powerful industrialist and fervent nationalist, acquired Ufa, buying out all American interests in the company. Ufa's production programme was rapidly rationalized and fewer films were hence-forth commissioned from independents. All but the best-funded of Ufa's rivals soon went under: as profits and production declined only the export end of the business was expanded. Aware as the German majors were of the dangers of financial, aesthetic and technological dependence upon America, they had little alternative.

Sound cinema, it was hoped, would cut down foreign imports because of language difficulties, while still allowing Germ: an exports to exploit the possibility of dual versions. German film companies had begun taking out patents on sound systems as early as 1924, and in 1929 an agreement was eventually signed to employ the Tobis-Klangfilm process. Some early Gel-man sound films, such as *The Blue Angel*, (*Der blaue Engel*) (1930), M (1931) and *Kameradschaft* (1931) all enjoyed international success. *The Blue Angel* and M, produced in English and German versions, made world-famous stars of Marlene Dietrich and Peter Lorre, while *Kameradschaft*, made simultaneously in German and French to suit its subject matter, was popular across Europe. By 1933, however, when M was finally released in America by Paramount both Lorre and Lang were already in the USA, as were Josef von Sternberg, director of *The Blue Angel*, and Dietrich.

1.《卡里加里博士的小屋》

罗伯特·维内（Robert Wiene）执导的《卡里加里博士的小屋》融合恐怖、幻想和心理变态等元素，依托三位先锋派画家绘制的夸张变形的场景和道具，将一个发生在疯人院内外的谋杀故事讲述得扑朔迷离，又将妄想狂疯子焦虑恐怖的内心世界展现得淋漓尽致。该片实现了表现主义者"用活生生的绘画来构造全片"的勃勃野心，也将电影化的视觉呈现推向一个新的高度。

The Cabinet of Dr. Caligari (1919)

The film that signaled the start of the new era, *The Cabinet of Dr. Caligari* (released in February 1920), is a tale of fantasy and horror with a psychological twist. It was produced by Erich Pommer for Decla-Bioscop before that company was absorbed by Ufa. The camerawork is primitive, and the direction is uneven, but the mood of this definitively antirealist film is unshakably disturbing.

Its central plot is a story of horror, murder, and almost mystical power. An enigmatic and menacing yet oddly seductive hypnotist, who calls himself Dr. Caligari (Werner Krauss), opens a stall at a fair in the town of Holstenwall; his act demonstrates his mastery over a sleepwalker he has apparently hypnotized, Cesare (Conrad Veidt). A rash of murders breaks out in the town. The police have no clues. The film's narrator-protagonist, Francis (or Franz, played by Friedrich Feher), suspects Caligari, shadows him, and eventually discovers that he forces his slave, Cesare, to murder the victims while the hypnotist substitutes a life-sized dummy resembling Cesare in the coffin-like box (the cabinet) to fool the police. Francis continues to follow the master who, it turns out, is also the director of the

《卡里加里博士的小屋》中怪异和神秘的场景

state insane asylum. The keeper of the insane is himself insane, a monster who has discovered the medieval formula of Caligari for controlling men's minds and who has set out to "become Caligari". Francis exposes the monster; the monster goes mad. The orderlies stuff Caligari into a straitjacket and lock him in a cell. This is as far as the central plot of Caligari goes. It is also as far as its writers, Carl Mayer and Hans Janowitz, wanted it to go.

But *Caligari* goes further. The entire central plot is bracketed by a frame, conceived by Fritz Lang. The film begins with Francis informing a listener (and us) that he has a dreadful story to tell. To set a horrific, supernatural tale within a frame is, of course, a traditional literary device (as in Mary Shelley's Frankenstein or Henry James's The Turn of the Screw), the means to anchor a fantastic story in reality (as well as isolate it, fence it in) and thereby increase our credulity. The setting of this opening, framing sequence seems like a park—there are trees, vines, a wall, benches. But it is too bare, too cold; the woman (Lil Dagover) who walks past seems somnambulistic, ethereal. Only at the end of the film do we discover that the opening and closing framing sequences are set not in a park but on the grounds of an asylum, that Francis himself is a patient, that many of the characters in his tale (like the gentle Cesare—who had died in the inner narrative but is now quite alive) are also patients, and that the so-called Caligari is the director of the asylum. And it is not *Caligari* who winds up in a cell with a strait, jacket but Francis. The surprise at the end of the film is our discovery that the tale we assumed to be true is a paranoid's fantasy.

Our discovery of the disease in the narrator's brain suddenly illuminates the principle of the film's unnatural decor. Throughout the film the Expressionist world of the horror tale has been striking: the grotesque painted shadows on streets and stairs; the irregular, nonperpendicular chimneys, doors, and windows; the exaggerated heights of the furniture; the boldly painted make-up. This grotesque world is not simply a decorative stunt; it is, thanks to Lang's psychological "twist", the way Francis sees the world. That was how Lang, the original director assigned to the project, saw it; how Robert Wiene did direct it; and why the writers objected. Rather than exposing an insane world (that could tyrannically send an innocent— or soldier—like Cesare to kill against his will), their story now implied that the world is fine, Francis is nuts, and *Caligari* knows best.

Caligari is interesting not just for how it looks but for the ambiguities generated by the tension between its inner and framing narratives. The central story is no simple tale told by an idiot. If the kindly doctor is really not the demented Caligari, why does it feel so creepy when he says, at the very end, that he now knows "how to cure" Francis? And why does the asylum look no more natural in the closing framing sequence (supposedly an objective point of view) than it did in Francis's narration?

Perhaps the film's ambiguities and internal contradictions stem from the conflict between the writers, who conceived one kind of story, and the director, who told another. Whatever the underlying reason, the ambiguities and ambivalences of Caligari enrich it.

Although it started the Expressionist film movement, decisively influenced the horror film (which had flourished in Germany since 1913), and set the pattern for a film with an "unreliable narrator"—one of the key devices of modern fiction—*Caligari* has been attacked since it came out. Theorists André Bazin, Erwin Panofsky, and Siegfried Kracauer are unanimous in believing that the film is a cinematic mistake, that it "prestylizes reality", that it violates the inherent photographic realism of the medium, that it substitutes a world of painted artifice for the rich resources of nature. Despite these later arguments, the film had an immense influence not only in Germany but in France, where "Caligarism", though detested by some, inspired many of the early avant-garde experiments in abstract cinema, in film as "painting-in-motion" rather than as realistic narrative. If it was the first "art film" and the first feature that had to be shot in a studio, *The Cabinet of Dr. Caligari* has also been capable of scaring and fascinating audiences for scores of years.

2. 德国经典大师：朗格、茂瑙和巴布斯特

弗朗兹·朗格（Fritz Lang）与茂瑙（F. W. Murnau）、刘别谦（Ernst Lubitsch）并称为"德国电影三剑客"，纳粹德国甚至任命他为帝国电影总监（他连夜出逃拒绝这一头衔）。他的《大都会》对恐怖异化的未来世界进行了表现主义式的呈现，而《被诅咒的人》则将表现主义手法用于人性化的社会关注。1934年朗格定居好莱坞，长期致力于拍摄涉及人性道德的社会心理剧，却一直无法再现德国表现主义时期的辉煌。

英年早逝的电影天才茂瑙留下了宝贵的电影遗产，著名的《卑贱的人》触及社会人性敏感的心理神经，成为德国室内心理剧（Kammerspiel）的代表作品。他的《吸血僵尸》体现着德国表现主义的典型特征，而《日出》则赋予情感故事行云流水般的诗意。

乔治·威廉·巴布斯特（G. W. Pabst）以反映严峻现实生活的街道片《没有欢乐的大街》成为"新客观派"（New Objectivity）代表作，赢得电影化社会写实的国际声誉，并影响到后来的意大利新现实主义等电影运动。

《大都会》的科学家与人造人

《日出》的男人与女人

Fritz Lang

Born in Vienna, the son of a municipal architect, Fritz Lang began studying architecture, but in 1911 set out on a two-year journey around the world which ended in Paris, where he learnt painting while supporting himself by selling painted postcards and drawings. When war broke out he enlisted in the Austrian army. He served at the front and was wounded several times. In 1918, he moved to Berlin to write scripts, becoming a director in 1919. In 1920, he married the well-known screen-writer and novelist Thea von Harbou. All of Lang's subsequent German films were made in collaboration with her.

With Murnau and Lubitsch, Lang was one of the giants of the German silent cinema. His films helped to win a strong international audience for German films and maintain an aesthetic distinctiveness that offered a serious alternative to Hollywood. His fascination with the parallels between criminal psychology and ordinary psychological processes is already evident in *Dr Mabuse, der Spieler* (*Dr Mabuse, the Gambler*, 1922), in which an evil genius attempts to gain total control over society. Mabuse manipulates the stock market as easily as a private poker game, using hypnosis, seductive women, and psychological terror to drive his wealthy victims to self-destruction. Fittingly, it is a woman who causes Mabuse's inevitable downward spiral into a madness so profound that his once omnipotent vision is turned against himself as he hallucinates his victims returning from the dead to accuse him.

Die Nibelungen (1924) and *Metropolis* (1926) were lavish super-productions designed for international audiences. They were remarkable for the Persuasiveness of their artificial monumental words and their superb pictorial beauty in which dramatic contrasts in architectural scale and graphic composition convey their principal themes. Siegfried, the first part of Die Nibelungen, is characterized by strong geometrical patterns in contrast to the asymmetrical confusion that dominates Part 2, Kriemhilds Rache (Kriemhild's Revenge). The imbalance in visual composition correlates with the inhuman brutality of Kriemhild's revenge against her own family for Siegfried's murder, ultimately destroying two civilizations. In Metropolis, the rhythmic, forced march of the workers at the beginning is contrasted with their chaotic attempts later to escape the flood they have let loose on their own homes. As in Die Nibelungen, a woman is the vehicle for the destruction of an entire society: the "bad" Maria (Brigitte Helm), a sexy, hypnotic robot created to wreak havoc on the workers, is a replica of the "good" Maria, who unites the workers through their blind faith in her as their saviour. The tyrant's son falls in love with the virginal Maria only to be deceived by her deceitful, evil twin, much as the workers are. In the end, brotherly love unites the tyrant with the workers and, unconvincingly, everyone seems to win.

In Lang's first sound film, *M* (1931), Peter Lorre portrays a serial child murderer whose crimes terrorize an entire city. The twin forces of the police and the underworld, at times deliberately juxtaposed through editing to emphasize the similarities between their organizations and motives, race against each other to capture the person responsible for disrupting both spheres of business. If the underworld is the dark mirror of the police, the murderer's unconscious compulsion to repeat his crime is the dark side of his rational self, and he is helpless to control it. Nazi censors did not approve the release of Lang's next film, *Das Testament des Dr Mabuse* (1932). According to Lang, he was then summoned to a meeting with oebbels who, rather than discuss the film, announced that Hitler wanted him to head the Nazi film industry. Lang, however, promptly left Germany for Paris and ended his marriage with Thea von Harbou, who was sympathetic to the new regime. In 1934 he moved on to Hollywood with a one-year contract from MGM. Between 1936 and 1956, Lang was to make twenty-two American films, changing studios almost continuously.

While waiting for his assignment from MGM, Lang took steps to gain fluency in American popular culture so he could understand his new audience. Above all, he was told, Americans expect characters to be ordinary people. With this lesson in mind, Lang convinced the studio to let him make *Fury* (1936), a film in which an ordinary man is mistakenly arrested on suspicion of kidnapping and possibly murdering a child and eventually succeeds in wreaking revenge on his accusers while sacrificing his family and sweetheart in the process. One of Lang's most powerful films, Fury shows the inhabitants of a small town turning into a lynch mob under instigation from the media, but it also shows (as do other of Lang's films, from *Kriemhild's Revenge* to *The Big Heat*, 1953) how revenge dehumanizes people-not only the mob, but also the hero himself.

In Lang's German films, the spectator is in a superior position of knowledge to the characters. This omniscience is undermined in the American films, where circumstantial evidence plays a large role, and where appearances are often deceptive for the spectator as well as the characters. In *You Only Live Once* (1936), circumstantial evidence and Lang's framing, lighting, and point-of-view editing lead the audience to believe that the ex-convict committed another robbery, despite his fiancée's trust in his innocence. As in Fury, at the end of the film romantic love is wholly believable and social change still seems possible. In the films Lang was to make twenty years later, this is no longer the case.

After some unusual Westerns and a series of suspenseful anti-Nazi films (including *Hangmen Also Die*! (1942), with Brecht collaborating on the script), Lang went on to make three films starring Joan Bennett. The success of the dreamlike suspense drama *The Woman in the Window* (1944) led to a partnership with Bennett's husband, producer Walter Wanger, in two further films which portray

the fatalistic dreamscape of film noir in explicitly psychoanalytic terms: *Scarlet Street* (1945), *a remake of Renoir's La Chienne* (1931) and *Secret beyond the Door* (1947)....

Lang's films during the 1950s are sharply critical of the American media, particularly While *the City Sleeps* (1955) and *Beyond a Reasonable Doubt* (1956). He presents his characters in an increasingly distant manner, discouraging audience identification in the usual sense and communicating instead through structure, repetition, editing, and effects of mise-en-scène. His most successful film of this period, The Big Heat, escapes depersonalization through the exceptional performances of Gloria Grahame and Lee Marvin.

At the end of his career Lang returned briefly to Germany to shoot two films based on his adventure scripts from the 1920s: the two-part *Der Tiger von Eschnapur/Das indische Grabmal* (1959) and a third Mabuse film set in the age of surveillance cameras (the paranoid icon par excellence), *Die tausend Augen des Dr Mabuse* (1960). These films show an extreme stylization and distillation of Lang's preoccupations and incorporate references to many of his earlier films.

In the eyes of some critics, there are two Fritz Langs: the mighty genius of the German period, and the American refugee who became a cog in the wheels of the Hollywood film industry and was never again able to achieve mastery over his art. In the 1950s this received opinion was challenged, particularly in the French magazine Cahiers du cinéma. Lang's American films were seen as enactments of a personal vision that articulated a deeply moral view of the individual's place within society. His pessimism and his return to individuals who are caught by accident in a series of events that spiral out of their control is consistent throughout his career, as is his preoccupation with structures of doubling and reversal, processes of psychological manipulation, and the limits of rationality and social institutions. In 1963, Lang played himself in Godard's Contempt (Le Mépris), a director persisting-in articulating his own vision in the cinema with seriousness and dignity despite the depersonalizing conditions of the international co-production.

F. W. Murnau

One of the most gifted visual artists of the silent cinema, F. W. Murnau made twenty-one films between 1919 and 1931, first in Berlin, later in Hollywood, and finally in the South Seas. He died prematurely in a car accident in California at the age of 42. Born Friedrich Wilhelm Plumpe in Bielefeld, Germany, Murnau grew up in a cultured environment. As a child, he immersed himself in literalry classics and staged theatrical productions with his sister and brothers. At the University of Heidelberg, where he studied art history and literature, he was sported by

Max Reinhardt in a student play and offered free training at Reinhardt's school in Berlin. When the war began in 1914, he enlisted in the infantry and fought on the Eastern Front. In 1916 he transferred to the air force and was stationed near Verdun, where he was one of the few from his company to survive.

In *Nosferatu* (1921), Murnau created some of the most vivid images in German expressionist cinema. Nosferatu's shadow ascending the stairs towards the woman who awaits him evokes an entire era and genre of filmmaking. Based on Bram Stoker's Dracula, Murnau's Nosferatu is a "symphony of horror" in which the unnatural penetrates the ordinary world, as when Nosferatu's ship glides into the harbour with its freight of coffins, rats, sailors' corpses, and plague. The location shooting used so effectively by Murnau was rarely seen in German films at this time. For *Lotte Eisner* (1969), Murnau was the greatest of the expressionist directors because he was able to evoke horror outside the studio. Special effects accompany Nosferatu, but because no effect is repeated exactly, each instance delivers a unique charge of the uncanny. The sequence that turns to negative after Nosferatu's coach carries Jonathan across the bridge toward the vampire's castle is quoted by Cocteau in Orphée and Godard in Alphaville. Max Schreck as Nosferatu is a passive predator, the very icon of cinematic Expressionism.

The Last Laugh (*Der letzte Mann*, 1924), starring Emil Jannings, is the story of an old man who loses his job as doorman at a luxury hotel. Unable to face his demotion to a menial position, the man steals a uniform and continues to dress with his usual ceremony for his family and neighbours, who watch him come and go from their windows. When his theft is discovered, his story would end in tragedy were it not for an epilogue in which he is awakened, as if from a dream, to news that he has inherited a fortune from an unknown man he has befriended. Despite the happy ending required by the studio, this study of a man whose self-image has been taken away from him is the story of the German middle class during the ruinous inflation of the mid-1920s. Critics around the world marvelled at the 'unbound' (entfesselte), moving camera expressing his subjective point of view. Murnau used only one intertitle in the film, aspiring to a universal visual language.

For Eric Rohmer, *Faust* (1926) was Murnau's greatest artistic achievement because in it all other element's Were subordinated to mise-en-scène. In *The Last Laugh* and *Tartüff* (1925), architectural form (scenic design) took precedence, Faust was the most pictorial (hence, cinematic) of Murnau's films because in it form (architecture) was subordinated to light (the essence of cinema). The combat between light and darkness was its very subject, as visualized in the spectacular "Prologue in Heaven". "It is light that models form, that sculpts it, The filmmaker allows us to witness the birth of a world as true and beautiful as painting, the art which has revealed the truth and beauty of the visible world to us through

the ages" (*Rohmer* 1977). Murnau's homosexuality, which was not acknowledged publicly, must have played a role in aestheticizing and eroticizing the body of the young Faust.

Based on the phenomenal success of The Last Laugh, Murnau was invited to Hollywood by William Fox. He was given complete authority on *Sunrise* (1927), which he shot with his technical team in his accustomed manner, with elaborate sets, complicated location shooting, and experiments with visual effects. Sunrise: A Song of Two Humans is about sin and redemption. A femme fatale from the city (dressed in black satin like the arch-tempter Mephisto in Faust) comes to the country, where she seduces a man and nearly succeeds in getting him to drown his wife before he recovers himself and tries to recreate the simplicity and trust of their lost happiness. Sunrise overwhelmed critics with its sheer beauty and poetry, but its costs far exceeded its earnings and it was to be the last film Murnau made within a production, system which allowed him real control. His subsequent films for Fox, Four Devils and City Girl, were closely supervised by the studio. Murnau's decisions could be overridden by others, and in his eyes both films were severely damaged. None the less, City Girl should be appreciated on its own terms as a moral fable in which the landscape (fields of wheat) is endowed with exquisite pastoral beauty that turns dark and menacing, as in Nosferatu, Faust, and Tabu.

In 1929 Murnau set sail with Robert Flaherty for the South Seas to make a film about western traders who ruin a simple island society. Wanting more dramatic structure than Flaherty, Murnau directed *Tabu* (1931) alone. It begins in "Paradise", where young men and women play in lush, tropical pools of water. Reri and Matahi are in love. Nature and their community are in harmony. Soon after, Reri is dedicated to the gods and declared tabu. Anyone who looks at her with desire must be killed. Matahi escapes with her. 'Paradise Lost' chronicles the inevitability of their ruin, represented by the Elder, who hunts them, and by the white traders, who trap Matahi with debt, forcing him to transgress a second tabu in defying the shark guarding the black pearl that can buy escape from the island. In the end, Matahi wins against the shark but cannot reach the boat carrying Reri away. It moves across the water as decisively as Nosferatu's ship, its sail resembling the shark's fin. Murnau died before *Tabu*'s première.

G. W. Pabst and New Objectivity

The first feature of G. W. Pabst was in the Expressionist style: Der Schatz ("The Treasure", 1923). His next, *The Joyless Street* (1925), remains the most widely seen of the street films. Set in Vienna during the period of hyperinflation, the film follows the fates of two women: Greta, the middleclass daughter of a civil servant,

and Maria, a woman from a poverty-ridden home. When Greta's father loses his money, she is nearly prostituted, while Maria becomes the mistress of a rich man. The Joyless Street portrays the era's financial chaos, perhaps most vividly in the scenes of women lining up to buy meat from a callous butcher who extorts sexual favors in exchange for food. (Owing to the film's controversial subject matter, it was often censored abroad, and truncated versions still circulate.)

Pabst's subsequent career was uneven. He turned out some ordinary films, such as the conventional triangle melodrama Crisis (1928). However, his Secrets of a Soul (1926) was the first serious attempt to apply the tenets of the new Freudian school of psychoanalysis in a film narrative. This desire for a scientific approach to psychological problems marks Secrets of a Soul as another variant of the New Objectivity. It is virtually a case study, following a seemingly ordinary man who develops a knife phobia and seeks treatment from a psychoanalyst. Though the depiction of psychoanalysis is oversimplified, the Expressionist style of some of the dream sequences adds considerable interest to the film.

Pabst also made another major New Objectivity film, The Loves of Jeanne Ney, in 1928. amous opening exemplifies what critics admired in his work. Rather than showing the villain immediately, the sequence begins with a tightly framed panning shot that builds a quick sense of his character though realistically observed details.

Pabst's two late silent films starring the luminous American actress Louise Brooks, Pandora's Box (aka Lulu, 1929) and Das Tagebuch einer Verlornenen (Diary of a Lost Girl, 1929), enhanced his reputation and have received renewed attention recently. By the late 1920s he was a favorite with critics and intellectual audiences in Europe and the United States. Pabst also made some of the most notable early German sound films.

3. 乌发电影公司

德国乌发电影公司（UFA）于1917年由一系列小公司整合而成，政府出资三分之一意在提升战时的国内民族士气、并以高质量的作品扩大德国电影在海外的影响，战败后出售给德意志银行等私营企业。20世纪20年代，魏玛时期的乌发公司在埃里希·波默（Erich Pommer）领导下，汇聚了刘别谦、朗格、茂瑙、巴布斯特和斯登堡（Josef von Sternberg）等众多导演大师，成为群星灿烂的德国电影大本营。

纳粹德国在20世纪30年代接管乌发公司，使其沦为宣传工具，并在1945年关张大吉。

乌发公司

UFA

UFA, Universum Film A.G., Universum Film Aktien Gesellschaft. A major and internationally influential film company organized in Germany in 1917 when a number of smaller production companies were brought together, with the government supplying one-third of the financial support for the new organization. The initial aim of the new company was to uplift the spirit of the German people at home and increase the reputation of the nation abroad through a national cinema with the highest standards of production. The company built its impressive studios at Neubabelsberg, near Berlin, and began to put together a staff of performers, directors, and production personnel that was equaled only by the staffs of the major studios in Hollywood; it also began to develop its distribution capacity and accumulate a large number of theaters, becoming the most important force in Germany's film industry. In 1918, after Germany's defeat in World War I, the government sold its shares in the company to the Deutsche Bank and several private corporations, thus making UFA into a private organization dependent upon its financial success in the international market place. UFA, seeking to produce lavish costume spectacles similar to those coming out of Italy such as *Cabiria* (1914), produced Joe May's *Veritas Vincit* in 1918 and a number of lavish historical dramas directed by Ernst Lubitsch, most notably his international success *Madame Dubarry* (entitled *Passion in America*) in 1919, which starred Pola Negri. In the same year the company released *The Cabinet of Dr. Caligari*, directed by Robert Wiene. The first of its great expressionist works, this motion picture also marked the start of Germany's "Golden Age of Film". The three most significant directors

to work for UFA were Fritz Lang, among whose films were his visually evocative two-part version of the Sigfried legend, *Die Nibelungen* (1924), and his futuristic fantasy, *Metropolis* (1927); F. W. Murnau, whose classic horror film *Nosferatu* (1922) remains one of the best treatments of the vampire story and whose 1924 film, *The Last Laugh* (Der Letzte Mann in German), is the best of the Kammerspiel (i.e., "intimate theater") films made by UFA; and G. W. Pabst, a stunning realist and film stylist who directed the "street" film, *Joyless Street* in 1925 and *Pandora's Box* in 1929.

In spite of Erich Pommer's excellent administration as chief of production beginning in 1923 and the many fine films produced by the company, UFA's financial fortunes progressively worsened during the decade because of the high cost of its productions and American competition. An agreement signed with Paramount and MGM in 1926 brought UFA a desparately needed loan, but at the cost of opening its theaters, at disadvantageous terms, to films from the American companies and making available to Hollywood its best personnel. The very next year the American interest was bought out by Dr. Alfred Hugenberg, a National Socialist supporter who became chairman of the board and moved the company in a decidedly political direction, especially by having UFA newsreels give prominent attention to Nazi rallies. With the coming of sound, UFA produced a number of musical films, but moved further in a political direction once the National Socialists came into power in 1933 by making blatantly pro-Nazi movies. In 1937, the government actually took over the company, which, after a dismal period, was to expire with Nazi Germany at the end of the war in 1945.

4. 北欧电影、德莱叶和《圣女贞德》

北欧斯堪的纳维亚电影的影响主要来自于丹麦和瑞典。丹麦导演大师卡尔·西奥多·德莱叶（Carl Theodr Dreyer）的《圣女贞德》以其经典的黑白摄影和精致的近景特写展现纯粹的视觉化美感，而瑞典导演莫里兹·斯蒂勒（Mauritz Stiller）凭借《哥斯塔·伯林的故事》将格丽泰·嘉宝（Greta Garbo）介绍到好莱坞，维克多·斯约特洛姆（Victor Sjostrom）又通过《幽灵马车》成为伯格曼的导师（曾主演的《野草莓》也成为斯约特洛姆的电影绝唱）。

Scandinavian Cinema

No countries with populations so small, British film historian Forsyth Hardy

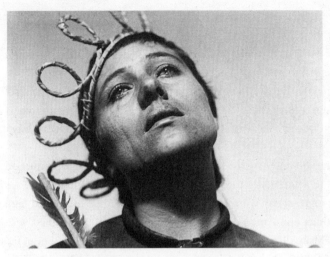

《圣女贞德》受难的偶像

wrote in the early 1950s, had made so great a contribution to world cinema as Sweden and Denmark (and this was before Sweden's Ingmar Bergman became famous as a leading director of international art cinema). Denmark's Nordisk company was one of Europe's leading film producers before World War I. Carl Th. Dreyer of Denmark, whose directing career covered six decades, ranks among the most important figures of film history, and his work is treated throughout this book. Danish actress Asta Nielsen was a star of German silent cinema; because German films of the 1910s are so little known, her fiery, passionate performances have not received sufficient recognition.

After World War I the Swedish company Svensk Filmindustri, formed in 1919 from a merger of smaller firms, became the major production center in the Scandinavian countries. Swedish films gained international stature through the work of directors Mauritz Stiller (1883-1928) and Victor Sjöström (1879-1960). Born in Finland, Stiller began working in Swedish films in his late twenties. His principal films include *Erotikon* (1920), a comedy of manners, and Gösta Berlings saga (known in English as *The Story of Gösta Berling* or *The Atonement of Gösta Berling*, 1924). The latter film marked Greta Garbo's second screen appearance, and Stiller became her mentor.

They went to Hollywood together in 1925 with contracts from MGM; whether the studio hired Stiller only to secure Garbo, or whether the actress was signed at the director's insistence, has been a matter of conjecture ever since. Stiller was able to finish only one film, *Hotel Imperial* (1927 for Paramount), before returning to Sweden, where he died in 1928.

Sjöström began directing in 1912 and also performed in both his own films and those of other directors. Two of his early Swedish films continue to circulate widely: Berg-Ejvind och hans hustru (literally "Berg-Ejvind and His Wife", known in English as *The Outlaw and His Wife*, 1918), filmed on location in rugged mountain terrain and admired for its realism, and Körkarlen (literally "The Coachman", known in English as *The Phantom Chariot*, 1921).

Sjöström went to Hollywood in the 1920s and adopted the name Victor Seastrom; he directed several notable films, including *The Wind* (1928) with Lillian Gish. Returning to Sweden in 1930, he worked thereafter mainly as an actor. His last film appearance was in Bergman's Smultronstället (*Wild Strawberries*, 1957).

Carl Theodor Dreyer: European Director

The epitome of the international director of the late silent era was Carl Dreyer (1889-1968). He began in Denmark as a journalist and then worked as a scriptwriter at Nordisk from 1913 on, when the company was still a powerful force. Dreyer's first film as a director, *The President* (1919), used traditional Scandinavian elements, including eye-catching sets, a relatively austere style, and dramatic lighting. His second film, Leaves from *Satan's Book* (1920), was also made for Nordisk; influenced by D. W. Griffith's Intolerance, it told a series of stories of suffering and faith.

At this point, one of the pioneers of Nordisk, Lau Lauritzen, departed, and the company declined. Both Dreyer and Benjamin Christensen left to work in Sweden for Svenska, Christensen making Witchcraft though the Ages while Dreyer did a bittersweet comedy, *The Parson's Widow* (1920). Over the next few year, Dreyer moved between Denmark and Germany, making *Michael* (1924) at the Ufa studio. Back in Denmark, he moved to the rising Palladium firm and made *Thou Shalt Honor Thy Wife* (aka *The Master of the House*, 1925). This chamber comedy shows a family deceiving an autocratic husband in order to make him realize how he has bullied his wife. It established Dreyer's reputation internationally and particularly in France. After a brief sojourn in Norway making a Norse-Swedish coproduction, Dreyer was hired by the prestigious Société Générale de Films (which was also producing Gance's Napoléon) to make a film in France.

The result was perhaps the greatest of all international-style silent films, *The Passion of Joan of Arc* (1928). The cast and crew represented a mixture of nationalities. The Danish director supervised, Hungarian cinematographer Rudolph Maté, and designer Hermann Warm, who had worked on Caligari and other German Expressionist films. Most of the cast was French.

Joan of Arc blended influences from the French, German, and Soviet avant-

garde movements into a fresh, daring style. Concentrating his story on Joan's trail and execution, Dreyer used many close-ups, often decentered and filmed against blank white backgrounds. The dizzying spatial relations served to highlight the actors' faces. Dreyer used the newly available panchromatic film stock, which made it possible for the actors to do without makeup. In the close framings, the images revealed every facial detail. Renée Falconetti gave an astonishingly sincere, intense performance as Joan. The sparse settings contained touches of muted Expressionist design, and the dynamic low framings and the accelerated subjective editing in the torture-chamber scene suggested the influence of Soviet Montage and French Impressionism.

Despite criticisms that *Joan of Arc* depended too much on lengthy conversations for a silent film, it was widely hailed as a masterpiece. The producer, however, was in financial difficulties after Napoléon's extravagances and was unable to support another Dreyer project. Since Danish production was deteriorating, Dreyer turned to a strategy common among experimental filmmakers: he found a patron. A rich nobleman underwrote *Vampyr* (1932) in exchange for being allowed to play its protagonist.

As the name suggests, *Vampyr* is a horror film, but it bears little resemblance to such Hollywood examples of that genre as Dracula (which Universal had produced the previous year). Instead of presenting bats, wolves, and clear-cut rules about vampires' behavior, this film evokes unexplained, barely-glimpsed terrors. A tourist who stays at a country inn in a foggy landscape encounters a series of supernatural events as he wanders around the neighborhood. He finds that the illness of a local landowner's daughter seems to be connected with her mysterious doctor and a sinister old lady who appears at intervals. The protagonist's investigation brings on a dream in which he imagines himself dead. Many scenes in Vampyr give a sense of dreadful events occurring just offscreen, with the camera tracking and panning just too late to catch them. Dreyer used lighting, misty landscapes, and camera movement to enhance the macabre atmosphere.

Vampyr was so different from other films of the period that it was greeted with incomprehension. It marked the end of Dreyer's international wanderings. He returned to Denmark and, unable to find backing for another project, to life as a journalist. During World War II, he recommenced feature filmmaking.

第五节　苏俄蒙太奇

1. 苏俄蒙太奇理念和社会主义现实主义

　　一直作为法国和斯堪的纳维亚电影殖民地的俄罗斯在 1907 年建立了自己的电影公司，虽然在接下来的十年间成效不大，但 1917 年的十月革命却改变了世界电影的基本格局。第一次世界大战和十月革命后西方世界的封锁，使苏俄电影举步维艰，但正是这样严酷的环境培育了绽放的蒙太奇电影艺术之花。

　　鉴于列宁对于意识形态宣传和电影的极端重视，苏俄在 1919 年创建了全球第一所电影高校——莫斯科电影学院（VGIK，爱森斯坦、普多夫金、杜甫仁科、罗姆和格拉西莫夫都曾在此任教，而塔尔科夫斯基、邦达尔丘克、帕拉杰诺夫、米哈尔科夫和索科洛夫也都毕业于此），曾任学院领导人的列夫·库里肖夫（Lev Kuleshov）指导学生利用收缴的欧美电影拷贝（包括格里菲斯的《党同伐异》）进行剪辑实验，证明剪辑产生意义（A 镜头分别与 B、C、D 镜头组接后，A 镜头本身的含义会发生变化），"库里肖夫效应"（Kuleshov effect）成为蒙太奇理论的坚实基础。

　　库里肖夫的得意门生普多夫金（Vsevolod I. Pudovkin）称"电影的基础是剪辑"，并将蒙太奇定义为"组接和堆砌"；而爱森斯坦 (Sergei Eisenstein) 则将蒙太奇界定为"对立和冲突"，并系统地阐述了从"杂耍蒙太奇"到"理性（辩证）蒙太奇"的演进和电影蒙太奇技巧强烈的表意功能。

　　爱森斯坦等电影大师对于蒙太奇的偏爱和苏俄政权对于意识形态宣传的倚重，致使斯大林时代所谓的"社会主义现实主义"原则长期主导苏俄的电影创作。

The Soviet Cinema: Industry and Aesthetics

Until 1907 the only film companies operating in Russian were foreign, and the domestic market was dominated by the likes of Lumière Brothers and Pathé. In 1907, however, the first Russian production company, Drankov, was set up in competition with the foreign films and film companies which nevertheless continued to flourish in Russia until the outbreak of World War I and the consequent collapse of the import boom. By 1917 there were more than twenty Russian film companies exploiting a steadily expanding home market, whose output consisted mainly of literary and dramatic adaptations, and costume spectaculars. This situation was suddenly and radically changed by the October Revolution. Veteran directors, actors and technicians emigrated as a period of violent transition totally disrupted normal conditions of production. The new Bolshevik government saw film as a vital tool in the revolutionary struggle, and immediately set about reconstructing the film industry to this end. On 9 November, 1917, a centralised film subsection of the State Department of Education, Narkompros, was set up. This centralisation was resisted at first by the private sector, which boycotted the State-sanctioned films, and even went so far as to destroy precious raw film stock. Lack of supplies of equipment and new film stock made production very difficult for the emerging revolutionary cinema, but nevertheless, by the summer of 1918 the first agit-trains (mobile propaganda centres) left for the Eastern front, specially equipped to disseminate political propaganda through films, plays and other media to the farthest corners of Russia.

The transition from entrepreneurial to State control of film production, distribution and exhibition proved a slow and difficult process, with post-war famine and continuing political and military conflict postponing the revival of the industry until the early to middle 20s. By 1920 Soviet film production had dwindled to a trickle, but in 1921 when Lenin's New Economic Policy encouraged a cautious short-term return to limited private investment releases rose from II in 1921 to 157 in 1924. The resumption of imports in the early 1920s following the restabilisation of the economy allowed profits to be ploughed back into domestic production, and, as film equipment and stock resurfaced, the several Soviet studios by then in existence began to expand to pre-revolution proportions. In 1922, Goskino, the State Cinema Trust, was established as a central authority with a virtual monopoly over domestic film production, distribution and exhibition m Russia, although certain companies retained a degree of independence, and film industries in the more distant republics were allowed some autonomy from Moscow and Leningrad. Studios were set up in the various regions, such as VUFKU in the Ukraine, while others, Mezhrabpom-Russ for example, expanded in mergers with private industry. In 1923 a special propaganda production unit,

Proletkino, was formed specifically for the production of political films in line with party ideology. Until 1924, films remained conventional in style, apparently untouched by the explosion of avant-garde experiment transforming the other arts in post-Revolutionary Russia. Then in 1925, when the industry was allowed an increased aesthetic independence in the wake of a Politburo decision endorsing State non-intervention in matters of form and style in the arts, the new Soviet cinema entered its most exciting and formally adventurous period.

By the mid-1920s all the production units including Goskino (renamed Sovkino in 1925), Proletkino, Kultkino, Sevzapkino and Mezhrabpom-Russ, had begun to assemble their own personnel - directors, cinematographers, editors and so on, as well as performers. Vsevolod Pudovkin worked at Mezhrabpom, Sergei Eisenstein at Sovkino, Alexander Dovzhenko at VUFKU, for example. During this period, cinema came into productive collision with the energetic theoretical and artistic activity taking place in the other arts. The work of poet Vladimir Mayakovsky and theatre director Vsevolod Meyerhold, for example, profoundly influenced the early work of Eisenstein, whose avant-garde film experiments were accompanied by an impressive body of theoretical writings which are still influential today.

In the wake of the 1925 Politburo decision, Eisenstein was commissioned by the Central Committee to produce a him commemorating the 1905 revolution. This film, *Battleship Potemkin*, was premiered at Moscow's Bolshoi Theatre, an indication of its industrial prestige. But despite a relatively positive critical response, the film's domestic release was relegated to Russia's second-run cinemas and its foreign sales delayed until pressure from influential writers, journalists and party officials induced Sovkino to send it to Berlin. Subsequently it was a huge international success, reflecting small credit on the conservative policies of the Soviet film industry at that time. *Battleship Potemkin*'s success heralded a series of ambitious and expensive productions. In 1926 Mezhrabpom-Russ released Pudovkin's *Mother*, another prestigious film which, like *Battleship Potemkin*, exceeded average budget allowances. By 1927 all the major production units were engaged in equally extravagant and prestigious projects in order to celebrate the tenth anniversary of the 1917 Revolution.

Emergence of Socialist Realism

In the words of the 1928 Congress resolution: "the basic criterion for evaluating the art qualities of a film is the requirement that it be presented in a form which can be understood by the millions". On completing *October* Eisenstein returned to the unfinished *The General Line* and decided to simplify his

experimentations to a level more easily understood by a general audience, choosing objects like a bull, a tractor and a cream separator to symbolise the transition from primitive farming to mechanised modern agriculture, though he did not abandon his montage experiments. *The General Line* was symptomatic also of the transition to centralised control of film production: indeed, its title was changed to *The Old and the New* because the original title was criticised for implying that the film had received official sanction which, for all its extensive re-editing on Stalin's orders, it never actually achieved. Earth was similarly symptomatic: its controversial poetic lyricism was condemned as "counter-revolutionary" and "defeatist", though it managed to escape outright prohibition.

Other projects managed to sidestep, if not altogether escape, the aesthetic consequences of the directives of the 1928 Congress by producing or selling films at some geographical distance from the metropolitan centres of power in the Soviet Union. The Vertov Unit's experimental *Man with a Movie Camera* (1929) was produced at VUFKU in the Ukraine, for instance. Vertov had been sacked by Sovkino in early 1927 and ordered to leave Moscow, in some measure no doubt because his work was regarded as overly formalist. With his editor wife Elisaveta Svilova and cameraman brother, Mikhail Kaufman (Kino-Eye's Council of Three), Vertov made his way to the Ukraine. Between 1926 and 1928 VUFKU was engaged in an embargo on all Sovkino films, and employed the exiled Vertov on condition that his first project would be to complete the film The Eleventh Year, which was to have been Vertov's contribution to Sovkino's celebration of the tenth anniversary of the October Revolution. Once this film was finished Vertov embarked on another ambitious project, *Man with a Movie Camera*, whose formal extravagance marks it off from others in the 1920s "City" cycle of films, exemplified by Kaufman's *Moscow*, Ruttmann's *Berlin*, Cavalcanti's *Rien que les heures* and Vigo's *A propos de Nice*. Vertov continued his imaginative experiments after the advent of sound, but then gradually faded away after Stalin's consolidation of power.

Stalin's decrees under his first Five Year Plan led to increased production of documentaries in support of its industrial objectives, and in 1930 Sovkino was dissolved and replaced by Soyuzkino, an organisation directly supervised by the Politburo's Economic (rather than as previously, the Education) Department. In future Soyuzkino, under Stalin's appointee Boris Shumyatsky, was to function in close correspondence with Proletkino. It also officially adopted the resolution of the 1928 Congress in determining its aesthetic policy. After a brief transition period in which some interesting sound experiments emerged (e.g. Vertov's *Enthusiasm*, 1931), the coming of sound in 1930 combined with government-imposed restrictions on form and content encouraged an increasing realism of dialogue and character. Musicals and literary adaptations dominated the film

industry's output, though there was also a spate of historical biopics celebrating the achievements of Lenin and Stalin. Eisenstein's first sound film *Alexander Nevsky* (1938) was made during this period, after a campaign by Shumyatsky to discredit and humiliate the director which involved hostile government interference in the production of Bezhin Meadow, and finally abandonment of the project. Only after a painful confession in which he was forced to renounce his film was Eisenstein assigned another important production, the patriotic *Alexander Nevsky,* intended to strengthen Russian national identity in the face of the growing threat from Nazi Germany. In 1938 Shumyatsky was sacked, though there was no change in policy as a result. The administrative reshuffling in the film industry which followed, combined with the outbreak of World War II, led to a reduction in film output and a revival of the documentary. During the war film industry personnel were evacuated from Moscow to remote parts of the USSR, and feature film production gave way to morale-boosting political propaganda in the form of documentary material gathered from the fronts. *Alexander Nevsky*, which had been made as implicit anti-fascist propaganda, was withdrawn in 1939 in the wake of the German-Soviet Pact. In 1940 Eisenstein, having emerged from disgrace for his formalism in 1938, was appointed artistic head of Mosfilm, the revamped Soyuzkino, and in 1945 won the Stalin Prize for Part I of *Ivan the Terrible*. The following year Eisenstein began work on a sequel, but Part II met with none of the support that had greeted Part I, and its release was postponed for a decade. During the Cold War period Stalinist repression reached its highest level, repudiating the faintest hint of formalism as deviation from Socialist realism, and several films were banned outright. It was only in 1956, three years after Stalin's death, that the effects of Khrushchev's denunciation of some aspects of Stalinism allowed a gradual withdrawal from the aesthetic orthodoxies of the Cold War years and a return to a more 'poetic' cinema.

2. 爱森斯坦和《战舰波将金》

"电影沙皇"谢尔盖·爱森斯坦不仅是彪炳史册的电影艺术大师，而且也是伟大的电影理论家。工程、舞台和美术背景加上强烈的马列意识形态倾向，使得爱森斯坦成为苏俄蒙太奇理论的核心和意识形态电影创作主将。《战舰波将金》成为苏俄电影的楷模，其中"敖德萨阶梯"段落更被称为蒙太奇理论的经典教科书案例。

爱森斯坦认为，蒙太奇的本质在于选取各种不同元素、在它们之间的动态冲突中产生一种全新的综合物（质变后的意义）、并对观众形成冲击和震撼。爱森斯坦援引黑格尔的"正反合"辩证法概念，将前后镜头作为元素正

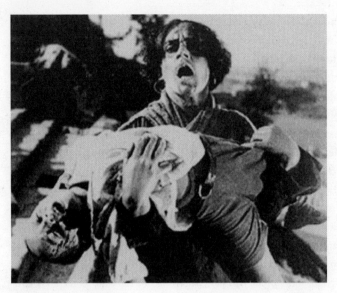

《战舰波将金》的敖德萨阶梯

题和元素反题组合在一起,产生重要的意义合题,而电影就是通过意义合题(主题思想)而非故事来建构的。爱森斯坦还总结阐述了杂耍蒙太奇、节奏蒙太奇、音色蒙太奇、隐喻蒙太奇和理性蒙太奇等概念,为世界电影艺术的发展提供了极具建设性意义的理论基础。

爱森斯坦还拍摄过《十月》《亚历山大·涅夫斯基》和《伊凡雷帝》等名片。命运多舛的他后期执教莫斯科电影学院,撰写过《电影感》《电影形式》《电影导演手记》和《有声电影宣言》等论文论著。

Sergei Eisenstein

Inspiration and challenge were surely among the goals of theater director Sergei Eisenstein (1898-1948) when he turned to full-time film work around the time of Mr. West. Within a few months of their release in 1925 his first two films, *Stachke* (*The Strike*).and especially *Bronenosets Potemkin* (*The Battleship Potemkin*), had given notice to the world of an important new presence. These were works that seemed to represent not only a personal triumph but also a revolutionary art forged in the aesthetic and ideological ferment of the new Soviet state. Though Eisenstein was soon to suffer the proverbial fate of prophets in their own countries, to those elsewhere who followed cinema and the arts the Soviet Union never had a more prestigious or persuasive ambassador.

Eisenstein's voluminous endeavors as the most important film theorist of his era mainly came later in his career, but even in his early theater work he was developing ideas that would have impact on his films. When his training as an engineer was interrupted by the revolution (he was nineteen), Eisenstein went into military service and eventually shifted toward the theater, working as a designer for agit-train productions. He became associated with Proletkult (the name stood for "proletarian cultural-educational organizations"), a group advocating the development of a new culture for the working classes. As designer, sometime actor, and then director, Eisenstein worked on experimental Proletkult theater productions. One strand of his efforts drew on an antinaturalistic "biomechanical" performance style, based on actors' movements rather than expressions of feeling (later, in his film work, Eisenstein preferred to cast "ordinary people" as performers rather than professional actors); another borrowed from popular entertainments like the circus and pantomime.

Theory of Montage

His first published essay, "*The Montage of Attractions*" (1923), though concerned with theater rather than film, related closely to the cinematic debates of the period. Like Kuleshov, Eisenstein emphasized the centrality of the spectator's response. He defined "attraction" as whatever element of a production "that subjects the audience to emotional or psychological influence". The stress is not on constructing a narrative or representing the actual world but on creating a shock that leads to audience perception and knowledge. In a sense Eisenstein's aesthetic harkened back to primitive cinema, with its play of spectacle rather than orderly narrative progression.

As he shifted into filmmaking Eisenstein developed and transformed his montage theories. He placed greater emphasis on what he called "intellectual montage", which built on the concept of "attraction" but which aimed, in the words of the French Eisenstein scholar Jacques Aumont, at "a conceptual effect… the production of meaning". Among the techniques he favored in "intellectual montage" were synecdoche (the part standing for the whole) and metaphor (in his cinematic usage, the juxtaposition of unrelated images to generate associations in the spectator's mind). A famous example of montage as metaphor is a sequence in *Oktyabr'* (*October*, 1928), in which a shot of a soldier in a trench is intercut with a shot of a tank rolling off an assembly line, metaphorically shaping an intellectual perception that the soldier is being (or will be) run over by the tank.

Eisenstein moved into film with a proposal from Proletkult to the state film organization to make a series of seven films on events leading up to the

Bolshevik revolution, "Towards Dictatorship of the Proletariat". The Strike and The Battleship Potemkin developed from that plan. The first film was a Proletkult project, but afterward the director and the group had an acrimonious falling-out (ostensibly from a dispute over whether Eisenstein should get a screenplay credit), and future work went forward with Eisenstein's own group of coworkers. His cinematographer Eduard Tisse and scriptwriter Grigori Alexandrov stayed with him.

Still, nearly all the director's films of the silent era grew out of this Proletkult concept—*October*, his third released film, was an assignment to commemorate the tenth anniversary of the 1917 revolution. We might consider the significance of these historical subjects, particularly from the viewpoint Soviet theorists placed such importance on, that of the audience. Eisenstein's historical films were addressed foremost to Soviet spectators, as works of interpretation and emotional reinforcement. "Proletarians, Remember!" exhorts the final intertitle in The Strike: remember how bad things used to be. They also spoke vividly to sympathizers elsewhere, who could be inspired to carry on their own struggles by visions of Soviet tribulations and triumphs. At the end of the twentieth century, however, what remains of these films' power? It's unlikely that their director would have accepted the idea that their art was separate from their ideology.

Perhaps the simple answer is that Eisenstein's films, viewed at far remove from their historical and contemporary struggles, both gain and suffer from ideology. Writing his own critique of *The Strike* some years later, the director stressed how the film was among the first to treat collective and mass action, to make the mass rather than the bourgeois individual the hero. What it failed to do, he said, was show the development of the individual within the collective. Only after the general image of the collective was established as a screen subject, Eisenstein reflected, could this deeper meaning be attained.

The Battleship Potemkin (1925)

The lessons of *The Strike* were applied immediately to *The Battleship Potemkin*. Drawn from events that occurred during an unsuccessful uprising against the Russian monarchy in 1905, the film depicts a mutiny aboard a naval vessel. In the first of five separate parts, or "acts", entitled "Men and Maggots", individuals were created among the sailors, and their discontent was made human and immediate through the rotten food they were given and their officers' cruelty and indifference. The mutiny itself, beginning on the ship's foredeck, is choreographed intimately rather than massively, as were the events in *The Strike*. Though filled with temporal leaps ("real time" becomes "reel time", and can be

《带摄影机的人》的电影眼睛

lengthened or foreshortened for psychological effects) and visual disjunctions, the editing style avoids The Strike's virtuoso display of effects for their own sake. Not much shorter in length than The Strike, The Battleship Potemkin has the appearance of a briefer, more direct work, moving forward tautly with an economy that seems to absorb its intricate and complex montage strategies.

ODESSA STEPS SEQUENCE. The events culminate in the Odessa Steps sequence, one of the most famous set-pieces in cinema history. As the crowds in the port city Odessa pour into the harbor area to view the liberated battleship and mourn a dead sailor soldiers appear behind them and march down the steps, firing their rifles. From the intertitle "Suddenly..". (in English-language versions), which introduces a shot of empty steps and then soldiers' boots beginning their downward march, the sequence lasts about four minutes twenty seconds, and contains approximately 155 separate shots. Though it may appear a welter of crowds and individuals, dose-ups and long shots, movement up and down, in ever accelerating tempo, the sequence also relies on specific narrative and character elements: the mother whose son is wounded and trampled, who picks up the child and confronts the soldiers, only to be shot in cold blood; the mother with the baby in a carriage, whose fall, after being shot in the stomach, sends the carriage careening down the steps; the older woman in a white scarf and pince-nez glasses, who first proposes appealing to the soldiers, then is slashed in the eye by a soldier's saber. The baby carriage segment perhaps deserves most detailed scrutiny for a sense of Eisenstein's montage principles and editing style. Strict temporality is discarded. Separate shots of the carriage wheels, ominously moving and then

precariously stopped, are intercut with the mother's fall, which is itself presented in separate, overlapping shots, elongating and repeating "real time". Over the years *The Battleship Potemkin* has received many tributes and homages from other filmmakers—for one Hollywood example, a careening baby carriage in a crucial sequence of Brian De Palma's *The Untouchables* (1987)—but few have come close to matching the intricacy and delicacy of Eisenstein's montage.

3. 普多夫金的《母亲》、维尔托夫和杜甫仁科

与爱森斯坦不同，普多夫金（Vsevolod I. Pudovkin）倾向于将蒙太奇理解为建构性的剪辑（汇集和组接），在节奏和情绪上也没有爱森斯坦那么极端，叙事更为流畅、人物性格更为鲜明。根据高尔基小说改编的《母亲》就利用蒙太奇和自然景象的震撼效果，强化了人性故事的情感力量和流畅叙事的剪辑功效，成为苏俄时代的电影经典。普多夫金还执导过《圣彼得堡的末日》和《成吉思汗的后代》等作品。

亚历山大·杜甫仁科来自乌克兰农村，民间文化、民族风情和自然美景构成了杜甫仁科电影的主体，承继俄罗斯诗性传统的他成为苏俄时代最具原创精神的"电影诗人"，他的《土地》和《兵工厂》也开创了俄罗斯"诗电影"传统的先河。

作为苏俄电影的先驱之一，吉加·维尔托夫（Dziga Vertov）将纪录片素材与意识形态政治宣言和实验电影手法巧妙地融合，拍摄出著名的《带摄影机的人》，影片提出"电影眼睛"（Kino Eye）的概念，首次直接呈现电影的反省性问题（关于拍电影的电影），并以"电影真理"（film truth）触及纪录电影的真实性。

Vsevolod I. Pudovkin

Vsevolod I. Pudovkin and Eisenstein were friendly opponents. Whereas Eisenstein's theory of montage was one of collision, Pudovkin's was one of linkage. For Pudovkin, the shots of the film combine to build the whole work, as bricks combine to make a wall, rather than conflict with one another in dynamic suspension. Pudovkin, a trained scientist, sometimes considered film viewers to be a bit like the dogs in the experiments of his contemporary, Pavlov: The proper cinematic stimulus could elicit the desired intellectual, physical, or emotional response. Eisenstein, however, believed that the method of argument itself must be

rigorously dialectical: Shot A collides with shot B to create concept (or metaphor) C. Eisenstein's goal was to convert cinematic practice into a means of dialectical reasoning. If his primary method was dialectical montage, Pudovkin's was constructive editing.

Whereas the tone and pace of an Eisenstein film are generally nervous and tense, exciting and jostling, the tone and pace of Pudovkin's are more intimate and measured. He reserves the shocking, violent montage effects for sequences of fighting and rebellion—or exuberance. Whereas Eisenstein's usual human focus is the mass, Pudovkin's is the individual, a single person's revolutionary decision rather than the revolutionary action of a whole group. Whereas Eisenstein's montage is rich in intellectual commentary, Pudovkin's assembles the scene or sequence out of relatively complementary shots to construct the action and advance its metaphoric and emotional complexity.

Pudovkin believed that the "plastic material"—visually expressive objects and images— could communicate emotions and ideas more effectively than any other cinematic tool. The writer or director must, he wrote, "know how to find and to use plastic (visually expressive) material: that is to say, he must know how to discover and how to select, from the limitless mass of material provided by life and its observation, those forms and movements that shall most clearly and vividly express in images the whole content of his idea". The fact that he followed this principle throughout his career gives his work a deeply rewarding degree of richness, power, and precision.

In 1920, Pudovkin began his studies at the State Film School, entering Kuleshov's workshop two years later. His scientific training ably suited him for his first major project, *Mechanics of the Brain* (1926), a cinematic investigation of Pavlovian research on conditioned reflexes in animals and children. He took time off from the Pavlov picture to shoot his first fiction film, *Chess Fever* (1925), an ingenious and charming short comedy that paid homage to his teacher, Kuleshov.

Mother (1926)

Pudovkin's unique style emerged in his later fiction films. In *Mother*, he reveals his ability to combine sensitive treatment of a human story, fluid narrative editing that uses the shock cutting of montage for isolated, showcase effects, and natural images that comment on the action and reinforce the film's values. Produced, like *Battleship Potemkin*, for the 20th anniversary of the ill-fated 1905 revolution, *Mother* is a loose adaptation of Gorky's novel about a woman (Vera Baranovskaya) who learns that radical action is the only protection against a wicked state. In 1905, her abusive, drunken husband (who isn't in the

novel) is lured into helping a group of strikebreakers; he is shot and killed in a scuffle. The mother then betrays her own son, Pavel (Nikolai Batalov), revealing to the police, whose promises she naïvely trusts, that the youth was in collusion with the strikers. The judges are more interested in dozing or breeding race horses than in administering justice; the unsympathetic gallery has come to the trial for a good sadistic show. The unjust social process turns the old woman into a radical. She helps her son escape from prison, and together they march in the forefront of a workers' demonstration. Although both she and Pavel die, cut down by the bullets of the Cossacks and the hooves of their horses, the story of her education serves as a model for all the workers of Russia mid a metaphor for the results of their education that would eventually surface in 1917.

Pudovkin's handling of actors and shaping of scenes are exceptional. His principle of acting—that the film's context, its decor its business, its use of objects work with the actor to create a performance—is demonstrated throughout Mother. A most effective example is the scene of mourning in which the mother sits by the corpse of her husband. Pudovkin alternates among several setups: a far shot of the mother sitting beside the bier, the walls gray and bare behind her; a close shot of water dripping in a bucket; a close shot of the mother's face, motionless. The mother's face needs no motion. Her still, quiet face—expressive plastic material, as much as the pan—mirrors all the sorrow that has been built around her.

The camera angle Pudovkin uses to shoot a scene is always significant. The far shot of the mourning mother beside the corpse is a downward shot from a high camera position (a high-angle shot). Pudovkin discovered that the downward angle emphasizes the characters' smallness, their feeling of being alone, their insignificance. Conversely, tile extreme upward angle (a low-angle shot) can magnify the self-importance of characters, their smugness and petty self-esteem—or can make them appear more formidable, like the guard outside the courthouse. Pudovkin mirrors the state of the mother's mind and the progress of her education with his choice of camera positions. He often shoots her from above before her conversion; he shoots her from below to ennoble her after it.

Like Eisenstein, Pudovkin knew how to analyze a quick action into its component movements to add emphasis, shock, and drama to the event. For example, in the climactic demonstration sequence, Pudovkin emphasizes the brutality of the slaughter by breaking the moment of the soldiers' initial attack into 13 shots. Out of the sudden loss and violence of this moment the mother learns her last political lesson; courageously, she picks up the fallen flag and walks toward the charging troops (an excellent series of cuts with contrasting directions and rhythms). Though they kill her, she dies a rebel, the metaphorical mother of the nation that is born with her death.

Alexander Dovzhenko

Alexander Dovzhenko was the third of the great Soviet directors. Though he shared both the political philosophy of Marx and the montage methods of Kuleshov with Eisenstein and Pudovkin, Dovzhenko's style was completely original. Unlike Eisenstein and Pudovkin, Dovzhenko came from the provinces, not the capital, from Ukraine, not Moscow or St. Petersburg. As early as his first major work, *Zvenigora* (1928), Dovzhenko's films are saturated in Ukrainian life and customs as well as in the folk-legend spirit and poetry of the country. His is a world where horses talk, where paintings of heroes in picture frames roll their eyes at the bastardization of their principles, where animals sniff the revolutionary spirit in the air. The Dovzhenko film is structured not as narrative but as lyric, a visual poetry that develops a theme and allows immense elliptical jumps in time, space, and continuity.

Arsenal (1928, released 1929) is the first of his mature film poems. Its subject is, roughly, the birth and growth of the revolutionary spirit in Ukraine. Whereas Pudovkin might develop such a theme by showing a single Ukrainian's radicalization, Dovzhenko seems to spread all the events of the revolutionary years before him and then to select those images and vignettes that appeal to him.

Dovzhenko uses a central figure—a soldier who deserts the czar to serve the revolution—as a loose peg on which to hang the film's action. Scenes with the soldier flow through *Arsenal*'s many vignettes. In the final sequence, the White army captures the soldier and shoots him. The Ukrainian soldier does not die; the bullets do not strike him. He stands there defiantly. Although the forces of tyranny can capture a single arsenal, although they can shoot a single rebel, they cannot murder the spirit of rebellion and freedom in the hearts of the people. The Ukrainian becomes an image of that spirit. His presence throughout the film has been as metaphor, not as traditional protagonist. Dovzhenko's films are not narratives of events but metaphors for the feeling and the significance of the events.

Dovzhenko's striking compositions in light and space reveal the eye of the painter he once was. Though his montage sequences are vivid and powerful, even more effective are the relatively long takes in which he allows a great image all the time it needs. And his painter's eye sees the power and tension of shooting with the tilted camera, on an angle to rather than parallel with the world he is filming.

Dovzhenko's greatest silent film poem, *Earth* (1930), is another series of images and vignettes, this one revolving around the earth, the harvests, the relationships of people, machines, and the cycles of life. His sound films, *Ivan*

(1932), Aerogard (1935), and *Shchors* (1939), also were daring, episodic, and imagistic. Not surprisingly, Dovzhenko ran into stiff Soviet criticism; he was the most elliptical director of them all. How could his films be socially useful if the audiences could not follow them? Dovzhenko made only two films in his last 15 years and died in 1956, another great innovative mind stifled by the state's ever-narrowing definitions of artistic utility.

Dziga Vertov

Dziga Vertov , one of the Soviet Union's pioneers in combining documentary footage with political commitment, experimental cinema with ideological statement, suffered similar artistic strangulation as Stalinism took hold—partly because he was a Jew, partly because his aesthetic was formalist, and partly because he didn't praise Stalin enough in the last film he was allowed to make, *Three Songs About Lenin* (1934). His brother, cameraman Boris Kaufman, left Russia to shoot all the films of Jean Vigo in France before going to Hollywood, where he shot such pictures as *On the Waterfront* (1954) and *The Pawnbroker* (1965). His other brother, cameraman Mikhail Kaufman, stayed to direct documentaries and shoot Vertov's *The Man with a Movie Camera* (1928, released 1929), one of the most distinctive and adventurous films of any era.

Dziga Vertov's intense energy was evident not only in his documentaries and manifestos, but also in the name he chose for himself, which translates roughly as "fidgety spinning top" (Dziga is Ukrainian for "spinning top" or "restless person"; Vertov is derived from the Russian verb "to rotate" or "to fidget"); he was born in Poland as Denis Kaufman. Vertov began by compiling footage into weekly newsreels in 1918-1919, went on to edit full-length compilation films and shoot some of his own footage in 1920-1922 (he called the camera his "Kino Eye"), then invented a documentary form that went beyond the reportage of the newsreel into creative journalism: a series of shorts that were called newsreels but each focused on specific topics and themes. That series, which ran from 1922 to 1925, was Kinó-Pravda ("film truth"; the French term, in homage to Vertov, is cinéna vérité), and its powerful emotional and didactic effects were created by the ways Vertov and his wife, editor Elizoveta Svilova, assembled the absolutely unstaged footage that was sent in from all over Russia. Beginning in 1919, he also published manifestos that were as brilliant and playful as they were radical; no film theorist is more fun to read. He attacked not only the narrative feature, but also the ordinary ways of looking at things, explored the cinema's relation to radio and television,

and argued that montage—of pictures as well as sounds—was an art not of the sequence but of a film's concept from start to finish.

In many of his films, Vertov brings to life the ordinary, laborious tasks of building a nation (laying an airstrip, planting crops, finishing a tram line) by examining the progress of the task from many stirring and awesome angles, endowing tile ordinary with wonder, and exploring, as would many later Soviet films, the vitality of machines and the powerful potential of the union of people and machines.

Like Ruttmann's *Berlin*, *The Man with a Movie Camera* is organized as an examination of life in a major city—its work and play from morning to night. Unlike Ruttmann, however, Vertov depicts the ways that the cinema itself has become an intrinsic part of modern life and a marvelous aid to seeing and understanding that life. Early in the film, we see ail empty movie theatre. When the patrons arrive, the seats fold down by themselves to greet them. Thus the film begins itself. The film they see is the film we see—for *The Man with a Movie Camera* is a film-within-a-film about filmmaking. Vertov compares the lens of the movie camera and its operations to the human eye and its operations—declaring the cinema an extension of human vision. He demonstrates the processes of editing (the movie "stops" while the editor decides which shot to use next) and the relationship of still frames to moving shots. He also draws parallels between the processes of cinema and other societal occupations that depend on machines that spin, wheel, or cycle repeatedly—the pumping of pistons, the winding of threads, the packing of cigarette boxes. If Vertov takes the "magic" out of cinema by exposing how it does its tricks, he also endows it with another form of magic—the magic of all processes of modern mechanical life that, like the movie camera, do their work in the service of human beings and the world they are building together.

Despite this inspired synthesis of radical form and radical ideology, Vertov made few films after 1930, the most important of which were *Enthusiasm* (1931), which had a loud, complex, contrapuntal soundtrack, exploding with the energy of sound/picture montage, and *Three Songs About Lenin*, which combined documentary footage with lyrical passages in honor of the founding father. He died in 1954 after 20 years of reduced influence and enforced idleness.

第六节　欧洲先锋派电影

欧洲先锋派电影（avant-garde cinema）又称为实验电影（experimental film），是 1918 年至 20 世纪 30 年代早期发生在欧洲各国、内涵庞杂的系列电影运动，大致包括印象派、超现实主义、抽象主义、达达派和诗意纪录片等。欧洲先锋派电影不外两大倾向：向外发展呈现电影本身的诗意、纯粹和抽象，向内发展挖掘心灵世界的梦幻、欲望和纷乱。

1. 印象派和冈斯

法国《电影》杂志主编路易·德吕克（Louis Delluc）唾弃法国艺术电影的观念，推崇美国和德国北欧电影，成为欧洲先锋电影的精神领袖和远早于爱森斯坦的电影理论先驱。

受到画家莫奈、德加和雷诺阿、作曲家德彪西和拉威尔为代表的法国印象派艺术的影响，法国印象派电影（impressionism）强调活动影像（客体）与观看者（主体）的互动结合，创造诗意化的感觉印象。阿贝尔·冈斯（Abel Gance）展现蒸汽火车头运动节奏的蒙太奇段落可以看作印象派电影的经典例证。德吕克的《狂热》、杜拉克的《西班牙的节日》、爱浦斯坦的《厄舍古厦的崩塌》和莱赫比耶的《黄金国》也属于法国印象派电影的范畴。

Avant-Garde Impressionism, 1921-1929

Next to America's, the film industry with the most prominent national image in the thirties was that of France. After World War I, Paris had become the center of an international avant-garde encompassing cubism, surrealism, Dadaism, and Futurism, and many intellectuals involved with these movements had become intensely interested in the possibilities of film to embody dream states arid to express modernist conceptions of time and space. The most prominent among them was the young author and editor Louis Delluc (1890-1924), who founded the journal Cinéma and became, long before Eisenstein, the first aesthetic theorist of the film. Delluc's practical mission was the founding of a truly French national cinema which would be authentically cinematic. To this end, he rejected much of French cinema as it had evolved before the war—especially the theatrical abuses of film d'art—and turned instead to the models of Sweden (Sjöström and Stiller), America (Chaplin, Ince, and Griffith), and Germany (Expressionism and Kammerspiel). Delluc began to write original scenarios and gathered about him a group of young filmmakers which became known as the French "impressionist" school, or the "first avant-garde"—Germaine Dulac, Jean Epstein, Marcel L'Herbier, and Abel Gance—although, as Richard Abel points out, "narrative avant-garde" would be a better term, since all of them worked at the periphery of the French commercial industry making features. Delluc himself directed a handful of important films, including *Fièvre* (Fever, 1921) and *La Femme de nulle part* (*The Woman from Nowhere*, 1922), both of which are reminiscent of Kammerspiel in their concern with creating atmosphere and preserving the unities of time and place.

Germaine Dulac, one of cinema's first female artists, directed Delluc's first scenario *La Fête espagnole* (*The Spanish Festival*, 1920) and went on to become an important figure in the avant-garde and documentary cinema. Her most significant impressionist films were short, forty-minute features: La Souriante Madame Beudet (*The Smiling Madame Beudet*, 1923), an intimate psychological portrait of middle-class marriage in a drab provincial setting adapted from the play by avant-gardists André Obey and Denys Amiel, and *La Coquille et le clergyman* (*The Seashell and the Clergyman*, 1928), a surrealist exposition of sexual repression from a scenario by Antonin Artaud. La Souriante Madame Beudet employs a minimal storyline as an armature for the subjective camera, which is used to convey the interiority not only of its main character but of others as well (and predates the subjective camera of Murnau's Der letzte Mann by at least a year). As Sandy Flitterman-Lewis points out, more than half the film is devoted to a form of cinematic internal monologue, which conveys an enormous range of internal states, from ideas and memories through fantasy and hallucination. The Seashell

and the Clergyman is arguably the first surrealist feature, constructed entirely on dream-logic and the materialization of unconscious processes, which links it more closely with the "second" avant-garde than with impressionism.

Jean Epstein, like Delluc, began his career in film as a theorist but contributed a major work to the impressionist cinema in 1923 with *Coeur fidèle* (*Faithful Heart*), the story of a working-class love triangle in Marseilles with a fine feeling for landscape and atmosphere which is nevertheless boldly experimental in form. Yet according to the film historian Georges Sadoul, this film, for all its sophisticated use of the moving camera and rapid cutting, incarnates the quality of populisme which may be seen in French films as early as the Lumière shorts and which was the major legacy of impressionism to the French cinema—a fascination with ordinary people and settings, with dramas of the working class, and with outdoor shooting in natural settings such as seaports, fairgrounds, and bistros. *Epstein's later La Chute de la maison Usher* (*The Fall of the House of Usher*, 1928) used a variety of brilliant technical effects to create for this Edgar Allan Poe tale what Henri Langlois called "the cinematic equivalent of Debussy", while his *Finis Terrae* (1929), shot on location at Land's End in Brittany, was an avant-garde forecast of neorealism.

The most faithful follower of Delluc's theories was Marcel L'Herbier , who had been a prominent symbolist poet before turning to filmmaking in 1917. The most cerebral member of the impressionist group, L'Herbier was concerned largely with abstract form, and with the use of visual effects to express inner states. His *L'Homme du large* (*The Big Man*, 1920) was an adaptation of a short story by the nineteenth-century realist Honoré de Balzac shot on location on the southern coast of Brittany, whose frames were composed to resemble Impressionist paintings. The visual texture of *El Dorado* (1921), a melodrama of Spanish lowlife set in a cabaret, recalls the paintings of Claude Monet and virtually synthesizes early avant-garde technique, while Don Juan et Faust (*Don Juan and Faust*, 1923) used cubism to the same end. L'Herbier's most extravagant impressionist film, L'Inhumaine (*The Inhuman*, 1924), with a score by Darius Milhaud and sets by the cubist painter Fernand Léger and Robert Mallet-Stevens, was an essay in visual abstraction thinly disguised as science fiction; it ends with an apocalyptic montage sequence designed to synthesize movement, music, sound, and color. But *L'Argent* (1929)—a spectacular updating of Zola's 1891 novel about stock-market manipulation during the Second Empire (c.1868)—is widely regarded today as L'Herbier's greatest fihn. In it, he employed antitraditional camera and editing strategies to create a destabilized narrative space within a series of immense, streamlined studio sets designed by André Barsacq and Lazare Meerson, providing both an image and a critique of unbridled capitalism on the brink of the Great Depression.

Abel Gance

The most important commercial director of the decade, whose Promethean ambitions led many a bureaucrat to feast on his liver and whose vast energy pushed his films beyond the limits of commerce and convention, Abel Gance applied an experimental, almost avant-garde concern with visual forms, tricks, and devices to the narrative feature. This should not be surprising, since his 1915 short, *The Folly of Dr. Tube*, used distorting mirrors to convey distorted perception and may well have been the first "experimental" film. His *J'accuse* (*I Accuse*, 1919) and *La Roue* (The Wheel, 1922) explored tragedy and social injustice in the context of intimate, melodramatic studies of passion and vision. *J'accuse*, which took its title from Emile Zola's 1898 article in defense of Alfred Dreyfus, let the ghosts of the soldiers of World War I ("the war to end all wars") return to discover whether their sacrifice had been effective and worthwhile. Shot in 1918 with soldiers on temporary leave from the front, who expected—in most cases, correctly—to be killed within the month, so that they knew they were playing their own ghosts and trusted Gance to carry their message into a future they would not see but urgently demanded to affect, *J'accuse* was the greatest antiwar film yet made. In 1937 Gance remade the film, hoping to stop the Second World War by re-evoking the horrors and lessons of the First. The second *J'accuse* did not halt the coming conflict but remains a gesture of immense belief in the power of the cinema.

Of *La Roue*, an eight-hour movie released in 1922, Jean Cocteau observed, "There is the cinema before and after *La Roue* as there is painting before and after Picasso". A tragic story of the wheel of fate (a crushing wheel that doubles as a rack), told with the romantic energy of a Victor Hugo and the melodramatic impact of a Euripides, this compelling picture brought its first audience to a standing ovation—no matter how long it was, they refused to leave until the final reel had been shown again—and decisively influenced the Soviets. Its rapid cutting—some of its shots are only one frame long—came to be called "Russian cutting" once *La Roue* had, like Gance, been forgotten. Gance resembled Griffith in many ways, not the least of which is that neither could find work in the conservative Studio Era, though each had, through his vision of what the cinema could be, brought the art to the peak of its powers. When they met in 1921 (immediately after the editing of *La Roue*), Gance and Griffith congratulated each other for having independently discovered the possibilities of the close-up, the dolly shot, and rhythmic editing. Each made films that were inseparably melodramatic and political, and each put much of himself into his typical romantic hero: for Griffith, the caring man who finds himself in right action, and for Gance, the inventor-genius who wants to change the world.

Like *The Birth of a Nation*, the 1927 *Napoleon* (which originally ran 9 hours—42 reels at 20 fps, polished by Gance to 29 reels—about 6 1—2 hours—and premiered at 17 reels in a special short version) used individuals to explore the history of an entire nation in a period of political instability and crisis. Unlike Griffith's concentration on a group of ordinary citizens, Gance's is on Napoleon, the idealized leader, the mythic man of destiny who pulls a divided nation out of the ideological chaos of the French Revolution. Some critics have found Napoleon either naïvely worshipful of a heroic leader or implicitly fascist. But one must note the stern warning delivered near the end of the film by ghosts of the leaders of the Reign of Terror (a key to Gance's plans), that Napoleon will fall if he betrays the original goals of the Revolution. Because of a lack of funding Gance was prevented from showing Napoleon's tragic development and fall in subsequent films (Napoleon closes with the Italian campaign, well before the general became the emperor). The energy of *Napoleon* is, like that of *La Roue*, the energy of an idealized cinema: a grand, vaulting belief in what unhindered genius can accomplish. The hero of *Napoleon* is Gance.

Among the many breakthroughs of *Napoleon* was its use of multiple imagery, for which Gance's general term was polyvision. Polyvision referred to superimposition (as many as 16 images laid on top of one another), the split screen (as many as 9 distinct images in a frame), and the multiple screen (the triptych—used three times in *Napoleon*, although two of them have been lost—whereby three cameras and projectors and screens could create a single widescreen image with an aspect ratio of almost 4:1, or three separate, side-by-side images that reinforced, reversed, or played against one another in counterpoint). With polyvision and rapid cutting, Gance became the unchallenged master of montage in France.

2. 超现实主义与《一条安达鲁狗》

法国诗人安德烈·布勒东（André Breton）1924年发表《超现实主义宣言》成为超现实主义（Surrealism）艺术运动领袖，超现实主义受到弗洛伊德学说的影响、反叛欧洲文化的传统价值和资产阶级的现代文明，他们执著于对梦幻、潜意识、畸形和自发形态的探索与表现，对现代艺术产生极大的影响。超现实主义画家萨尔瓦多·达利（Salvador Dalí）坚持认为艺术是"具体的非理性"，他与路易斯·布纽艾尔（Luis Buñuel）联合拍摄的超现实主义电影名片《一条安达鲁狗》非逻辑地展现有关性、欲望和复仇等一系列影像，创造出一个奇异迷狂的超现实主义内心世界。

《一条安达鲁狗》

超现实主义电影又称"主观电影(subjective)"或"诗意电影"(poetic cinema),在印象派电影之后被认为是欧洲先锋派电影的第二个浪潮,布纽埃尔和达利的《黄金时代》、让·谷克多(Jean Cocteau)的《诗人之血》和谢尔曼·杜拉克(Germaine Dulac)的《僧侣与贝壳》也是超现实主义的代表作品。

Surrealism

Surrealism resembled Dada in many ways, particularly in its disdain for orthodox art. Like Dada, Surrealism sought out startling juxtapositions. André Breton, who led the break with the Dadaists and the creation of Surrealism, cited an image from a work by the Comte de Lautréamont: "Beautiful as the unexpected meeting, on a dissection table, of a sewing machine and an umbrella". The movement was heavily influenced by the emerging theories of psychoanalysis. Rather than depending on pure chance for the creation of artworks, Surrealists sought to tap the unconscious mind. In particular, they wanted to render the incoherent narratives of dreams directly in language or images, without the

interference of conscious thought processes. Max Ernst, Salvador Dalí, Joan Miró, and Paul Klee were important Surrealist artists.

The ideal Surrealist film differed from Dada works in that it would not be a humorous, chaotic assemblage of events. Instead, it would trace a disturbing, often sexually charged story that followed the inexplicable logic of a dream. With a patron's backing, Dadaist Man Ray moved into Surrealism with *Emak Bakia* (1927), which used many film tricks to suggest a woman's mental state. At the end she is seen in a famous image, her eyes closed, with eyeballs painted on them; she opens her eyes and smiles at the camera. Many Surrealists denounced the film as containing too little narrative. Ray's next film, *L'Étoile de mer* ("*The Starfish*",1927), hinted at a story based on a script by Surrealist poet Robert Desnos. It shows a couple in love, interspersed with random shots of starfish, trains, and other objects. At the end, the woman leaves with another man, and her cast-off lover consoles himself with a beautiful starfish.

Germaine Dulac, who had already worked extensively in regular feature filmmaking and French Impressionism, turned briefly to Surrealism, directing a screenplay by poet Antonin Artaud. The result was *The Seashell and the Clergyman* (1928), which combines Impressionist techniques of cinematography with the disjointed narrative logic of Surrealism. A clergyman carrying a large seashell smashes laboratory beakers; an officer intrudes and breaks the shell, to the clergyman's horror. The rest of the film consists of the priest's pursuing a beautiful woman through an incongruous series of settings. His love seems to be perpetually thwarted by the intervention of the officer. Even after the priest marries the woman, he is left alone drinking from the shell. The initial screening of the film provoked a riot at the small Studio des Ursulines theater, though it is still not clear whether the instigators were Artaud's enemies or his friends, protesting Dulac's softening of the Surrealist tone of the scenario.

Perhaps the quintessential Surrealist film was created in 1928 by novice director Luis Buñuel. A Spanish film enthusiast and modernist poet, Buñuel had come to France and been hired as an assistant by Jean Epstein. Working in collaboration with Salvador Dalí, he made *Un Chien andalou* (*An Andalusian Dog*). Its basic story concerned a quarrel between two lovers, but the time scheme and logic are impossible. The film begins with a sequence in which a man inexplicably slices the heroine's eye with a razor—yet she appears, unharmed, in the next scene. As the quarrel goes on, ants crawl from a hole in a man's hand, the hero hauls a piano stuffed with rotting mule's carcasses across a room, and a pair of hands protrudes through the wall to shake a cocktail. Throughout, intertitles announce meaningless intervals of time passing, as when "sixteen years earlier" appears within an action that continues without pause.

Dalí and Buñuel followed this film with a longer, even more provocative one,

L'Age d'or ("*The Age of Gold*" 1930). The tenuous plot concerns two lovers kept apart by the woman's wealthy parents and a disapproving society. An early scene shows a pompous ceremony at the seaside in which presiding bishops wither to skeletons. Later, a man who is shot falls up to the ceiling, and the heroine sucks on the toes of a statue to express her sexual frustration. The film teems with erotic imagery, and the ending portrays a figure clearly intended to represent Christ emerging from a sadistic orgy. *L'Age d'or*, which provoked riots during its initial screenings, was banned. It remained almost impossible to see for over four decades.

During the early 1930s, Surrealism as a unified movement was breaking up. Some artists became involved in leftist or anarchist politics, and Dalí earned their wrath through his fascination with Hitler. By 1933, the European phase of the movement was over, but, as with Dada, Surrealism's influence was felt strongly in the era after World War II.

3. 达达主义、抽象主义和诗意纪录片

达达主义（Dadaism）源于对理性主义的反叛和世界大战的幻灭，跟超现实主义关系密切，大部分达达主义电影出自现代画家、摄影师和装置艺术家之手。曼·雷（Man Ray）的《回归理性》曾因反理性的意念和挑衅性的画面组接引发观众骚乱而名声大噪。达达主义电影的代表作还包括雷内·克莱尔（Rene Clair）的《幕间休息》、马塞尔·杜尚（Marcel Duchamp）的《贫血电影》和汉斯·里希特（Hans Richter）《早餐前的魔鬼》等。

抽象主义（Abstraction）又称为"纯电影"（pure cinema）或"绘画与节奏学派"（graphic and rhythmic school），倾向于将电影画面简化抽象为线条、平面和立体，追求纯粹的形式美感和节律动感，其中动画元素占有相当大的比重。汉斯·里希特（Hans Richter）的《韵律21》、沃尔特·鲁特曼（Walter Ruttmann）的《作品1号》、维金·艾格林（Viking Eggeling）的《对角线交响曲》和费尔南德·莱谢尔（Fernand Leger）的《机械舞蹈》都是抽象派电影的杰作。

诗意纪录片（Lyrical Documentaries）将主体情感和客体美感综合起来、用以展现都市生活的诗情画意。1921年的《曼哈塔》是最早反映纽约大都会欣欣向荣的作品，而鲁特曼的《柏林：大城市交响曲》、尤里斯·伊文斯（Joris Ivens）的《桥》和《雨》则是此类作品的翘楚。

Dada Filmmaking

Dada was a movement that attracted artists in all media. It began around 1915, as a result of artists' sense of the vast, meaningless loss of life in World War I. Artists in New York, Zurich, France, and Germany proposed to sweep aside traditional values and to elevate an absurdist view of the world. They would base artistic creativity on randomness and imagination. Max Ernst displayed an artwork and provided a hatchet so that spectators could demolish it. Marcel Duchamp invented "ready-made" artwork, in which a found object is placed in a museum and labeled; in 1917, he created a scandal by singing a urinal "R. Mutt" and trying to enter it in a prestigious show. Dadaists were fascinated by collage, the technique of assembling disparate elements in bizarre juxtapositions. Ernst, for example, made collages by pasting together scraps of illustrations from advertisements and technical manuals.

Under the leadership of poet Tristan Tzara, Dadaist publications, exhibitions, and performances flourished during the late 1910s and early 1920s. The performance "soirées" included such events as poetry readings in which several passages were performed simultaneously. On July 7, 1923, the last major Dada event, the "Soirée du 'Coeur à Barbe'" ("soirée of the 'Bearded Heart'"), included three short films: a study of New York by American artists Charles Sheeler and Paul Strand, one of Richter's rhythmus abstract animated works, and the American artist Man Ray's first film, the ironically titled *Retour à la raison* ("*Return to Reason*"). The element of chance certainly entered into the creation of *Retour à la raison*, since Tzara gave Ray only twenty-four hour's notice that he was to make a film for the program. Ray combined some hastily shot live footage with stretches of "Rayograms". The soirée proved a mixed success, since Tzara's rivals, led by poet André Breton, provoked a riot in the audience.

This riot was symptomatic of the disagreements that were already bringing Dada to an end. By 1922, it was in serious decline, but key Dada films were still to come. In late 1924, Dada artist Francis Picabia staged his ballet Relâche (meaning "performance called off"). Signs in the auditorium bore such statements as "If you are not satisfied, go to hell". During the intermission (or entr'acte), René Clair's *Entr'acte* was shown, with music by composer Erik Satie, who had done the music for the entire show. The evening began with a brief film prologue (seen as the opening segment of modern prints of *Entr'acte*) in which Satie and Picabia leap in show motion into a scene and fire a cannon directly at the audience. The rest of the film, appearing during the intermission, consisted of unconnected, wildly irrational scenes. Picabia summed up the Dada view when he characterized Clair's film: "*Entr'acte* dose not believe in very much, in the pleasure of life, perhaps; it believes in the pleasure of inventing, it respects nothing except the desire to burst

out laughing".

Dada artist Marcel Duchamp made one foray into cinema during this era. By 1913, Duchamp had moved away from abstract painting to experiment with such forms as ready-mades and kinetic sculptures. The latter included a series of motor-driven spinning discs. With the help of Man Ray, Duchamp filmed some of these discs to create Anémic cinéma in 1926. This brief film undercuts traditional notions of cinema as a visual, narrative art. All its shots show either turning abstract disks or disks with sentences containing elaborate French puns. By emphasizing simple shapes and writing, Duchamp created an "anemic" style. (Anémic is also an anagram for cinéma.) In keeping with his playful attitude, he signed the film "Rrose Sélavy", a pun on *Eros c'est la vie* ("*Eros is life*").

Entr'acte and other dada films were on the 1925 Berlin program, and they convinced German filmmakers like Ruttman and Richter that modernist style could be created in films without completely abstract, painted images. Richter, who had been linked with virtually every major modern art movement, dabbled in Dada. In his *Ghosts before Breakfast* (1928), special effects show objects rebelling against their normal uses. In reverse motion, cups shatter and reassemble. Bowler hats take on a life of their own and fly through the air, and the ordinary laws of nature seem to be suspended.

Riven by internal dissension, the European Dada movement was largely over by 1922. Many of its members formed another group, the Surrealists.

Cinéma Pur

In 1924, a casual collaboration of artists resulted in an abstract film that did not use animated drawings but rather everyday objects and rhythmic editing. American set designer Dudley Murphy had decided to mount a series of "visual symphonies", the first of which was a rather literal-minded ballet film, *Danse macabre* (1922). In Paris, he encountered Man Ray and modernist poet Ezra Pound, who inspired him to do a more abstract work. Ray actually shot some footage, but the French painter Fernand Léger completed the filming of Ballet mécanique. Murphy did the cinematography, and Léger directed a complex film juxtaposing shots of objects like pot lids and machine parts with images of his own paintings. There were prismatic shots of women's faces, as well as an innovative shot of a washerwoman climbing a flight of steps, repeated identically many times. Léger had hoped to make a film about Charlie Chaplin, and he opened and closed Ballet mécanique with an animated figure of the comedian rendered in his own painting style.

In the wake of works like Ballet mécanique, some filmmakers realized that

纯电影代表作《对角线交响曲》

they could organize nonnarrative films around abstract visual qualities of the physical world. Since commercial cinema, especially that of Hollywood, was strongly associated with narrative, such abstract films seemed untainted, owing nothing to literary or theatrical influences. These filmmakers were not unified by membership in any modernist movement, like Dada or Surrealism. Indeed, they largely avoided the irreverence of Dada and the psychic explorations of Surrealism. These diverse, widely scattered filmmakers wanted to reduce film to its most basic elements in order to create lyricism and pure form.

Indeed, French proponents of this approach soon termed it cinéma pur, or "pure cinema". One of these was Henri Chomette, who had worked as an assistant director for commercial filmmakers like Jacques de Baroncelli and Jacques Feyder. In 1925, a commission from a rich count for an experimental short led to *Jeux des reflets et de la vitesse* ("*The Play of Reflections and Speed*", 1925). For the "speed" portion Chomette mounted his camera at various angles on a moving subway car, often filming in fast motion. He juxtaposed these shots with views of a series of shiny objects. His next film, *Cinq minutes de cinema pur* ("*Five Minutes of Pure Cinema*", 1926), was made for the growing circuit of specialized cinemas. After these two films, Chomette became a commercial director.

Following her venture into Surrealism, Germaine Dulac embraced cinéma pur in *Disque 927* (1928), *Thème et variations* (1928), and *Arabesque* (1929). As the titles suggest, Dulac tried to make her short, lyrical studies equivalent to musical pieces. With the coming of sound, Dulac could not finance her films independently,

诗意记录片代表作品《桥》

and, unwilling to return to mainstream filmmaking, she worked primarily in newsreels after 1929.

The concept of pure cinema surfaced in other countries, though seldom under that name. Some photographers experimented briefly with cinema. László Moholy-Nagy, a Hungarian photographer and sculptor, created several films in the late 1920s and early 1930s. Among these was *Lichtspiel, Schwarz-weiss-grau* ("*Play of Light, Black-White-Gray*", 1930), made while he was teaching at the Bauhaus. The title is a pun: Lichtspiel means both "movie" and "play of light". American photographer Ralph Steiner's *H_2O* (1929) consisted of increasingly abstract images of water. Steiner made two similar films and then went on to photograph some of the most important documentaries of the next decade. The pure-cinema impulse has had a strong influence on experimental filmmakers since the 1920s.

Lyrical Documentaries: The City Symphony

Some filmmakers experimented by taking their cameras outdoors and capturing poetic aspects of urban landscapes. Their films formed another new genre, the city symphony. These works were part documentary, part experimental film.

The earliest known city symphony, and, indeed, perhaps the first experimental film made in the United State, was created by modern artist Charles Sheeler and photographer Paul Strand in 1920. It was shown as a scenic short in a commercial

theater in New York the following year under the title *New York the Magnificent*, but the filmmakers later dubbed it *Manhatta*, and that is the title by which it has come to be known. The pair filmed scenes near the Battery Park area of southern Manhattan, creating evocative, often nearly abstract views of the city. Although the film had little distribution initially, it was revived in art theaters during the second half of the decade and probably inspired later filmmaking.

By that era, the city symphony had become more common. In 1925, Brazilian director Alberto Cavalcanti, working in France, made *Rien que les heures* ("*Nothing but the Hours*", 1926). It juxtaposes two different types of material: candid documentary shots and staged scenes. Shopkeepers open their shutters, patrons eat at cafés, a pimp kills a woman, an old lady staggers through the streets. Cavalcanti refuses to develop any of these situations into a coherent plot, instead weaving together motifs to suggest the passage of time all over Paris.

Cavalcanti's film was followed by Walter Ruttmann's feature, *Berlin: die Symphonie der Grosstadt* (*Berlin, Symphony of a Great City*, 1927). It also provided a cross section of life in a city during one day. Coming from the tradition of abstract animation, Ruttmann begins the film with some geometric shapes, matching them graphically with documentary images. Subsequent shots explore the abstract qualities of machines, building façades, store-window displays, and the like. Ruttmann also includes social commentary, as when during the noontime segment he cuts from a homeless woman with her children to plates of food in a fancy restaurant. *Berlin* circulated widely in commercial theaters and was one of the silent era's most influential documentaries.

The poetic city symphony proved fertile ground for young filmmakers working for the art-cinema and ciné-club circuit. For example, the Dutch documentarist Joris Ivens began as cofounder of a major club, the Filmliga, in Amsterdam in 1927. His first completed film was a lyrical, abstract study of a drawbridge, *The Bridge* (1928). Its success in art-film circles led to other films, including *Rain* (1929). Rain explores the changing look of Amsterdam before, during, and after a shower: the sheen of water on tile roofs and windows and the spatter of raindrops in the canals and in puddles. Again, *Rain* was well received among art-cinema audiences across Europe and inspired many imitations.

The city-symphony genre was diverse. The film might be lyrical, displaying the effects of wind and water. Henri Storck, who had formed the ciné-club for the Belgian seaside town of Ostende, recorded the town summertime sights in his *Image d'Ostende* (1929). In contrast, Dziga Vertov's *Man with a Movie Camera* commented on Soviet society by weaving together several cities in a "day-in-the-life-of" documentary. Vertov demonstrated the power of the cinema by showing the filmmaking process within his film and by using extensive special effects. The city symphony has proved an enduring genre among documentarists and experimental filmmakers.

第二章

经典时期

1927—1945

世界电影的经典时期正好跟经济大萧条与第二次世界大战遭遇，1929年美国股市的"黑色星期二"导致全球性的经济萧条，而意大利法西斯开始执政（1922）、日本军国主义对中国的入侵（1931）和纳粹德国的掌权（1933）又不可避免地挑起又一次世界大战。有趣的是，越是在灾难深重的时候、人们越是需要精神的抚慰，此时的电影义不容辞地承担起这一历史使命，在远离战争的美国获得突飞猛进的发展，结合有声片等一系列的技术革新，使好莱坞电影一举成为主导世界电影的中流砥柱。

第一节　好莱坞体制和经典叙事

1. 有声电影的出现

迪金森声称早在1889年就录制过粗糙的有声画面，1894—1895年间还用西洋镜留声机进行过音乐和画面的同步尝试。但初创阶段电影都是由钢琴或乐队伴奏的默片，直到1927年华纳公司（Warner Bros.）推出《爵士歌王》成为第一部有声片。

电影声音的出现使电影能够更完整、更准确地还原现实，同时又使（无声）电影艺术的理念和表现手法受到巨大挑战。知名电影理论家家鲁道夫·爱因汉姆（Rudolf Arnheim，《电影作为艺术》作者）就坚持认为，有声对白使表现性的电影艺术堕落成一种复制现实的工具；爱森斯坦联合普多夫金和亚历山大洛夫在1928年发表著名的《有声电影宣言》（Statement on Sound），谴责有声片在美学上威胁电影艺术本体的假定性；而卓别林则坚持将《城市之光》和《摩登时代》等名作拍成无声片。

有声电影的出现将更加成熟的叙事、更加真实的表演和闻所未闻的音乐对话展现给观众，引发了音乐歌舞片（Musical）和对白片的盛行。而笨重的隔音摄影机和录音设备又使电影的拍摄受到一定的限制。电影对白的出现强化了电影所表达的情感浓度和思想深度。当然，有声电影的出现也改变电影字幕的功能，并使译制片流行开来。

《爵士歌王》是公认的第一部有声电影

Sound

According to legend, sound unexpectedly descended on the film industry from the skies, like an ancient god out of a machine, when *The Jazz Singer* opened on Broadway on October 6, 1927. Although the success of *The Jazz Singer* overthrew the film industry of 1927 with incredible speed, preparation for the entrance of sound had been building for over 30 years. The idea for the sound film was born with the film itself. W. K-L. Dickson even claimed to have produced a rough synchronization of word and picture in 1889, and he did use the Kineto-phonograph to synchronize music and picture in 1894 or 1895 for the first surviving sound film.

Imaginative inventors in France, Germany, and America experimented with various processes for synchronizing moving pictures with sounds using discs, cylinders, and film. Aside from these early picture-sound novelties, live sounds were extremely common in the nickelodeons of 1905-1912. Not only was there the piano, the organ, or a trio of musicians, but live actors sometimes stood behind or beside the screen to speak the lines accompanying the pictures—or a narrator (called *the benshi* in Japan, where this practice flourished throughout the Silent Era) might comment on the action as well as deliver the dialogue. It seemed inevitable that movies would make their own noise.

The first practical, dependable synthesis of picture and sound came just after World War I. Two primary problems confronted the inventor of a sound-film

process. The first was synchronization. How were the film and the sound to be kept permanently and constantly "in sync"? (Sync is short for synchronization.) The problem with using one machine was that the picture had to stop and start for every frame but the sound had to roll evenly, like a tape. The problem with two machines was that they were two machines. The method of coupling a projected film with a recorded disc was risky; it was terribly easy for the two to slip "out of sync". The film could break; the stylus could skip. *Singin' In The Rain* (1952), a marvelous parody of the transitional era from silent to sound films, revealed the unintentionally comic results when the cavalier's voice issued from the damsel's moving lips. Although the first commercially successful American sound-film process, the Vitaphone, synchronized a record player with the film projector, a more stable method had been developed as early as 1919. Three German inventors had discovered the means of recording the soundtrack directly on the film itself (optical sound) and crucially smoothing, with a simple flywheel, the movement of film through a sound projector; they were Josef Engl, Joseph Massole, and Hans Vogt. Using the principle of the oscilloscope, the Germans used a photocell to convert the sound into light beams, recorded the beams on one side of the strip of film, and then built a reader on the projector that could retranslate the light beams into sound. This German discovery, known as the Tri-Ergon Process, later became the ruling sound-film patent of Europe. Successfully demonstrated in 1922, the Tri-Ergon Process was very similar to the optical-sound process on which the American inventor Lee de Forest had begun working in 1913 and which he perfected in 1920: the Phonofilm.

An earlier de Forest invention solved the second problem of the sound film—amplification. The sound not only had to be synchronized, it had to be audible. A film had to make enough noise to reach all the patrons who filled the movie palaces. The earliest phonographs and radios, lacking the means of amplification, could entertain only one listener, who wore a listening tube. In 1906, de Forest invented the audion tube, which magnified the sound so that an entire audience could hear it. De Forest patented an early version of the audion tube in 1906 and the perfected version in January 1907. It used three electrodes: a cathode to produce electrons, a plate to attract them, and—the crucial innovation—a grid to control them so that a signal could be reduced or increased without distortion. The tube's amplifying power was increased in 1913 by Edwin Howard Armstrong.

It was in 1913 that de Forest experimented with the photographing of sound; his first subject was an acrobatic barking dog. The phonograph, he said, was "a triumph over a bad principle" because it relied on a needle that could scratch the record; his solution—similar to that employed in today's compact disc—was to use light, not a metal shaft, to write and read the sound. From 1919 to 1921, he invented and improved the Phonofilm, whose optical soundtrack ran between the

picture area and one row of sprockets. He began shooting sound films in 1921, making hundreds of shorts between then and 1927. In 1924 he invented the sound newsreel; his first subject was President Calvin Coolidge.

The optical soundtrack in use today is a direct outgrowth of de Forest's Phonofilm—as the Academy of Motion Picture Arts and Sciences acknowledged when it awarded him a special Oscar in 1959. But de Forest made little money, and for decades received little credit, for bringing sound to the motion picture. And the optical-sound processes demonstrated in 1922 in Europe (the TriErgon Process) and America (the Phonofilm) were not the first to succeed commercially.

A competing process that recorded the soundtrack on 78 RPM records (sound on disc), with each record large enough to hold ten minutes of sound so that there could be one disc for each reel of film, yielded relatively inferior sound quality but was used on the right movie: *The Jazz Singer*. Both sound-on-film and sound-on-disc processes, as well as all subsequent sound filming, required that the speed with which film was exposed and projected be standardized. A speed of 24 fps was established as an industry standard, the normal duration of a reel became ten minutes, and film length began to be given in minutes rather than feet or meters.

The sound-on-disc process—a "double system" that relied on two interlocked machines, the projector and the turntable, as opposed to the "single system" of sound-on-film projection—was developed by Bell Telephone's research lab, Western Electric. In 1925 the company began trying to market the invention, which it named the Vitaphone.

Rejected by the most powerful producers, Western Electric offered Vitaphone in 1926 to Warner Bros., a family of four producing brothers whose small company had recently embarked on a costly program of major expansion. Having bought the remains of the Vitagraph Company (the last of the original Trust Companies) in 1925 and made it their distribution chain, the Warners wished to expand their small network of theatres, to achieve full vertical integration, and to take on the big boys—Loew, Zukor, First National—who controlled enough theatre and distribution chains to choke the market for Warners' films. The Warner brothers bought the Vitaphone. Within three years they had swallowed First National and most of the theatres in that chain.

The Warner sound films started cautiously enough. On August 6, 1926, the Warners presented a program of short sound films; the first was an address by Will Hays praising the possibilities of the sound film, followed by the New York Philharmonic Orchestra and by leading artists of the opera, the concert, and the music hall. The Vitaphone shorts were similar to de Forest's Phonofilms. But on the same program, the Warners presented a feature film, *Don Juan* (directed, like *The Jazz Singer*, by Alan Crosland), with a synchronized musical score. A canned orchestra had replaced the live one in the pit. This put many musicians out of

work, but it allowed filmmakers to decide exactly what music would accompany their images, a significant advance in artistic control.

Like the Warners, another lesser producer, William Fox, was a film businessman who gazed enviously at the Zukors and Loews on the heights. Fox decided to use sound the same way as the Warners did. Early in 1927 Fox began presenting mechanically scored films, the greatest of which was Murnau's *Sunrise* (planned and shot as a silent), whose music and sound effects were post-synchronized. The effects on these soundtracks were recorded in a studio rather than created on the spot with musical instruments, an advance in realism that proved as important to the sound film as audible dialogue. Like the Warners, Fox presented a series of short novelty films—performances by famous variety artists and conversations with famous people. In addition, Fox started his own sound newsreel, the Fox Movietone News. Unlike Vitaphone, the Fox system, called Movietone, was a sound-on-film process, exactly like the Phonofilm.

Fox exploited the novelty of coupling the sound of the human voice with the picture of moving lips. In the Movietone short referred to as Shaw Talks for *Movietone News* (1928) and as Greeting by George Bernard Shaw, 1928, the audience is amused by seeing the image of the crusty playwright, hearing his voice, enjoying his garrulous, improvised pleasantries, aid recognizing the mechanical reproduction of other natural sounds like birds chirping and gravel crackling on the garden path. The moving pictures had become a simple recording device once again. The camera stopped speaking as the movies learned to talk.

The Jazz Singer was neither the first sound film nor the first film to synchronize picture with speech and song. It was, however, the first full-length feature to use synchronized sound as a means of telling a story. Most of the film was shot silent, with intertitles and a post-synchronized score. In this respect Warners' *Jazz Singer* went no further than their Don Juan. But at least five sequences used synchronized speech.

In one, the jazz singer (Al Jolson) returns to his Orthodox Jewish home to visit his parents. His mother (Eugenie Besserer) enjoys seeing him and listening to his "jazzy" singing of "Blue Skies". His father (Warner Oland), a cantor, orders an end to all profane jazz in his house. The father's command to stop the music is the cue for the film to revert to silence—then the old orchestral music and the intertitles start. That brilliant strategy made the sound film modern and the silent film old-fashioned.

The divided nature of *The Jazz Singer*—part silent, part talkie—revealed both the disadvantages and the advantages of the new medium. Whereas the silent sections of the film used rather flowing camera work and terse narrative cutting, the synchronized sections were visually inert. For Jolson's third song, "Blue Skies", the camera was restricted to two setups: a medium shot of Jolson at the piano and a

close shot of Besserer responding (intercut sparingly). Most visually inert of all is the dialogue shot: a rambling, improvised series of Jewish jokes between choruses of the song—a full shot of Jolson and mama, one long take. When the film starts making synchronized noises, the camera stops doing everything but exposing film.

On the other hand, this moment of informal patter at the piano is the most exciting and vital part of the entire movie. In the silent sequences Jolson is a poor mime, with hammy, overstated gestures and expressions. But when Jolson acquires a voice, the warmth, the excitement, the vibrations of it, the way its rambling spontaneity lays bare the imagination of the mind that is making up the sounds, convert the overgesturing hands and the overactive eyes into a performance that seems effortlessly natural. "Wait a minute," Jolson tells an applauding audience in his first song-and-dialogue scene, "You ain't heard nothin' yet! Wait a minute, I tell ya, you ain't heard nothin". You want to hear "Toot Toot Tootsie'? All right, hold on ..". The addition of a Vitaphone voice revealed the particular qualities of Al Jolson that made him a star. Not only the eyes are a window on the soul.

Aesthetic Differences

Sound was a somewhat mixed blessing for the art as well as for the industry. In a book entitled *Heraclitus*; or *The Future of Films* (1928) the young English author, Ernest Betts, went to the trouble and expense of adding, after publication, a special footnote: "Since the above was written, speaking films have been launched as a commercial proposition, as the general pattern of the film of the future. As a matter of fact, their acceptance marks the most spectacular act of self-destruction that has yet come out of Hollywood, and violates the film's proper function at its source. The soul of the film—its eloquent and vital silence—is destroyed. The film now returns to the circus whence it came, among the freaks and the fat ladies".

Betts was not alone among the critics in mourning the death of a great visual art. Exacerbated by the crudities of the early technology, certain basic aesthetic problems were raised when the spoken word was joined to the moving image. Rudolf Arnheim, writing a foreword in 1957 to a new edition of his *Film as Art*, first published in 1932, saw no reason to change his mind about dialogue as corruption rather than addition. Some of the finest creators, too, resented and resisted the imposition and didn't know what to do with sound once they had it. Chaplin is the extreme case: He did not make a sound film (in the sense of using dialogue) until *The Great Dictator* (1940).

While the addition of sound brought film closer to a full rendition of physical reality, it also turned it into the sort of recorded theater it had been attempting to escape from its earliest days. All the efforts of the great film makers up to this

point had been directed toward advancing the medium beyond mere photographic record, to make of it an expressive and distinctive art form. "Canned theater", as the early sound films were called by some, represented a mixed, reproductive art at best. Talkies slowed the editing pace and tended to restrict the use of closeup of anything but the faces of actors. In filmed conversation the words dictate what will be seen, and the choice of images becomes limited to the person speaking, the person(s) listening, or both together. This spatial limitation is accompanied by a temporal one: Words require natural time in which to be spoken, and they communicate much less in that amount of time than could images. To those who regarded editing and the close-up as the bases of film technique, sound seemed to bring losses rather than gains. With sound, emphasis shifted from the images and action—with which film was uniquely qualified to deal—to plot and performance—elements shared with theater.

As for the new realism added by sound, this too presented a kind of aesthetic danger. As art draws closer to life, it loses some of its value as art. The artist's function is to select from reality and arrange in significant form: to reduce and clarify the "blooming, buzzing confusion" that surrounds us. Art demands limitations and thrives upon them; to a degree, the more limited, the more pure and expressive. Music, that art to which all other arts are said to aspire, can say much more about the human spirit with its purely abstract tones than can the detailed accuracy of wax figures, for all their simulated lifelikeness.

Another loss was the universality of silent film art. Chaplin was well known not only as "Charlie", but also as "Chariot", "Carlino", "Carlos", or "Carlitos", and could be enjoyed equally by all. With sound, there is no really satisfactory means of presenting film dialogue to audiences who don't understand the language. Initially, multiple-language versions were produced with separate and/or multilingual casts. For example, *The Blue Angel* (1930), directed by Josef von Sternberg, with Emil Jannings and Marlene Dietrich, had an English as well as a German version; *Don Quixote* (1933), directed by G. W. Pabst and starring the renowned Russian basso Fyodor Chaliapin, was produced in French and English. But this practice proved cumbersome and expensive. Usually, only one version, the original, had a dynamic life of its own, the others being merely dutiful copies. Subtitles, superimposed on the images themselves rather than being placed between them on separate intertitle cards as in silent film, restrict and inevitably distort the meaning of the dialogue and distract attention from the visual. The "dubbing" of native voices for foreign ones became the accepted European practice; in Italy, for example, there developed a regular subindustry employing actors to supply Italian voices for James Cagney, Gary Cooper, Bette Davis, and the rest. But the personalities expressed through the original quality of voice and style of delivery could be only faintly approximated, as technically skillful as some of the dubbing became.

Finally, the much greater expense and technological complexity of the sound film limited artistic experimentation and increased the pressure to play it safe. The introduction of sound, more than anything else, ended the individual and small-group film making of the French avant-garde of the twenties. In Hollywood the standard-size crew increased to about sixty persons, and production by committee, with the producer as chair, prevailed.

But after all, we're glad to have sound; only a few FOOFs, as they're called (Friends of Old Films), cherish silence as golden anymore. In actuality, there never were silent films; there was always music and frequently sound effects—of horses' hooves and thunder claps, for instance. By the late twenties the titles, too, had pretty much abandoned the earlier narrative and expository functions to substitute for dialogue; it was as if the film makers, perhaps unconsciously, had already started to feel a need for "lip-sync" sound recording. In these silent films that weren't really silent, the means of providing sound was clumsy and approximate, an aspect over which film makers could have little control. Unless a complete score was provided, which was rarely done, the film maker was at the mercy of the theater musicians. Inappropriate or clichéd music can go a long way towards destroying the most effective scenes.

With the arrival of sound, the music, noises, and words were added by the people who made the film, and became an integral part of it. Sound also reduced the awkwardness of silent narrative and permitted films to flow more freely without interruption of titles or the tortuous circumlocutions of visual exposition. In the final shoot-out in von Sternberg's silent *Underworld* (1927) we are constantly being shown bits of wood chipping off and bottles breaking as reminders that a gunfight is being waged. Persenting a simple point—like a couple's intention to meet next day under the big oak—often challenged the ingenuity of silent film makers in ways that now seem wasteful of creative effort. In one of F. W. Murnau's last great silent films, Sunrise (released with a synchronized musical score in 1927), scriptwriter Carl Mayer and Murnau characteristically minimized titles. But following the film's climax it is necessary for an old fisherman to explain how he had rescued the young wife washed overboard during a storm; this is accomplished through a redundant flashback that slows and diverts the main narrative thrust.

There is no doubt that sound has permitted the tackling of more complex ideas and emotions. This is particularly evident in a greater depth of characterization and increased precision in communicating it. With sound, actors can reveal more nuance and ambivalence, even contradiction, through saying what they think and feel as well as showing it. Though dialogue didn't necessarily add emotional intensity (the moments of highest drama in the sound film tend often to be without dialogue), it certainly contributed a new intellectual weight.

Sound—noises and music as well as speech—offered an artistic resource in

itself, and in support or counterpoint to the images. Rather than the single line of shot to shot, like unison Gregorian chants, there was a polyphonic blending of four separate lines—image, word, music, noise. This meant that films had to be created and understood in a totally different way: The sound film is not simply a silent film with sound added. Vertical montage, as Eisenstein called the relationships between sight and sound, offered a new source of expressiveness.

2. 电影技术革新

彩色电影（color film）的最初尝试可以追溯到爱迪生、梅里爱和百代公司时代的逐格手绘着色，但彩色电影的真正实现则基本与有声电影同步。20世纪20年代后期好莱坞就在《百老汇旋律》等电影中加入彩色段落，1932年工艺彩色公司（Technicolor）推出三色印片法，受到米高梅、华纳和迪斯尼等公司的追捧，《白雪公主和七个小矮人》《绿野仙踪》和《乱世佳人》则标志着彩色电影的成熟。

景深摄影（deep focus cinematography）利用充足的光线加大镜头内前后景的清晰范围，符合写实主义强调时空统一的观念。好莱坞著名摄影师格莱格·托兰德（Gregg Toland）掌镜的《公民凯恩》《黄金时代》和《愤怒的葡萄》都是景深摄影的惊艳之作，受到电影理论大师安德烈·巴赞的高度赞扬。

电影最初依赖自然光源照明（包括室外拍摄或玻璃摄影棚），好莱坞的出现跟南加州充足的日照密切相关。1915年电影布光（lighting）从普通照明逐步转向追求布光的戏剧性效果，这种强调视觉美感的"戏剧光效"（dramatic lighting）成为好莱坞经典时期电影的主导倾向，而德国表现主义强调暗部和对比的光效又为好莱坞电影增加了多元的意味。这一态势直到20世纪50、60年代才受到"自然光效"（natural lighting）理念的挑战。

Colour

Unlike sound, which was taken up by the entire film industry within a few years, colour took more than thirty years from its commercial introduction to fully dominate the industry.

Like sound, however, colour has been asscaited with the cinema in one form or another from the earliest years of the medium: as early as 1896, for example, teams of women were employed to handcolour films, frame by frame. As films increased in length and the number of film prints soared and hand-colouring

《乱世佳人》等影片标志彩色电影的成熟

became less practicable, Pathé Frères patented a device for stencilling prints according to simple colour correspondences. At the same time in America less expensive tinting and toning processes converted black and white images to colour chemically. By the time of the transition to sound, this process was a long-standing tradition for the more prestigious productions. However, as soon as the sound-on-disc device was replaced by the recording of sound directly on to film, tinting and toning were discontinued because it became evident that the process affected the quality of the soundtrack. It was eventually decided that post-production conversion of black and white images to colour was less sensible than actually filming with colour stock.

The principle of colour photography had been introduced in the 1850s and demonstrated in 1861 by the Scottish physicist James Clerk Maxwell. The cinematic process that first successfully employed those principles- Kinemacolour - was exhibited in 1911. This process, which made use of a red and green filter through which black and white frames could be projected, was a considerable commercial success. Nevertheless these 'additive' colour processes had several drawbacks, and were soon superseded by other two-colour methods such as Koda-chrome (1915), a 'subtractive' process in which colour images were formed directly in the film rather than indirectly on the screen. In 1922, Technicolor also introduced a two-colour process; but the limited effects of the two-colour systems hardly justified their expense, and in 1932 it was replaced by Technicolor's superior three-colour format. Technicolor was able to capitalise on the coming of sound by offering a process that had no adverse effect on the sound track. By means of combining superior print quality with patent control, Technicolor continued to dominate the American colour movie market for three decades.

At first, the two-colour process proved insufficiently attractive to the majors to induce them to experiment with it, and so Technicolor began to produce shorts of its own and also to provide MGM and Warner Bros with Technicolor supervisors when the two companies began their own series of colour shorts and introduced short colour sequences into primarily black and white films. Finally, in 1929, Warner Bros released two "all colour, all talking" features—*On with the Show* and *Gold Diggers of Broadway*, the first results of a twenty-feature contract Jack Warner had signed with Technicolor. At the beginning of the new decade, when the industry began to feel the effects of the Depression, the majors, unable to withdraw from their commitment to sound, chose instead to reduce their interest in colour cinema-tography, and the musical - the genre with which colour had been most closely associated - was briefly considered to be "boxoffice poison". Undaunted, Technicolor invested a further $180 in their three-colour process, and instead of entering the market themselves, offered exclusive contracts to two independent production companies—Walt Disney and Pioneer Films. Disney acquired

exclusive rights for colour cartoons and released a series of "Silly Symphonies" which won critical acclaim, Academy Awards and massive box-office returns. Meanwhile Pioneer, after experimenting with three-colour shorts and sequences, released the first three-colour feature, *Becky Sharp*, in 1935. When *Becky Sharp* proved only a modest commercial success, Pioneer's executives joined forces with another independent producer, David O. Selznick, and under the banner of Selznick International absorbed Pioneer's eight-feature contract with Technicolor. There followed a string of three-colour successes from Selznick International: *The Garden of Allah* (1936), *A Star Is Born* (1937), *The Adventures of Tom Sawyer* (1938) and *Gone with the Wind* (1939).

By the time the economic viability of Technicolor was established, World War II, the shrinking world market for films, and reduced budgets and production schedules curtailed the expansion of colour cinematography for some time. While in 1935 it was estimated that colour added approximately 30% to production costs - which then averaged about $300,000, in 1949 this figure had fallen to 10% while the average costs of American "A" features had risen to about $1 million. In I948, Variety estimated that colour could add as much as 25% to a feature film's financial return, but this was not sufficient to cover additional production costs. In 1940, only 4% of American features were in colour. By 1951, this figure had risen to 51% but in 1958 had fallen to 25%, as a result of shrinking budgets and the emergence of the black-and-white TV market. By 1967, however, the TV networks having turned to colour broadcasting, the percentage rose once more to 75%, and in 1976, 94%.

Deep-focus

Deep-focus cinematography is characterised by a film image of some depth from foreground to background, in which all the components of the image are in sharp focus. This style of film making is commonly associated with certain Hollywood films of the 1940s. Patrick Ogle dates its emergence at around 1941, and argues that its development was influenced by a matrix of cinematic and non-cinematic factors, such as the rise of photojournalism and social realist and documentary film movements during the 1930s, and the availa bility of new kinds of film stock, lighting equipment and lenses. According to this argument, cinematographers at this period were attempting to duplicate on film the perspective and foreground-background image size relationships seen in picture magazines. Since the normal focal length of a 35 mm still camera is (relatively speaking) half that of the 35 mm motion picture camera, most still camera pictures take in an angle of view twice as wide as that taken in by a movie camera filming

the same event from the same distance. In order to reproduce the effects of stil photographs, cinematographers had to use what, in motion picture terms, were considered unusually wide angle lenses.

In the mid-1930s improved arc lightswhich, because of noise and flicker problems, had been virtually abandoned in favour of incandescents better suited to panchromatic film stock and sound filming—were introduced specifically, at first, for Technicolor cinematography, which demanded high levels of lighting. In the latter half of the decade, however, faster film stocks became available, and while many cinematographers chose to underdevelop their footage in order to maintain the soft tones and low contrast levels they had been used to, a few opted for the possibilities of increased crispness and depth of field. In 1939, a new emulsion type was introduced which reproduced both sound and image more clearly and criply than ever before, and, at the same time, new lens coatings were produced which resulted in improvements in light transmissions of more than 75% under some conditions. This more efficient use of light led to better screen illumination, image contrast, and sharpness of focus for both colour and black-and-white cinematography. Although this conjunction of powerful point source arc lights, fast film emulsions and crisp coated lenses were necessary preconditions for deepfocus cinematography, they were by no means sufficient. According to Ogle, for deep-focus to develop as it did, a number of essentially aesthetic choices and creative syntheses had to occur. The aesthetic in question is cinematic realism, which Ogle defines as "a sense of presence" similar to that experienced by spectators in the theatre, in that the viewer is provided with "visually acute high information imagery that he may scan according to his own desires without the interruptions of intercutting...". This argument echoes Bazin, for whom deep-focus brought the spectator into a relation with the image closer to that which s/he enjoyed with reality. For Ogle, deep-focus cinematography as a recognised visual style first came to critical and public attention with the release of *Citizen Kane* (1941), though it had certainly been practised before. Although not obviously realistic in style, *Citizen Kane* manifested an unprecedented depth of field in the scene photographed, which led a contemporary reviewer to claim that it produced ... a picture closely approximating to what the eye sees ... The result is realism in a new dimension: we forget we are looking at a picture, and feel the living, breathing presence of the characters'.

Although Ogle disagrees that the human eye sees in deep-focus, he believes the sense of realism celebrated by the reviewer consists in deep-focus cinematography's tendency towards long duration sequences, avoidance of cut aways and reaction shots, the employment of a relatively static camera, and the use of unobtrusive editing—once again echoing Bazin.

Avoiding an argument based on technological determinism, Ogle insists that

deep-focus could never have emerged without the timely creative input of Gregg Toland, William Wyler, John Ford and Orson Welles, and indeed, without certain production conditions. He considers that *Citizen Kane*, for example, "constituted a major coming together of technological practice with aesthetic choice in an environment highly conducive to creativity".

Against Ogle's account, however, it has been argued that neither technological practice nor aesthetic'choice are independent of ideological and economic choices and practices, as Ogle's analysis suggests; moreover, realism is not simply an aesthetic but also an ideology, an 'ideology of the visible'. The importance of deep-focus' cinematography for film criticism lies in its encapsulation of issues concerning economics and technology, aesthetics and ideology. An economic imperative might be detected, for instance, in the industry's need to mark a difference, a new kind of product; and part of the aesthetics of deepfocus may well have emerged from the cinematographers' desire to assert their 'creative' status in the industry hierarchy.

Lighting

While the technologies of sound, colour and deep-focus are relatively wellresearched areas of film scholarship, comparatively little work has been done on the history of film lighting, a history which has both influenced and been influenced by various other film technologies. In the 1890s the major source of illumination for shooting film was sunlight. Sets were built and filmed on outdoor stages with muslin diffusers mounted on wires and various kinds of reflectors employed to adjust the levels of brightness and to reduce obtrusive shadows, The first film studio, Edison's "Black Maria", built in 1893, had its walls covered in black tarpaper and its stages draped in black cloth; its roof opened to adjust sunlight, and the whole building could be rotated to maximise daylight. Only occasionally did early films employ artificial lighting effects: in 1899 D.W. Griffith's camera operator Billy Bitzer installed some 400 arc lights in order to film an indoor boxing match. By 1905 several studios including Biograph and Vitagraph, had equipped themselves with Cooper-Hewitt mercury vapour lamps.

At first the Cooper-Hewitt lamps were used only sparingly in order to supplement the diffuse sunlight which filtered through studio roofs. Only around 1910 did supplementary light from arc floodlights on floor stands begin to be added. These lights permitted more distinct facial modeling and separation of actors from their backgrounds, as well as offering the possibility of simulating directed lamp or window light with far greater precision than the diffused vapour lights that had preceded them. For some time, however, all that was expected of

film lighting was an adequately exposed negative and an evenly diffused light, preferably flat, bright and shadowless. Rudolph Arnheim in his book Film as Art has remarked: "In the early days any auspicious light effect was avoided, just as perspective size alterations and overlapping were shunned. If the effects of the lighting sprang to the eye too obviously in the picture, it was considered a professional error". How then did film lighting. as a meaning ful element of mise-en-scène, develop? Barry Salt has suggested that the main thrust in the development of lighting interior scenes in American films was the change to overall use of directional artificial light and its application separately to actors and to sets, though he offers no explanation as to why this change took place. Another historian, Charles W. Handley, has argued that it was intercompany competition between members of the Motion Picture Patents Company and independent producers which encouraged camera operators to introduce carbon arc floodlights and spotlights and so differentiate their own sets and stars from others.

For whatever reason, by 1915 lighting for illumination was gradually being replaced by lighting for dramatic effect, and Klieg spotlights were becoming normal in studio practice:

"Light becomes atmosphere instead of illumination, coming naturally from some window, lamp, or doorway, it illuminates the centre of the picture and the people standing there with a glow that in intensity, in volume, or in variety of sources has some quality expressive of the emotion of the scene."

Peter Baxter argues that during this crucial period for the American film industry, when its industrial organisation was consolidated, the expressive potential of lighting, its ability to achieve dramatic "effects" was harnessed to a naturalist aesthetic which paralleled developments in commercial American theatre at the time. By 1918 the conventions of lighting (revelation and expression) which were to dominate Hollywood production up to the present day were more or less established: lighting should never be so artificial or abstract as to disconcert the cinema audience. Its potential for abstraction became subordinated to the representational codes characteristic of seventeenth-century Dutch painters—Rembrandt in particular; in other words, it was given source and direction. In 1930 a cinematographer wrote: In a well photographed picture the lighting should match the dramatic tone of the story. If the picture is a heavy drama... the lighting should be predominantly sombre. If a picture is a melodrama... the lighting should remain in low-key but be full of strong contrasts. If the picture—is, on the other hand, a light comedy... the lighting should be in a low-key throughout. For two reasons: first, to match the action, and secondly, so that no portion of the comedy action will go unperceived'.

As the Klieg lights came into general use so too did three-dimensional rather than painted sets, and sunlight was finally eliminated altogether from-studios. The

1920s saw the gradual conventionalisation of the use of stronger and weaker arc floodlights functioning as key (hard, direct light), fill (soft, diffused light filling in the shadows cast by key lighting) and back lighting, The coming of sound, however, called forth a new range of technological demands, and "restricted to small sets and with his camera static, the cinemato grapher...began casting about for light sources that would not be restricted, as were his cameras, by the noise they created". Humming carbon lights were replaced by silent Mazda tungsten incandescent lamps, and the hard light of the arcs was considerably softened by the more diffused incandescents. Incandescent lights were also better suited to the panchromatic stock which began to replace orthochromatic in 1928. By 1931, however, improved carbon arcs had been introduced to provide the high-key bright light necessary for the new two-colour Technicolor process. In the latter half of the 1930s, the brightly-lit look was further encouraged by the successful introduction of three-colour Technicolor. Arc lights were too powerful for monochrome work, and pre-sound Mazda incandescents were still used. By the end of the decade, however, the arrival of faster Technicolor film stock allowed a reduction in lighting power requirements for colour cinematography and the modern arc lights began to be used in black-and-white production also, in preference to old-fashioned incandescents. The move to more economical location filming after World War II was encouraged by war-developed technology like the Colortran, a relatively lightweight and mobile source which required fewer lighting units and involved a cruder use of fill lights. Until the late 1940s, studio lighting was either low-key (for film noir) or high-key (for deep-focus cinemotography). But the codes of 'dramatic lighting' which had been established much earlier, and which demanded that lighting should be subordinated to aesthetic coherence, continued to dominate Hollywood production.

However, the ideology of aesthetic coherence was not the only factor governing the development of lighting conventions and technology. Some studios, for instance, worried by high electricity bills, sought to economise by using the lowest possible lighting levels and automated machinery which would reduce manning requirements. As with other cinematic technologies,their development (or, in some cases, such as 3D, non-development) is often uneven rather than chronologically linear, due to pressure from a variety of sources, economic and institutional as well as aesthetic and ideological.

3. 八大电影公司

从默片时代逐步建立起来的八大电影公司成为主导经典好莱坞时期二十

好莱坞八大电影公司标志

年的垄断性电影寡头,其中派拉蒙(Paramount)、米高梅、20世纪福克斯、华纳兄弟和雷电华五大公司拥有制作、发行和院线的一条龙产业链,而环球、哥伦比亚和联美三个相对较小的公司则基本没有院线。

派拉蒙为好莱坞最早的大公司(1912年创建、1927年落户好莱坞),范朋克、璧克馥、斯旺森都是它早期的签约明星,后来的明星包括梅·韦斯特、玛丽·黛德丽、加利·古柏和劳伦·白考尔等。派拉蒙热衷于斯登堡和刘别谦式的欧洲风格电影(《摩洛哥》和《璇宫艳史》),在马克斯兄弟喜剧片(《鸭汤》)和西席·地密尔式的史诗大片(《十诫》)方面颇有建树。树大招风的派拉蒙在1948年反垄断审判中被定罪,"派拉蒙判例"(the Paramount case)标志着好莱坞大制片厂体制的解体。

米高梅偏爱明星阵容、大预算和高回报的豪华制作(如《乱世佳人》),老板梅耶号称拥有多过天上星星的明星(包括葛丽泰·嘉宝、克拉克·盖博、裘蒂·迦伦、凯塞琳·赫本、斯宾塞·屈赛、金·凯利等),而剧情片大师乔治·顾柯和歌舞片圣手文森特·米内利则是米高梅的看家导演。

20世纪福克斯最大的家产曾是风靡世界的童星秀兰·邓波儿,而西部片大师约翰·福特也是20世纪福克斯的长期签约导演,其间执导过《愤怒的葡萄》《青山翠谷》和《侠骨柔情》等优秀作品。

华纳兄弟主要制作中小成本的黑帮片、歌舞片和剧情片,签约明星包括亨弗莱·鲍嘉(《北非谍影》和《马耳他之鹰》)、詹姆斯·卡格尼(《人民公敌》)、爱德华·罗宾逊(《小凯撒》)和贝蒂·戴维斯(《红衫泪痕》和《女人女人》),导演包括迈克尔·寇提兹、马文·勒罗伊和威廉·维尔曼等。

雷电华(RKO)作为最短命的好莱坞大制片厂(1928—1957),致力于阿斯泰尔和罗杰斯的歌舞片,还制作过奥逊·威尔斯的《公民凯恩》和《安倍逊大族》、希区柯克的《深闺疑云》《美人计》及幻想片《金刚》等著名影片。

在好莱坞三个较小的制片工厂中,环球(Universal)靠拍摄惊悚恐怖片(《吸血鬼》和《弗兰肯斯坦》)起家,并钟情于B级电影和中小城市观众;哥伦比亚(Columbia)曾有过当家导演弗兰克·卡普拉《一夜风流》的辉煌,但基本上还是拍摄B级西部片和滑稽喜剧等低成本影片;联美(United Artists)由格里菲斯、卓别林、范朋克和璧克馥四位艺术家合资建立,致力于拍摄和发行艺术性较强的影片,包括卓别林的《淘金记》《摩登时代》和《大独裁者》、格里菲斯的《凋谢的花朵》和《东方之路》等。

The New Structure of the Film Industry

During the silent era, the Hollywood film industry had developed into an oligopoly in which a small number of companies cooperated to close the marker to competition. While the structure of this oligopoly remained relatively stable into the 1930s, the coming of sound and the onset of the Depression caused some changes.

Only one large new company was formed as a result of the coming of sound: RKO, created to exploit RCA's sound system, Photophone. Fox's successful innovation of sound-on-film led it to expand considerably during the late 1920s, but the beginning of the Depression forced Fox to cut back on its investments. Most notably, it sold its newly acquired controlling interest in First National to Warner Bros. Thus Warners, which had been a small company, grew into one of the largest firms of the 1930s.

By 1930, the Hollywood oligopoly had settled into a structure that would change little for nearly twenty years. Eight large companies dominated the industry. First were the Big Five, also called the Majors. In order of size, they were Paramount (formerly Famous Players-Lasky), Loew's (generally known by the name of its production subsidiary, MGM), Fox (which became 20th Century-Fox in 1935), Warner Bros., and PKO. To be a Major, a company had to be vertically integrated owning a theater chain and having an international distribution operation. Smaller companies with few or no theaters formed Little Three, or the Minors: Universal, Columbia, and United Artists. There were also several independent firms. Some of these (such as Samuel Goldwyn and David O.Selznick) made expensive, or "A", pictures comparable to those of the Majors. Those firms (such as Republic and Monogram) making only inexpensive B pictures were collectively known as Poverty Row. We shall survey each of the Majors and Minors briefly and then look at the phenomenon of independent production.

The Big Five

Paramount Paramount began as a distribution firm and expanded by buying up large numbers of theaters. This strategy succeeded in the 1920s, but once the Depression hit, the company earned far less money and owed sizable amounts on the mortgages of its theaters. As a result, Paramount declared bankruptcy in 1933 and underwent court-ordered reorganization until 1935. During that time it produced films but at a loss. In 1936, Paramount theater executive Barney Balaban became president of the entire company and made it profitable again (so successfully that he retained his post until 1964).

In the early 1930s, Paramount was known partly for its European-style productions. Josef von Sternberg made his exotic Marlene Dietrich films there, Ernst Lubitsch continued to add a sophisticated touch with his comedies, and French import Maurice Chevalier was one of its major stars. The studio also depended heavily on radio and vaudeville comedians. The Marx Brothers made their earliest, most bizarre films there (notably *Duck Soup*, directed by Leo McCarey in 1933), and Mae West's suggestive dialogue attracted both audiences and controversy.

In the second half of the decade, Balaban turned paramount in a more mainstream direction. Bob Hope and Bing Crosby, consistently among the top box-office attractions of the World War II period, helped sustain the studio, as did tough guy Alan Ladd and comedian Betty Hutton. One of the studio's popular wartime directors, Preston Sturges, made several satirical comedies. Throughout the 1930s and 1940s, Cecil B.De Mille continued as a mainstay of the studio he had helped start, with a series of big-budget historical films.

Loew's /MGM Unlike Paramount, MGM did well all the way through the period from 1930 to 1945. With a smaller theater chain, it had fewer debts and was the most profitable American film firm. This was partly due to the quiet guidance of Nicholas Schenck, who managed Loew's from New York. Louis B. Mayer ran the West Coast studio on a policy of high-profile, big-budget films (supervised by Irving Thalberg until his early death in 1936), backed up by mid-range films (mostly supervised by Harry Rapf) and B pictures.

MGM's films (even the Bs) often looked more luxurious than those of other studios. Budgets for features averaged $500,000 (higher, for example, than the $400,000 Paramount and 20th Century-Fox were spending). Cedric Gibbons, head of the art department, helped create an MGM look with large, white, brightly lit sets. MGM boasted that it had under contract "more stars than there are in heaven". Important directors who worked consistently for MGM included George Cukor and Vincente Minnelli.

In the early 1930s, MGM's biggest star was the unglamorous, middle-aged Marie Dressler, remembered today mainly for her Oscar-winning performance in *Min and Bill* (1930) and her sardonic role in *Dinner at Eight* (1933). Later in the decade, Clark Gable, Spencer Tracy, Mickey Rooney, and Judy Garland all became major drawing cards. It is some measure of MGM's emphasis on quality that Rooney, who was acting in A musicals like Busby Berkeley's *Strike Up the Band* (1940), could simultaneously be delegated to the relatively low-budget, but popular, "Andy Hardy" series. Greta Garbo was more a prestige star than a box-office draw in the United States, but her films did well in Europe; once the war broke out and European markets were closed to American films, MGM let her go. During the war, new stars emerged for the studio, including Greer Garson, Gene Kelly, and Katharine Hepburn—the last teaming up with Spencer Tracy.

20th Century-Fox Partly as a result of its expansion after the innovation of sound, Fox entered the Depression in worse shape than the other Majors. The company remained in trouble until 1933, when Sidney Kent, former head of distribution for Paramount, took over and helped turn the frm around. One crucial step was a merger with a smaller company, Twentieth Century, in 1935. This deal brought in Darryl F. Zanuck as head of the West Coast studio, which he ran with an iron hand.

20th Century-Fox had relatively few long-term stars. Folk humorist Will Rogers was immensely popular up to his death in 1935; skating star Sonja Henie and singer Alice Faye were both famous for a few years. But the studio's biggest draw was child-star Shirley Temple, who topped national box-office polls from 1935 to 1938. Her popularity waned as she grew up, and 20th Century-Fox's biggest wartime profits came instead from Betty Grable musicals. (A photograph of Grable in a bathing suit was the favorite pin-up among the troops.) Major directors who worked steadily at Fox during this period included Henry King, Allan Dwan, and John Ford.

Warner Bros. Like Fox, Warner Bros. had been borrowing and expanding just before the Depression began. It coped with its debts not by declaring bankruptcy but by selling off some holdings and cutting costs. Harry Warner ran the company from New York, insisting on making a relatively large number of low-budget projects, resulting in modest but predictable profits.

The effects on the films were apparent. Although in total assets Warners was as big as MGM, its sets were much smaller, and its stable of popular actors—ames Cagney, Bette Davis, Humphrey Bogart, Errol Flynn, and others—worked in more films. Plots were recycled frequently (the screenwriting department was known as the "echo chamber"), and the studio concentrated on creating popular genres and then mining them: the Busby Berkeley musical, the gangster film, the problem film based on current headlines, the "bio-pic", and, once the war began,

a series of successful combat films. Warners depended on prolific, solid directors such as William Wellman, Michael Curtiz, and Mervyn LeRoy to keep the releases flowing. The many Warners films of the era that have become classics attest to the ability of the studio's filmmakers to succeed with limited resources.

RKO This was the shortest-lived of the Majors. In 1928, the Radio Corporation of America (RCA), unable to convince any studio to adopt its sound system, went into the movie-making business itself as RKO. Unfortunately, RKO always lagged behind the other Majors. By 1933 the firm was in bankruptcy, and it was not reorganized until 1940. At that point, the general wartime prosperity helped RKO achieve profitability, though its problems would return shortly after the war's end.

RKO had no stable policy during this period, and it lacked big stars. Katharine Hepburn, for example, was popular during the early 1930s, but a series of indifferent and eccentric films labled her "box-office poison". RKO had isolated hits, such as the 1933 fantasy *King Kong*, but the studio's only consistent moneymakers during the 1930s were Fred Astaire and Ginger Rogers, whose series of musicals ran from 1934 to 1938. To a considerable extent, RKO's slim profits dependent on its distribution of animated films made by an independent firm, Walt Disney.

During the early 1940s, RKO turned to producing prestigious Broadway plays, including *Abe Lincoln in Illinois* (1940). One controversial young theatrical producer hired at this time was Orson Welles. His *Citizen Kane* (1941) would later be remembered as the most important RKO film, though it was financially disappointing at the time. During the early 1940s, RKO's B unit, supervised by Val Lewton, produced some of the most creative low-budget films of Hollywood's studio era.

The Little Three

Universal Although it had an extensive distribution system and was the largest of the Little Three, Universal had constant money problems from 1930 to 1945 (and beyond). It had few major stars, and its successful filmmakers tended to move to bigger studios. Universal's early strategy was to promote new stars in visually striking horror films. The firm made stars of Bela Lugosi (*Dracula*, 1931), Boris Karloff (*Frankenstein*, 1931), and Claude Rains (*The Invisible Man*, 1933). After 1935, Universal increasingly targeted small-town audiences, building up another new star, the cheerful teenage singer Deanna Durbin. B series were important to the studio, such as the Sherlock Holmes films of the 1940s, starring Basil Rathbone, and the slapstick Abbott and Costello series.

Columbia Under the consistent leadership of studio head Harry Cohn, Columbia weathered the Depression and remained profitable. Despite low budgets, it turned out popular films, often by borrowing stars or directors from bigger studios (thus avoiding the costs of keeping them under contract). The studio's most important director, Frank Capra, remained there throughout the 1930s. His 1934 film *It Happened One Night* starred Claudette Colbert (loaned out from Paramount) and Clark Gable (from MGM); film, director, and stars all won Oscars, and the picture was one of Columbia's biggest hits.

Although several major directors worked briefly at Columbia—most notably John Ford for *The Whole Town's Talking* (1935), George Cukor for *Holiday* (1938), and Howard Hawks for *Only Angels Have Wings* (1939) and *His Girl Friday* (1940)—they did not stay. During this period, the studio was largely dependent on its B Westerns, Three Stooges films, and other cheaper fare.

United Artists The sound era saw the beginning of a slow decline for UA. D. W. Griffith, Mary Pickford, and Douglas Fairbanks all retired in the early to mid-1930s, and Charles Chaplin released a feature only about once every five years. UA distributed films for other prominent independent producers such as Alexander Korda, David O. Selznick, Walter Wanger, and Samuel Goldwyn—who all switched to other firms by the end of World War II. As a result, UA was the only company whose profits fell during most of the wartime boom years.

UA's releases from 1930 to 1945 reflect their origins from a batch of diverse independent producers. Prestigious British imports like *The Private Life of Henry VIII*, slapstick musicals with popular Broadway star Eddie Cantor, a few of Alfred Hitchcock's American films (including *Rebecca and Spellbound*), and some of William Wyler's finest works (*Dodsworth, Wuthering Heights*) provided a varied output. Unlike in the silent period, however, UA now had to fill out its feature schedule with mid-budget, or even B, pictures.

4.《海斯法典》与美国电影协会

1922年好莱坞成立旨在推展制片厂电影和改善好莱坞形象的美国电影制片人发行人协会（Motion Picture Producers and Distributors of America，MPPDA）。

《海斯法典》（the Hays Code，又称《美国电影制作法典》）就是以时任美国电影制片人发行人协会主席的威尔·海斯（Will Hays）之名命名的好莱坞电影审查的自律规范。《海斯法典》在1930年推出，1934年成为强制性措施。因为当时的保守政治倾向将美国经济大萧条和好莱坞丑闻归咎于社会道

德的堕落和电影的诲淫诲盗。《法典》涉及两性、婚姻、宗教、犯罪、自杀、谋杀、吸毒、绑架孩童、流产和卖淫等范畴，规定电影不准渲染性和暴力、不得宽恕犯罪及变态行为、不得亵渎宗教等。

美国电影制片人发行人协会于 1945 年改名美国电影协会（Motion Picture Association of America, MPAA），致力于提升好莱坞电影在全美乃至全世界的影响力，历任协会主席威尔·海斯（曾任哈定总统邮政部长）、埃里克·约翰斯顿（Eric Johnston, 曾任美国商会会长和罗斯福总统特使）、杰克·瓦伦蒂（Jack Valenti, 曾任约翰逊总统特别助理）和丹·克鲁格曼（Dan Glickman, 曾任克林顿总统农业部长）均与美国政府关系密切，为权势巨大又不折不扣的"好莱坞电影大使"。

The Hays Code: Self-Censorship in Hollywood

The popular image of Will Hays and other officials of the Motion Picture Producers and Distributors of America (MPPDA) casts them as sour puritans imposing censorship on the film industry. The reality is more complex. The MPPDM was a corporation owned jointly by the film companies themselves. One of the MPPDA's tasks was to help *avoid* censorship from the outside.

The MPPDA was formed in 1922 to improve public relations after a series of Hollywood scandals, to provide a lobbying link to the era's sympathetic Republican administrations, and to handle foreign problems like quotas. Similar functions continued into the 1930s, but the MPPDA became more famous for its policy of industry self-censorship: the Production Code (often called the Hays Code).

The early 1930s were an age of conservatism. Many believed that lax morality during the 1920s Jazz Age had been one cause of the Depression. State and municipal film censorship boards, formed in the silent era, tightened standards. Pressure groups promoting religious beliefs, children's welfare, and the like protested against sex, violence, and other types of subject matter. In 1932 and 1933, a series of studies by the Payne Fund investigated the effects of filmgoing on audiences—particularly children. More voices demanded regulation of filmmaking.

By early 1930, outside pressure for censorship forced the MPPDA to adopt the Production Code as industry policy. The Code was an outline of moral standards governing the depiction of crime, sex, violence, and other controversial subjects. Provision of the Code demanded, for example, that "methods of crime should not be explicitly presented" and that "sexual perversion or any inference to it is forbidden". (In this period, "sexual perversion" referred primarily to

homosexuality.) All Hollywood films were expected to obey the Code or risk local censorship. In enforcing the Code, MPPDA censors often went to absurd lengths. Even respectably married couples had to be shown sleeping in twin beds (to suit British censors), and the mildest profanity was forbidden. When *Gone with the Wind* was filmed in 1939, there was lengthy controversy before the MPPDA finally permitted Clark Gable to speak the famous closing line "Frankly, my dear, I don't give a damn".

The MPPDA's efforts were initially resisted by the film companies. Most of the firms were in financial trouble, some moving into or near bankruptcy as theater attendance fell; they knew sex and violence could boost theater patronage. Gangster films and sex pictures, however, drew the wrath of censors and pressure groups. Films like *The Public Enemy* (1931), *Little Caesar* (1930), and *Scarface* (1932) were seen as glorifying criminals. Although the protagonists were killed in the end, it was feared that youngsters would copy the tough-guy images of James Cagney and Edward G. Robinson. More notoriously, several films centered on women who traded sexual favors for material gain. *Baby Face* (1933) and *Red-Headed Woman* (1932) showed women attaining elegant apartments, clothes, and cars through a series of affairs. Even *Back Street* (1932, John M. Stahl), in which the heroine lives modestly and truly loves the man who keeps her, was found offensive. According to the Code's author, the film approved "of extramarital relationship, thereby reflecting adversely on the institution of marriage and belittling its obligations".

Mae West presented a formidable challenge to the MPPDA. She was a successful Broadway performer and playwright whose fame rested on sensational plays like *Sex* (1926). Although the MPPDA fought to keep her out of films, Paramount, facing bankruptcy, hired her; for a few years she was the company's top moneymaker. Her first star vehicle, *She Done Him Wrong* (1933, Lowell Sherman), took in many times its cost. A typical bit of dialogue occurs as the virtuous young hero chides the heroine, Lou, by asking her, "Haven't you ever met a man that could make you happy?" Lou replies, "Sure...lots of times". West's drawling delivery could make any line seem salacious.

The timing of the premiere of *She Done Him Wrong* could not have been worse. The first Payne Fund studies had just appeared. Moreover, in early 1933, the Roosevelt administration took over, severing Hays's ties to Republican officials in Washington. With growing ferment against the film industry, a national censorship law seemed to be in the offing. As a result, in March 1933, Hays pushed the film industry to enforce the Code.

Still, studios hungry for patrons tested the Code's limits. Mae West's films continued to cause problems. *Belle of the Nineties* (1934) was recut at the insistence of the New York State Censorship Board. The negotiations concerning

this film coincided with mounting pressure from religious groups, especially the Catholic Legion of Decency. (The legion had a rating system that could condemn films either for young people or for all Catholics. This stigma could cause the industry considerable lost revenues.)

The danger of increased official censorship was too great to be ignored, and, in June 1934, the MPPDA established a new set of rules. Member studios releasing films without MPPDA seals of approval now had to pay a $ 25, 000 fine. More important, a film without a seal was barred from any MPPDA member's theaters—which included most first-run houses. This rule forced most producers to comply with the Code. Of course, "objectionable" material was still used, but it became more indirect. A strategic fade-out might hint that a couple was about to make love, extreme violence could occur just offscreen; sophisticated dialogue could suggest much without violating the Code.

The MPPDA may have been repressive, but it blocked potentially more extreme national censorship. In practical terms, the Code was not a tool of the prudish minds of MPPDA officials but a summary of the types of subject matter that could get movies cut by local censors or banned for Catholic viewers. The Code saved Hollywood money by pressuring filmmakers to avoid shooting scenes that would be snipped out. The MPPDA did not seek to eliminate every risqué line or violent moment. Instead, it allowed the studios to go just far enough to titillate the public without crossing the lines defined by local censorship authorities.

Motion Picture Association of America (MPAA)

At first organized by the film producers and distributors as the Motion Picture Producers and Distributors of America (MPPDA) in 1922 and given its present name in 1945, this organization was originally created in response to public indignation over apparent sex scandals and immoral behavior among the members of the film industry. The public reacted strongly against such events as the death of a young actress at a party thrown by Fatty Arbuckle. The once-admired comedian was tried for her death and judged innocent, but the scandal ruined his career. The industry worried about the effect of such scandals on the box office and foresaw the possibility of censorship from state and local governments. Movies were a family entertainment and it was necessary to keep them free from any taint of immorality if the industry was to continue in its present lucrative state. The MPPDA was formed by the major studios and distributors to clean up the industry. Will Hays, post-master general under President Harding, a man of impeccable credentials and high moral reputation, was named its head. Throughout the remainder of the decade, the MPPDA, informally called the Hays Office,

applied pressure to the industry to encourage noral rectitude—its argument was for self-censorship, but the organization became both a place of judgment and court of appeal. The organization also formed the Central Casting Bureau for scrutinizing the backgrounds and morals of bit players and extras. It worked diligently in public relations, creating a better image of the industry in the press and warding off censorship from government institutions.

Moral indignation again began to rise at the end of the decade while new problems arose from the use of dialogue in the new sound film. The result was the Motion Picture Production Code, formulated in 1930 and made binding in 1934, No motion picture was to be released without a seal of approval, and heavy fines were established for any producer, distributor, or exhibitor who might be involved with such a film. The MPPDA set up machinery to help guide the industry from the writing of the screenplay to the final editing of the film. Revised on two occasions, the code was finally discarded in 1968, and replaced by a rating system that advised viewers about the content of films.

The MPPDA performed other functions besides censoring the content of films and working on the industry's image in the press. The Central Casting Bureau, as well as screening out undesirables. offered an efficient means of hiring. The organization set up a Titles Registration Bureau, which kept an index on all films and arbitrated title disputes. Its Foreign Department negotiated for foreign distribution and kept itself informed about censorshiu abroad, while its Theater Services Department sought to improve the relationship between production, distribution, and exhibition. The MPPDA, with its Labor Committee, also became the major trade agency for the production companies.

In 1945, the Hays Office became the Johnston Office when Eric Johnston took over as head of the organization, which changed its formal name to the Motion Picture Association of America (MPAA). Under Johnston's administration, the organization confronted such problems as the studios' loss of theaters brought about by the Supreme Court's Paramount decision in 1948, the decline of movie audiences in the 1950's because of the rise of television, the need for increased foreign distribution and more foreign production facilities, and the erosion of the Production Code. To facilitate work concerning foreien distrioution, a sister agency, the Motion Picture Export Association (MPEA), was formed in 1945; it also came under the leadership of Johnston. In 1966, Jack Valenti, former aide to President Lyndon Johnson, became head of the MPAA and MPEA. Valenti was instrumental in getting the 1968 ratine svstem approved and represented the studios in negotiations with exhibitors. He was also much concerned with increasing the distribution of American films in foreign countries.

5. 美国电影艺术与科学学院与奥斯卡奖

美国电影艺术与科学学院（The Academy of Motion Picture Arts and Sciences，AMPAS）在米高梅公司老板梅耶的倡导下于1927年成立，旨在改善和提升电影业的公众形象、推动电影艺术与技术的发展、表彰电影创作的突出成就、促进电影与各界的学习交流。学院设有十几个专业行会负责各自领域的工作。格里菲斯、地密尔和刘别谦等都是学院的创始人，而范朋克、卡普拉、贝蒂·戴维斯、斯蒂芬斯和怀斯曾先后出任学院领导人。

学院奖（Academy Awards）俗称"奥斯卡奖"（Oscars）是美国电影艺术与科学学院颁发的年度奖励，在好莱坞乃至全世界拥有巨大的影响力。奥斯卡奖从1929年开始颁授，分为最佳影片大奖（由全体学院成员投票选出）和单项奖（由学院的各专业行会专家提名）。奥斯卡金像奖代表着美国电影的最高成就，《一夜风流》《乱世佳人》《北非谍影》《彗星美人》《音乐之声》《教父》和《辛德勒名单》等都获得过奥斯卡大奖的肯定，而1959年《宾虚》和1997年的《泰坦尼克号》则并列保持着获奖11项的最高纪录。

The Academy of Motion Picture Arts and Sciences (AMPAS)

奥斯卡金像奖

The Academy of Motion Picture Arts and Sciences (AMPAS) was founded in 1927 by Louis B. Mayer and other film industry leaders-including Cecil B. DeMille, Douglas Fairbanks, and Mary Pickford, in their roles as producers-with the expressed purpose of advancing the educational, cultural, and technical standards of American movies. Its real, and, ultimately, unsuccessful, purpose was to combat trade-unionism among the growing ranks of directors, technicians, and performers who were pressing for higher wages and better working conditions as filmmaking became one of the nation's largest industries. In 1937, in the wake of

considerable negative publicity, the Academy officially removed itself from the arena of labor relations and concentrated in earnest on its annual awards for professional achievement and on technical research, helping to achieve within a decade the industry wide standardization of everything from script format, to back projection, to the official shade of white in black-and-white panchromatic film. The Academy's membership (originally thirty-six, now over 5,000) is drawn from prominent individuals in every branch of the industry, and its chief function is, and always has been, the annual presentation of "Oscars" (Academy Awards) for distinguished film achievement in the previous year. In actual practice, the correlation between Academy Awards and cinematic excellence is not at all precise. For one thing, the winning of Oscars involves a great deal more than prestige, since they inevitably increase the earning power of the films and performers that receive them. Each year, expensive campaigns are mounted by studios and other financial backers to "lobby" Academy members for votes which can be translated into profit in the market-ace. Furthermore, Hollywood is a closed and really rather small community, many of whose members have known one another for a long time. The Academy's judgment is often colored by personal sentiment, both positive and negative, and there is always the implicit bias that what is good for the community in material terms (financially successful films and film careers) is good in critical terms as well. In short, it would be a mistake to assume that Academy Awards invariably signal excellence in films or performances. In fact, the Awards are probably best regarded as a company town's certification of the company product, and in this regard they do at least provide some indication of Hollywood's ever-changing image of itself as fabricator of American dreams. In addition to giving its annual Awards, the Academy also maintains a large collection of printed matter relating to film, and an extensive film archive with screening facilities open to the public in Hollywood; retrospectives are common.

Academy Awards

The awards given in the form of golden statuettes called Oscars by the Academy of Motion Picture Arts and Sciences for the best achievements in performance and filmmaking for each calendar year, and for distinguished career and technical achievements. Except for Best Picture, where nominations are voted by all the members of the Academy, specialists first vote for nominations in their own field, and then the entire Academy votes for the winner in each major category. Major categories for awards are now Best Picture, Actor, Actress, Supporting Actor, Supporting Actress, Directing, Screenplay Written Directly for the Screen, Screenplay Based on Material from Another Medium,

Cinematography, Art Direction and Set Direction, Sound, Film Editing, Original Score, Original Song Score and Its Adaptation or Adaptation Score, Original Song, Costume Design, Animated Short Film, Live-Action Short Film, Short-Subject Documentary, Feature Documentary, Foreign-Language Film, and Visual Effects. The first awards were given on May 16, 1929, for film achievements during 1927-28. Since 1934 awards have been given for each calendar year, except in the category of Foreign Film, where the year of eligibility is from November 1 to October 31, The most honored films are *Ben Hur* (1959; dir. William Wyler), which won eleven awards; *West Side Story* (1961; dir. Robert Wise), which won ten; and *Gigi* (1958; dir. Vincente Minnelli), which won nine. Awards are given in March or April for the previous year in a lavishly staged ceremony that has appeared on national television since 1953. Because major awards for a film mean increased publicity and revenue at the box office, as well as increased professional opportunities for the winners, a considerable amount of politicking and advertising precedes the voting.

6. 奥逊·威尔斯和《公民凯恩》

奥逊·威尔斯既是才华横溢的电影神童，又是惊世骇俗的好莱坞反叛者。他执导并主演的《公民凯恩》被公认为现代电影的最佳典范，成为与格里菲斯《一个国家的诞生》和爱森斯坦《战舰波将金》比肩的伟大作品。《公民凯恩》借用美国报业大亨赫斯特的生平，摹写美国梦的实现与幻灭，强调人性的失落和资本主义的精神实质。更重要的是，《公民凯恩》引进多视点的电影化现代叙事手法，全方位展示情节、人物和影片内涵；影片充分运用景深镜头和场面调度，最大限度呈现现实的完整一体性和暧昧多义性，成为巴赞长镜头学派理论的经典例证；广播和舞台出身的威尔斯还大量运用台词旁白（"早餐蒙太奇"段落）和灯光变化，形成摇摄镜头和推轨镜头行云流水的场景剪切。

威尔斯此后还执导过《安倍逊大族》《上海小姐》《奥赛罗》和《历劫佳人》等名作，但艺术个性膨胀的他在好莱坞体制打压之下，逐渐失去最初的光芒。

Orson Welles

Orson Welles was born in Kenosha, Wisconsin. His mother, a pianist, died in

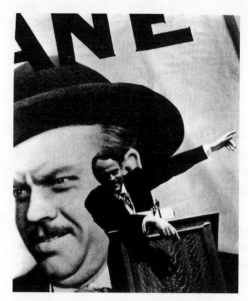

野心勃勃的《公民凯恩》

1923, and his father four years later. Young Orson quickly affirmed his theatrical talent, staging and acting in plays, especially Shakespeare, at the Todd School in Illinois. Often seen as a self-created prodigy, Welles's culture was formed first by his home background, and then by the diverse cultural institutions with which he interacted in both the United States and Europe. Having left school at 16, he became an actor with the Gate Theatre in Dublin and, on his return to the USA, became involved in the radical theatre movement in New York, whose experiments with making highbrow culture, both literary and theatrical, accessible to popular audiences (particularly via the radio) played a formative role in his precocious development.

In New York he joined forces with John Houseman to direct a number of productions first for the short-lived New York Federal Theater and then for the Mercury Theatre, which he and Houseman founded in 1937. He also directed and acted in weekly broadcasts of adaptations of literary classics, notably Dickens and Shakespeare. These broadcasts displayed some of the features which were to distinguish Welles's films-a dependence upon voice-over narration, and complex narrative structures involving embedded narratives. His most famous broadcast, however, was his 1938 Hallowe'en adaptation of H. G. Wells's *The War of the Worlds*, which simulated a special news broadcast interrupting a normal evening of radio programming. Although clearly marked as fiction, the broadcast deceived thousands of

listeners, creating a panic on the east coast. Welles's velvety baritone had already become so well known that Welles remarked after the panic, "Couldn't they tell it was my voice?"

For all its baroque stylization and exploitation of the medium-deep focus, a fake newsreel replete with phoney historical footage, multiple narrators, and complex narrative structure—Welles's first feature film, Citizen Kane (1941), would also strike too close to reality, just as the War of the Worlds broadcast had done. Newspaper tycoon William Randolph Hearst saw in Charles Foster Kane an intentional portrait of his own megalomaniac personality. Hearst threatened legal action against the film and blocked publicity in his own newspapers, successfully delaying release of the film and muting the impact of its numerous rave reviews.

Fifty years on, *Kane* remains contentious. French critic André Bazin, who saw it in 1946 at the same time as Italian neo-realism, argued that its extensive use of deep focus promoted the reality of the phenomenal world of the film, but subsqunet critics have noted that the film is also highly self-conscious, artificial, and even baroque. The use of deep focus was not unique, and director of photography Gregg Toland had already experimented with it on other productions. Welles's role as "author" of the film has also been hotly contested, notably by Pauline Kael (1974), who argued, probably incorrectly, that the script was solely the work of Herman J. Mankiewicz. But even if *Kane* was not completely novel in its structures or techniques, it remains the fact that these techniques are masterfully integrated in the film's complex texture. When Welles arrived at RKO, he compared the studio to the biggest toy train set in the world, and there is no doubt that he enjoyed manipulating the studio technology just as he had the radio.

Welles's first studio film, *Citizen Kane* also marked the beginning of his problems with the studio system. These problems were to mar his subsequent films within the system and eventually force him to leave Hollywood for European independent production. His next completed film was *The Magnificent Ambersons* (1942), which further developed the use of complex camera movements and long takes, as well as deep focus, this time with director of photography Stanley Cortez. But when Welles left Hollywood early in 1942 to film the abortive *It's All True* in Brazil, *Ambersons* was drastically edited by the studio in order to make the film fit into a double bill. Welles then attempted to make three films on time and under budget for various studios in order to demonstrate his ability to work within the system, but *The Lady from Shanghai* (1948), starring Welles himself and his then wife Rita Hayworth, met with anger and incomprehension from Columbia studio boss Harry Cohn; and neither *The Stranger* (1946), filmed according to an editor's pre-set shooting plan, nor *Macbeth* (1948), made for the low-budget studio Republic, had any box-office success.

During the 1940s Welles continued his career as a film actor (including a bravura performance as Rochester in *Jane Eyre* in 1943). In 1947 he moved to Europe, hoping to earn enough money as an actor to produce his own films. For most of the rest of his career (apart from a brieftu return to Hollywood to make *Touch of Evil* in 1958), Welles filmed on location with post-sync sound, with borrowed costumes or with none, taking several years to complete each film due to the necessity of constantly stopping to raise money. *Othello* (1952), *Mr. Arkadin* (also known as *Confidential Report*, 1955), *The Trial* (1962) and *Chimes at Midnight* (1966) were filmed under such trying circumtances, much of *The Trial* being shot in the Gare d'Orsay, then an abandoned railway station, after funding had collapsed. If Welles's Hollywood work relied heavily for its technical brilliance upon studio technicians, in his European films Welles relied upon his own talent for assembling disparate footage filmed miles and months apart into an ingenious puzzle. During this period welles retained his reliance on literature, but his style took on a greater simplicity. *Chimes at Midnight*, based on the Falstaff scenes from *Henry IV* and *the Merry Wives of Windsor*, is generally recognized as the culmination of his Shakespearian career.

At the time of his death, he left numerous unfinished projects, ranging from scripts to scraps of film to partially edited works. His film *Don Quixote*, which he had never finished, was recently completed by other hands. Welles's films often centre on a powerful figure and an outsider, the latter being caught up in the former's earth for a lost past, the narrative that emerges itself caught between truth and fiction, He enjoyed creating (and playing) figures who were braggarts and liars, or were surrounded by a web of mystery and deceit, never fully uncovered. When Welles died in 1985 al the age of 70, he had for nearly forty years been both the powerful man and the outsider, the master trickster and the roving vagabond. Two years after his death, when Welles's ashes were buried in Spain, the grave bore no name.

Citizen Kane

Behind the scenes, however, Welles was gifted at gathering around him talented collaborators. Besides the Mercury Theatre performers he brought with him—including Joseph Cotton, Agnes Moorehead, and Everett Sloane—he enlisted established professionals for his first production, Citizen Kane (1941). These included writer Herman Mankiewicz ; cinematographer Gregg Toland, who had worked with John Ford on The Grapes of Wrath, among other films; and art director Van Nest Polglase. He also gave opportunities to newcomers Robert Wise (b. 1914) as editor and Bernard Herrmann as composer. With a

working title of "American", Citizen Kane was no less serious and ambitious than the works of Ford and Capra, a biographical mystery story seeking to unravel the character and cultural significance of a media baron whose dying word was "Rosebud". It incurred the wrath of a living media baron, newspaper publisher William Randolph Hearst, who felt, not without reason, that Welles's Charles Foster Kane was modeled after him.

Recognized as a major work at its release, despite the controversy generated by Hearst, *Citizen Kane* has continued to grow in stature as the American commercial cinema's most important film. It enabled the spectator not only to look through the frame at a make-believe world, but to see once again, so to speak, the frame as a constructed image: to take delight not only from stories but from the virtuosity and splendor of cinematic art.

As with D. W. Griffith's early films, no single aspect of *Citizen Kane* was entirely original or previously unknown to filmmakers, but the work's startling impact came from its total effect, the concentration, comprehensiveness, and unity of its stylistic effort. Where innovation in Hollywood tended to occur only in isolated sequences and shots, Welles strove with his collaborators to utilize multiple innovations in nearly every shot and scene throughout the entire film.

These began with the basic narrative, fragmenting the story to different voices and viewpoints, refusing linearity or unity of perspective. This was carried forward through mise-en-scène, the construction of exceptionally deep sets so that action as well as narrative could fragment into different planes of space and depth. It was augmented by long camera takes that enabled greater movement in performance and ensemble acting by the Mercury players. It was all made possible by Gregg Toland's cinematography and lighting, using camera lenses that maintained focus through the deep space of the sets (Toland gave credit to Welles's unusually detailed preproduction planning, which was required for building camera locations into sets for extraordinary low- and high-angle shots to convey symbolic meaning). And finally, it was embedded in the shot continuity, which used sound and lighting changes as editing devices to avoid direct cuts in favor of scene changes through camera panning or dollying, or overlapping dissolves.

7. 好莱坞经典叙事系统

好莱坞经典叙事系统（classic narrative system）包括经典叙事结构和叙事

电影的经典符码两大部分。

经典叙事结构（classic narrative structure）涉及神话故事原型（从出事到解决问题的大团圆）、因果逻辑关系（提供经验理性的思维逻辑）和线性渐进结构（适应生命的时序逻辑）等元素，电影化的时空统一性仿造真实的世界、而拥有特殊动机和鲜明个性的主人公（hero）成为推进叙事的根本动力。

叙事电影的经典符码（classic code of narrative cinema）当中最重要、也最具电影化特征的无疑就是连续性剪辑（continuity editing）。首先要通过镜头的组接推动符合逻辑的故事情节发展，其次通过剪辑形成的时空一体化创造真实的幻觉（这包括180度动作轴线、视平线原则、正反打匹配、建制镜头交待环境和近景特写刻画人物等手段），再次是操控视点关系让观众认同于银幕世界（身临其境）和电影主人公（感同身受），最后是连续性剪辑不仅符合人类的视觉观看逻辑、而且以神不知鬼不觉地隐身姿态呈现在观众眼前。从格里菲斯年代建立起来的所有这一切，构造出好莱坞电影逼真又迷人的梦幻世界。

The Classic Narrative System

By the early to middle 1930s, the modes of representation now held to be characteristic of "classic" narrative cinema were more or less consolidated and had already attained a large degree of dominance, certainly in Hollywood, but also in varying degrees in film industries elsewhere. By this time, of course, sound cinema was also established. The era of classic cinema may be regarded as a period in which the cinematic image remained largely subservient to the requirements of a specific type of narrative structure. This structure is that of the classic, sometimes also called the "realist", narrative which calls forth certain modes of narration which are then put into effect by a limited set of cinematic codes.

The Classic Narrative Structure

In the classic narrative, events in the story are organised around a basic structure of enigma and resolution. At the beginning of the story, an event may take place which disrupts a pre-existing equilibrium in the fictional world. It is then the task of the narrative to resolve that disruption and set up a new equilibrium. The classic narrative may thus be regarded as a process whereby problems are solved so that order may be restored to the world of the fiction. But the process of the narrative-everything that takes place between the initial disruption and the final resolution-is also subject to a certain ordering. Events in the story are typically

organised in a relationship of cause and effect, so that there is a logic whereby each event of the narrative is linked with the next. The classic narrative proceeds step-by-step in a more-or-less linear fashion, towards an apparently inevitable resolution. The 'realist' aspects of the classic narrative are overlaid on this basic enigma-resolution structure, and typically operates on two levels: firstly, through the verisimilitude of the fictional world set up by the narrative and secondly through the inscription of human agency within the process of the narrative.

The world of the classic narrative is governed by verisimilitude, then, rather than by documentary-style realism. The narration ensures that a fictional world, understandable and believable to the recipient of the story, is set up. Verisimilitude may be a feature of the representation of either, or preferably both, the spatial location of events in the narrative and the temporal order in which they occur. Temporal and spatial coherence are in fact preconditions of the cause-effect logic of events in the classic narrative. In classic narrative, moreover, events are propelled forward through the agency of fictional individuals or characters. Although this is true also of other types of narrative, the specificity of the classic narrative lies in the nature of the human agency it inscribes, and also in the function of such agency within the narrative as a whole. The central agents of classic narrative are typically represented as fully-rounded individuals with certain traits of personality, motivations, desires and so on. The chain of events constituting the story is then governed by the motivations and actions of these characters. An important defining feature of the classic narrative is its constitution of a central character as a "hero", through whose actions narrative resolution is finally brought about. These actions are rendered credible largely in terms of the kind of person the hero is represented to be.

Finally, classic narrative may be defined by the high degree of closure which typically marks its resolution. The ideal classic narrative is a story with a beginning, a middle and an end (in that order), in which every one of the questions raised in the course of the story is answered by the time he narration is complete.

Classic Codes of Narrative Cinema

Narratives may be communicated through various modes of expression, that is, stories can be told through a variety of media. The classic narrative is perhaps most often considered in its literary form, as a certain type of novel. However, stories may also be transmitted by word of mouth, in live theatre, on the radio, and in comic strips. Film is simply one narrative medium among many but the distinguishing features of film are its mode of production and consumption, and the specifically cinematic codes by which fihn narratives are constructed. Cinematic

codes constitute a distinct set of expressive resources which can be drawn on for, among other things, telling stories.

The classic narrative system would appear to make certain basic demands of these resources. Firstly, it demands that cinematic codes function to propel the narrative from its beginning through to its rcsoltution, keeping the story moving along. Secondly, it is important that in the narration of fictional events the causal link between each event be clear. Thirdly, the narration called for would encompass the construction of a location, a credible fictional world, for the eents of the story. Finally, it should be capable of constructing the individuated characters pivotal to the classic narrative, and of establishing and sustaining their agency in the narrative process.

Perhaps the foremost of the specifically cinematic codes is that of editing. Although editing is simply the juxtaposition of individual shots, this juxtaposition can take place according to a variety of principles. Editing in classic cinema works in conjunction with the basic demands of the classic narrative structure in highly circumscrlbed ways. First, the individual shots are ordered-according to the temporal sequence of events making up the story. In this way, editing functions both to move the story along and also, through the precise juxtapositions of shots, to constitute the causal logic of narrative events. The specificity of classic editing lies in its capability to set up-a coherent and credible hctional sbace, and often also to orchestrate quite complex relationships of narrative space and time.

The principles of classical editing have been codified in a set of editing techniques whose objective is to maintain an appearance of "continuity" of space and time in the finished film; all learning film-makers have to master the rules of continuity editing. Continuity editing establishes spatial and temporal relationships between shots in such a way as to permit the spectator to "read" a film without any conscious effort, precisely because the editing is "invisible". Despite the fact that every new shot constitutes a potential spatial disruption, and each gap of years, months, days and even minutes between narrated events a potential temporal disjuncture, an appearance of continuity in narrative space and time can be set up (*Mildred Pierce*). The function of continuity editing is to "bridge" spatial and temporal ellipses in cinematic narration, through the operation of such conventions as match on action, consistency of screen direction, and the 30° rule. Coherence of fictional space is ensured by adherence to the 180° rule, whereby "the line" is never crossed in the editing of shots taken from different set-ups in a single location. Since the 180° rule, in particular, depends on the hypothesis that screen direction signified direction in three-dimensional space, the credibility of the fiction is maintained through a form of editing which signifies verisimilitude.

In the classic narrative system editing is governed by the requirements of verisimilitude, hence the characteristic pattern in any one film sequence of

establishing shot, closer shots which direct the gaze of the spectator to elements of the action to be read as significant, followed by further long-shots to re-establish spatial relations (*His Girl Friday*). Since the classic narrative sets up fictional characters as primary agents of the story, it is not surprising that characters' bodies, or parts of their bodies, notably faces, figure so frequently in close shots. Close shots of this kind function also in relation to characterisation: personality traits are represented through costume, gesture, facial expression and speech (*Klute*). At the same time, relationships between fictional protagonists are typically narrated through certain configurations of close shots, particularly those where an exchange of looks between characters is implied (*Marnie*). Here, editing is organised on the principle of the eyeline match, according to the direction of characters' gaze. The eyeline match also governs point-of-view in the shot/reverse- shot figure, which in fact reached the peak of its exploitation during the 1940s, at the height of the classic era of cinema. This method of organising the looks of protagonists, through a combination of *mise en scène* and editing, is a crucial defining characteristic of classic narrative cinema.

The conventions of classical editing constitute a particular mode of address to the spectator. In accepting a certain kind of verisimilitude in the spatial and temporal organisation of the film narrative the spectator becomes witness to a complete world, a world which seems even to exceed the bounds of the film frame. In looking at the faces of characters in close-up, and in identifying with characters in the text through taking on their implied point-of-view, the spectator identifies with the fictional world and its inhabitants, and so is drawn into the narration itself. Consequently, a resolutiou of the narrative in which all the ends are tied up is in certain ways pleasurable for the spectator.

Although classic narrative cinema moves towards the regulation of cinematic codes according to the requirements of a particular narrative structure, it is arguable that this objective can never be completely attained. Narrative and image in film are never entirely reducible to one another, if only because the demands of the classic narrative could in fact be met by a range of conventions of cinematic narration, of which the classic system is but one. Conventions, by their nature, are subject to change. Even if the classic narrative retains its dominance as a structure, its basic requirements could conceivably be met by *cinematic codes* different from those of classic cinema. And indeed, since the 1950s it appears that a rather wider range of cinematic codes has entered circulation in forms of cinema which still on the whole rely on a classic approach to narrative structure. This trend is exemplified by modes of narration characteristic of films on wide-screen formats (*River of No Return*) and by the recent development of a New Hollywood cinema (*Klute*).

第二节　美国类型电影和经典大师

类型片（genre）是指一组拥有相同或相近主题内涵、故事情节、人物类型、场景设计和视听技巧的影片。好莱坞经典类型片大致包括西部片、剧情片、警匪片、黑色电影、歌舞片、喜剧片和惊悚恐怖片等，每一类型都有特定的类型规范，便于观众识别和亲近；而每一部优秀的类型片又锐意创新，给予观众意外的惊喜。

Genre

A group of films having recognizably similar plots, character types, settings, filmic techniques, and themes. Such conventions are repeated sufficiently from film to film to make it obvious that all these works belong to a single group and that the filmmaker is relying upon the past use of these conventions and the audience's familiarity with them. The simple repetition of generic convention creates films that are dull and clichéd. The creative filmmaker relies upon conventions but also infuses his or her own vision into the work. It is the infusion of the innovative within the familiar that invokes the special pleasure we feel from a genre film. At the same time, genre films alter and develop as the culture changes, reflecting shifts in attitudes—films generically similar can still show the different attitudes of a particular era to traditional character types and values. The primary question, though, is why audiences respond so strongly to the repetition of generic film conventions. There is a great satisfaction in finding one's self in a

familiar filmic world, in knowing the kinds of people and action one will confront. We go to a genre film because we already know the kind of emotional experience to be enjoyed. More significantly, genre films often evoke some aspect of our cultural heritage by presenting mythic patterns of character and action endemic to our country's history, patterns that embody the nation's moral values and moral conflicts. We can also say that genre films are popular because they repeatedly deal with universal dilemmas and appeal to universal psychic needs (note the appropriation of the American Western by Italian filmmakers). But it must be emphasized that the talented filmmaker by his or her innovative use of these conventions makes us confront the old and familiar, with all that they imply, in a new way—that the filmmaker makes us confront the traditional and universal with extended and even new responses.

Genre films in America and Japan have been especially popular, and the similar filmic environments of these nations explain additional reasons for the popularity of these kinds of films. Both America and Japan have had large film industries making motion pictures in great numbers for vast audiences. For financial reasons, studios have been anxious to make motion pictures that appeal to the widest audiences, and, to do so, they have depended on formuis that have already been found to be successful. At the same time, the film industry, in following public tastes, has perpetuated these tastes.

In America, the most popular and discernibie film genres have been the gangster, detective, war, and horror film, as well as the musical and Western (some would consider comedy as another genre, though it is composed of many disparate types). All of these films began during the days of silent films, except for the musical, which had to wait for sound. All of them have reflected, on some level, national concerns and values, and all have appealed to universal conflicts and psychological needs. The American film industry has changed, the old hard-and-fast mass audience is gone and, with it, the old studios that readily produced these formula films. As a result, the genre films are less apparent. But some of them still flourish, especially the horror film, though it is now more violent and frequently tasteless. The detective film has been updated because of the influence of the James Bond films. Gangster films appear on occasion, though now with a new veneer as a result of the *Godfather* films. The musical is under relapse because of high costs and has not yet recovered from such financially disastrous products as *Camelot* (1967; dir. Joshua Logan), though a great talent like Bob Fosse can still produce a movie such as *Cabaret* (1972) or *All That Jazz* (1979). War films depend on international events and the national mood, which means that they remain popular with some consistancy. After refighting and winning the Vietnamese war in a series of films dealing with missing prisoners of war, America has also gone through a period of contrition with Oliver Stone's *Platoon* (1986). Perhaps the Western, of all

the genres, seems to be a victim of overexposure, but occasionally a film such as *The Long Riders* (1980; dir. Walter Hill) comes along and shows that we can still respond to the traditional if it is presented with taste, intelligence, and cinematic skill.

1. 西部片和约翰·福特

西部片（Western）有"美国创世神话"之称，是最具美国特色的类型片，也是美国最早拍摄（可以追溯到《火车大劫案》）和拍得最滥的类型电影。经典时期的西部片表现开拓进取、乐观向上的美国精神，展示西部荒野法则与东部法制文明、个人英雄主义与社区集体利益、善良义举与凶残罪恶之间的冲突，虽然最终人物善恶有报、社会重归和谐，但是牛仔英雄还是注定要独自浪迹天涯。

西部片大多取材于19世纪后半叶的西部传奇和牛仔故事，涉及复仇、惩恶扬善和匡扶正义；主要人物明确划分为善（穿浅色服装的牛仔或警长）、恶（穿深色服装的印第安人或匪徒）两大阵营；选择典型的西部环境（如喀斯特地貌的犹他州纪念谷）作为影片外景，并出现西部小镇（街道、酒吧和警长办公室等）、马匹、左轮手枪、马车、火车和电报等固定元素。

约翰·福特是举世公认的经典西部片大师，其《关山飞渡》几乎成为西部片的同义词，后来的《侠骨肉情》《搜索者》和《双虎屠龙》也是西部片名作，但他四度赢得奥斯卡最佳导演奖的作品竟然没有一部西部片。好莱坞著名的西部片还有威尔曼的《黄牛惨案》、霍克斯的《红河》、津纳曼的《正午》和斯蒂芬斯的《原野奇侠》等。

Western

A film genre popular since the earliest days of motion pictures that derives from the history and legends of the western part of this country, especially during the last half of the nineteenth century. Although the West has been fictionalized in countless novels. such works have themselves been influenced by the motion picture, which has largely developed the conventions, themes, and iconography for this world. The Western, more than any other film genre and more than any other creative form, has both embodied America's cultural history and helped shape the nation's image of itself. The Western has consistently created a world of

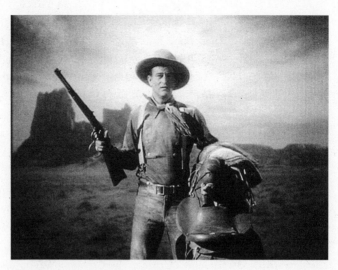

《关山飞渡》牛仔英雄约翰·韦恩

expansiveness and expectation, where the vast, untamed landscape is indicative of the independence and potentiality of its inhabitants. Although such a location is far from the stifling reality and social restrictions of the civilized East, the people who live there—and struggle against the wildness of the terrain, its indigenous inhabitants, and the outlaws with their rampant individualism—have created a code of personal ethics that affirm their own dignity and independence without denying their responsibility to others. But even within such a liberating world, elements of civilization—the farmer, the town, the encroaching system of law and order—are already being felt; indeed, the eventual demise of this type of life is an inherent part of the very films which celebrate it. Although the Western has established its code of conventions—its character types, such as the independent hero, black-clad outlaw, and attractive female schoolteacher; its plot elements, such as the chase or shootout; its images, such as the saloon or majestic landscape—this type of film has also shown remarkable adaptability to the changing times of its audience, manifesting certain enduring qualities while also showing them in the context of the very forces challenging the world outside the theater.

 Edwin S. Porter's The Great Train Robbery, made for the Edison Company in 1903 and filmed in New Jersey, is notable not only for its early use of parallel cutting and the close-up, but for first presenting to American audiences such perennial ingredients of the Western as the potent six-shooter, train holdup, and chase on horses. Appearing in this film was G. M. Anderson, born Max Aronson, who later played Broncho Billy in The Bandit Makes Good for his own Essanay

company in 1908 with such success that he was to become the first cowboy star, playing the same role in some four hundred films. Thomas H. Ince, the pioneer director and producer, made a number of authentic-looking and exciting Westerns (he used the cast of a Wild West show for The War on the Plains in 1912), but is especially notable for bringing to the screen in 1914 the second major star of the Western, William S. Hart in The Bargain. Hell's Hinges (1916) is a good example of the many films directed by and starring Hart, with their morally complex protagonist, dramatic focus, and authentic locals. Hart's last film, Tumbleweeds, which he made for Paramount in 1925, has more spectacle and humor than his previous works and also contains a classic landrush sequence. Tom Mix, coming directly from a Wild West Show, appeared in over a hundred films for Selig between 1911 and 1917 and then went on to Fox, where his daredevil horsemanship in excitement-filled films ultimately made him America's number one cowboy. In 1923, James Cruze's The Covered Wagon opened up America's landscape to the Western in spectacular fashion; and in 1924, John Ford, who had already made a number of Westerns, directed The Iron Horse, the story of the building of the transcontinental railroad and the first of his popular epic Westerns.

The 1930's were not a propitious decade for the Western, perhaps because the national spirit was not in the mood for any celebrations of America's past and American individualism, although the decade did begin with Wesley Ruggles's *Cimarron* (1931), the only Western ever to win an Academy Award as the year's best picture. The decade instead featured such low-budget "B" Westerns as the Hopalong Cassidy series, starring William Boyd, and introduced in its second half the mild-mannered films of the singing cowboys, Gene Autry and Roy Rogers. But 1939 gave new impetus to the Western with the Cecil B. de Mille railway epic *Union Pacific*, John Ford's skillful and dramatic *Stagecoach*, the first of his Westerns to star John Wayne, and George Marshall's classic comic Western, *Destry Rides Again*. A type of anomaly, the anti-Western appeared in 1943 with William Wellman's attack against lynching in his dark but moving *The Ox-Bow Incident*. In the same year, Howard Hughes's *The Outlaw* brought sex to the genre, also something of an anomaly in the Western world of independent masculinity. Sex was to be exploited again in David O, Selznick's pretentious production of *Duel in the Sun* (1946; dir. King Vidor), but was not to become a staple of the genre.

The postwar years at first brought a feeling of relief and pride to the nation along with a resurgence of the Western: John Ford's *My Darling Clementine* (1946), the best of the OK Corral shoot-out movies; Howard Hawks's splendid *Red River* (1948), and Ford's action-packed cavalry film *She Wore a Yellow Ribbon* (1949) are all classics of the genre. The Westerns of the 1950's, however, reflect the complex social and political issues of the decade. Henry King's *The Gunfighter* (1950), with Gregory Peck, and Fred Zinnemann's *High Noon* (1952), with Gary Cooper,

explore the Western hero more introspectively and show him in confrontation with the values of society; while Delmer Daves's *Broken Arrow* (1950) begins a tradition of sympathetic Indians who are also victimized by the values of white society. George Stevens's *Shane* in 1953 uses all the stock elements of the Western with great beauty and expertise, but the hero, played by Alan Ladd, seems part of a vanishing breed, a nostalgic vision of values that are disappearing from the bold but tamed landscape. John Wayne appears in John Ford's 1956 production of *The Searchers*, brutalized and victimized by the Indians and their culture; but reappears three years later in Howard Hawks's *Rio Bravo* as an indomitable and spirited presence in a Western world that has become more comic-book than real.

There seem to have been two general traditions of Westerns in the 1960's and early years of the 1970's, the first showing the demise of both the values and landscape of the Old West in films such as David Miller's very touching Lonely Are the Brave, John Ford's The Man Who Shot Liberty Valance, and Sam Peckinpah's Ride the High Country, all in 1962; and the second group offering violence and brutality to feed the jaded appetites of a culture itself feeling brutalized by domestic violence and its country's foreign policy, especially in such films as the "spaghetti Westerns" made by the Italian Sergio Leone and starring Clint Eastwood, beginning with A Fistful of Dollars in 1967, and Sam Peckinpah's The Wild Bunch in 1969, rightfully judged the bloodiest Western made to that time. George Roy Hill's Butch Cassidy and the Sundance Kid in 1969 brought a sizable amount of humor and charm to the Western, while Robert Altman's McCabe and Mrs. Miller in 1971 brought a fresh though unheroic vision to the disappearing frontier. In recent years, however, the Western has been unable to flourish. Perhaps the Western has been exhausted as a film genre; perhaps we have lost faith in the simple heroics of time past because of our own disillusion with the time in which we live; perhaps the population that makes up so much of today's film audience has become detached from our nation's heritage—whatever the reasons, the Western itself seems to have become as much a part of our history as the world which it explored and glorified.

John Ford

Ford's famous definition of himself at a meeting of the Screen Directors Guild ('My name's John Ford. I am a director of Westerns.') was a simplification, and he knew it. His long and continuously successful career went through several distinct phases. Born in Maine, the thirteenth child of Irish immigrants named Feeney, at the age of 20 he followed his older brother Francis to California. Francis already had a flourishing career as actor and director, and he gave the young Jack work as

a props man and later as an actor. Ford's first film as director, *The Tornado* (1917) was a Bison Western, distributed by Universal, in which he himself played the lead role. Over the next four years Ford withdrew from acting and made a series of twenty-five films with Harry Carey, one of the leading Western stars of the era, playing the character of "Cheyenne Harry".

In 1921 Ford moved to the Fox studio, where he was allowed to extend his range. There were still plenty of Westerns, with Hoot Gibson, Buck Jones, and Tom Mix, but there were also stories of the New York ghetto, rural melodramas, and tales of the sea. In 1924 came *The Iron Horse*, an epic Western about building the trans-continental railway. It was a great success, but when his next Western, *Three Bad Men* (1926), failed, he abandoned the genre for thirteen years. His films for Fox in the late 1920s and early 1930s alternated between Irish comedies like *Riley the Cop* (1928), action pictures such as *The Black Watch* (1929) and *Airmail* (1932), and melodramas such as *Arrowsmith* (1931).

Another change in direction came in 1935. Working from a script by Dudley Nichols, Ford directed *The Informer*, Liam O'Flaherty's novel of Irish republicanism, in a heavily atmospheric style. It won him critical awards and a reputation as a quality director of important literary works. Adaptations of Maxwell Anderson's *Mary of Scotland* and Sean O'Casey's *The Plough and the Stars* followed in 1936.

In 1939 Ford made a triumphant return to the Western with *Stagecoach*. Its success rescued John Wayne's career from the doldrums, and helped revivify a genre which had fallen into decline. Ford described *Stagecoach* as a 'classic' Western, several cuts above his series Westerns of the silent days. By now he was one of the most respected directors in Hollywood, dependent on the studio system to finance his films, but with a measure of choice in his projects. *The Grapes of Wrath* (1940), from John Steinbeck's justly celebrated novel, brilliantly wedded the key Fordian themes of family and home to a bleak vision of the social deprivation of the Depression.

Ford's Hollywood career was interrupted by war service. His lifelong fascination with the military was rewarded with a commission as a lieutenant commander in the navy, and he made a succession of short films for the war effort, including *The Battle of Midway* (1942), one of the war's finest documentaries.

After the war Ford produced, in a short burst of four years, a series of great Westerns, including his Wyatt Earp story *My Darling Clementine* (1946), his so-called cavalry trilogy (*Fort Apache*, 1948; *She Wore a Yellow Ribbon*, 1949; and *Rio Grande*, 1950), and one of his own personal favourites, *Wagon Master* (1950).

Ford's films of the 1950s are often intensely personal projects. *The Quiet Man* (1952) was a comedy in which John Wayne played an American in search of his roots in Ireland. *The Rising of the Moon* (1957) also had an Irish setting; one

of its three separate stories concerns the IRA. *The Sun Shines Bright* (1953) was based on Irvin S. Cobb's Judge Priest stories, set in the South, which Ford had first filmed in 1934 with Will Rogers.

After a break from the genre which had lasted six years, Ford returned to the Western with *The Searchers* (1956), which many consider to be his masterpiece. John Wayne, in one of his finest performances, plays the Confederate veteran Ethan Edwards, condemned by his own inner turmoil to roam the West for seven years in pursuit of his niece kidnapped by Comanches. In this film Ford brought to perfection his measured and assured shooting style, his command of landscape as realized in his extraordinary vistas of his beloved Monument Valley, and his great skill in humanizing the epic.

Old age and the more protracted schedules of Hollywood production slowed Ford's output in the 1960s. But he still managed to produce a trio of major Westerns, though Ford himself never much cared for *Two Rode Together* (1961), a captivity narrative with a bleak view of human tolerance, in which James Stewart stars as a venal and cynical marshal. *The Man who Shot Liberty Valance* (1962), Ford's last film in black and white, is an elliptically told story about the inseparable mix of fact and myth in the Western, shot in a deliberately archaic style. *Cheyenne Autumn* (1964) is an honourable, if rather pious, attempt to atone for the Western's failure to accord respect to the Indian.

By the time of his death Ford's critical reputation had slipped a little in comparison with other directors of his generation such as Hawks or Hitchcock. The young critics of *Cahiers du cinéma* and *Movie* found him folksy, even sentimental. In the years since, that judgement has been seen as superficial. Ford's sympathies with the underdog have outlasted radical chic, and his unsurpassed instinct for knowing both where to put the camera and what to put in front of it resulted in works of incomparable visual beauty and generosity of spirit.

2. 歌舞片和米内里

歌舞片是好莱坞电影中以歌唱和舞蹈为中心内容的特殊类型，有声片的出现（《爵士歌王》可以称为首部歌舞片）和大萧条的逃避主义倾向使歌舞片一举成为美国最受欢迎的类型电影之一。歌舞片跟古典音乐、民间歌舞、歌剧和轻歌剧，特别是百老汇音乐剧有着很深的渊源。

经典歌舞片主要有三种：（1）根据百老汇音乐剧改编的歌舞片（《画舫璇宫》）；（2）集合歌舞群星的集锦式"舞台演出剧"歌舞片（《1929年好莱坞滑稽剧》和《派拉蒙巡礼》）；（3）浪漫梦幻的"后台浪漫剧"歌舞片（《百老

《雨中曲》雨中的歌唱

汇旋律》和《淘金女郎》系列)。

　　华纳的巴斯比·巴克利(Busby Berkeley)精心编排的歌舞场面和眩目的视觉美感确立了歌舞片的标准,雷电华的金童玉女弗雷德·阿斯泰尔(Fred Astaire)和琴裘·罗杰斯(Ginger Rogers)优雅浪漫的翩翩舞姿成为经典前期的流行时尚,而米高梅制片人亚瑟·弗雷德(Arthur Freed)相继主持拍摄出《相逢圣路易斯》《海盗》《锦城春色》《一个美国人在巴黎》《雨中曲》和《琪琪》等综合性豪华歌舞片杰作,与歌舞片大师文森特·米内里(Vincente Minnelli)和明星金·凯利(Gene Kelly)、裘蒂·迦伦(Judy Garland,还主演过另一部歌舞名片《绿野仙踪》)成为经典后期歌舞片的主导力量。

Musical, Musical Comedy

　　A specific genre of American film that focuses on song and dance. The United States was already a musical nation with its Broadway musical (the harbinger of this type of film), radio music, and developing record industry. With the advent of sound, the Hollywood studio system was prepared to use its finances and technology to create a world of music never before seen and heard, If the Hollywood film had already established itself as a dream factory, what better way for the viewer to escape from reality and the Depression years than imagining himself or herself as the extraordinarily talented people on the screen? Many plots enforced this dream by telling stories of nobodies suddenly thrust into stardom, of a talented group of decent "kids" struggling to put on the big show.

　　The Jazz Singer (1927), the first feature film with sound, could be considered the first musical, since it featured a number of songs, but the film lacked the obligatory dance numbers and emphasized drama more than the music. Three types of musicals dominated the early years of sound: the Broadway musical brought from stage to film, such as *Rio Rita* (1929) and *Showboat* (1929); the review, which presented a series of musical numbers featuring well-known singers, dancers, and comedians, such as *The Hollywood Revue of 1929* (1929) and *Paramount on Parade* (1930); and the "backstage" musical, which used a story about performers as an excuse for the song and dance—*Broadway Melody* (1929) is the film that began this tradition. Lloyd Bacon's *42nd Street* (1933), with its "backstage" plot that features the last-minute substitution of an unknown for the leading star, points the way for the development of this last type of musical. The production numbers in this film were staged by Busby Berkeley in a style impossible to present on any stage. Elaborate sets, large numbers of female dancers choreographed with precision into astonishing patterns, a mobile camera that filmed these patterns from

a range of positions including the famous overhead shots—all became standard elements in a series of films that Berkeley choreographed for Warner Brothers, including the *Gold Diggers* films of 1933, 1935, and 1937. Also popular were the operetta musicals, especially those starring Jeanette Macdonald and Nelson Eddy, beginning with *Naughty Marietta* in 1935, while The *Wizard of Oz*, which appeared in 1939, has remained a popular favorite until the present time. Perhaps the most charming musicals of this period, and the ones that seem least dated, are the series of films made for RKO by Fred Astaire and Ginger Rogers, beginning with *Flying Down to Rio* in 1933.

The postwar years saw the dominance of MGM in the musical film with a series of lavish Technicolor works produced by Arthur Freed. With gusto and spirit, yet controlled by taste and intelligence, MGM produced this series of color films that encapsulated the optimism of the postwar years before the doldrums and fears of the 1950's set in. Vincente Minnelli directed for MGM such films as *Meet Me in St. Louis* (1944), *The Pirate* (1948), and *An American in Paris* (1951), the last of which featured the music of George Gershwin. The last two films starred the dancer Gene Kelly, who added considerable energy and imagination to the musical. Stanley Donen's *Seven Brides for Seven Brothers* (1954), an MGM CinemaScope production that featured Michael Kidd's brilliant choreography, remains a classic musical in spite of its rather dated attitudes about the relation of men and women.

The 1960's began with some extraordinarily successful musicals and ended with the genre's near collapse. Robert Wise's impressive and moving *West Side Story* (1961), the very sophisticated and entertaining *My Fair Lady* (1964) directed by George Cukor, the saccharine but sometimes stirring *The Sound of Music* (1965), also directed by Robert Wise, and *Mary Poppins* (1964); dir. Robert Stevenson) from the Disney corporation were all so expensive and lucrative that they tempted studios to continue with lavishly financed musicals, most of which failed at the box office. Film audiences had shrunk considerably since the advent of television, and film production had become enormously expensive. one were the studios that could easily finance this kind of film. The musical as a film genre was much in abeyance. But since musicals exploit the full possibilities of the medium with its exciting use of sound and picture, such films are still occasionally made and some have been successful partly because they have moved in new directions. Milos Forman's intelligent and sensitive film adaptation of the stage musical *Hair* in 1979 has managed to convey through music and dance the joys and frustrations of young people in the turbulent 1960's; and Bob Fosse has offered some of the best drama and most evocative dancing yet to appear in the musical in *Cabaret* (1972) and his autobiographical *All That Jazz* (1979).

Vincente Minnelli

A prolific director at MGM for over three decades, Vincente Minnellimade important contributions to some of the most celebrated entertainments in history. American critics in the 1940s praised his sophistication and lyrical humanism, and many of the French and Anglo-American auteurists in the 1950s and 1960s regarded him as a sly satirist of bourgeois values. He received an Oscar (for *Gigi*, 1958), and his work profoundly influenced such later directors as Jean-Luc Godard and Martin Scorsese.

Minnelli's first ambition was to paint, but he learnt many of his directorial skills in Chicago's burgeoning consumer economy during the 1920s, working by turns as a window decorator for the Marshall Field department store, an assistant to a portrait photographer, and a designer of stage settings for the Balaban and Katz chain of picture palaces. He subsequently moved to New York, where he created sets and costumes at Radio City Music Hall, and became famous as a designer-director of Broadway revues. After a brief and uneventful stay at Paramount in the late 1930s, he was brought permanently to Hollywood by Arthur Freed, who had assembled a unit of Broadway and Tin Pan Alley artists at MGM. Minnelli remained at that studio until the 1960s, specializing in musicals, domestic comedies, and melodramas. An aesthete who seemed happy in a factory, he frequently made MGM's motto—*Ars Gratia Artis*—sound almost plausible. At the same time, he never forgot his commercial origins. It is no accident that he once filmed a charming comedy entitled *Designing Woman* (1957), and it seems appropriate that one of his melodramas. *The Cobweb* (1955), involves a crisis that breaks out in a mental institution when new curtains are selected for the common room.

Nearly all of Minnelli's work was indebted to the classical Hollywood musical, which might be described as a late, commercialized vehicle for the romantic imagination. Art, show business, and various kinds of dreaming were his favourite subjects. His female characters were reminiscent of Madame Bovary, and his males were often artists, dandies, or sensitive youths. Most of his stories took place in exotic or studio-manufactured worlds, where the boundaries between fantasy and everyday life could easily be transgressed. Even when they were set in provincial America, they burst into remarkable oneiric passages, such as the terrifying Halloween sequence in *Meet Me in St. Louis* (1944), the nightmare in *Father of the Bride* (1950), the berserk carnival in *Some Came Running* (1958), and the mythic boar hunt in *Home from the Hill* (1960).

Minnelli was strongly influenced by three Parisian artistic formations: the decorative art nouveau of the 1880s, the early modernism of the impressionist painters, and the dream vision of the surrealists. Although he was frequently

preoccupied with the kind of psychoanalysis that could be safely adjusted to the Production Code, he was among the least macho of Hollywood directors, and he brought a rarefied sense of camp to musical numbers, making several films that were ahead of popular taste. His pictures were filled with swooping crane shots, voluptuous plays of fabric and colour, and skilfully orchestrated background detail. In the final analysis, however, his musicals were hymns to entertainment, and he never questioned MGM's plush standards of glamour and style.

The paradoxes and contradictions of Minnelli's aestheticism are especially evident in the four melodramas he made with producer John Houseman: *The Bad and the Beautiful* (1952), *The Cobweb* (1955), *Lust for Life* (1956), and *Two Weeks in Another Town* (1962). These all deal with the relation between neurosis and artistic imagination. In each, the artist-hero is a lonely character, who is inhabiting an oppressively patriarchal and capitalist society, and who cannot fully sublimate desire into art. Unlike the musicals, the art melodramas never achieve a utopian integration of daily life with creative energy; as a result they have a distinctly melancholy tone and achieve an impressive atmosphere of stylistic "excess" or delirium. A fascinating mixture of *Kunst* and kitsch, Minnelli's films challenge the traditional distinction between commerce and artistic legitimacy.

3. 喜剧片：卓别林、刘别谦和马克斯兄弟

喜剧片以幽默、搞笑和皆大欢喜的结局为主体内容。以"启斯东喜剧"为起点的美国电影喜剧片在经典时期可以基本划分为滑稽闹剧、浪漫喜剧和讽刺喜剧三大亚类型。

滑稽闹剧（Slapstick, Clown or Physical Comedy）以滑稽（小丑）的出丑和外部动作达到搞笑的喜剧效果，是最早出现的电影喜剧亚类型（《水浇园丁》就有它的雏形），也是默片时期最受欢迎的喜剧。森内特、劳莱和哈台、W. C. 菲尔兹、哈里·朗顿、哈罗德·劳埃德和勃斯特·基顿（Buster Keaton）等共同创造出默片时代喜剧的黄金时代，而查理·卓别林（Charles Chaplin）则以其天才作品《淘金记》《城市之光》《摩登时代》和《大独裁者》成为喜剧片之王。

浪漫喜剧（Screwball）以爱情和婚姻的冲突作为幽默和轻松的故事内容，涉及两性关系、社会阶层、个性矛盾和道德观念等话题，有情人终成眷属往往成为最后的大团圆结局。来自德国的喜剧导演大师欧内斯特·刘别谦（Ernst Lubitsch）以《璇宫艳史》《天堂陷阱》《异国鸳鸯》和《街角书店》

《摩登时代》的卓别林

等成为经典浪漫喜剧的翘楚,而好莱坞经典时期浪漫喜剧的代表作品还包括《一夜风流》《育婴奇谈》《费城故事》和《摩根河的奇迹》等。

讽刺喜剧(Satire, Spoof or Parody)对社会现实进行辛辣和夸张地嘲弄讽刺,对时尚热点进行滑稽甚至荒诞地戏仿恶搞,以玩世不恭的手法表达严肃深刻的批判精神。经典时代著名的喜剧组合马克斯兄弟(Marx Brothers)的《鸭汤》和《歌剧院之夜》就兼具滑稽摹仿和嘲笑讽刺的喜剧色彩,并成为当今无厘头恶搞电影的先驱。

Comedy

A basic definition of comedy both in drama and film is a work inciting within the viewer humor and mirth and ending happily, but there are many types of comedy that inspire degrees of humor and mirth; sometimes, as in black comedy, laughter is somewhat muted by our realization of serious implications and perhaps even by an unhappy ending. Uniting all comic works is a view of the ludicrous in human behavior and affairs, and an attempt to have viewers laugh at the mistakes and misfortunes of people a little less smart and secure than themselves. Such a position allows the audience to feel superior; it also allows the audience, safely and good-naturedly, to work out its own aggressions. Even in comedies of wit,

we associate with the smart talker and see the world from his or her superior position—except when he or she becomes someone else's victim. Films make us far more aware of visual reality than theater, and far more consistently integrate physical reality into comedy. With the absence of sound, early films relied on the visual dimension, and, although influenced by vaudeville, burlesque, and even the circus, largely invented their own comedy.

The Frenchman Max Linder, with his dandyish comic character, is heralded as the first major force in comic film. Linder's influence in this country is apparent in Mack Sennett's films and in the work of Charlie Chaplin. Comedy begins in this country with the world of Mack Sennett's Keystone films, a world of confusion and chaos, where machines ran wild and attacked the living, and where the living often became machines. It was a world of motion and action, of fights and chases at dizzying speeds—a world in which space and time became distorted, people became victimized by the physical world and their own physical natures, and human nature was reduced to ridiculous sight gags. It was the arrival of the great comic heroes of the silent period—Charlie Chaplin, Buster Keaton, Harry Langdon, and Harold Lloyd—that developed—the comic style and created "The Golden Age of Comedy". To the chaos and confusion of the comic world was added, in counterpoint, the heroic clown. Slapstick and mime now functioned to draw out both the ridiculous and the human in a single figure. All of these figures used their bodies as physical instruments, showing the mechanical and comic in human action and behavior, but also interjecting both a befuddled and triumphant human soul.

With the advent of sound, comedy changed considerably. There were still the marvelous sight gags, the excruciating and hilarious confusion between man and reality in the films of Laurel and Hardy; but now comic performers were as aggressive and ridiculous in speech as earlier comics had been in action. The Marx brothers and W. C. Fields survived in a pretentious and silly world through a marvelous sense of the ridiculous in themselves and others, and through their own zany logic and verbal assaults. Another kind of comedy developed during the 1930's, one closer to the comedies of the theater by being more realistic, socially aware, dramatically structured, and intellectual. Such comedies, depending on dialogue for sophisticated and witty humor, were, in a sense, a compliment to movie audiences, who had become mature. These films included the slightly dry, genteel humor of the Thin Man series; the amorality and wit of Lubitsch's polished and sophisticated world, especially evident in *Trouble in Paradise* (1932); and the "screwball" comedies, which featured irresponsible, sometimes irrational behavior and a witty, energetic battle of the sexes between genuinely likable figures in films such as Frank Capra's *It Happened One Night* (1934) and Howard Hawks's *Bringing Up Baby* (1938). Although the 1940's began auspiciously with Cukor's

The Philadelphia Story, the decade of the war years and the beginning of the Cold War seemed less receptive to witty comedy and more prone to outright farce or sentimentality. Still funny and intelligent, however, were the comedies of Preston Sturges.

During the late 1950's and early 1960's a series of Doris Day films, the most popular of which was *Pillow Talk* (1959; dir. Michael Gordon), took the wit and bite out of sex. Some comedies of the same period, however, seemed sexually aware and realistic, if somewhat less witty and intellectual than the social comedies of the 1930's. *Some Like it Hot* (1959), which combined farce and verbal humor with a new sexual drive, and the somewhat darker *The Apartment* (1960), both directed by Billy Wilder, are among the best of these sexual comedies. The 1950's also gave rise to the films of Jerry Lewis, whose work at first seemed an energetic return to old-fashioned farce, but ultimately declined into artistic confusion. It is difficult to sum up comedy during the recent decades. The decrease in the number of films produced, the end of studio productions and the star system that allowed the development of comic talents, and the influence of television have resulted in comic films that are more painful than funny. On the positive side have been the farces and outrageous humor of Mel Brooks and the neurotic sensibility of Woody Allen. Allen has managed to create his own subgenre, a mixture of satire, farce, and verbal wit in a contemporary post-Freudian and Marshall McLuhan world. Also significant have been such satiric comedies as Kubrick's *Doctor Strangelove* (1963) and Mike Nichols's *The Graduate* (1967), films with a provocative visual dimension and with low-keyed, absurd, and scaringly funny dialogue; and satire equally serious but lighter in touch, such as Philippe de Broca's *King of Hearts* (1966) and Hal Ashby's *Harold and Maude* (1971). In general, however, comedy has become less deft and subtle, alternating between the sit-com one-liners of Neil Simon and the schoolboy vulgarity of such films as *National Lampoon's Animal House* (1978; dir. John Landis).

Charlie Chaplin

Sennett's most important and influential protégé was Charlie Chaplin (1889-1977). Chaplin, the son of impoverished British music hall entertainers, had spent his childhood on stage. Like Charles Dickens and D. W. Griffith, both of whom he greatly resembled, Chaplin's vision of the world was colored by a youth of economic deprivation, and he felt deeply sympathetic toward the underprivileged all of his life. Chaplin was already a performer on an American vaudeville tour when he was engaged by Keystone Film in 1913 for 150 dollars a week. In his first film for Sennett, *Making a Living* (1914), he played a typical English dandy,

but by his second, *Mabel's Strange Predicament* (1914), he had already begun to develop the character and costume of "the little tramp" which would make him world-famous and become a kind of universal cinematic symbol for our common humanity. Chaplin made thirty-four shorts and the six-reel feature *Tillie's Punctured Romance* (Mack Sennett, 1914) at Keystone, progressively refining the character of the sad little clown in oversized shoes, baggy pants, and an undersized coat and derby.

But Chaplin's gifts were meant for a more subtle style of comedy than the frenetic rhythms of the Keystone films allowed, so in 1915 he signed a contract with Essanay to make fourteen two-reel shorts for the then-enormous sum of 1,250 dollars a week. He directed these and all of his subsequent films himself, based on his experiences at Keystone, evolving his brilliant characterization of the little tramp, totally at odds with the world about him, through the exquisite art of mime. Chaplin best Essanay films were The Tramp, Work, The Bank, and A Night at the Show (all 1915), and they made him so popular that in the following year he was able to command a star salary of ten thousand dollars a week plus a signatory bonus of 150,000 dollars in a contract for twelve films with Mutual, of which the greatest are The Floorwalker (1916), The Fireman (1916), One A.M. (1916), The Pawnshop (1916), The Rink (1916), Easy Street (1917), The Immigrant (1917), and The Adventurer (1917). These two-reelers were produced with infinite care and constitute twelve nearly perfect masterpieces of mime. They also made Chaplin internationally famous and first showed his great gift for social satire—a satire of the very poor against the very rich, of the weak against the powerful, which endeared him to the former but not to the latter, especially during the Depression. In The Immigrant, for example, one of the most memorable sequences is predicated upon the hypocrisy of American attitudes toward immigration and upon the brutality of the immigration authorities themselves. As Charlie's ship arrives at Ellis Island, he looks up with hope and pride at the Statue of Liberty. Then a title announcing "The Land of Liberty" is followed by a shot of the New York port police forcibly herding together a large number of immigrant families for processing like so many cattle. In the next shot, Charlie casts another glance at the Statue of Liberty—this one suspicious, even disdainful.

By June 1917 Chaplin had gained such star power that he was offered a one-million-dollar contract with First National to produce eight films for the company, regardless of length. This deal enabled him to establish his own studios, where he made all of his films from 1918 until he left the country in 1952. His cameraman for all of these productions was Rollie Totheroh (1891-1967), whom he had first met in 1915 at Essanay. Most of Chaplin's First National films were painstakingly crafted two- and three-reelers, like *A Dog's Life* (1918), *Shoulder Arms* (1918), *The Idle Class* (1921), and *Pay Day* (1922), which continued the vein of social criticism

begun at Mutual. But Chaplin's most successful effort for First National was the first feature-length film he directed, *The Kid* (1921). This was an autobiographical comedy/drama about the tramp's commitment to an impoverished little boy of the slums which combined pathos with tender humor and became an international hit, earning over 2.5 million dollars for its producers in the year of its release and making its child lead, the five-year-old Jackie Coogan, a star. Chaplin's last film under the First National contract was the four-reel feature *The Pilgrim* (1923), a social satire in which an escaped prisoner (Chaplin) is mistaken for a minister by the venal parishioners of a small Texas town, with hilarious results. The film is a brilliant comic assault on religious hypocrisy, and it may well have contributed to the venomous personal attacks launched against Chaplin by religious groups a few years later.

After he had fulfilled his obligation to First National, Chaplin was free to release his films through United Artists. His first United Artists film was the much-admired *A Woman of Paris* (1923), a sophisticated "drama of fate" whose subtle suggestiveness influenced filmmakers as diverse as Ernst Lubitsch and René Clair. Chaplin appeared only briefly as a porter in *A Woman of Paris*, which like all of his films after 1923 was a full-length feature, but in his comic epic *The Gold Rush* (1925) he returned to the central figure of the little tramp. Set against the Klondike gold rush of 1898, this film manages to make high comedy out of hardship, starvation, and greed as three prospectors fight it out for the rights to a claim. In the subtlety of its characterization, the brilliance of its mime, and its blending of comic and tragic themes, *The Gold Rush* is Chaplin's most characteristic work. It is as popular today as it was in 1925, and it remained his personal favorite. *The Circus* (1928), in which the tramp attempts to become a professional clown, is a beautifully constructed silent film released during the conversion to sound. In honor of it, Chaplin was given a special award at the first Academy Awards ceremony in 1929 for "versatility and genius in writing, acting, directing, and producing." During the filming of *The Circus*, however, Chaplin was involved in a divorce suit brought by his second wife, and he became the target of a vicious campaign of personal abuse on the part of religious and "moralist" groups which nearly drove him to suicide. It was the first of many clashes between Chaplin and the established order in America.

Characteristically, Chaplin's first two sound films were produced with musical scores (written by Chaplin) and sound effects but little spoken dialogue: it was his way of extending the great art of silent mime into the era of sound. *City Lights* (1931) is a sentimental but effective film in which the unemployed tramp falls in love with a blind flower girl and goes through a series of misadventures, including robbery and a jail term, in order to raise money for the operation which can restore her sight. Chaplin called the film "a comedy romance in pantomime", and it is, but

City Lights is also a muted piece of social criticism in which the cause of the poor is defended against that of the rich. If there were any remaining doubts about the nature of Chaplin's social attitudes, they were dispelled by *Modern Times* (1936), a film about the dehumanization of the common working man in a world run for the wealthy by machines. In it, Chaplin plays a factory worker who is fired when he suffers a nervous (but hilarious) breakdown on the assembly line, moves through a variety of other jobs, and ends up unemployed but undefeated. The film's satire on industrialization and inequity in the "modern times" of the Great Depression earned it little popularity among the powerful in the United States, where in some quarters it was called "Red propaganda," or in Germany and Italy, where it was banned. But *Modern Times* was enormously successful in the rest of Europe, and it remains today one of Chaplin's funniest, best structured, and most socially committed works.

In *The Great Dictator* (1940) Chaplin produced his first full talkie and one of the first anti-Nazi films to come out of Hollywood. A satire on European dictatorships, the film chronicles the rule of Adenoid Hynkel, dictator of Tomania, as he persecutes the Jews and plunges Europe into yet another war. Chaplin played the dual role of Hynkel and an amnesiac Jewish barber who is Hynkel's double. Released some eighteen months before Pearl Harbor, the film was not well received by the critics: many thought its politics too serious, others found them not serious enough. Still, *The Great Dictator* was a commercial hit owing to its maker's continuing popularity as a star. During the war, however, Chaplin gave a series of openly political speeches in support of the Soviet Union which made him a prime candidate for the postwar blacklist. Worse, he became ensnared in a notorious paternity suit by a former "protégée" (Joan Barry) and was put on federal trial in 1944 for violating the Mann Act. Not unreasonably, Chaplin's next film was the dark and cynical *Monsieur Verdoux* (1947), "a comedy of murder" based upon the exploits of the infamous French mass-murderer Landru, originally suggested to him by Orson Welles. In it, a Parisian bank clerk (Chaplin) loses his job and takes up the practice of marrying and then murdering rich, middle-aged women in order to support his invalid wife and small son. He is caught, and while awaiting execution Verdoux states the film's theme concisely in an argument with a fellow prisoner: "Wars, conflict, it's all business. One murder makes a villain; millions a hero. Numbers sanctify." The film was bitterly attacked in the United States, where it was released on the eve of the hysterical anti-Communist witch-hunts of the Cold War era; it was with-drawn from circulation after six weeks but had great success in France. The relationship between Chaplin and his American audiences had grown increasingly strained since the disappearance of the little tramp and the emergence of the liberal social critic, but resentment of Chaplin went back at least as far as the moralistic campaigns of the twenties. Some of this animosity was

generated by Chaplin's retention of British citizenship since coming to the United States and his inconsistency in paying his federal income tax.

In his last American film, *Limelight* (1952), Chaplin returned to the London music halls of his childhood to tell the bittersweet tale of an aging performer who triumphs over his own declining power and imminent death by curing a young ballet dancer of paralysis and starting her on her career. The film is long (two and a half hours), slow, and cinematically archaic, but it is one of Chaplin's finest testaments to that dignity and decency of human nature which he felt the twentieth century had done so much to destroy. In September 1952, Chaplin and his family were granted six-month exit visas to attend a royal premiere of *Limelight* in London. On the first day at sea, Chaplin received news by radio that the U.S. Attorney General had rescinded his re-entry permit, subject to his appearance before an Immigration and Naturalization Service board of inquiry to answer charges of political and moral turpitude. In this manner, the highest-paid and most popular star in the history of American film was forcibly ushered from his adopted country. Chaplin chose to take up residence in his homeland and, later, in Switzerland.

Five years later he responded to the U.S. Justice Department with *A King in New York* (1957). This strained political parable, independently produced in England, is about a European head of state who, while visiting the United States, is ruined by the malicious charges of the House Un-American Activities Committee, as Chaplin himself had been. *Lime light* had been subjected to an American Legion picketing campaign that forced the major theater chains to withdraw it after several weeks of distribution, and, given the prevailing climate, *A King in New York* could not be distributed in the United States at all. The former was rereleased in this country in 1972 and promptly won an Academy Award for the year's Best Original Score. (In that same year, Chaplin received an Honorary Academy Award "for the incalculable effect he has had on making motion pictures, the art form of this century".) *A King in New York* had its first American release in 1976, to generally unenthusiastic reviews. The film is understandably bitter and indifferently directed, but it does contain some fine satire on life in America during the fifties.

Chaplin's last film was a limp bedroom farce, *The Countess from Hong Kong* (1966), starring Marlon Brando and Sophia Loren. The film is misconceived in terms of both script and direction, and it underscores the fact that Chaplin's greatest genius was as an actor and a mime. His sight gags turned on brilliantly conceived and executed camera blocking, and so long as his little tramp character stood at the center of his films, they were masterworks of comedy and pathos. When the tramp disappeared, the limitations of Chaplin's directorial ability became increasingly apparent. During the twenties, however, the image of the little tramp became a worldwide symbol for the general excellence of the American cinema, and Chaplin

himself will always remain one of its most important and distinguished directors.

Ernst Lubitsch

The son of a Jewish tailor, Ernst Lubitsch joined Max Reinhardt's Deutsches Theater in 1911 as supporting actor, and had his first starring part in a film farce, *Die Firma heiratet* (1914). The role, an absent-minded, accident-prone, and over-sexed assistant in a clothing shop, established him as a Jewish comedy character. Between 1914 and 1918 he acted in about twenty such comedies, the majority of which he also directed (among the ones to have survived are *Schuhpalast Pinkus*, 1916; *Der Blusenkönig*, 1917; and *Der Fall Rosentopf*, 1918).

Lubitsch was the most significant German film talent to emerge during the war, creating a type of visual and physical comedy familiar from pre-war Pathé films, but situated in a precise ethnic milieu (the German-Jewish lower middle class) and mostly treating the staple theme of much early German cinema: social rise. After 1918, Lubitsch specialized in burlesque spoofs of popular operettas (*Die Austernprinzessin*, 1919), of Hoffmannesque fantasy subjects (*Die Puppe*, 1919), and of Shakespeare (*Romeo und Julia im Schnee* and *Kohlhiesels Töchter*, both 1920). Centred on mistaken identities (*Wenn vier dasselbe tun*, 1917), doubles (*Die Puppe, Kohlhiesels Töchter*), and female cross-dressing (*Ich möchte kein Mann sein*, 1918), his comedies feature foppish men and headstrong women, among them Ossi Oswalda (*Ossis Tagebuch*, 1917) and Pola Negri (*Madame Dubarry*, 1919).

Working almost exclusively for the Projections-AG Union, Lubitsch became the preferred director of Paul Davidson, who from 1918 onwards produced a series of exotic costume dramas (*Carmen*, 1918; *Das Weib des Pharao*, 1922), filmed plays (*Die Flamme*, 1923), and historical spectacles (*Anna Boleyn*, 1920) which brought both producer and director world success. The "*Lubitsch touch*" lay in the way the films combined erotic comedy with the staging of historical show-pieces (the French Revolution in *Madame Dubarry*), the *mise-en-scène* of crowds (the court of Henry VIII in *Ann Boleyn*), and the dramatic use of monumental architecture (as in his Egyptian and oriental films). But one could also say that Lubitsch successfully cross-dressed the Jewish *schlemihl* and let him loose in the grand-scale stage sets of Max Reinhardt.

Lubitsch's stylistic trademark was a form of visual understatement, flattering the spectators by letting them into the know, ahead of the characters. Already in his earliest films, he seduced by surmise and inference, even as he built on the slapstick tradition of escalating a situation to the point of leading its logic *ad absurdum*. Far from working out this logic merely as a formal principle, Lubitsch, in comedies like *Die Austernprinzessin* (1919) or *Die Bergkatze* (1921), based it on

a sharply topical experience: the escalating hyperinflation of the immediate post-war years, nourishing Starvation fantasies about the American way of life, addressed to a defeated nation wanting to feast on exotic locations, erotic sophistication, and conspicuous waste. What made it a typical L.ubitsch theme was the *mise-en-scène* of elegant self-cancellation, in contrast to other directors of exotic escapism, who dressed up bombastic studio sets as if to signify a solid world. Lubitsch, a Berliner through and through, was also Germany's first, and some would say, only, "American" director. He left for the United States in 1921, remaking himself several times in Hollywood's image, while, miraculously, becoming ever more himself.

If his first calling card was *Rosita* (1923), an underrated vehicle for Mary Pickford's ambitions to become a *femme fatale*, Lubitsch cornered the market as the definitive Continental sophisticate with comedies that not so much transformed as transfigured the slapstick theme of mistaken identities. *The Marriage Circle* (1923), *Forbidden Paradise* (1924), *Lady Windermere's Fan* (1925), and *So This is Paris* (1926) are gracefully melancholy meditations on adultery, deceit, and self-deception, tying aristocratic couples and decadent socialites together to each other, in search of love, but settling for lust, wit, and a touch of malice. After some Teutonic exercises in sentimentality (*The Student Prince*, 1927; *The Patriot*, 1928), the coming of sound brought Lubitsch new opportunities to reinvent his comic style. Prominent through his producer director position at Paramount Studios, and aided by the script-writing talents of Ernest Vajda and Samson Raphaelson, Lubitsch returned to one of his first inspirations; operetta plots and boulevard theatre intrigues, fashioning from them a typical 1930s Hollywood *émigré* genre, the "Ruritanian" and "Riviera" musical comedies, starring mostly Maurice Chevalier, with Jeanette MacDonald, or Claudette Colbert (*The Love Parade*, 1929; *The Smiling Lieutenant*, 1931; *The Merry Widow*, 1934). Segueing the songs deftly into the plot lines, and brimming with sexual innuendoes, the films are bravura pieces of montage cinema. But Lubitsch's reputation deserves to rest on the apparently just as frivolous, but poignantly balanced, comedies *Trouble in Paradise* (1932), *Design for Living* (1933), *Angel* (1937), and *Ninotchka* (1939). Invariably love triangles, these dramas of futility and *vanitas* between drawing room and boudoir featured, next to Melvyn Douglas and Herbert Marshall, the screen goddesses Marlene Dietrich and Greta Garbo, whom Lubitsch showed human and vulnerable, while intensifying their erotic allure. During the 1940s, Lubitsch's central European *Weltschmerz* found a suitably comic-defiant mask in films like *The Shop around the Corner* (1940) and *To Be or Not to Be* (1942), the latter a particularly audacious attempt to sabotage the presumptions not only of Nazi rule, but of all tyrannical *bolds* on the real: celebrating, as he had always done, the saving graces and survivor skills of make-believe.

The Marx Brothers

As with the silent comedies, many of the sound comedies wore the personalities of their comics rather than their directors. Because Langdon and Keaton and numerous other clowns who were schooled in the silent tradition never successfully combined talk and movement, Hollywood imported clowns from Broadway who had already effected the combination. The Marx Brothers even shot their first films in New York. In 1929 they re-created their current stage hit, *The Cocoanuts*, for the screen. The Marx Brothers combined the great traditions of American physical comedy with a verbal humor that perfectly suited their physical types. The plots of the Marx Brothers' films were irrelevant, providing occasions for gags and irreverent parodies of conventional behavior: self-important worlds into which the zany comics dropped.

The Marx Brothers made some of the funniest movies in history. People are still arguing about whether *Duck Soup* (1933) and the Paramount films are better than *A Night at the Opera* (1935) and the MGM films. Starting with the eldest, the five brothers were Chico (Leonard), Harpo (Adolph, called Arthur), Groucho (Julius Henry), Gummo (Milton), and Zeppo (Herbert). In vaudeville, Milton was part of the team; on Broadway and in the first films, he was replaced by Zeppo. When Zeppo left after *Duck Soup*, the Four Marx Brothers became three: Groucho, Chico, and Harpo. In a number of the best pictures, Margaret Dumont played a conventional woman trying to manage the chaos but also attracted to it. Almost all of their movies featured musical sequences in which Chico plays the piano or Harpo plays the harp; they were part of the act as much as Groucho's cigar and painted mustache—or the verbal and visual puns.

The Marx Brothers pictures were brilliantly written and directed at a screwball pace that could slow down to watch in wonder as an almost infinite joke became more funny the more it went on. They were masters of timing, both visual and verbal, and they were planted in the silent and the sound comedy by Harpo's miming and Groucho and Chico's dialogue. In themselves they were figures as fundamental as Chaplin's tramp. The films abound with physical comedy and mad visuals: the football sequence in *Horse Feathers* (1932), the mirror scene in *Duck Soup*, the stateroom packed with human sardines or the split-second timing of the bed-shifting sequence in *A Night at the Opera*. And for brilliant verbal doubletalk there is the "Why-a-duck?" sequence in *The Cocoanuts* in which Groucho tries to sell Chico a piece of island property with a viaduct. Like their puns, their gags built and built until audiences were weak with laughter. From Harpo's horn to Groucho's walk, the Marx Brothers films revealed the key elements of sound comedy—comic physical types suited to their comic personalities, to the physical-comedy situations, and to the verbal wit. Comic talkies had to move as well as talk.

4. 警匪片（黑帮犯罪片）：霍克斯和休斯顿

警匪片包括黑帮犯罪片和警探片两类。黑帮片（gangster）又称当代犯罪片（contemporary crime），其源头可以追溯到鲍特的《火车大劫案》和格里菲斯的《猪巷火枪手》，美国社会经历的经济发展和城市诱惑，导致心理失衡、道德沦丧和暴力泛滥，而美国人笃信成功和金钱的心态，又经常将犯罪黑帮想象和塑造成迷人的英雄。当然，美国的司法制度和好莱坞的道德主义也必然赋予犯法、背德的黑帮毁灭的最终下场。经典时期的黑帮片经常来自头条新闻、跟经济大萧条直接相关，《小凯撒》《人民公敌》和《疤脸大盗》就是典型代表，而后来的《邦妮和克莱德》《教父》和《美国往事》等也就是发扬光大的黑帮片。

自古"警匪一家"，侦探片（detective）被认为是黑帮片的近亲，大多改编自雷蒙德·钱德勒（Raymond Chandler）等人的硬派侦探（hardboiled-detective）小说，影片重心从黑帮片的犯罪变成警探片的破案，警察和私家侦探也就成为影片的主角。《马耳他之鹰》算是经典的警探片，而《唐人街》则是20世纪70年代警探片的代表作品。

另外，黑帮片和警探片也经常与黑色电影发生交叉关系。经典时期著

《马耳他之鹰》

名的黑帮片和警探片导演霍华德·霍克斯（Howard Hawks）和约翰·休斯顿（John Huston）亦执导过杰出的黑色电影《沉睡》和《夜阑人未静》。

Gangster Film, Criminal Film

A distinct genre in American films that traces the rise and fall of a gangster, either fictitious or based on some well-known person. People have always been interested in such lives because they allow vicarious thrills—we all wish to unleash hostility or aggression and we all wish to triumph over the world around us. By associating with such criminal figures, we can feel such power for a brief period, while at the same time our moral sense can be satisfied when these wicked people are punished. Criminal stories are also appropriate for film since they offer a good deal of action, color, and suspense.

Such stories originate even before the time of Robin Hood, and during the spread of literacy they took the form of fictitious accounts or memoirs of actual figures. Criminal activities provoked by prohibition were the subject of a number of successful gangster films during the silent-film era, namely Josef Von Sternberg's *Underworld* (1927) and Lewis Milestone's *The Racket* (1928). But the modern gangster film really begins with the advent of sound, specifically with Mervyn LeRoy's *Little Caesar* (1930), William Wellman's *Public Enemy* (1981), and Howard Hawks's *Scarface* (1932), films which set the pattern for future works with their violence, urban setting, and criminal character types. Public outcry against a somewhat sympathetic and glamorous approach to such figures led to a rash of police enforcement films that simply gave the same leading men guns in the cause of justice; but it also led to far more condemning portraits of gangsters in criminal films such as *Dillinger* (1945; dir. Max Nosseck). A later development was the psychological focus on the criminal in films such as Raoul Walsh's *White Heat* (1949), where James Cagney plays the role of a psychopathic criminal with a severe oedipal complex.

The 1950's, a period that, like the war years, saw events in black and white, offered criminals who were vicious and evil, as in Don Siegel's *Baby Face Nelson* (1957). But resentment against the establishment and traditional cultural values during the next decade led to portrayals of gangsters who were more complex and attractive, who seemed as much sinned against as sinning. A good example of this type of film is Arthur Penn's *Bonnie and Clyde* (1967), a rural gangster film where the urban landscape has been exchanged for the American countryside during the Depression days—Robert Altman's *Thieves Like Us* (1974) follows the same track seven years later. A similar complexity and sympathy is evident in the portrayal of gangsters in Francis Ford Coppola's *The Godfather* (1972), but

the film also reflects the public's growing resentment against organized crime and large organizations of all kinds. The parallels between the Mafia and big business are drawn frequently and even more emphatically in Coppola's 1974 sequel, *The Godfather, Part II*.

Detective Film

A genre of film that features the search for clues and culminates with the solution to a crime by either a private detective or some agent of the police force (sometimes acts of investigation are also performed by journalists, insurance investigators, and lawyers), Detective films are one type of mystery film, distinguished from other films of that group by the well-defined central figure. Detective films rely heavily on plot and plot complications; they involve the audience by establishing a mystery and then sending the protagonist forth to discover the solution—the audience both associates with the protagonist and matches wits with him or her. Anticipation and suspense give added emphasis and meaning to every detail in the film. A well-known group of detective films has featured the master British sleuth Sherlock Holmes. Detective films also offer the opportunity for a wide variety of character types, both sinister and comic, and for much action, especially fights, mayhem, and chases.

But the detective film in America has also developed certain defining characteristics and a certain ambience. Films such as Roman Polanski's *Chinatown* (1974) have featured a decadent, immoral, and brutal urban world, spanning the poor and rich, through which the protagonist must make a journey to discover the facts, but also sometimes to discover some moral truth about that world and himself. The detective figure, such as Humphrey Bogart's portrayal of Sam Spade in John Huston's *The Maltese Falcon* (1941), is a tough, morally complex, but basically sensitive figure, Although he seems independent and alone, and sometimes almost as brutal as the criminals around him, he also understands the need for law and order, the need for some kind of social contract to fight off the chaos,even though he may find society itself, and its very institutions, greedy and corrupt. Such a figure is, to some degree, an update of the hero of the Western, but denied the mythic landscape, with all its grandeur and freedom, of the West. He is an assertion of American toughness and individuality, and he takes part in a drama that condemns the decay of American values and the corruption of the modern world.

Detective figures who have worked for the police force have traditionally been more law-abiding and less morally complex figures, as in the G-Man films of the 1940's and works such as Jules Dassin's *The Naked City* (1948). In general,

these figures have seemed to be bulwarks of social and moral order. But in recent years, especially in America, the police detective and private eye have come closer together. Police organizations have seemed as corrupt or unreliable as the world outside and, like Gene Hackman's portrayal of Popeye in William Friedkin's *The French Connection* (1971) or Clint Eastwood's portrayal of the title character in Don Siegal's *Dirty Harry* (1972, the police officer has become a loner, frequently violent and complex, but ultimately with that higher sense of morality that marks most of the figures in the genre.

Howard Hawks

The son of a wealthy paper mill owner, Howard Hawks moved with his family from the Midwest to California at the age of 10. After graduating from Cornell, where he studied mechanical engineering, he returned to Los Angeles to work in the property department of the Famous Players-Lasky studio. During the First World War he served as a flight instructor for the US army in Texas and, after his discharge, he raced cars and built and flew aeroplanes. In 1922 he went to work in Paramount's story department. By 1925 Hawks had moved to Fox, where he was first a screen-writer and was then given a chance to direct (*The Road to Glory*, 1926). He worked, under short-term contracts, for a variety of studios for the remainder of his career, though in the post-war era he took increasing control over his own projects through a series of independent production companies in which he was part owner.

Hawks's social vision was shaped in the 1930s as his films began to examine the dramatic interaction among groups of men engaged in common professions or activities, such as pilots in *The Dawn Patrol* (1930), *Ceiling Zero* (1936), and *Only Angels Have Wings* (1939); gangsters in *The Criminal Code* (1931) and *Scarface* (1932); soldiers in *Today We Live* (1933) and *The Road to Glory* (1936): racing car drivers in *The Crowd Roars* (1932); and fishermen in *Tiger Shark* (1932). These action films glorify male interdependency, collective activity, and the cathartic release of interpersonal tension through action. Though his films celebrate the ethos of action, professionalism and male stoicism, they also expose the conflict that arises between repressive, professional codes of behaviour and personal desires and feelings. Hawks tends to cast this conflict in terms of a struggle between male and female elements at war within a single (male) psyche. Thus the male stoicism symbolized by the Hawksian hero (e.g. Cary Grant in *Only Angels Have Wings* or John Wayne in *Red River*, 1948) is seen as excessive. These characters need to be humanized by undergoing a feminization of sorts, effected by the influence of women and by the male characters' ultimate recognition not of only of their own

vulnerability but also of their need for others.

The male characters in Hawks's action films resist change; those in his comedies learn to adapt to it. The comedies involve a similar sexual conflict in which the female characters oversee the "feminization" of the men, a trans for mation most brilliantly realized in *Bringing up Baby* (1938), and *I Was a Male War Bride* (1948), when Cary Grant is forced to wear female attire. But in the comedies, Hawks remains more interested in the fluidity of sexual roles and in the unleashing of sexual repression than in resolving any sexual imbalance within a single psyche or between the sexes. Thus the comedies tend to perpetuate sexual antagonism, dramatizing it as a process without closure, while the dramas re-establish sexual harmony, balance, and order.

Hawks's visual style gradually evolved during the 1930s and 1940s to reflect his social vision. His camera remained steadfastly eye-level, engaging with his characters on their own ground; but the space within which they interacted gradually expanded from the relatively shallow depth of field of the early 1930s to the modified deep focus of the 1940s, represented by his work with Gregg Toland (*The Road to Glory*, 1936; *Come and Get it*, 1936; *Ball of Fire*, 1942; *A Song is Born*, 1948), James Wong Howe (*Air Force*, 1943), and Russell Harlan (*Red River*, *The Big Sky*, 1952; *Rio Bravo*, 1959; *Hatari!*, 1962; and *Man's Favorite Sport?*, 1964). In these films, Hawks's characters occupy a well-lit middleground in which they exchange dialogue and gestures with one another in an egalitarian process of give and take. The relationship of the Hawksian individual to a larger group is regularly worked out in spatial terms—through that individual's incorporation into a democratically structured, communal space.

Although his thematic vision was shaped in the 1930s, Hawks remains one of the most "modern" of Hollywood film-makers. Like Buster Keaton, Hawks is an artist of the machine age. His aviators and race car drivers realize their identity, in part, through their relationship with machines. Though his films are occasionally set in the past, his characters always live in an existential present. Indeed, obsession with the past is viewed as neurotic; psychic health is seen in the ability constantly to revise earlier judgements on the basis of new information and intuitively to make split-second decisions. Hawks's "modernity" also informs his representation of women, who enjoy rare independence, autonomy, and power in his films. His women are post-Victorian; neither virgins nor whores, they belong to the post-war (First World War) phenomenon of the "New Woman". New Women are women who were "emancipated" by mass culture (and by the Nineteenth Amendment to the American Constitution). They entered the pnblic sphere, voted, worked, smoked, and engaged in a variety of activities previously reserved for men. The typical Hawks woman, epitomized in Lauren Bacall, has pronounced "masculine" traits; she is husky-voiced, worldly, tough, insolent, cynical, and

sexually aggressive. She lives in a man's world and engages with men on more or less equal footing, yet she also retains her identity as a woman as well as an essential innocence. Though partly a fantasy figure concocted by narcissistic male desire in search of an idealized, female alter ego, the Hawksian woman addresses issues of female desire and agency with an openness and directness that are uncommon in American cinema.

Hawks is generally regarded as one of the three greatest American directors, along with Alfred Hitchcock and John Ford. In 1962 the British magazine Movie placed Howard Hawks in the "Great" category, a ranking which he shared with only one other American director, Alfred Hitchcock. (Orson Welles was only "Brilliant", and John Ford merely "Very Talented".) Though Hawks was the subject of a number of full-length Studies prior to his death in 1977, relatively little has been written about him since 1982. He has reverted to the state of invisibility in which Andrew Sarris found him back in 1968: "the least known and least appreciated Hollywood director of any stature." The problem lies in Hawks's apparent transparency in a stylistic presence that is relentlessly invisible, self-effacing, difficult to see, and extremely difficult to analyse. The subtlety of Hawks's styie is one of the most significant features of his work, but it is also the greatest obstacle to the widespread recognition of his talent as a film maker.

John Huston

John Huston was born in Nevada, Missouri, son of the actor Walter Huston and the journalist Rhea Gore. After his parents separated he spent a peripatetic childhood shuttling between them, and a picaresque youth which took in boxing, journalism, and a brief spell with the Mexican cavalry. He finally settled to more-or-less steady employment in 1937 as a script-writer at Warner Bros., where his credits included such prestige hits as *Jezebel* (1937), *Juarez* (1939), *Sergeant York* (1941), and *High Sierra* (1941). But he longed to direct, and the studio, pleased with his work, decided to indulge him with 'a small picture'.

The Maltese Falcon (1941), adapted from Dashiell Hammett's thriller and filmed in clean, uncluttered style with a flawless cast, was hailed as an instant classic-scrupulously faithful to Hammett while exploring Huston's fascination with character under stress. (It also, along with *High Sierra*, helped to crystallize the definitive Bogart screen persona.) In 1942 Huston joined the Signal Corps and made three documentaries, all stark, direct, and free from patriotic bombast: *Report from the Aleutians* (1943), *The Battle of San Pietro* (1944) and *Let there Be Light* (1945), about soldiers disabled by psychological battlescars, which so alarmed the War Department that it suppressed the film for thirty-five years.

Huston's first postwar film, *The Treasure of the Sierra Madre* (1948), mapped out his favorite theme—a quest, obsessionally pursued to a disastrous end. James Agee, his most consistent champion, called it "one of the most visually alive and beautiful movies I have ever seen; there is a wonderful flow of fresh air, light, vigor, and liberty through every shot". *Key Largo* (1948), by contrast, was claustrophobic and fog-bound. Another study of relationships under pressure, it suffered from the staginess of its origins (a Maxwell Anderson verse drama), though redeemed by fine performances from Bogart, Bacall, and Edward G. Robinson.

With *The Asphalt Jungle* (1950), Huston laid down the template for every heist movie that followed. Presenting crime as an occupation like any other, "a left-handed form of human endeavor", he watched his bunch of doomed, small-time hoods with dispassionate sympathy. The genial upside of his habitual pessimism was indulged in *The African Queen* (1951) where the overreachers for once succeed in their quest. Both films revealed Huston's flair for casting: the shrewdly chosen character actors, not a star player among them, as the crooks of *The Asphalt Jungle*, and the inspired pitting of Bogart against Katharine Hepburn in *The African Queen*.

After this, Huston's career lurched badly off the rails. He was always an uneven director, interspersing committed films with throwaway assignments-not to mention sardonic private jokes like *Beat the Devil* (1953) or *The List of Adrian Messenger* (1963). But at this period overblown seriousness blighted his most deeply felt projects, such as the ambitious attempts to film the unfilmable in *Moby Dick* (1956) and *Freud* (1962). His love of the visual arts prompted him to seek aesthetic correlatives in the look of his films-Toulouse-Lautrec's paintings in *Moulin Rouge* (1952), or Japanese prints in *The Barbarian and the Geisha* (1958)-but they seemed merely attempts to compensate for the shortcomings of the scripts.

Matters improved in the 1960s. *The Unforgiven* (1960), his first Western, and *The Misfits* (1961), a latter-day Western whose modern cowboys catch wild mustangs for dogfood, wore their allegories a little too consciously, but were lifted by Huston's wry tolerance and instinct for spatial dynamics. His knack of defusing potentially melodramatic material served him well in Tennessee Williams's *Night of the Iguana* (1964), and even better in *Reflections in a Golden Eye* (1967), an expertly controlled version of Carson McCullers's hothouse Southern Gothic.

Post-Agee, Huston's critical reputation had plum-meted. Andrew Sarris (1968) summed up for the prosecution, accusing him of middle-brow banality and "evasive technique", of "displaying his material without projecting his personality". The pendulum began to swing back with *Fat City* (1972), a study of small-time, dead-end boxers, filmed with laconic sympathy and unmistakable, seemingly effortless authority.

Huston's run of assured late masterpieces continued with *The Man who Would Be King* (1975), a sweeping, resonant expansion of Kipling's fable of the delusions of adventure and empire. Self-delusion also fuelled *Wise Blood* (1979), a blackly comic parable of sin and salvation set in Bible Belt Georgia and filmed with ironic relish for its characters' absurdities. By now, even Sarris (1980, in Studlar and Desser's anthology) was moved to recant: "What I have always underestimated in Huston was how deep in his guts he could feel the universal experience of pointlessness and failure." Not that Huston ever renounced his what-the-hell, gambler's-luck attitude to film-making: *Wise Blood* was followed by the offhand rubbish of *Phobia* and *Escape to Victory* (both 1981).

His final two films, though, found him at his best. The ruthless farce of *Prizzi's Honor* (1985) gleefully sent up Mafia movies (and propelled Huston's daughter Anjelica to stardom). And *The Dead* (1987), the last and perhaps most perfect of his many literary adaptations, treated Joyce's short story with love, joy, and quiet regret- an achingly poignant valediction, glowing with the beauty and transience of life.

5. 黑色电影

黑色电影源于法国的黑色小说，涉及黑暗的人性和自毁的宿命。德国表现主义电影的主题和基调、美国硬派侦探小说的人物和故事激发黑色电影的创意灵感；而"二战"及其后冷战导致对人性的怀疑和对世界的焦虑、加上大战时后方女性地位的提升，又成为黑色电影的现实基础。

出现在"二战"后期到20世纪50年代初期的黑色电影总是脆弱的男人受到"蛇蝎美人"（femme fatale）的色诱而犯下重罪，最后却往往堕入人财两空、小命不保的境地。比利·怀尔德的《双重赔偿》被称为经典黑色电影的最佳范例，而《洛拉》《沉睡》《杀手们》《上海小姐》和《歼匪喋血战》也是黑色电影的代表作品。

Film Noir

This period of difficulty in the American motion picture industry nevertheless saw the flourishing of perhaps Hollywood's most famous film movement— film noir. Distinctive in a dark and oppressive visual style, and in narratives of desperation and entrapment that defied Hollywood's conventions of happy endings and good triumphing over evil, film noir has influenced younger filmmakers for decades, and grown in critical importance ever since the movement was named,

《双重赔偿》的夺命鸳鸯

retrospectively, by two French critics in their 1955 book entitled *Panorama du film noir américain*. (The name derived from a French series of translations of American hard-boiled detective and crime novels, called "*Série Noire*", which gave rise to the term *noir roman*, or dark novel, hence *film noir*.)

With its themes of paranoia and betrayal, of suspicious innocence and attractive guilt, of greed and desire in a world whose moral signposts have disappeared, film noir might appear a natural outgrowth of Hollywood's postwar troubles. The film movement got its start, however, during World War II (a period to which, of course, many of its themes also apply), and its sources date back to the 1930s. These varied circumstances have generated a critical debate about the fundamentals of film noir. Was it a genre, was it a movement, was it a style? How many films belong to the film noir canon? A reference book on film noir lists nearly two hundred titles from 1944 to 1952, with 1950 as the peak year, and a rapid falloff into the mid-1950s. If this seems perhaps too inclusive, there are viewpoints at the other end of the spectrum whose definitions are so precise that only a half dozen or so titles qualify as "true" film noir. Somewhere between these numerical extremes lies a film movement whose distinctive style and perspective cropped up in a wide variety of existing genres-gangster, crime, private eye, police procedural, and espionage films, even women's melodramas, historical costume pictures, and literary adaptations.

Sources of Film Noir

One of the anomalies of film noir in its historical context was that so many of its important films were drawn from hard-boiled crime and detective novels of

the 1930s. These holdovers from the depression era were available in part because Hollywood's self-regulating body, the Production Code Administration, had at first refused approval for their film adaptation, then grew more lenient during the war and postwar period. The French authors of *Panorama du film noir américain* cite as the beginning of film noir *The Maltese Falcon* (1941), directed by John Huston and based on the 1930 novel of the same name by Dashiell Hammett. Others regard the emergence of film noir as dating from two 1944 films, *Double Indemnity*, directed by Billy Wilder, and *Murder, My Sweet*, directed by Edward Dmytryk; the former was adapted from the 1936 novel of the same name by James M. Cain, the latter from the 1940 novel *Farewell, My Lovely* by Raymond Chandler. Chandler cowrote the script for *Double Indemnity* with director Wilder.

German Emigrés

Another source for film noir was German cinema of the Weimar era, with its dark psychological moods and eerie visual effects associated with expressionism. Many of the key early works of the film noir movement were directed by German (or Austrian) émigrés: in 1944, *Double Indemnity* by Wilder (b. 1906), *Laura* by Otto Preminger (1905-1986), *Phantom Lady* by Robert Siodmak (1900-1973), *Ministry of Fear* by Fritz Lang; in 1945, *Detour* by Edgar G. Ulmer (1904-1972) and Lang's *The Woman in the Window* and *Scarlet Street*. These directors brought not only expressionist cinematography's odd angles and dark shadows but also a pessimism drawn from witnessing the rise of fascism in modern mass societies. Coincidentally, Wilder, as writer, and Siodmak and Ulmer, as co-directors, had made their film debut on a 1929 work, *Menschen am Sonntag* (*People on Sunday*), on which Fred Zinnemann (b.1907), later the director of *High Noon* (1952), also worked.

Postwar Anxiety

Along with these prewar and foreign influences, film noir was shaped by the experience of war's horrors, by the deep-rooted anxieties touched off by the dawn of the nuclear age, and by the difficult postwar adjustment faced by veterans. Moreover, after the HUAC hearings progressive filmmakers learned to couch their social critiques within familiar genre frameworks, which may help to account for the surge of noir films around 1950, just before many of the progressives were driven from the industry. Not all film noir works were concerned with criticizing society, to be sure, but in most of them something was amiss; the individual was

out of step with social order and doomed to pay the consequences.

Film Noir Style

Film noir has been defined in terms both of narrative and of visual style. Its most common narrative element involves a male protagonist's fascination with an alluring, dangerous woman, which leads him away from certainty and order into a world of lawlessness and guilt. Formally, these stories were often told as flashbacks, with action in the present alternating with or framing past events, as the protagonist searches for his lost identity, for the place where things went wrong. These narratives of psychological distress and social disruption were also shaped by the films' visual style. Film noir emphasized dark and claustrophobic framing, with key lighting from sources within the mise-en-scène casting strong shadows that both conceal and project characters' feelings. This visual style marked a sharp break with the brightly lighted and carefully balanced look of Hollywood films of the 1930s.

Women in Film Noir

A significant trend in recent criticism has been to explore the representation of women in film noir. The roster of beautiful women who lure or impel men to transgression is a long one: it includes performances by Barbara Stanwyck in Double Indemnity, Joan Bennett in *The Woman in the Window* and *Scarlet Street*, Jane Greer in *Out of the Past* (1947, directed by Jacques Tourneur), and Rita Hayworth in *The Lady from Shanghai* (1948, directed by Orson Welles). Hayworth's famous performance in *Gilda* (1946, directed by Charles Vidor), in which she sings the sultry song "Put the Blame on Mame" while peeling off her long black gloves, has come to epitomize the *femme fatale* of film noir, though, curiously, Hayworth's character does not play that role in the film's narrative. Crudely put, while exciting the spectator this figure also warned against—and suffered—the dire consequences of sexual freedom and desire.

One distinctive mark of film noir is how well many of its works have stood the test of time. Their mordant approach is sometimes despairing, but more often it leads to a sharpened energy and surprise in visual technique and performance. For performers especially, film noir was a tonic. Barbara Stanwyck (1907-1990), Fred MacMurray (1908-1990), and Edward G. Robinson all used *Double Indemnity* to forge new screen personas. Dick Powell (1904-1963) shifted from a singing juvenile to a tough guy private eye in *Murder, My Sweet*. Dropped by MGM,

Joan Crawford signed with Warner Bros. and won the Best Actress Oscar for her performance in *Mildred Pierce* (1945, directed by Michael Curtiz).

Narrative Innovations in Film Noir

Film noir also innovated in narrative techniques. Double Indemnity is marked by two temporal movements: of "real" time and remembered time. The filmopens with Walter Neff (MacMurray) arriving at his office in the middle of the night and delivering into a dictating machine his confession for killing a man—"for money" (pause) "and for a woman". These words trigger a flashback that is occasionally narrated by his voice-over confession. Gradually the narrative brings "real" time and memory together, while the unusual juxtaposition of temporalities gives the spectator a premonition of what will occur/has occurred in the flashback story. Finally, they meet as Neff is about to die from the gunshot wound he suffered at the end of his flashback. In *Scarlet Street*, another tale of allurement and murder—and a remake of Jean Renoir's 1931 French film La Chienne—the novelty (under Production Code rules) is that the murderer gets away with it, while another man dies in the electric chair for the crime. Because of this apparent breach of the Code, the city of Atlanta, Georgia, tried to stop the film from screening there. In an affidavit supporting the film, Joseph I. Breen of the Production Code Administration wrote, "It was our contention and belief that in this particular motion picture, the murderer was adequately punished by a higher power, working through his own conscience, which drove him to become a social outcast and a hopeless derelict". In Detour, the male protagonist's voice-over persistently addresses an impersonal "you"—giving the spectator the impression that he or she is the person spoken to—and assumes that the listener is smug, unsympathetic, and unbelieving. Produced by one of Hollywood's small companies, Detour has become a film noir classic, it is significant in part because its genre traits shine through so strongly, unmediated by the presence of familiar stars. The man feels passive, controlled by fate and women's ambitions. His crimes are committed "accidentally" but out of deep anger and resentment.

Voice-over and flashback were persistent stylistic and narrative elements of film noir. While *Double Indemnity* carefully clues the spectator to who is speaking, when, and from where, other films use voice-over and flashback temporality more ambiguously. Often we need to inquire about the motives of narrative voices, how much they know and whether they are telling the truth, when and to whom they are speaking. If the dominant Hollywood style provided all the information spectators would need to follow the narrative, film noir seems to emphasize narrative gaps, and even the possibility of narratives that can deceive. *Invisible Storytellers*,

a study of voice-over narration by Sarah Kozloff, shows that its occurrence in Hollywood films is closely linked to the rise and decline of the film noir movement. Besides *Double indemnity* and *Detour*, voice-over is a key narrative aspect of *Mildred Pierce*, *Gilda*, *The Lady from Shanghai*, and *Out of the Past*, among film noir works already noted, as well as many others.

The enduring critical question is how useful it is to apply the film noir label broadly to films of the postwar era. *Mildred Pierce*, for example, clearly demonstrates elements of film noir in its narrative structure (such as its use of the flashback) and parts of its visual style, but these aspects should not obscure the work's important status as a women's melodrama, where the issues of female representation are considerably different from film noir's typical concerns with male protagonists lured by *femmes fatale*. It is even more dubious to count such films as Howard Hawks's *The Big Sleep* (1946) or John Huston's *The Asphalt Jungle* (1950) as film noir if such designation deflects attention from these works as part of their primary genres, respectively private eye and crime. The same holds true for another postwar classic from a small company, *Gun Crazy* (1950), directed by Joseph H. Lewis. This film about an adventure-seeking couple who launch a crime spree contains few film noir aspects, but it is revealing to see from Production Code records how the code enforcement agency pushed the work in a film noir direction by proposing changes that would make the man more of an "unwilling victim" of the woman's "desire for wealth, no matter how this is obtained". The original release title of *Gun Crazy* was *Deadly is the Female*.

6. 恐怖片和悬疑惊悚大师希区柯克

恐怖片（horror）运用视听形象造成惊吓和恐怖的情绪，涉及神怪、灵异、幻想和精神变态等多种元素，根据哥特式神话传说、霍夫曼故事和爱伦·坡小说等创作的《吸血鬼》《弗兰肯斯坦》《金刚》和《化身博士》成为好莱坞20世纪30、40年代经典的恐怖片。发轫于梅里爱时代的恐怖片也为日后的科幻片等开辟了必不可少的道路。

如果说恐怖片重视直接的感官刺激的话，作为恐怖片一个亚类型的悬疑惊悚片（suspense & thriller）则更强调对于观众内在心理状态的操控，运用惊悚悬疑造成极端的焦虑感和紧张感成为这类电影的核心价值。而经典时期的阿尔弗雷德·希区柯克（Alfred Hitchcock）以其《蝴蝶梦》《深闺疑云》《爱德华大夫》和《美人计》获得了悬疑惊悚的超级电影大师名声。

《美人计》的加里·格兰特和英格丽·褒曼

Horror Film

A genre of film that seeks to cause fright and even terror in the viewer. The term "horror", which is applied to all works of this genre, means an extreme feeling, almost to the point of revulsion and disgust, caused by something shocking, so that the term itself does not precisely apply to the classic works of the genre made in earlier years, though it certainly can be accurately applied to some of the more recent and violent films of the genre. The horror film offers the occasion for us to see all kinds of frightening events, to feel something of the same fear and terror as the characters on the screen, yet to enjoy these feelings because we know, sitting safely in the audience, that ultimately no harm can happen to us. A form of catharsis takes place within us, a confrontation with fears that normally exist on the preconscious and unconscious levels and a cessation, at least for a while, of the devils that haunt us. From this experiencing of fear and terror in a secure situation and from this catharsis comes a unique aesthetic pleasure that the horror film evokes—but to do this the film must be made with sufficient skill and tact so that we do not feel exploited and revolted. Horror films deal with our fears of violence and death, but they also deal with subjects beyond the pale of normal

human knowledge and experience, subjects that frighten us because we know so little about them. Most of these films deal with some form of the unknown—the dead, the spirit world, science, outer space, madness - which unsettles—disturbs, and threatens us, which causes unrecognized anxiety from some region within us. These films also force us to confront the "beast within us", a subject about which religion, morality, reason, and conscience have caused us great uneasiness. Horror films do not so much satisfy our animal and aggressive nature as force us to realize and fear the instincts or drives within us. Not only do horror films appeal to us on the level of individual psychology, they also play out and appease fears that are evoked from the political and social level of our existence, fears perhaps of nuclear energy and radiation, or even fears of oppression and conformity.

Good horror films have always been made, films that do not revolt or disgust us, that do not assault our sensibilities, but that appeal to these human fears. In the era of silent film, one can find in America such fine works as John Robertson's *Dr. Jekyll* and *Mr. Hyde* (1920), starring John Barrymore, and Rupert Julian's *Phantom of the Opera* (1926), starring Lon Chaney; and one can find in Germany two significant expressionist horror films, Robert Wiene's *The Cabinet of Dr. Caligari* (1919) and F. W. Murnau's *Nosferatu, A Symphony of Terror* (1922). The great decade of American horror films in sound was the 1930's, beginning with Tod Browning's *Dracula* and James Whale's *Frankenstein* (both in 1931). In such films, German expressionism merged with American film technique and technology to create a particularly evocative and striking nightmare world, with images that still haunt the imagination. Perhaps the culmination of this period's achievement is James Whale's *The Bride of Frankenstein* (1935), but one must also commend such films as Tod Browning's *Freaks* (1932), Cooper and Schoedsack's *King Kong* (1933), and Edgar Ulmar's *The Black Cat* (1934). Though horror films began to be produced as inexpensive B-films in the 1940's, some works in the genre still achieve a level of excellence. Most notable were the low-budget horror films produced by Val Lewton for RKO. With taste and skill, he oversaw some of the most scary and poetic films of the genre, especially *Cat People* in 1942 and *I Walked with a Zombie* in 1943, both directed by Jacques Tourneur.

In the 1950s, three significant developments occurred in the horror genre: the treatment of the anxieties of the atomic age in Japanese holocaust films such as *Godzilla* (1955; dir. Inoshiro Honda) and in American mutation films such as *Them* (1954; dir. Gordon Douglas); the Communist and McCarthy paranoia films, especially Don Siegel's *Invasion of the Body Snatchers* (1956); and the color films of violence and sex by Hammer Studios in England. Hammer's best films were probably two of its earliest, *The Curse of Frankenstein* (1957) and *The Horror of Dracula* (1958), both directed by Terence Fisher.

The next decades were a more eclectic period, beginning with Hitchcock's

notable *Psycho*, which took the violation of the suffering woman a step beyond earlier films and opened the door for future exploitation, and, in Italy, with Mario Bava's stunning film about witches and vampires, *Black Sunday* (*La Maschera del Demonio*), both in 1960. Two very successful ghost stories were Jack Clayton's *The Innocents* (1961) and Robert Wise's *The Haunting* (1963). William Friedkin's *The Exorcist* in 1973 brought demonology and Satan to a Vietnam generation anxious to put responsibility for the world's evil on some force other than human. *The Exorcist* spawned a whole series of witchcraft and satanic films, none of them as cinematically rich as their progenitor. Perhaps Brian De Palma's *Carrie* (1976) can be seen as a witchcraft film, but certainly it is much more than that: an intelligent but still terrifying film, it explores and sets loose our fears about puberty, sexuality, isolation, harassment, revenge, the dead, and telekinetic powers in a film style that is both manipulative and poetic.

A large number of recent films have been concerned with the violation of young women, a theme always prevalent in the horror film, but never before done in such an explicitly violent and revolting manner. This development has been attributed to a reaction by filmmakers and audiences to the sexual revolution and the feminist movement. Such explanations always seem glib, but the number and popularity of these films suggest some connection to social and cultural disturbances. John Carpenter's *Halloween* (1978), which gave impetus to this wave of films, now seems the least offensive because it is so skillfully made. Related to these films because of its explicit connection between sex and violence is Paul Schrader's *Cat People* (1982), based on the 1942 film produced by Val Lewton. Schrader's film, however, instead of being exploitative, s one of the more visually stunning and poetic horror films of recent years.

Also worthy of notice is Ridley Scott's *Alien* (1979), a film that combines both science fiction and the horror genre, and makes the first a means of dealing with the psychological fears of the second. Science fiction and horror films have generally been two separate genres, but, ever since *Frankenstein* in 1931, the two have sometimes overlapped. Pure science-fiction films seem to glamorize science; science-fiction horror films make it part of the dreaded un-known.

Alfred Hitchcock

Alfred Hitchcock is one of the few directors whose image— especially in profile—is famous and whose name has passed into the vernacular in the word "Hitchcockian". Unanimously recognized as one of the great directors of world cinema, his films gain in stature because of the very tensions and intersections they both embody and conceal. Despite the fact that he worked over a span of fifty

years, in both silent and sound cinema, in three countries for numerous studios, as well as independently, his films exhibit an extraordinary unity, a unity which includes the most opposed aesthetic tendencies and which has made these films a critical touchstone for the most diverse interpretations.

Born in 1899 in London's East End, Hitchcock began working for British film studios in 1920 as an artist and set designer, then as a writer, assistant director, and finally director. This context, however, does not by itself reveal the influences of other national cinemas on Hitchcock's work. His first work for the British arm of Paramount already steeped Hitchcock in American studio methods before he even set foot in the USA. He was also heavily influenced both by the montage of Soviet cinema he saw in London and by German expressionist film, having shot some early films in Germany alongside Murnau and Lang.

Hitchcock's name quickly became recognized as a marker of professional polish, as well as thrills. Even in his early films like *The Lodger* (1926), Hitchcock already combined the diverse traits which together make up his "signature": the pictorial arrangement of light and shadow and complex camera movements reminiscent of German silent cinema; the metaphoric editing of Soviet montage; the tense cross-cutting developed in American cinema. In addition, Hitchcock developed distinctive plots, like the "wrong man" story, in which a man wrongly accused tries to clear his own name, and a careful control of audience identification through restricted information and point-of-view editing. With the introduction of sound, Hitchcock also explored innovative use of sound and music, as well as silence. The changes he made to accommodate sound in *Blackmail* (1929), which was in production when sound was introduced, demonstrate that he, unlike many of his peers, understood the dramatic potential of the new technology. His most famous English films such as *The 39 Steps* (1935), *The Lady Vanishes* (1938), and *The Man Who Knew Too Much* (1934) were complex and effective spy thrillers, but he also filmed popular melodrama, romantic, comic, and historical films.

Arriving in Hollywood in 1939 to film *Rebecca* (1940) for producer David O. Selznick, Hitchcock began a complex relation with the studio system, working not only for Selznick but for Walter Wanger, RKO, Universal, and 20th Century-Fox. Hitchcock depended upon the studios' high degree of organization, but bridled against interference from producers. The greatest interference came from Selznick, who felt personally responsible for all his productions. The resulting conflict both enriched and impeded their films together. Hitchcock had already adapted himself to working within the studio system by his system of "cutting in the camera", in which he only shot what was absolutely necessary, making it virtually impossible to edit the film other than as he had conceived it.

Nevertheless, Hitchcock did not simply accommodate himself to the studio system but sought independence from it. After a string of films for Selznick,

Hitchcock pursued some independent ventures. The first of these, *Rope* (1948), was commercially risky and aesthetically and technically ambitious, involving elaborate, ten-minute long takes. In the end this film brought slim remuneration. After four films for Warner Bros., including *Strangers on a Train* (1951), Hitchcock made five pictures for Paramount. Among these were the popular successes *To Catch a Thief* (1954) and the 1955 remake of *The Man Who Knew Too Much*, previously filmed in Britain in 1934, as well as the two films which perhaps most clearly encapsulate the Hitchcock universe, *Rear Window* (1954) and *Vertigo* (1958). To these films Hitchcock wisely retained all rights.

Hitchcock's popularity and identifiability, solidified by his cameo appearances in his own films, afforded the director the opportunity for an unprecedented diversification into television and publishing. Between 1955 and 1965, Hitchcock distantly supervised first *Alfred Hitchcock Presents* and then *The Alfred Hitchcock Hour*, as well as directing over a dozen episodes. He also lent his name to a magazine of horror and mystery stories. These ventures added to his revenue and his mythic status. Hitchcock's signature, soon as recognizable as his profile, functioned like a brand name.

After the spectacular success of *North by Northwest* (1959), made on a lavish scale for MGM, Hitchcock turned in an unlikely direction. Borrowing its shooting schedule and black and white photography from television, and its grisly subject-matter from cheap horror films, *Psycho* (1960) demonstrated the growing influence of the less prestigious end of the industry. But with its mix of brilliant montage and long mobile camera shots, as well as its dramatic shifts in audience identification, *Psycho* also bore the mark of Hitchcock's long-developed techniques. His contract at Paramount by now afforded Hitchcock a profit on the gross box-office over a set amount. This arrangement reportedly repaid $20 million for *Psycho*.

With *Psycho* Hitchcock's films became increasingly unsettling and strange. When at the end of *North by Northwest* the train carrying Mr. and Mrs. Roger Thornhill vanishes into a tunnel, the marriage has been consummated in a visual joke. But it is virtually the last happy marriage in any Hitchcock film. *Psycho* begins with an illicit lunch-hour affair in a hotel room, and the narrative movement of Hitchcock's earlier romantic adventures gives way to the impossibility of sexual or romantic happiness. In his later films violence towards women increases, and Hitchcock's tendency for narrative and camera to control, investigate, and immobolize his female characters becomes overwhelming. *The Birds* (1963) and *Marnie* (1964) were uneasily received. Later films did even worse, and Hitchcock never regained his popularity with film audiences.

Hitchcock's work has always provided a stepping stone for the development of new theories of film, beginning with his creative use of sound in the early 1930s. His visibility as an auteur guaranteed his importance to the French critics

of Cahiers du cinéma, who argued for the thematic, visual, and structural unity of a director's corpus. Claude Chabrol and Eric Rohmer's book emphasized the relevance of Hitchcock's Catholicism and the proximity of guilt and innocence in the "wrong man" theme. Francois Truffaut's book-length interview with the director canonized Hitchcock's own interpretation of his work, and English-language auteurist studies like those of Peter Bogdanovich and Robin Wood helped introduce the perspective into England and America.

Subsequent critical analyses have placed Hitchcock films as a site of contestation for structuralist, psychoanalytic, and, more recently, feminist theories. The amenability of his films to techniques of close analysis, pioneered by Raymond Bellour in his study of a sequence from *The Birds* first published in 1969, has made his work a proving ground for every possible sort of methodology. By contrast, recent historical work on Hitchcock's activities of self-promotion and his interaction with Selznick have helped to place Hitchcock in a historical context, as against the tendency of theorists to see his films as embodying an abstract principle or system, an idea which is already well founded in Hitchcock's films and his commentary on them.

Indeed, the excessive brilliance of Hitchcock's work, which makes it amenable to so many interpretations, seems to lie in the almost mathematical purity of conception in which technique, narrative, and structure are integrated, each aspect self-consciously folding in on the others, in part by a complex reflection on character and audience knowledge. If guilt and innocence are constantly contested in Hitchcock's films, Hitchcock himself leaves us no doubt as to who is the author of the guilty deeds which are his films. These films stand as the perfect crime, not because the author of the crime is hidden, but because he is so clearly exposed in a brilliance at once deeply flawed and absolutely flawless.

7. 剧情片（家庭情节剧）：斯特劳亨、斯登堡、顾柯、惠勒和卡普拉

剧情片（Drama）又称家庭情节剧（Melodrama），原意为依据人物性格和心理动机而引发的情节动作和戏剧冲突，主要涉及家庭纠葛、两性情仇、阶级矛盾和道德冲突等主题，成为一种涵盖广泛又界定模糊的好莱坞类型。

格里菲斯的影片就具备很强的剧情片倾向，后期的《世界之心》《真心的苏珊》和《赖婚》更是典型的剧情片。埃里克·冯·斯特劳亨的《贪婪》、茂瑙《日出》和约瑟夫·冯·斯登堡（Josef von Sternberg）的《蓝天使》（*Blue Angel*, 1930）也是早期著名的剧情片。

斯登堡的《蓝天使》

经典时期的剧情片代表作品包括《瑞典女王》《红衫泪痕》《魂断蓝桥》《北非谍影》《青山翠谷》《煤气灯下》《欲海情魔》和《生活多美好》等，代表导演则有乔治·顾柯、威廉·惠勒（William Wyler）和弗兰克·卡普拉等。

Melodrama

A term originally applied to plays that focused on plot and action at the expense of character and motivation. Such plays are uncomplicated and emotional in nature, appealing to the audience's feelings instead of minds. Moral issues are reduced to a struggle between good and evil with characters clearly representing one or the other. Such plays generally have a happy ending in which virtue is rewarded. Nineteenth- and early-twentieth-century theater in America and England featured such plays which had a marked influence on a number of early silent films. Certainly this influence can be seen in many of Griffith's films, even though some fine filmic technique and strong performances raise these works above the level of simple melodrama (note, for example, his impressive *Way Down East* in 1920, based on the stock melodrama by Lottie Blair Parker).

Erich von Stroheim

The actor and director known as "Von" to his friends was born Erich Oswald Stroheim on 22 September 1885 in Vienna, to a middle-class Jewish family. In 1909 he emigrated to the United States, giving his name on arrival as Erich Oswald Hans Carl Maria von Stroheim. By the time he directed his first film *Blind Husbands* in 1919 he had converted to Catholicism and woven various legends about himself, eagerly seized on and elaborated by the Hollywood publicity machine. In these legends he was always an aristocrat, generally Austrian, with a distinguished record in the imperial army, but he also passed himself off as German, and an expert on German student life. His actual military record in Austria seems to have been undistinguished, and it is not known if he had ever been to university, let alone in Germany.

The "German" version seems to have been merely, though bravely, opportunist, helping him to an acting career as an evil Prussian officer in films made during the anti-German fever of 1916-18, and contributing to his screen image as "the man you love to hate". But the Austrian identity struck deeper. He became immersed in his own legend, and increasingly assumed the values of the world he had left behind in Europe, a world of decadence but also (in both senses of the word) nobility.

As an actor he had tremendous presence. He was small (5' 5") but looked larger. His gaze was lustful and his movements were angular and ungainly, with a repressed energy which could break out into acts of chilling brutality. Both his charm and his villainy had an air of calculatibnunlike, say, Conrad Veidt, in whom both qualities seemed unaffectedly natural.

His career as a director was marked by excess. Almost all his films came in over-long and over budget, and had to be salvaged (and in the course of it often ruined) by the studio. He had fierce battles with Irving Thalberg, first at Universal and then at MGM, which ended in the studio asserting control over the editing. To get the effects he wanted he put crew and cast through nightmares, shooting the climactic scenes in *Greed* on location in Death Valley in midsummer 1923, in temperatures of over 120° F. Some of this excess has been justified (first of all by Stroheim himself) in the name of realism, but it is better seen as an attempt to give a extra layer of conviction to the spectacle, which was also marked by strongly unrealistic elements. Stroheim's style is above all effective, but the effect is one of a powerful fantasy, drawing the spectator irresistibly into a fictional world in which the natural is indistinguishable from the grotesque. The true excess is in the passions of the characters—overdrawn creations acting out a mysterious and often tragic destiny.

On the other hand, as Richard Koszarski (1983) has emphasized, Stroheim was much influenced by the naturalism of Zola and his contemporaries and followers. But this too is expressed less in the representational technique than in the underlying sense of character and destiny. Stroheim's characters, like Zola's, are what they are through heredity and circumstance, and the drama merely enacts what their consequent destiny has to be. Belief in such a theory is, of course, deeply ironic in Stroheim's case, since his own life was lived in defiance of it. Unlike his characters, he was what he had become, not what fate had supposedly carved him out to be.

What he had become, by 1925 if not earlier, was the unhappy exile, for ever banished from the turn-of-the-century Vienna which was his imaginary home. A contrast between Europe and America is a constant theme in his work, generally to the disadvantage of the latter. Even those of his films set in America, such as *Greed* (1924) or *Walking down Broadway* (1933) can be construed as barely veiled attacks on America's myth of its own innocence. Most of his other films are set in Europe (an exception is the monumental *Queen Kelly*, set mostly in Africa). Europe, and particularly Vienna, is a site of corruption, but also of self-knowledge, Goodness rarely triumphs in Stroheim's films, and love triumphs only with the greatest difficulty. Nostalgia in Stroheim is never sweet and he was as savage with Viennese myths of innocence as with American. His screen adaptation of *The Merry Widow* (1925) turned Lehar's operetta into a spectacle in which decadence, cruelty, and more than a hint of sexual perversion cloud the fantasy Ruritanian air.

The Merry Widow was a commercial success. Most of his other films were not. Stroheim's directing career did not survive the coming of the synchronized dialogue film, and he had increasing difficulty finding roles as an actor in the changed Hollywood climate. In his later years he moved uneasily between Europe and America in search of work and a home. In the last, unhappy decades of his life he created two great acting roles, as the camp commandant Rauffenstein in Renoir's *La Grande Illusion* ("The great illusion", 1937), and as Gloria Swanson's butler in Wilder's *Sunset Boulevard* (1950). It is for his acting that he is now best remembered. Of the films he directed, some have been lost entirely, while others have survived only in mangled versions. This tragedy (which was partly of his own making) means that his greatness as a filmmaker remains the stuff of legend—not unlike the man himself.

Josef von Sternberg

On seeing *The Salvation Hunters* in 1925, Charlie Chaplin declared its tyro director, Josef von Sternberg (1894-1969), to be a genius. In 1932, advertising *Blonde Venus*, Paramount also called him a genius. French critics freely used the term to explain why his silent films *Underworld* and *The Docks of New York* so

easily acquired a cultish admiration among Parisian audiences. In the 1930s, his discovery and protégée Marlene Dietrich vociferously reconfirmed his genius, and her willing submission to it. Geniuses, however, are not always welcome, especially in Hollywood. By 1939, Sternberg would be declared "a menace to the business".

In his autobiography Sternberg noted of his experience in Hollywood: "I proved to be an outsider and as such I remained." The industry's rejection of him was justified in the press by accounts of his personality. He was depicted as petulantly arrogant and unreasonably dictatorial, even for a director. Legend has it he would sit on a boom and throw silver dollars to actors who pleased him, but Dietrich's daughter describes him as a shy little man with sad eyes and more than a measure of self-abnegating sensitivity.

Born in Vienna, Sternberg emigrated to the United States with his family shortly after the turn of the century. He was apprenticed to a millinery shop, but ran away from home. In New York City, he found a job working for a motion picture film repairer, and in his spare time he started observing film production at the studios in Fort Lee, New Jersey. After non-combat service in the First World War, he drifted to Hollywood, where he became an assistant director. In 1924, with $5,000, he made *The Salvation Hunters*, whereupon Chaplin offered to produce his second film, *A Woman of the Sea* (1926), only to withdraw the film after one public screening. Sternberg was hired briefly by MGM, but was replaced on his first assignment *The Exquisite Sinner* (1926) and found himself again demoted to assistant director. His attempts to achieve what he regarded as filmic perfection were seen as outrageous, and columnist Walter Winchell publicly ridiculed him as an "out of work" and, therefore, "genuine" genius.

Paramount-Famous Players Lasky, however, were willing to take a chance and in 1927 assigned Sternberg to direct a minor gangster film *Underworld*, which proved a huge success, with memorable performances (from George Bancroft, Clive Brook, and Evelyn Brent), psychologically fascinating characters in a love triangle, and evocative images, including a gorgeous, confetti-filled gangsters' ball. Two further successes followed in 1928: *The Docks of New York* (with Victor McLaglen) and *The Last Command* (with Emil Jannings). In 1930 he went to Germany to direct a Ufa-Paramount co-production to be made in both German and English versions. This film, *The Blue Angel*, was planned as a starring vehicle for Jannings, but it was Sternberg's casting of Marlene Dietrich as the *femme fatale* Lola Lola that would create a sensation. It would also begin their seven-film collaboration that would earn the director the epithet of "Svengali Joe".

Sternberg returned to Hollywood, with Dietrich. Their pictures together at Paramount over the next five years would be marked by variations on the theme of the sexual humiliation of a masochistic male: *Morocco* (1930), *Dishonored* (1931),

Blonde Venus (1932), *Shanghai Express* (1932), *The Scarlet Empress* (1934), and *The Devil Is a Woman* (1935). At first critics and public responded enthusiastically to the films' ornate visual style, their ambiguous insinuations of sexual abnormality and melodramatic exoticism, but after *Shanghai Express* (1932), poor box-office returns and unfavourable reviews became the rule rather than the exception. While Dietrich's star rose, Sternberg's fell. The director was blamed for creating "tonal tapestries, two-dimensional fabrications valuable only for their details", of making that "beautiful creature", Marlene Dietrich, a mere "clothes-horse". But it was precisely through his attention to detail and his apparent obsession to fill what he termed "dead space" that Sternberg was able to create a visual poetry of unusual pictorial expressivity. He was not a genius merely because he used soft focus or elaborately artificial scenic effects, but because his films achieved uncommon structural unity and thematic complexity through their unique visual style.

After the release of *The Devil Is a Woman*, Paramount no longer required Sternberg's services. Other than the remarkably decadent film *The Shanghai Gesture* (1942), the rest of Sternberg's career in Hollywood would be marked by assignments either embarrassingly unworthy of his talents (*The King Steps out, Sergeant Madden*) or with a promise only fitfully realized, as in the case of *Crime and Punishment* (1935, with Peter Lorre). His attempt to make *I, Claudius* for Alexander Korda in England was aborted after one of the stars (Merle Oberon) was incapacitated. Sternberg's last feature film would be a Japanese production, *The Saga of Anatahan* (1953). Sternberg himself was disappointed with the film, but defiantly reaffirmed his work's primary and continuing virtue: his films were visual experiences without need for the encumbrance of dialogue or even, he once asserted, narrative.

Sternberg recounts that he was warned that "so much talent will always be punished", but his talent would ultimately be vindicated. Before his death in 1969, he had the satisfaction of seeing a new generation of critics restore to him the title of genius first granted and then torn away by Hollywood early in his career.

George Cukor, William Wyler, and Frank Capra

Three other directors of historical importance emerged from Hollywood in the thirties, although their work was less substantial and cohesive than that of the four major figures discussed in this chapter.

George Cukor originally came to Hollywood from Broadway as a dialogue director, working with both Lewis Milestone and Ernst Lubitsch before directing his first important film, *A Bill of Divorcement*, starring Katharine Hepburn and John Barrymore, in 1932. With a series of stylish comedies and sophisticated literary adaptations, he established himself as one of the foremost craftsmen of

the American cinema. Cukor had a flair for elegant decor and witty dialogue, and a facility for directing female stars which has typed him as a "women's director", but his talent was really more versatile than the term implies. Cukor worked exclusively under contract to MGM in the thirties and forties but began to freelance in the postwar era.

Among his most important films are *Dinner at Eight* (1933), *Little Women* (1933), *David Copperfield* (1935), *Camille* (1936), *Holiday* (1938), *The Women* (1939), *The Philadelphia Story* (1940), *Gaslight* (1944), *Adam's Rib* (1949), *Born Yesterday* (1950), *The Marrying Kind* (1951), *Pat and Mike* (1952), *It Should Happen to You* (1954), *A Star Is Born* (1954), *Bhowani Junction* (1956), *Les Girls* (1957), and *My Fair Lady* (1964), which earned him a long-deserved Oscar for direction. These are all handsome, graceful productions which feature brilliant performances by some of the most talented actors and actresses in the American cinema, many of whom he guided to awards: John Barrymore, Jean Harlow, Marie Dressler, Greta Garbo, Katharine Hepburn, Cary Grant, Norma Shearer, Joan Crawford, Rosalind Russell, James Stewart, Ingrid Bergman, Charles Boyer, Judy Holliday, Spencer Tracy, Judy Garland, Jack Lemmon, James Mason, and Audrey Hepburn. Cukor's work reveals no strong personal vision, but it is remarkably consistent in its intelligence, sensitivity, and taste. In 1981, he received the prestigious D. W. Griffith Award from the Directors Guild of America and, with *Rich and Famous*, became the oldest director ever to make a major studio film; in 1982, the film won the Golden Lion at Venice.

William Wyler was another fine American filmmaker. He began his career by directing B-Westerns and shorts for his uncle, Carl Laemmle, at Universal Pictures. In 1935 he went to work for Samuel Goldwyn and earned a reputation as an accomplished adaptor of other people's work—most notably Lillian Hellman's play *The Children's Hour*, which Wyler filmed as *These Three* in 1936 and remade under its original title in 1962; Sidney Kingsley's play *Dead End*, with a screenplay by Hellman (1937); and Hellman's play *The Little Foxes* (1941). He also directed adaptations of novels—*Dodsworth* (1936), *Wuthering Heights* (1939), *Mrs. Miniver* (1942, MGM), and *The Heiress* (1949, Paramount—from Henry James'- *Washington Square*)—and other plays (*Jezebel*, 1938; *The Letter*, 1940, both for Warners). His collaborator for much of this period was the brilliant cinematographer Gregg Toland, who experimented with deep-focus photography in Wyler films like *Wuthering Heights* and *The Little Foxes* before he used the process so magnificently in Orson Welles' *Citizen Kane* (1941). Wyler's *The Best Years of Our Lives* (1946), his last film for Goldwyn, was hailed as a masterpiece in the year of its release and swept the Academy Awards (as *Mrs. Miniver* had done four years before), although it is really a rather conventional, if intensely felt, drama of the problems of servicemen attempting to adjust to postwar American

life. The inflated reputation brought him by his wartime films led Wyler to pursue ever more inflated projects in the fifties, culminating in the widescreen block busters *The Big Country* (1958, UA) and *Ben Hur* (1959, MGM), which set an all-time record by receiving eleven major Oscars. Nevertheless, he continued to produce interesting work during this period, much of it for Paramount, including his tough, cynical action film *Detective Story* (1951), his adaptations of Dreiser's turn-of-the-century novel *Sister Carrie* (Carrie, 1952) and Joseph Hayes' tense contemporary drama *The Desperate Hours* (1955), the delightful romantic comedy *Roman Holiday* (1953), and the unconventional (for the fifties) *Friendly Persuasion* (1956, Allied Artists), the story of an Indiana Quaker family trying to maintain its pacifism in the midst of the Civil War. In the sixties, Wyler staged something of a critical comeback with a powerful adaptation of John Fowles' novel *The Collector* (1965), but *Funny Girl* (1968) and *The Liberation of L. B. Jones* (1969) did little to confirm his renewed reputation. Nevertheless, in 1975 Wyler was selected for the American Film Institute's Life Achievement Award, in recognition of his past contributions.

Frank Capra was a Sicilian who emigrated with his family to Los Angeles in 1903, where he ultimately earned a degree in chemical engineering from the California Institute of Technology. Unable to find employment in that field, he went to work as a gag writer for Hal Roach, Mack Sennett, and finally Harry Langdon, for whom he wrote the hit *Tramp, Tramp, Tramp* (1926) and directed *The Strong Man* (1926) and *Long Pants* (1927). When this collaboration ended in creative differences, Capra went to work for Harry Cohn at Columbia Pictures, where he made the studio's first talking feature (*The Donovan Affair*, 1929) and a popular series of armed forces adventure films with the team of Jack Holt and Ralph Graves (*Submarine*, 1928; *Flight*, 1930; *Dirigible*, 1931). In 1931, Capra made his first film with screenwriter Robert Riskin (the Jean Harlow vehicle *Platinum Blonde*) and began the collaboration that would produce the great Columbia screwball comedies *Lady for a Day* (1933), *It Happened One Night* (1934), *Mr. Deeds Goes to Town* (1936), *You Can't Take It with You* (1938), and *Mr. Smith Goes to Washington* (1939), as well as the sumptuous utopian fantasy *Lost Horizon* (1937). Capra won the Academy Award for direction three times with this series, and he ended the decade as one of the most sought-after filmmakers in Hollywood. Such was his clout that he and Riskin were able to form an independent company (Frank Capra Productions) to produce and distribute their next film, the antifascist parable *Meet John Doe* (1941), which was a failure and ended their relationship.

During World War II, Capra was inducted into the army and quickly became head of the Morale Branch's newly formed film unit. Here, with the backing of Army Chief of Staff General George C. Marshall, Capra became producer-director of the extraordinary documentary series *Why We Fight*. Originally commissioned

卡普拉作品《一夜风流》

to indoctrinate servicemen, this seven-film series was ultimately shown to general audiences in theaters around the country at President Roosevelt's behest, so powerful was it as an instrument of mass persuasion (Capra won his fourth Oscar for *Prelude to War*, 1942, the series' first installment). Only months after the war, Capra attempted independence again by forming Liberty Films with George Stevens and William Wyler. Capra made only two Liberty films before the company was sold to Paramount in 1947, *It's a Wonderful Life* (1946) and *State of the Union* (1948), both of which failed at the box office. After two Bing Crosby films (*Riding High*, 1950, and *Here Comes the Groom*, 1951) made to fulfill his part of the Liberty deal with Paramount, Capra went into semiretirement, emerging to direct the Frank Sinatra vehicle *A Hole in the Head* (1959) and *Pocket Full of Miracles* (1961), a remake of *Lady for a Day*. After he published his best-selling autobiography, *The Name Above the Title*, in 1971, Capra became something of a cult figure but made no more films. His influence, however, has been acknowledged across so wide a range of directors as John Ford, Ermanno Olmi, Miloš Forman, Satyajit Ray, and Yasujiro Ozu, and he received the American Film Institute's Life Achievement Award in 1982. During the thirties, Capra had achieved a degree of autonomy and recognition unprecedented within the American studio system, and it may be that the failure of his own company after the war, embittered him to the filmmaking establishment. Whatever the case, he made only one great film after his triumphs of the Depression years, *It's a Wonderful Life*, and that is a work which, for all of its apparent buoyancy, suggests some extremely dark possibilities for postwar American life.

第三节 法国电影黄金时代的"五虎将"

1. 诗意现实主义

诗意现实主义（poetic realism）以其对社会现实的关注和诗意风格的坚守造就了 20 世纪 30 年代法国电影的黄金时代，这些讲述法国社会中下层小人物梦想、挣扎和幻灭的故事，总是伴随着人性的光辉和感伤的氛围，对日后的法国电影和世界电影产生着深远的影响。

Poetic Realism

A term used by Georges Sadoul (see Histoire du Cinéma Mondial) and others to describe a group of French films made from 1934 to 1940 that integrates both realism and a lyrical style of filmmaking. The subject matter of these films often deals with common, everyday life, but such concerns are infused with a lyrical treatment, a kind of moody and brooding sensitivity achieved by a strong emphasis on mise-en-scène—especially on composition, impressionistic lighting, and static shots. Often evident as well are suggestive symbolism and stylistic acting.

Jacques Feyder was one of the first of these filmmakers, and his two films, *The Great Game* (1934), about the foreign legion, and *Carnival in Flanders* (*La Kermesse Héroïque*; 1935), a rich Flemish tapestry about sixteenth-century life in Flanders, are significant. Julien Duvivier also created a number of these films; perhaps the best remembered is *Pépé le Moko* (1937), a spinoff from the American gangster film with Jean Gabin as the romantic antihero of the Casbah. Marcel

Carné, with the screenwriter Jacques Prévert, made several significant films of poetic realism, especially the heavy and fatalistic *Port of Shadows* (1938), also with Jean Gabin; but undoubtedly their greatest film, a landmark in world cinema, *Children of Paradise* (1945), a stylish, elegant, and spectacular poetic drama dealing with theater life in nineteenth-century Paris. Although made in occupied France during the war years, this film is the culmination of French poetic realism. Also important in this group of directors is Jean Renoir, son of the great French impressionist painter, who, developing out of a career in silent films, went on to make a series of moving and powerful sound films, culminating with his antiwar *Grande Illuaion* (1937), with a script by Charles Spaak and starring Jean Gabin and Erich von Stroheim, and his extraordinarily delicate, profound, and pessimistic comedy of manners about a decaying social world, *The Rules of the Game* (1939), both prime examples of poetic realism.

2. "黄金五虎"费德赫、杜维威赫、帕尼奥尔、卡尔内和雷诺阿

20世纪30年代活跃于法国影坛的五位著名导演并称为"黄金五虎",代表了法国诗意现实主义的最高成就。而雅克·费德赫(Jacques Feyder)的《弗兰德狂欢节》、朱利安·杜维威赫(Julien Duvivier)的《生命之舞》、马塞尔·帕尼奥尔(Marcel Pagnol)《面包师之妻》、马塞尔·卡尔内(Marcel Carné)的《雾码头》《黎明》和《天堂的孩子》,以及下面将要讨论的雷诺阿影片都是法国诗意现实主义的传世杰作。

Five Major Directors

The quality of French films of the late thirties depended heavily upon the contributions of scriptwriters and performers. The directors who did the most important work in France from 1935 through 1939 came to film out of essentially theatrical or literary careers. Jacques Feyder began by acting in the theater; Julien Duvivier started as an actor as well; Marcel Pagnol had achieved distinction as a playwright and theatrical producer; Marcel Carné had been a journalist and film critic. Only Jean Renoir, younger son of the great Impressionist painter Pierre Auguste, had begun his artistic career with an interest in the visual/plastic arts (ceramics).

Jacques Feyder was a veteran commercial director, his career beginning far

back in the silents with *Thérèse Raquin* (1928) the most enduring. After the coming of sound Feyder established the style of "poetic realism" that would become predominant in the late thirties. *Pension Mimosas* (1935), especially, became a prototype for later work, and Feyder's principal collaborators—Charles Spaak as scriptwriter and Marcel Carné as assistant director—would carry forward and elaborate on the themes, characterizations, and moody visual surface of that film.

Feyder's next effort, *Carnival in Flanders* (1935), was his greatest success. Essentially a richly amusing comedy about the battle between the sexes, it had certain political implications that gave it another kind of interest as well. Set in the Spanish Netherlands of the seventeenth century, it deals with the threat to a small Flemish town posed by an approaching military expedition led by the duc d'Olivarès. Pusillanimous and fearful of bloodshed, the men of Boom go into hiding, leaving the stalwart women to greet the conquerors. What develops between the women and the dashing Spaniards, with the Flemish men looking jealously on from their hiding place, is the main line of comic invention. Note, however, that Feyder (and the writer of the script and the novel from which it was taken, Charles Spaak) has the Flemish undergoing an invasion and occupation and, as it happens, indulging in fraternization and collaboration with the occupying power. (The ironic French title, *La Kermesse héroique*, means "the heroic village festival".) At the time, Feyder and Spaak, both Belgians, were attacked by Flemish nationalists among their fellow citizens for their unflattering portrayal. Subsequently, in World War II, the Flemish became notorious collaborators under German occupation, whereas Feyder and others who worked on the film were persecuted by the Nazis.

In Carnival in Flanders the arrival of the Spanish messengers in town—galloping horsemen shot from low angle with fluid camera movement and cutting to the music—is as lively a piece of cinema of that sort as can be found. Francoise Rosay gives a striking performance as the mayor's spirited wife, who takes command ("Femmes!" she shouts authoritatively from a balcony as she begins a speech to the assembled women below) and perhaps yields softly to the elegant duc. Louis Jouvet, in a lesser part as the cadaverous and wordly priest, is an equal delight; this is the first in a long series of such roles for him. The re-creation of the town and of the burghers themselves is a succession of Dutch paintings brought to life, reminiscent of Rembrandt, Vermeer, and particularly of Breughel in shots of the town square from an upper window in the burgomaster's house. The wit and sophistication, however, add a distinctly Gallic flavor.

Julien Duvivier, who also began directing in silent films, reached the height of his achievement between 1935 and 1939. He worked even more consistently and successfully within the style of poetic realism. Among his successes of the latter half of the thirties, most memorable (or perhaps merely most likely to be remembered in

the U.S.) are *La Belle Équipe* (1936), *Pépé le Moko* (1936), and *Carnet de bal* (1937). The first two, starring Jean Gabin, explore the theme of escape; the third, in a way, deals with escape from self, escape to the past. *La Belle Équipe*, which means something like "the good gang", concerns a group of urban working-class buddies who win a lottery and attempt to establish a restaurant in the country. *Pépé le Moko* is set in Algiers, with Gabin as the fugitive who desperately wants to return to his native Paris but is safe only so long as he hides from the authorities in the Casbah. *Carnet de bal* began Duvivier's experimentation with the anthology film, which he continued in *La Fin du jour* (1939). (In Hollywood during the war he made *Tales of Manhattan*, 1942, and *Flesh and Fantasy*, 1943; and back in France, *Under the Paris Sky*, 1950; all employing a similar form.) A "carnet de bal" is a dance program, and the film revolves around a lonely widow who tracks down—some twenty years later—her partners from her very first dance. This scheme allowed for the stringing together of seven varied vignettes and a chance to display a galaxy of some of the most popular stars in French cinema: Francoise Rosay plays the demented mother of one of the old beaux who has committed suicide; Harry Baur is a disillusioned musician turned monk; Pierre-Richard Willm is an Alpine guide; Raimu, the hen-pecked mayor of a little town; Louis Jouvet, a master criminal and night club proprietor; Pierre Blanchar, a one-eyed abortionist beset by a harridan mistress and epilepsy; Fernandel, a philosophical beautician.

Marcel Pagnol was resolutely a man of the theater who saw film as "a printing press for drama". If the pleasures he offers aren't essentially cinematic, they are very good theater indeed. His main preoccupations are with rural France—the simple and enduring way of life in the villages. His themes provide fascinating, if broad, understandings of traditional modes of French thought and behavior. With Raimu at their center, both the theatrical aspects of fine performance and the earthy wisdom and humor of provincial France are at their best.

Pagnol's *Marius* trilogy of the early sound years has already been mentioned. Before it was completed he produced *Joffroy* (1933), a charming anecdote about an old Provencal peasant who sells his orchard land but claims that the fruitless old peach trees on it still belong to him. Perennial in its charm, it appeared in the United States nearly two decades later as one of three short films that formed *The Ways of Love*. (Renoir's *A Day in the Country* and Rossellini's *The Miracle* were the other two.) *Regain* (or *Harvest*, 1937) is also set in Provence and concerns an abandoned village. It has a back-to-the-earth theme and stars the popular comedian Fernandel in a role embodying a certain plaintiveness.

Pagnol's culminating achievement of the late thirties was *The Baker's Wife* (1938). Like *Regain* it is adapted from a Jean Giono story. The baker is played by the marvelously droll Raimu, one of the world's great comic actors, who has a distinctively French provincial quality. When his attractive young wife runs off

with a handsome shepherd, he refuses to bake any more bread, thus involving the whole village in a search for the adulteress and in efforts towards reconciliation. Though Raimu's style is in total contrast to Chaplin's, he has the same ability to edge comic situations with pathos.

Marcel Carné, a superb craftsman, did his best work in collaboration with the poet/screenwriter Jacques Prévert; in fact, it seems quite possible that Prévert was the *auteur* (author) in the filmic as well as the literary sense. Together they achieved an epitome of the poetic realism most characteristic of French film in the late thirties. The themes of doomed love, the tight dramatic structures, and the careful, evocative, and symbolic studio reconstructions of the real world mark their special aesthetic and give their work a sad beauty of lasting value. Their two greatest films of the period—*Quai des brumes* (*Port of Shadows*), 1938, and *Le Jour se lève* (*Daybreak*), 1939—are also remarkably consistent in the dark and despairing view they present of society. In them Carné and Prévert follow the ubiquitous Jean Gabin through urban lowlife on the fringes of the criminal world. Forced and led into a crime of passion that causes his own destruction, Gabin meets his end with the special sort of stoicism that he carried with him from film to film. Even individual scenes seem almost interchangeable: The lighting and wallpaper in the forlorn hotel rooms look alike; a woman (Michèle Morgan or Arletty), with a kind of tired sensuousness, peels off a silk stocking; the same little bistro reappears, as do the same unadorned and cheerless flights of stairs. It's as if a bleak vision of the society had been frozen on the screen and Carné-Prévert insist that we see it over and over again with them. The social implications of this vision will be dealt with in the following section.

Then there was Jean Renoir, the giant figure among French film makers of that time. In fact, Renoir stands astride nations and periods in his long and fruitful career. His total corpus places him among the foremost film makers in the history of cinema to date; he is protean, experimenting in many forms and styles, yet usually saying essentially the same things. For Renoir life is fundamentally good— the life of the heart and of the senses. Sexual love and natural countrysides are to be celebrated along with food and wine. In Renoir's world there are no bores and few villains. (In *The Rules of the Game* one of his characters, played by Renoir himself, remarks, "Everyone has his own good reasons".) His people may cause themselves and others difficulties, but they are never less than human; always they are interesting, and ultimately verifiable in what we can recognize as one of humanity's possible aspects. Clearly enough, this celebratory view of life matched that of his father's paintings.

As observed earlier, Renoir's world view had already been formed in his sound films preceding the high years of French cinema. *La Chienne* (1931), *Boudu Saved from Drowning* (1932), *Madame Bovary* (1934), and *Toni* (1934) can stand alongside his later work without apology. This is particularly true of *Boudu*. In it

Renoir developed the notion of the social group, with the "outsider" (in one sense or another) serving as catalyst. This protagonist stirs up the group, unhinges it a bit; when he or she leaves, the group re-forms, changed by the experience. But the cohesiveness of the social unit, the need of people for each other, is one of the *idées fixes* in Renoir's universe of discourse.

In *The Crime of Monsieur Lange,* made in the landmark year 1935, Renoir restates these thematic materials in even fuller detail and more controlled form. Around the courtyard and within the offices of the publishing firm, a virtual microcosm of society at large is created, with basic human needs and weaknesses motivating the action. Yet, with Renoir, these social themes never seem schematic: They are made manifest through close observation of particular, often mildly eccentric, human beings rather than through reliance on types. His use of the camera (shots of considerable duration, wide-angled, composed in depth, and often inconspicuously panning) seems designed to capture what is happening to his characters without intruding upon them. The performances are so fresh and spontaneous they surpass an impression of improvisation to convey a sense of authenticity, of real persons at their core. Though the films are not life itself, they are definitive comments upon life as seen by one wise and humane artist.

Even the Gorky drama *The Lower Depths* is turned into a film (1936) that becomes part of Renoir's cosmos, and the viewer can't quite be sure how the alteration has taken place. *The Grand Illusion*, a year later, is unquestionably one of the director's masterworks. The script, which he wrote with Charles Spaak, is based on his own experiences during World War I and those recounted to him by others. Here the tale is that of French prisoners of war in German prison camps, of two of the prisoners who have escaped, and of a German woman and her child with whom they stay for awhile. The First World War was sometimes called The Great War, and that is the illusion referred to in Renoir's title. War may be big, it may also be pervasive, but it is scarcely grand. It is an illusion that war can solve national problems according to the film; instead, it merely frustrates human needs. For the many soldier-prisoners, war is a deprivation—of freedom, primarily, and of women's love. For the two aristocratic professional soldiers, one French the other German, modern warfare doesn't even grant the traditional satisfactions of chivalry and comradeship.

It is also an illusion that war will ever end. (One of the characters says, in fact, that it is an illusion that this war will end all wars.) In fact the war itself may be an illusion— it remains offscreen throughout. What are not illusions? Friendship based on common humanity (cutting across national, economic, and ethnic differences), love (sexual, parental, and comradely), food and drink (which receive due attention) are real.

Renoir said that he was a pacifist, but this is not a clearly or at least a convention ally pacifist film. It contains no bloodshed, no atrocities, not even unbearable cruelties. (Punishment by solitary confinement comes closest; how like

Renoir to regard being deprived of human companionship the cruelist of tortures.) If this is an antiwar film, it is even more profoundly a prohuman film, against all those restrictions placed on the human potential—nationality, class, military rank, religious prejudice—that keep us from solidarity.

After *La Marseillaise* and *The Human Beast* (both 1938) there came the final masterpiece of the thirties, *The Rules of the Game* (1939). It was completed just before French liberty was extinguished by the nation's collapse in the face of German onslaught.

The "game" of this title in an overall sense is the behavior of the upperclass hosts and guests during a house party. We see much of the servants of the estate as well. Their jobs are to serve the masters; the masters' jobs are to entertain themselves. The chief entertainment (game) is sexual intrigue, in which all the principal players indulge. In addition there are the host's collection of mechanical toys, a costume party, a rabbit hunt, a variety show.

The "rules" in general require that things be done properly, style taking precedence over feeling. (The feelings of the characters seem atrophied; or, at most, light and variable.) Passion is not permitted, sexual infidelity is accepted; embarrassment is avoided, decorum preserved; the appearance of friendship, frankness and generosity is maintained. It is not just that the rules don't relate to human wishes and desires, they are in opposition to them (similar to the illusions of *The Grand Illusion*). Though essentially a comedy, the diagnosis of social illness is disturbing enough that the film was banned by the French during the Occupation. One of Renoir's few dark films, *Rules of the Game* became a requiem marking the end of an era.

3. 雷诺阿的《游戏规则》和《大幻灭》

让·雷诺阿（Jean Renoir）继承画家父亲的视觉艺术天赋，运用场面调度和景深构图将前景与后景、文明与自然、上层与下层、赢家与输家等融入自成一格的电影有机统一体，呈现出法国电影独特的社会价值与美学意味，为巴赞和"新浪潮"的出现打下了基础。雷诺阿执导过许多杰出的影片，而诗意现实主义的经典电影《大幻灭》和《游戏规则》则是无可争议的代表作。

Grand Illusion

Grand Illusion is also a microcosmic study. Its superficial action is the story of two French soldiers who eventually escape from a German prisoner-of-war

让·雷诺阿的《大幻灭》

camp during World War I—and one who does not. Its real action is metaphor: the death of the old ruling class of the European aristocracy and the growth of the new ruling classes of the workers and bourgeoisie. The prisoner-of-war camp is a microcosm of European society. The prison contains French and Russian and English, professors and actors and mechanics and bankers, Christians and Jews, nobility and capital and labor.

At the top of the social hierarchy are the German commander, Rauffenstein (played by Erich yon Stroheim, the director whose films most influenced Renoir's), and the French captain, Boeldieu (played by Pierre Fresnay). Though the two men fight on opposite sides, they are ideologically identical: They both use a monocle; they both wear white gloves; they both share the same prejudices and snobberies, the same educated tastes in wine, food, and horses. They are united by class more than they are divided by country. The supreme irony of the film is that the German commander must kill this man to whom he feels most closely allied because the rules of the war game demand that the commanding officer of the prison shoot men trying to escape, just as they demand that the prisoner (gentleman or not) attempt to escape. The two men are inflexibly, tragically responsible to their codes, their rules, and their duties. United as members of the cultured international elite, divided as prisoner and warden, they both transcend boundaries and acknowledge them in a paradox of roles whose only constant is honor. They are part of a dying breed that, like the old Europe, would not survive the war.

The two tougher, hardier prisoners do escape, while Boeldieu covers for them

and gives up his life in gentlemanly sacrifice. Maréchal (played by Jean Gabin), a mechanic, and Rosenthal (played by Marcel Dalio), a Rothschildean Jew whose family owns banks, land, and several chateaux, escape together from the German prison. The animosities, the tensions, the prejudices of the two men surface as the going gets rough, but the two finally make it to Switzerland—and they make it together. Overcoming their own set of social boundaries, they are the new Europe.

Consistent visual imagery is one source of the film's unity. Renoir's camera contrasts things that are hard, cold, and dead with things that are soft, warm, and vital. The final sequences take place during the winter; the consistent pictures of snow and frozen ground throw their cold, damp shadow over the entire film. The two escaped prisoners must struggle across an immense meadow of snow to reach safety in Switzerland. But the Swiss border is invisible. It is impossible to distinguish different nations beneath a common blanket of snow. Only the German officer's announcement that the two have made it—to freedom, in one of Renoir's characteristically open endings—informs us where the snow of Germany ends and the snow of Switzerland begins. That one can make such nationalistic distinctions is one of the film's grand illusions—as a breeder of war, perhaps the most destructive and coldly heartless.

Equally cold is the bare, stony castle that keeps the prisoners captive. And unforgettable is the piece of iron that replaces Rauffenstein's chin; it supports his face since his real chin has been shot away. The rigid, inflexible Rauffenstein himself is literally held together by metal—in the chin, the back, the knee—the embodiment of the film's contrast of the vital and the dead. The one soft thing in the prison castle is Rauffenstein's little geranium, which he carefully nurtures. When Boeldieu dies, Rauffenstein lops off the single blossom; he knows that his world is dead. Emphatically warm and vital are the woman and child, Elsa and Lotte, that Maréchal and Rosenthal encounter on their flight.

Grand Illusion shows how, with the Great War, the aristocracy of Europe committed elegant suicide. To turn life into a cold, murderous game with a series of artificial rules is ultimately to turn life into death. But how can a class that has lived according to certain codes and manners for centuries suddenly change to fit the new bourgeois and proletarian times? Rauffenstein and Boeldieu are admirable for their taste, their elegance, their integrity, and their honor. Is it their fault that they have been condemned by history to live in a century that barely understands those virtues? As Renoir would put the problem in his last film of the decade, "Everyone has his reasons".

The Rules of the Game

These ironies and paradoxes become the central issues of that last 1930s film,

perhaps Renoir's greatest, *The Rules of the Game* (*La Règle du jeu*; shot, released, censored, and banned in 1939; restored in 1956). The film uses sex rather than war to provoke a crisis of values in a dying society—two mutually dependent societies, in fact: the society of wealthy masters and the society of genteel servants. Both masters and servants value good form over sincerity and the open expression of emotion; both are equally aware of class distinctions. The rabbit hunt is one of the key sequences that shows how death is the price—paid by nature and the innocent—for the masters' dying way of life. But as in *Grand Illusion*, the dancers in this dance of death try to balance the demands of social form with the demands of human spontaneity. Like the aristocrats of *Grand Illusion*, they find that the conflicting demands are ultimately, and unfortunately, mutually exclusive and unbalanceable.

Renoir's complex structural parallels play several love stories against one another. In the main plot, a romantic aviator, André Jurieux, petulantly confesses his love for a stylish upperclass married lady, Christine de la Chesnaye. Although the rules of the game do not prohibit adultery, they do condemn such frank, impulsive, sincere expressions of it. In a subplot, the lady's maid begins her own adulterous dabbling with a new servant, Marceau: a poacher, an outsider (like André), not a genteel (if excitable) servant like her own husband, Schumacher. Other subplots concern Christine's husband's attempts to break off a boring love affair and André's best friend's discovery that he, Octave (played by Renoir), loves Christine. The love plots cross paths, as in a dance with changing partners or a wildly complicated bedroom farce. The maid's jealous husband, who also has problems observing the rules of the game, mistakenly shoots the aviator, thinking that André is really Octave, that Octave has become his wife's new lover (he has not), and that the woman wearing his wife's coat is his wife (it is Christine). The romantic aviator dies, and the game of lies goes on, but both represent codes that are dying out. The Marquis de la Chesnaye, Christine's husband (played by Marcel Dalio), formally announces to his guests that André has met with a "regrettable accident"; the group admires and accepts the baron's lie as a gentlemanly display of good form.

Renoir's sense of style and imagery again sustain the film. Its most memorable visual sequence is the rabbit hunt, a metaphor for the society's murderous conventionality and insensitivity. The wealthy masters go off to shoot rabbits; this hunt, like the lives of the rich, has its etiquette, its rules, its gentility. It is a civilized form of killing, a murderous game.

One of the film's key visual metaphors is the marquis's collection of mechanical toys—ornate clockwork birds and music boxes. The marquis collects people the way he collects toys, and he prefers winding up intricate predictable machines to manipulating unpredictable people. But even the machines break down—chaotically

but momentarily, like the supposedly inviolable rules of conrrect behavior. All those, the marquis can restore—but what dies cannot be fixed.

And yet Renoir's method is not so naive as to condemn artifice and praise the simplicities of spontaneity. For one thing, the Marquis de la Chesnaye—Renoir's representative of polite civilization—is a compasionate, considerate man who is trying not to hurt anyone, whereas the aviator—Renoir's representative of spontaneity—is a selfish, blundering fool. Although the music boxes are indeed mechanical, they also represent a degree of orderly and delicate perfection. De la Chesnaye's problem is that he would like to achieve an impossible ideal: a world in which the demands of love (which can be notoriously disruptive) and order are harmonious rather than mutually exclusive—or at least are pursued with restraint and good manners, with "class". As he tells his gamekeeper, he wants no fences around his property and he also wants no rabbits.

Renoir's comedies of manners are dark and very ironic. *The Rules of the Game* is a comedy full of failure and death. Even such comedies of survival as *Boudu* and *s* have an almost Chaplinesque sense of loss, along with a delight in reversed expectations.

During the Second World War, Renoir, like Clair, made excellent films in the United States: *Swamp Water* (1941), *This Land Is Mine* (1943), *The Southerner* (1945), *Diary of a Chambermaid* (1946). After the war, he, like Clair, returned to France. But he took a while to get there. In India, where he inspired Satyajit Ray, Renoir made his first color film, *The River* (1951). By way of Italy and another movie, he was back in the Paris studios by 1954 for *French Cancan*, which starred Jean Gabin. His eye, his sense of style, his perception of social strutures and human relationships were still keen. Renoir would serve as a historical bridge, uniting the tradition of French "literary" filmmaking with the emerging cinematic breeziness of the New Wave.

4. 让·维果和《零分操行》

让·维果（Jean Vigo）是英年早逝的法国电影天才，他的自传式作品《零分操行》直接启发了特吕弗的《四百下》，而《驳船亚特兰大号》则以其浓郁的抒情意味和辛辣的社会反讽成为诗意现实主义的又一代表性力作。

Jean Vigo

One of the most compelling visions of poetic realism was created by Jean

Vigo (1905-1934) in a brief, tragic career that included only a single feature-length fiction film. The son of an anarchist who was murdered in prison during World War I, Vigo embodied in his work the anarchist ideal of forging unity through the collaboration of free individuals. On his four films—two short documentaries, the short fiction film *Zéro de conduite* (*Zero for Conduct*, 1933), and *L'Atalante* (1934)—he worked with cinematographer Boris Kaufman (1906-1980), a younger brother of Soviet documentarian Dziga Vertov. Kaufman later went to Hollywood and won an Academy Award for cinematography on *On the Waterfront* (1954). For his two fiction films Vigo utilized composer Maurice Jaubert (1900-1940), who went on to write some three dozen additional scores for French films in the 1930s. Shaping his film music to the narrative and stylistic needs of specific films, Jaubert contributed significantly to the movement of poetic realism. He was killed in action just before France surrendered to Germany in World War II.

Zéro de conduite is less a work of poetic realism than an anthem for students. With strong ties to 1920s Surrealist films, it depicts a boys' boarding school as a world mingling the comic and grotesque. It climaxes in a spontaneous dormitory uprising, Where the boys stage a pillow fight shouting, "It's war! Down with school! Down with teachers!" The scene ends with a procession filmed in slow motion with floating pillow feathers filling the screen like snowflakes. The next morning the rebels take to the roof, raise a skull-and-crossbones flag, and bombard the school's alumni day activities with a shower of tin cans. The censors saw the film's spirit of revolt as a threat to public order, and it was banned in France until 1945.

Made during the director's final illness, *L'Atalante* is a work of overwhelming lyricism and poignancy. The skipper of a river barge (the barge's name gives the film its title) marries a provincial bourgeois woman. Their life aboard ship is alternatively idyllic and troubled, complicated by an irascible, curmudgeonly first mate, portrayed by one of the stars of 1930s French cinema, actor Michel Simon. When they dock on the Seine near Paris, the woman, yearning for the city's lively pleasures, leaves the boat; miffed, her husband pulls up anchor and leaves without her Apart, each is lonely and miserable. Seeking to reunite the couple, the first mate hunts for her, and finds her listening to a song about barge life. The film's sentimentality is leavened by Simon's raucous performance and sometimes leering humor (as in the scene where the woman explores his cabin and he shows her his tattoos), as well as by the ambient songs and accordion music contributed by Jaubert. Circulated for years in cut versions, a restored *L'Atalante* was released in 1990 to new acclaim as a remarkable achievement in cinema history.

第四节 纪录、宣传与政治

纪录片（documentary）一词首次出现在1926年，与故事片（虚构电影）不同，纪录片用于记录真实的人物、场景、事件和活动。当然，纪录片的真实性是一个相对和模糊的概念，纪录片制作者对于真实人物和真实事件的选择和呈现无疑会体现自己的主观倾向，这既对纪录片的真实性程度提出了疑问，也为纪录片的意识形态宣传导向提供了可能。

Documentary

A film that deals directly with fact and not fiction, that tries to convey reality as it is instead of some fictional version of reality. These films are concerned with actual people, places, events, or activities. The very act of putting reality on film must change that reality to some degree, must select from it and give it form and shape; and documentaries can be discussed in terms of the degree of control that the filmmaker imposes upon the reality he or she records. What is true of all of these films, however, is that they try to give us a feeling, a sense, a perspective of the reality that actually exists even if some filmmakers might use obvious cinematic techniques to achieve this or even preconceived scenes and narrative lines. Some documentaries have the purpose of persuading the audience to a particular view about some aspect of reality, as, for example, Pare Lorentz's "New-Deal" films of the 1930s. When indoctrination distorts reality, however, the work must be considered a propaganda film. Other documentaries seek basically to show and explore, to educate the public about certain social situations or governmental

agencies, as, for example, the films made by John Grierson's group in England, also in the 1930s.

The term "documentary" was derived from the French word *documentaire*, which means "travelogue", by Grierson in his review of Robert Flaherty's *Moana* (1926) in the *New York Sun*. Grierson later defined the term as "a creative treatment of reality". The World Union of Documentary in 1948 defined this type of work as recording on film "any aspect of reality interpreted either by factual shooting or by sincere and justifiable reconstruction, so as to appeal either to reason or emotion, for the purpose of stimulating the desire for, and the widening of human knowledge and understanding, and of truthfully posing problems and their solutions ..." Because the term "documentary" describes a wide variety of films, critics and filmmakers have suggested other nomenclature. Richard Barsam argues for the term "nonfiction film" for all these works, with "documentary" reserved for films that are concerned with opinion as well as fact and that seek to persuade the audience to some point of view, and "factual film" for works concerned primarily with fact (in *Nonfiction Film*). Other terms suggested are "propaganda documentaries", "educational documentaries", "romantic" or "lyric documentaries", "avant-garde" or "experimental documentaries", and, more specifically, "newsreels", "travelogues",and "compilation films".

Many of the actualities that the Lumiere brothers began to show in 1896 were documentaries of a sort, showing aspects of reality without any fictionalizing; but the modern documentary really begins with Robert Flaherty's *Nanook of the North*, first screened in 1922. *Nanook* inspired other films about foreign ways of life, includirig Cooper and Schoedsack's *Grass* (1925) and *Chang* (1927), and Flaherty's own *Moana* (1926) and *Man of Aran* (1934). Though planned and staged at times, Flaherty's films were remarkable achievements, focusing upon distant ways of life; bringing the remote into proximity with subtle artistry in his selection of scenes, camera work, and editing; and creating a visual poetry in his evocation of foreign cultures. In the Soviet Union, Dziga Vertov achieved some remarkable effects in his montage editing of newsreels in the *Kino-Pravda* (*Film Truth*) series, and later in the decade he applied his film techniques to documentaries about Soviet progress. Perhaps not technically documentaries, the avant garde films about cities, the city-symphonies made on the continent during the 1920s (e.g., Alberto Cavalcanti's *Hien que les Heures* about Paris in 1926) should also be mentioned. But after Flaherty and Vertov, John Grierson is the next significant name in the history of the documentary, although he directed only one work himself, *The Drifters* in 1929, a film about Scottish fishermen. Grierson, as head of various government units and later sponsored by private industry, led a movement that produced some three hundred films during the next decade. The films in this group educated the public about British life, governmental agencies,

and social problems. These films generally show excellent technique, but are largely educational rather than artistic and aesthetic. However, films such as *Song of Ceylon* (1935), directed and filmed by Basil Wright, achieved a high state of art and made reality both immediate and poetic. Also significant are the films made in America during the Depression and sponsored by the government, especially two works by Pare Lorentz, *The Plow That Broke the Plains* (1936), about the Dust Bowl, and *The River* (1937), about the Mississippi Valley and the Tennessee Valley Authority. World War II evoked some fine, patriotic documentaries, for example, Humphrey Jennings's *Fires Were Started* (1943) from England and John Huston's *The Battle of San Pietro* (1944) from America.

The most significant development in the documentary since that time undoubtedly has been the *cinéma-vérité* in France and direct cinema in America in the 1960s. Both of these movements were influenced by television news and documentary work and shaped by the new lightweight, portable equipment for photography and sound. Although *cinéma-vérité* is distinguished by the technique of probing interviews, both movements sought to achieve authenticity and immediacy, a truth and directness not achieved in film before. Mobile equipment allowed the filmmakers to get into their subjects with minimal technical intrusion. Their avoidance of preconceived attitudes and narrative lines, of apparent filming techniques and editing, produced films that at times seem amateurish but often seem as close to the truth of human nature as one can obtain on film. Marcel Ophiils's *The Sorrow and the Pity* (1970) is perhaps the most distinguished film to come out of *cinéma-vérité*, and the films of Frederick Wiseman are notable works of direct cinema. Although documentaries are difficult to finance because they rarely play commercial theaters often they are made for specialized organizations, institutions, and audiences a number of these films are so close to reality, causing us to see the world around us with such extraordinary clarity, and are so emotionally involving that they have reached the public at large (e.g., Barbara Kopple's *Harlan County, U.S.A.*, a journalistic account of a strike by miners and a moving portrait of human dignity, which won an Academy Award for 1976).

1. 弗拉哈迪与《北方的纳努克》

纪录片可以追溯到早期的卢米埃尔电影和游记片（documentaire），但大家公认的首部纪录片则是产生于1922年的《北方的纳努克》，其编导罗伯特·弗拉哈迪（Robert Flaherty）就被称为"纪录电影之父"。《北方的纳努克》

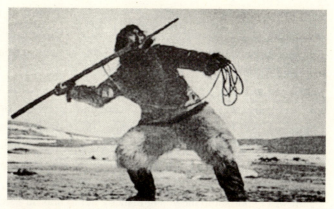

《北方的纳努克》

因记录爱斯基摩人纯朴生活和冰雪世界自然美景而赢得世人的赞誉，但影片搬演的呈现方式及其欧美文化猎奇理念从一开始就受到质疑。

Flaherty and the Silent Documentary

Many directors of the 1920s worked outside the fences of the Hollywood formulas. One of them was Robert Flaherty, the father of the documentary feature, who had been taking his camera to Hudson Bay since 1913; the eventual result was *Nanook of the North* (1922).

The first films had been nonfiction: records of actual human activity, snapshots in which things moved. There were *actualités* of trains rushing by, of life in foreign lands, and of newsworthy events (on-the-spot footage of the 1906 San Francisco earthquake). There were also faked reconstructions of events, from *Tearing Down the Spanish Flag* (1898) to the *Eruption of Mount Vesuvius* (1905).

Beginning in 1918, Dziga Vertov made newsreels by assembling the bits of film sent to him by traveling cameramen, in which the people and activities of the new Soviet Union were recorded. In 1922, the year of *Nanook*, Vertov began shooting film and expanding his experiments both in montage and in ways to capture unstaged reality ("life unawares"); he named the new series *Kinó-Pravda*, as if it were the film version of the newspaper *Pravda* ("truth"). Vertov's work led him to the genres of the "compilation film", in which a movie is created out of found footage; the "candid camera", in which people are photographed without being asked and without at first being aware of any camera, so that they have no opportunity to pose or to behave in an unnatural manner; *cinéma vérité* ("film

truth"; French for *kinó-pravda*) or "direct cinema", in which the camera is an acknowledged element of the scene it records; and the newsreel itself. He was also a pioneer in the feature-length avant-garde documentary, a genre that included not only his *The Man with a Movie Camera* (1928, released 1929), but also such poetic "city films" as Walter Ruttmann's *Berlin: The Symphony of a Great City* (1927).

So *Nanook* was not the first nonfiction film, even if it did set the pattern for what would later be called the documentary (the term was coined in 1926 by John Grierson—the prime mover of the British documentary film movement of the late 1920s and 1930s—in a review of Flaherty's *Moana*). But it was the first feature. length documentary to become a huge commercial hit.

It was important to the young Flaherty not to impose a story on his materials, but to live long enough with the people whose lives he was recording, and to shoot enough film, that the material would tell its own story, that the truth would reveal itself. Once that inner story, the key to organizing the material, had become clear to him, Flaherty could edit the footage into a nonfiction narrative that would convey that truth—the essence of the subject and the point he wanted to make about it. That was the theory, and it is one that has inspired nonfiction filmmakers ever since—but in practice Flaherty was a bit heavy, handed in conveying what was inevitably his interpretation of the material, the story he thought it told. Like many early ethnographic filmmakers, he brought back crucial records of distant cultures but was also willing to make up a fction that would encapsulate what he wanted to convey about the actual; he did this in several films, including *Moana* (1926) and *Louisiana Story* (1948).

Flaherty's *Nanook* is significant for the beauty of its photography of the white, frozen plains of ice and for its care in revealing the life of the man—and the family—who lived there. Flaherty's greatest asset was Nanook's lack of inhibition before the camera. Although he was clearly conscious of being watched, suggested many of the scenes, and knew he was performing, he did not quite know what a camera and movie were. Nanook was carefully directed to perform his specific business—hunting, building an igloo with his family, feeding the dogs—while Flaherty's camera recorded and, inevitably, commented. From *Nanook* on, the documentary has been defined as a nonfiction film that organizes factual materials in order to make a point—as distinguished from the *actualité*, which simply records an event.

Nanook was released by Pathé (which had, along with Revillon Frères, produced it) after Paramount and three other studios refused it. After *Nanook* proved itself at the box office, Hollywood asked Flaherty to make pictures for commercial release. For Paramount he made *Moana: A Romance of the Golden Age*—an idyllic study of life on a South Seas island. Hollywood, which expected a movie full of hula dancers, was disappointed and teamed Flaherty with other

directors, W. S. Van Dyke and F. W. Murnau, for his later silents, of which the greatest was his and Murnau's exquisite, troubling *Tabu* (1931). To preserve his independence, Flaherty left for England, where a whole group of filmmakers applying his principles had begun to produce films, and where he made *Man of Aran* (1934).

In America, the success of Flaherty's first documentary stimulated his contemporaries, Merian C. Cooper and Ernest B. Schoedsack. Their silent documentaries, *Grass: A Nation's Battle for Life* (1925) and *Chang: A Drama of the Wilderness* (1927), were also close and sensitive studies of people whose existence was totally dependent on the earth, the cycles of nature, and their own skills at adapting to them. For *Chang*, shot in the jungles of Siam (now Thailand), Cooper and Schoedsack made up a story; that decision made their film not a true documentary but a narrative film shot on location. But *Grass* was the real thing. To shoot it, they and journalist Marguerite Harrison went to Persia (now Iran), where they joined a tribe of nomads on their incredibly difficult biannual journey across the Zardeh Kuh mountain range to find grass for their animals. After the 46-day trek, they had 80 feet of film left to shoot an ending. With screenwriter Ruth Rose and stop-motion animator Willis O'Brien, Cooper and Schoedsack would later make the most famous and effective mixture of Hollywood fiction, documentary anthropology, and parody of documentary anthropology—*King Kong* (1933).

2.《意志的胜利》和《奥林匹亚》

从苏俄的共产主义理念到美国的罗斯福"新政",纪录片在不同程度上受到意识形态和政府宣传的利用,而这种现象的极端例子则出现在纳粹德国。演员出身的女导演兰妮·里芬斯塔尔（Leni Riefenstahl）受命拍摄纳粹纽伦堡党代会的纪录片《意志的胜利》和柏林奥运会的纪录片《奥林匹亚》,将纪录片的美学、人类的力量和仪式化的视觉美感与法西斯精神理念结合在一起,成为毁誉参半、争论不休的旷世经典。

Nazi Documentary

There were also documentaries made on the right wing of the political spectrum in the 1930s, notably in Nazi Germany. The most famous of these are *Triumph des Willens* (*Triumph of the Will*, 1935) and *Olympia* (1938), both made by Lent Riefenstahl. These have aroused more controversy than perhaps any other

nonfiction films yet made. Can we admire a film's artistry and abhor the ideals it propagates? "*Triumph of the Will* and *Olympia* are undoubtedly superb films (they may be the two greatest documentaries ever made)", Susan Sontag wrote in her essay "Fascinating Fascism", "but they are not really important in the history of cinema as an art form". The statement seems contradictory and requires further exploration.

Riefenstahl was a dancer who began acting in an important popular genre during the Weimar period, films about mountain climbing and the mystique of the high Alps. In 1932 she directed and starred in her own "mountain" film, *Das blaue Licht* (*The Blue Light*). Adolf Hitler is said to have admired the spectacular visual effects she achieved for night scenes with smoke bombs and special filters, and he invited her to make a film of the 1933 Nazi rally in Nuremberg for his private use. This led to the major effort that went into filming the 1934 Nuremberg rally as *Triumph of the Will* and the documentary on the 1936 Olympic Games staged in Berlin. After World War II Riefenstahl was detained and investigated for Nazi activities but ultimately cleared. In later years she wrote that she had tried to get out of making the films, and that in the case of *Olympia*, the Nazi party did not finance it and attempted to prevent its release. Researchers have produced documents refuting these claims.

Triumph of the Will (1935)

The 1934 Nazi party rally was not simply an event that was filmed; rather it was planned and constructed in considerable part for the film that was to be made of it. Later spectators, recalling Hitler as an invincible dictator until his regime was defeated by the Allies in World War II, rarely have knowledge of the historical context (nor is the film much help for non-German speakers, since the original full-length version has never been subtitled in English). On June 30, 1934, Hitler purged Ernst Röhm, leader of the SA (Sturmabteilung, or Storm Troopers, a paramilitary unit of the National Socialist party), and ordered his execution; Röhm had pushed for sweeping social changes after the Nazis seized power, challenging Hitler's efforts to forge alliances with traditional military and conservative elites. Hitler planned the September rally—and the film—as a carefully choreographed pageant to show a nation united behind him, with support from the army and loyal party officials.

Riefenstahl's film was central to this purpose, since it would create a vision of the event—beginning with the famous opening sequence of Hitler's plane descending through the clouds over Nuremberg—that no participant could have experienced. She was provided with a staff of more than one hundred, along with thirty cameras. Special elevators, platforms, ramps, and tracks were constructed for her camera operators at the parade grounds and throughout the city. In the

resources at its disposal, *Triumph of the Will* dwarfed all previous nonfiction films. The results are often awesomely apparent, as in its most frequently reproduced image, the high-angle shot of Hitler, flanked by two associates, walking down a wide path between the enormous massed columns of his followers.

For non-German spectators of the 1930s, what was remarkable about *Triumph of the Will* was its vivid revelation of a new politics mobilizing masses of people for public spectacle. The film's style is dedicated to driving that point home. Much of its last half consists of parade footage, with images of close-drilled units, flags, salutes, and cheering crowds endlessly repeated, and marching music incessantly blaring on the soundtrack. The numbing quality of these sequences seems purposeful, as if to deprive the spectator of mental ability, to force acquiescence in the literally stunning power of the Nazi appeal. Riefenstahl's adherents defend the film's artistry, arguing, as has critic Richard Meran Barsam, that "At times, the spectacle… soars beyond the insidious propaganda".

Olympia (1938)

The Olympic Games documentary was planned differently, for a different purpose. Germany had been awarded the 1936 Games before Hitler seized power; his racist ideology made the Games controversial. Riefenstahl's film aimed primarily to demonstrate that the Berlin Olympics had been a fair and friendly event in which athletes and spectators from many countries happily took part. Hitler and other Nazi leaders were shown only as faces in the crowd, cheering on the competitors.

Assessing *Olympia* is complicated by the fact that the film now exists in multiple versions. Circulating in the United States is a two-part film running three and one-half hours, with a voice-over narration in English. In recounting the men's high jump the English voice says, "America's great Negroes have the field to themselves", one sign, among several, that in this version at least the purpose was to highlight sportsmanship, rather than Nazi Germany's notorious racist ideology.

In shooting and editing, *Olympia* was a more complex project even than *Triumph of the Will*, and the film above all was a great technical achievement. (German commentators pointed out that the 1932 Olympics had been held in Los Angeles, home of the Hollywood industry, but that no comparable effort had been made to film the Games there.) The self-consciously "art" sequences that have been extracted from the film—such as the famous scene of men's diving—make up only a very small part and some were shot in empty stadia after the competition had ended. Otherwise the film consists primarily of reporting on events, with use of slow-motion cinematography the principal innovation.

Triumph of the Will and *Olympia* are important films in the history of cinema—they have had enormous impact both on films of political persuasion

and on sports films. If Sontag is correct in "Fascinating Fascism" that they are not important in the history of cinema "as an art form", it may be because their artistry is compromised by their propaganda goals. To say they are "undoubtedly superb films" is to be fascinated more by Fascism than by film.

3. 英国的格里尔逊和詹宁斯

约翰·格里尔逊（John Grierson）虽然只拍摄过《飘网渔船》一部纪录片，但他却是"纪录片"这一概念的发明者并领导了著名的英国纪录电影运动。格里尔逊关于纪录片应该对真实现实进行创意性处理、并且直接服务于媒介宣传的理念，为全球纪录电影带来过深远的影响。

亨弗莱·詹宁斯（Humphrey Jennings）作为英国纪录电影运动的杰出代表，以《不屈的伦敦》《聆听英国》和《救火英雄》展现英伦三岛人民顽强不屈的精神和勇于牺牲的壮举，极大地鼓舞了英国乃至全球反法西斯阵营的士气，也完美地诠释了格里尔逊纪录电影的理念。

John Grierson and British Documentary

The first signs of documentary's resurgence came not in the totalitarian countries, where film industries were instruments of state policy, but in Britain, where in a somewhat different manner state policy decided to make use of film. The Empire Marketing Board (EMB), a government body responsible for promoting products of Britain, its dominions, and its colonies, began in the 1920s to explore film as a means, as the board's secretary recalled, "for bringing the Empire alive to the imagination of the public". It commissioned a feature-length film "which began gloriously with shots of society ladies impersonating the different Dominions in the Throne Room at Buckingham Palace". The word "gloriously" is used in this context with irony. A new approach was called for.

Seizing the opportunity was John Grierson , after Flaherty and Vertov the most important figure in the development of nonfiction film. Born in Scotland, Grierson had gone to the United States on a fellowship in the 1920s to study public opinion and the media. There he became interested in film as a means of public communication. Grierson, in fact, is credited with coining the term *documentary* when he wrote in a 1926 review of Flaherty's *Moana* that the film possessed "documentary value". Inspired by Flaherty and Soviet filmmaking (Eisenstein

rather than Vertov, whose work was little known outside the Soviet Union), Grierson proposed to the EMB his plans to communicate social actuality to a wide public through cinema, and the British documentary movement was born.

The first step was a pilot project, and Grierson took on the task himself. The resulting film, *Drifters* (1929), was the only work of Grierson's career in which he took primary credit as a filmmaker. Its subject was herring fishing in the North Sea, and though, like Flaherty, it recorded humanity's encounter with the natural world *Drifters* reversed Flaherty's concern with the survival of tradition in the face of modernity. Its focus was on change: "Once an idyll of brown sails and village harbours", said the opening intertitle, herring fishing "is now an epic of steam and steel". This, of course, was in keeping with the EMB's mandate, and the film stressed this modern industry's capacity to market its harvest "to the ends of the earth". Grierson cannily premiered *Drifters* on the same program with the first British screening of Eisenstein's *The Battleship Potemkin*. With the film's success, he was authorized to set up an EMB Film Unit.

Grierson chose to make the Film Unit a training ground for British documentary filmmakers, rather than a site for his own personal creative work. He functioned thereafter, with few exceptions, primarily as a producer. Over one hundred films came out of the Film Unit over the next four years. In 1933, when the EMB was closed, the Film Unit continued its work for the General Post Office (GPO). Fighting resistance from commercial film companies and exhibitors, Grierson fostered nontheatrical screenings, traveling exhibitions, film libraries, and journals. In 1938, after leaving the GPO, he was commissioned by a newly established body, the Film Committee of the Imperial Relations Trust, to evaluate government film endeavors in Britain's dominions. He went first to Canada, and recommended the establishment of a government film-producing unit there; the following year Canada's National Film Board was set up, and Grierson accepted an offer to become its head. His visits to New Zealand and Australia in 1940 led to similar film boards in those countries.

Humphrey Jennings

Humphrey Jennings was born on 19 August 1907 into a family connected with the Arts and Crafts movement. Before his involvement with John Grierson's GPO film unit he had published verse and dabbled in painting and set design, and was undoubtedly regarded by many of his colleagues as the epitome of the middle-class dilettante. Yet this background brought a unique perspective to the documentary movement.

Jennings was one of the organizers of the International Surrealism Exhibition

in 1936 and it is his own interpretation of Surrealism which forms one of the major distinctions of his film-making methods. For Jennings rejected the surrealist dependence upon imagery generated from unconscious processes as too personal and idiosyncratic. His work prefers to focus instead upon an image repertoire that is public, producing a quest for the bizarre in everyday English life through juxtaposition. The other formative influence from the pre-war period was Mass Observation, which Jennings helped found as an attempt to 'make a scientific study of the British Islanders, their habits, customs and social life'.

 These two strands come together admirably in his first great film as a director, *Spare Time* (1939). The title alone seems like a challenge to the dominant philosophy of Griersonian documentary, interested in the working classes only when they can be seen to be working. Jennings's film is about the working classes as producers of culture, in times in between shifts in three areas of Britain associated with the steel, cotton, and coal industries. As the sparse commentary suggests, this is the time "when we can most be ourselves". Jennings takes images of apparently small significance—eating a pie, window shopping, rehearsing amateur dramatics—which are given great resonance by their juxtaposition and by the musical sound-track made by the brass ensembles, the male voice choirs, and the kazoo jazz bands of the participants themselves.

 But it was the war which provided Jennings with an infrastructure of film production sufficiently adaptable for his methods. Jennings became part of the Crown Film Unit making films for the Ministry of Information. Here he was able, usually in collaboration with the editor Stewart McAllister, to continue explorations in montage cinema at the very moment when the imperatives of wartime propaganda dictated that all aspects of British life should work together against a common foe. Jennings's form had found a worthy content.

 His most celebrated film from this period was *Listen to Britain* (1942), which in a mere twenty minutes evokes a day in the life of a nation at war, the sounds and the sights of Britain in the blitz. Throughout the film, images of factory work are juxtaposed with images of dancehall leisure, fighting men with women in machine shops, the popular singers Flanagan and Allen with Dame Myra Hess playing a Mozart concerto. The blitz produces its own images of surreal montage: an office worker walks through rubble carrying his steel helmet; the Old Bailey has become an ambulance station; tanks rumble past the half-timbered tea-room in a postcard English village.

 It was also the war that provided Jennings with the opportunity to make his first dramatic films. *Fires Were Started* (also known as *I Was a Fireman*) (1943) is about an East End unit of the Auxiliary Fire Service at the height of the blitz and employs the real firefighters as performers. Jennings worked without a dialogue script, improvising speech in a film which culminates in an impressively mounted

warehouse fire. Both this film and *The Silent Village* (1944), a restaging of the Lidice massacre in a pit village in south Wales, led Jennings into much closer personal involvement with working people. The war, indeed, was a time in which the hierarchically based, classbound cultural distinctions were temporarily relaxed. The ruins of the present reveal the possibility of a new, more equitable, and democratic society in the post-war world. This vision provides the thematic core to *Diary for Timothy* (1945), in which the diverse experiences of a farmer, a fighter pilot, and a miner are reviewed for an infant born on the eve of peace. The gentle commentary, written by E. M. Forster, poses a series of questions for the future and epitomizes the nation's aspirations.

Unfortunately, these hopes remained unfulfilled for Jennings as well as for the nation. His legacy from this period remains not a film but *Pandaemonium*, a collection of writings documenting the coming of the machine age: a montage of Science and Literature. His life came to a tragic conclusion on 24 September 1950, when he fell from a cliff during a reconnaissance trip to the Greek islands. Though his entire film work amounts to little more than five hours in length, the depth of his concerns and the mastery of his technique led to Lindsay Anderson's view, expressed in 1954, that Jennings was 'the only real poet the British cinema has yet produced'.

4. 美国纪录片和《我们为何而战》

20世纪30年代，美国政府曾以《开荒之犁》和《河流》等纪录片配合罗斯福总统的"新政"，而珍珠港事件之后，一向以爱国著称的好莱坞更是不遗余力地投入反法西斯的宣传战当中。著名导演弗兰克·卡普拉主持拍摄了美国著名的二战宣传纪录片系列《我们为何而战》，全景式地记录各国人民英勇抗击德意日法西斯轴心国艰苦卓绝的历程，再次显示纪录电影无与伦比的舆论导向优势。而威廉·惠勒的《孟菲斯美人号》和约翰·休斯顿的《圣彼得洛之战》也是著名的二战纪录片。

United States Documentaries

Hollywood entertainment films, no matter how patriotically motivated, could not by themselves adequately represent the war on film. The documentary impulse of the 1930s carried over into a desire to record as much as possible of the war itself, and training thousands of military recruits also called for visual

communication. Among the filmmakers who went to work in military documentary were many from Hollywood's creative talent and craft workers, including such major directors as Frank Capra, John Ford, William Wyler, George Stevens, and John Huston.

Why We Fight

The politically most important assignment went to Capra. He was asked to supervise a series of films explaining the background and goals of United States involvement in the war to service personnel, many of whom had scarcely paid attention to world events. This became the *"Why We Fight"* series, seven films that all U.S. Army soldiers were required to see and were also released for theatrical distribution both in the United States and overseas. These are remarkable cinematic documents, in part because they were produced with little bureaucratic supervision. Capra claims in his autobiography that when he asked the chief of staff, General George C. Marshall, what to do if he could not find out what U.S. policy was, the general replied, "In those cases make your own best estimate, and see if they don't agree with you later".

The films, each approximately an hour long, began with *Prelude to War* (1942); this was followed by *The Nazis Strike*, *Divide and Conquer*, *The Battle of Britain*, and *The Battle of Russia* in 1943, *The Battle of China* in 1944, and *War Comes to America* in 1945. Capra took full directorial responsibility only for the inaugural film; Anatol Litvak (1902-1974) and Anthony Veiller (1903-1965) directed the others. Although he expressed awe at *Triumph of the Will* (which he screened after taking his assignment, and from which he took footage), Capra emulated more *The March of Time*. *Prelude to War* was a film of compilation and montage: It linked together actuality footage, acted scenes, trick effects (Japanese troops marching in Washington, D.C.), and animation.

"What made us change our way of living overnight?" asks actor Walter Huston in the voice-over narration, and the seven films set out to answer that question, mostly by depicting the enemy's evil ambitions. The principles for which the United States was fighting were stated largely by symbol and inference: religious freedom; freedom from ideological indoctrination; freedom to be left alone.

The Negro Soldier

After completing the *"Why We Fight"* series, the production team Capra

had assembled went on to produce another half-dozen documentaries, most significantly *The Negro Soldier* (1944), directed by Stuart Heisler. This film was fraught with implications: though the "*Why We Fight*" series did not explicitly proclaim the United States a land of justice and equality, it did condemn the enemy nations for injustice and inequality, particularly on racial grounds. Yet one of the U.S. institutions that remained racially segregated was the Army. Thus the film became in effect, "Why African-Americans Should Fight".

Religious freedom was again a touchstone. The film is framed as a church service, and its narrative thread is a clergyman's sermon. It gives a capsule history of black involvement in American military struggles neglecting to mention the fact of slavery and shows black heroes like the high-jump champions of the 1936 Olympic Games (using footage from *Olympia*). Though it followed conventional compilation documentary style, *The Negro Soldier* could not help but be radical in content. It could not justify racial segregation; it went out of its way to find scenes of blacks and whites together in military settings. This was a case of General Marshall's words coming true: President Harry S Truman integrated the armed forces by executive order after World War II.

The Memphis Belle

William Wyler had been originally assigned as director on *The Negro Soldier* but left the project when he got a chance to make a combat documentary about a B-17 "Flying Fortress" daylight air raid over Germany. The circumstances forced a drastic change in technique, especially for Wyler, notorious in Hollywood as a meticulous director who sometimes shot the same scene dozens of times before he was satisfied. His equipment for the documentary was hand-held 16mm cameras, loaded with color stock (John Ford earlier had shot color combat footage in 1942 for his seventeen-minute film of a decisive naval engagement in the Pacific, *The Battle of Midway*). Wyler and two other cameramen shot the footage, flying on combat missions at 29,000 feet in the unpressurized B-17s, where temperatures fell to 40° below zero Fahrenheit; one of the cameramen was killed in action.

The Memphis Belle (1944) focused on a specific plane whose crew was flying its twenty-fifth and final mission before rotating back to the United States. At forty-two minutes it was long enough to give not only a sense of the broader strategy of the "air front", which sent up one thousand planes with eight thousand men in a daylight bombing mission, but also the intense experience of aerial combat between the bombers and enemy fighter planes. Even after half a century of ever more spectacular visual effects in cinema, *The Memphis Belle* retains a powerful immediacy in its low-key directness. It served as the source for a 1990 British

fiction film, *Memphis Belle*, directed by Michael Caton Jones.

Director John Huston made two of the most important U.S. war documentaries, though one was altered and the other suppressed by military authorities. *The Battle of San Pietro* (1945) was the record of an infantry operation in southern Italy that cost heavy casualties. It has none of the glory or triumph of war, as even *The Memphis Belle* does; instead it shows that war is hellish and men die. The film was at first withheld, then released in a half-hour version, a third shorter than its original length (some of the cut scenes show children's fear as U.S. forces enter their village, and American soldiers giving them candy to make them smile for the camera). Both versions currently circulate.

After the war Huston went to a hospital on Long Island, New York, to make an Army documentary on "the psychoneurotic soldier" men who suffered mental disturbance in the war. The tone of the film, *Let There Be Light* (1946), is basically upbeat, indicating that the men could be helped by psychotherapeutic techniques to resume functioning civilian lives. But its emphasis on the men's reactions to "death and the fear of death" apparently clashed with an official military view that soldiers invariably come home stronger for their war experience; this, at least, was Huston's view as to why the War Department refused to release the film. After being withheld for more than three decades, *Let there Be Light* was made available in the late 1970s.

第五节　东方电影的出现

1. 日本经典时期：沟口健二和小津安二郎

日本传统的歌舞伎（kabuki）在一定程度上阻碍了早期日本电影的发展，却极大地影响了格里菲斯、爱森斯坦（特别是他的蒙太奇理论）、路易·费拉德（Louis Feuillade，法国电影先驱）和茂瑙等人的电影艺术观念。由于早期日本电影大量改编自歌舞伎，歌舞伎的女角（onnagata）造型和无声电影的弁士（benshi）旁白也赋予日本电影鲜明的民族特色。

早期的日本电影分为古装片（jidai-geki，如武士片、浪漫爱情片和鬼片）和时装片（gendai-geki，如世俗喜剧片、儿童片和当代黑帮片）两大类，而经典时期最具代表性的两位日本电影大师则是执导过《西鹤一代女》《雨月物语》的沟口健二（Kenji Mizoguchi）和执导过《东京物语》《秋刀鱼之味》的小津安二郎（Yasujiro Ozu）。

Japan: The Early Years

The Japanese cinema, like most other aspects of Japanese culture, evolved in nearly total isolation from the West until the end of World War II. The Edison Kinetograph was introduced into Japan as early as 1896, and movies almost immediately became a popular cultural form. But Japanese cinema went through a much longer "primitive" period than the cinemas of the West (roughly 1896-1926)

沟口健二和他的《雨月物语》

小津安二郎的"榻榻米视点"

because of the persistence of an older, more venerable cultural form: the *kabuki* theater. Ironically, it was *kabuki* that had stimulated Eisenstein in elaborating his radically innovative theory of montage.

Kabuki is a highly stylized and somewhat overwrought dramatic form deriving from the feudal Tokugawa period (1603-1867), and because of its perennial popularity in Japan, the earliest Japanese fiction films were versions of famous *kabuki* plays (there exist some 350 of them). As Japanese cinema grew into a large-scale domestic industry in the first two decades of this century, the stylized conventions of *kabuki* became the mainstream conventions of Japanese narrative film. This prohibited the kind of formal experimentation then going on in the West in the work of Griffith, Eisenstein, Feuillade, and Murnau, but allowed Japanese cinema to develop along its own path.

Two conventions of kabuki are especially unusual relative to Western films. First, all female roles until well into the twenties were played by professional female impersonators known as *onnagata or oyama*, which worked against even the simplest sort of photographic realism. Second, and much more formative in the development of Japanese cinema, was the convention of the *benshi*—an actor who stands at the side of the stage (or screen, in the case of films) and narrates the action for the audience. In the earliest Japanese films, the *benshi* provided both voices for the characters and commentary on the action. After 1912, the benshi concentrated exclusively on dialogue in response to an influx of foreign films using intertitles, a practice quickly imitated by domestic producers. By 1920, however, the benshi had returned to the practice of mixing description/commentary with spoken dialogue—sometimes read from intertitles, sometimes interpolated from the action itself. As Donald *Kirihara* has pointed out, the effect on film form was immense: "[T]he presence of the benshi was a fact that filmmakers could assume during production, allowing them to make films with ambiguous spatial and temporal transitions or undermotivated plots with the knowledge that the *benshi* would be present to provide whatever narrative coherence was lacking".

In short, the presence of a human, *verbal* narrator permitted Japanese *cinematic* narrative to remain relatively diffuse. In 1923 an earthquake leveled the cities of Tokyo and Yokohama, including the physical facilities of the entire Japanese film industry. After the quake, the industry, like much of Japan itself, had to be rebuilt from scratch, and one result was a turning away from the past and an increased receptivity to modern ideas, especially those from the West. The *oyama* rapidly disappeared, and Japanese films adopted nonnative styles, such as the newly discovered Western modes of naturalism (in Minoru Murata's *The Street Juggler* [*Machi no tejinashi*, 1924]) and Expressionism (in Teinosuke Kinugasa's *A Page of Madness* [*Kurutta ippeiji*, 1926] and *Crossways* [*Jujiro*, 1928]). The *benshi*, however, many of whom had become stars in their own right, would

remain a potent force in Japanese cinema until well after the introduction of sound. In 1927, there were 6,818 *benshi*, including only 180 women, who were licensed to practice throughout the Japanese Empire. Though their stranglehold on the industry was eventually broken by reorganization, there were still 1,295 of them—mostly unemployed—in 1940. Nevertheless, the coming of sound insured that directors could finally become the major creative force in Japanese film, as they already were in most countries of the West.

By 1925 the *kabuki*-oriented cinema had been replaced by a new director's cinema consciously divided into two large genres, or types, that persist to this day: the *jidai-geki*, or period film set before 1868 (the year marking the beginning of the Meiji Restoration and the abolition of feudal Japan), and the *gendai-geki*, or film of contemporary life. Both genres are obviously very broad, and each has come to contain a large number of subtypes. Currently, for example, the *jidai-geki* encompasses the *chanbara*, or sword-fight film, which focuses on the figure of the masterless *samurai* ("warrior"), or *ronin*; the historical romance; and the ghost film. The *gendai-geki* includes such disparate types as the lower-middle-class comedy-drama (*shomin-geki*); the "children's film", in which the inanities and corruptions of the adult world are satirized by presenting them from a child's point of view; and the *yakuza-eiga*, or modern gangster film. The years 1926 to 1932 saw the appearance of the first major works of Japanese cinema in the beautiful period films of Teinosuke Kinugasa (1896-1982) and Kenji Mizoguchi, and in the *shomin-geki* of Yasujiro Shimazu (1897-1945), Heinosuke Gosho (1902-1981), Mikio Naruse (1905-1969), and—above all—Yasujiro Ozu. In careers that extended well into the postwar period, both Mizoguchi and Ozu became masters of the classical Japanese film (which followed the primitive period, from roughly 1926 until the fifties); the third master was Akira Kurosawa, whose career did not begin until the middle years of World War II, or the "Pacific War", as it is known to the Japanese.

Kenji Mizoguchi

Kenji Mizoguchi became internationally famous only in the last years of his life. Outside his native Japan his reputation still rests almost entirely on his films of the 1950s—mainly on the lyrical dramas with medieval settings such as *Ugetsu monogatari* (1953), *Sansho dayu* ("Sansho the bailiff", 1954), or *Shin-heike monogatari* ("New tales of the Taira clan", 1955), but also (to a lesser extent) on sensationalist modern dramas such as his very last film *Street of Shame* (*Akasen chitai*, 1956). But his career stretches back as far as 1920, when he first entered the Nikkatsu Mukojima studio as an assistant to New School (Shinpa) directors such

as Eizo Tanaka, and it is to his roots in the New School of the 1920s that one must look for an understanding of his art.

New School films were melodramas in the western sense. Derived from the urban drama that emerged in the Meiji period (particularly in the 1890s), they used male actors (*oyama*) to play female roles, and their stories typically focus on the sacrifice of women for the sake of the family. Mizoguchi began to direct his own New School dramas, employing *oyama*, at Mukojima in 1923, and the formula at the heart of the genre was to form the basis of his art throughout his career.

During his early years, Mizoguchi worked in a wide variety of genres and styles. Outside the New School melodrama, he made detective films, expressionist films, war films, comedies, ghost stories, and proletarian films. During this period he also borrowed boldly from the expressive repertoire of American and European art cinema. In the scenario of *Nihonbashi* (1929), for example, he specifically called for a scene to be directed like a scene from Murnau's *Sunrise* (1927). Using the formula of the New School as a foundation, he practised a variety of expressive techniques, which changed from film to film with each new-found enthusiasm. Throughout this early period he was a director with a multitude of faces, who cannot be easily grasped under the western notion of an *auteur*. It was with *Kaminingyo haru no sasayaki* ("*A paper doll's whisper of spring*", 1926), from a script by Eizo Tanaka, that he first revealed his own accomplished Japanese style, inheriting the spirit of Tanaka's own masterpiece *Kyoya erimise* ("*Kyoya, the collar shop*", 1922). But he also made a number of mediocre films, both then and later; even in the post-war period he continued to work outside his favoured mode (as in the American-influenced *Wara koi wa moenu*—"*My love has been burning*", 1949), with somewhat uneven results.

In spite of this diversity of output, his concern for persecuted women inherent in the New School tradition is consistent to the end. This is particularly evident in the trilogy of films adapted from the novels of Kyoka Izumi: *Nihonbashi*, *Taki no shiraito* ("*The water magician*", 1933) and *Orizuru Osen* ("*The downfall of Osen*", 1935). But the influence of New School schemas can also be seen in his 'tendency' films (realist, political dramas), such as *Tokai kokyogaku* ("*Metropolitan symphony*", 1929) or *Shikamo karera wa yuku* ("*And yet they go on*", 1931). Involvement in the tendency film seems to have changed Mizoguchi's attitude towards women. In New School films, women end up destroyed victims of male society. But in Mizoguchi's work from the 1930s onwards the women characters are vital enough to fight for their own survival against the social system, as in *Naniwa erejii* ("*Osaka elegy*", 1936). His later films are often centred on women who are resilient and even powerful.

In the early period Mizoguchi absorbed many stylistic influences from foreign cinema, beginning with the expressionist *Chi to fei* ("*Body and soul*", 1923). In the

late 20s he experimented with bold devices like rapidly changing scenes, frequent dissolves, and (in the trilogy of Izumi adaptations) a unique use of flashback. These traits are the opposite of what was to become his mature style, characterized by long takes and unobtrusive direction, as it emerges in *Zangiku monogatari* (*The Story of the Last Chrysanthemums*, 1939) and *Genroku chusingura* (*The Loyal Forty-seven Ronin*, 1941).

If one sees the New School film form as at the heart of Mizoguchi's work, his most *fanmus* post-war films can be more richly interpreted. The suffering women of *Ugetsu monogatari* and *Sansho dayu*, and the vital women of *The Life of Oharu* (*Saikaku ichidai onna*, 1952) and *Music of Gion* (*Gion bayashi*, 1953), may seem different, but they share the same roots. The static and yet lyrical images in his post-war works were only created after passing through the diverse film forms of the foreign avantgarde and the New School films of the Mukojima studio.

Yasujiro Ozu

At first an assistant Cameraman, Yasujiro Ozu began directing for Shochiku Films, one of Japan's largest studios, in 1927. When he died in 1963 at age 60, he had made fifty-three films, nearly all for Shochiku. By common consent, he had become Japan's greatest director. During the late 1920s, Japanese cinema was in the process of "modernizing", Studio heads had built a vertically integrated oligopoly comparable in many ways to America's. Directors adapted many stylistic and narrative conventions of Hollywood cinema in an effort to compete with the slick, smooth films that attracted Japanese audiences.

The young Ozu flourished in this milieu. Confessing himself bored by most Japanese films, he absorbed the lessons of Chaplin, Lloyd, and Lubitsch in order to create comedies that combined physical humour with social observation (*I Was Born, but...*, 1932). He made films about college life, street thugs (*Dragnet Girl*, 1933), and domestic tensions (*Woman of Tokyo*, 1933). In all of them he displayed a mastery of close-ups, editing, and shot design. His distinctive style was based on placing the camera at a low height and intricately intercutting objects with facial reactions. Ozu also displayed a quirky humour which could create *nansensu* ("nonsense") gags around the circulation of a pair of mittens (*Days of Youth*, 1929) or an empty coin purse (*Passing Fancy*, 1933). He could also turn modern Tokyo into a landscape of mysterious poignancy. A shot may dwell on a scrap of paper fluttering down from an office building, a secretary's compact on a window sill, an empty sidewalk. All of these tendencies came to focus in his first talking film, *The Only Son* (1936), about a country woman who comes to Tokyo and finds that her son has failed to make a career. By this time Ozu was already considered one of

Japan's top directors.

His output slowed during the war period as a result of military service, but he did make such "home-front" films as *Brothers and Sisters of the Toda Family* (1941) and *There Was a Father* (1942). His first post-war film was a "neighbourhood" movie reminiscent of his 1930s work, *Diary of a Tenement Gentleman* (1947), but his most famous films would be elaborations of *Brothers and Sisters*—patient studies of an extended family undergoing a quiet crisis that brings out contrasts across generations.

The most famous of these extended-family films is *Tokyo Story* (1953). Like the mother in *The Only Son*, an elderly couple journey to Tokyo. Their children, preoccupied with their jobs and families, treat them coldly; only their daughter-in-law Noriko, widow of their son lost in war, shows them affection. On the trip back, the grandmother falls ill; she dies at home. The grandfather gives Noriko his wife's watch and resigns himself to a life alone. This bare anecdote becomes, in Ozu's hands, an incomparable revelation of the varied ways in which humans express love, devotion, and responsibility.

A child grows up and leaves the family; friends must separate; a son or daughter must marry; a widow or widower is left alone; an aged parent dies. In film after film, Ozu and his script-writer Noda played a set of variations on these elemental motifs. Each film, however, reworks the material in fresh ways. *Late Spring* (1949) is a largely sombre study of the necessity for father and daughter to part; Ozu's last film, *An Autumn Afternoon* (1962), integrates the theme with a satire on consumerism and a nostalgia for pre-war values. *Early Summer* (1951) also centres on the daughter marrying, but here the action is embedded in a network of domestic comedy and lyrical evocation of suburban life. *Ohayo* (1959), in some ways a remake of the children's comedy *I Was Born, but...*, treats domestic conflict in a more vulgar key, giving us a boys' farting contest which Ozu and Noda compare to the aimless pleasantries of adult conversation.

Throughout these works, Ozu's style remained crisp, rigorous, and capable of great modulation of emphasis. His static shot/reverse-shots, often frontally positioned, match characters within the frame across the cut, so that the screen becomes a field of minutely changing masses and contours. His camera movements, often virtuosic in the 1930s work, are eliminated completely in the colour films—a decision which only throws into relief the vibrant hues of tiny props arranged carefully in the sets. Above all, his famous low camera height remains obstinately there, as if he aimed to show that across nearly forty years a single, simple stylistic choice could yield infinite gradations of composition and depth. The subtleties which Ozu found in apparently simple technique have their counterpart in the emotional richness of dramas which seem as close to everyday life as any the cinema has given us.

2. 20 世纪 30—40 年代中国电影

　　1905 年北京的丰泰照相馆拍摄了中国第一部电影《定军山》，初创期的《黑籍冤魂》（1916）和《劳工之爱情》（1922）体现了中国电影反对外来压迫和追求世俗幸福的两大主题。随着五四新文化运动的深入发展，对中国电影产生深远影响的明星公司（1922 年）和联华公司（1930 年）相继在上海成立，中国电影迎来了第一个黄金时代（1932—1937），代表作品有《神女》（吴永刚）、《渔光曲》（蔡楚生）、《大路》（孙瑜）、《马路天使》（袁牧之）和《联华交响曲》（八位导演执导的短片集锦）等。

　　日本的入侵沉重地打击了中国的电影产业，但在抗战胜利后国共内战的乱世之中，中国电影仍然以《一江春水向东流》（蔡楚生、郑君里）、《八千里路云和月》（史东山）、《小城之春》（费穆）、《万家灯火》（沈浮）和《乌鸦与麻雀》（郑君里）等影片创造出自己的第二个黄金时代（1946—1949）。

China Before 1949

　　Chinese cinema before the establishment of the People's Republic in 1949 was not only pre-revolutionary but also post-colonial. Primary source histories, written with the constraints of either Chinese Communist Party or Kuomintang Nationalist orthodoxy, and later works derived from them, have stressed the former and downplayed the latter. Yet it was precisely this paradox that animated the celebrated canon of resistant films from the two "golden ages" of the 1930s and 1940s, which are claimed as heritage by both the mainland and Taiwan-based governments.

　　Shanghai was the Chinese cinema capital throughout this period. The first film screening in China occurred there on 11 August 1896 as an "act" on a variety show bill. A great cosmopolitan entrepôt at the mouth of the Yangtze, Shanghai's growth and development was entirely the outcome of China's reluctant encounter with the west and the "modern". It was at once on the outermost margins of east and west, and also the central nexus of exchange between them; the point where they met, clashed, intermingled, hybridized, and, above all else, traded.

　　From Shanghai, the foreign cameramen-showmen fanned out along the trade tributaries, bringing the cinema to the other major littoral cities and the imperial capital, Beijing, in 1902. Right up until 1949, the cinema flourished where foreign penetration was most complete, and foreign films and foreign distribution and exhibition networks dominated the industry. Initially, the Japanese (in Manchuria) and the Germans showed greater skill in penetrating the interior, but by the 1930s

《小城之春》

90 per cent of product shown was foreign and 90 per cent of that American.

This utterly foreign pedigree positioned cinema as an exotic, rather expensive form of entertainment. Within the exhibition hierarchy, foreigners and cosmopolitan Chinese paid the most to see the latest foreign films and less well-off Chinese paid less to see older releases. It was in this lower echelon of marginal profitability that local production inserted itself in the 1910s and 1920s and planted the seeds for the remarkable hybrid that was to develop soon afterwards.

The Fengtai Photography Shop in Beijing became the unlikely home of China's first films, when its owners started to record local opera in 1905. However, they soon realized greater opportunity lay in Shanghai and moved there in 1909. Most Shanghai production companies in this initial period were joint ventures with foreigners, and it was only in 1916 that the Hui Xi Company became the first wholly Chinese concern.

Hui Xi's first effort, *Wronged Ghosts in an Opium Den*, does not survive, but the film was a notable success, still playing seven years later. An examination of its plot and the earliest surviving film, *Romance of a Fruit Pedlar* (1922), indicates affinity between the cinema and the "mandarin duck and butterfly" vernacular literature that also boomed in the cities at this time. These melodramatic and

《劳工爱情》

sentimental tales dramatized the disjunctures and contradictions of life in the modern, westernized city. If they were tragedies, decline and misfortune were inexorable, but if they were comedies, the wondrous device of coincidence would intervene. The scion of a rich Confucian family would fall in love with a poor mill girl, incurring the wrath of his parents, but then a long-lost relative would die, bequeathing her a fortune.

In the case of *Wronged Ghosts*, a family is ruined by the quintessential symbol of western imperialism in China: opium. *Romance of a Fruit Pedlar* is a gentler comedy, presenting the efforts of a greengrocer to woo a doctor's daughter in the rough and tumble of an urban streetscape full of conmen and gambling dens. The film mimics Hollywood silent comedy with much mugging for the camera and slapstick tumbling, but in its very mimicry asserts agency and represents scenes and events recognizable to its audience as their own.

Romance of a Fruit Pedlar was made by the Mingxing Company, which was to become one of the major production houses in Shanghai. However, the fate of Hui Xi was more typical of the chaotic and difficult economic conditions endured by early Chinese film-makers. While its first film was still playing seven years later, the company itself was long gone. It distinguished itself only by its ability to produce a film before going bankrupt, whereas many other film companies folded before shooting anything. Of the 120 companies established in 1921, only twelve were still operating a year later.

The incredible plots and sentimentality of the films of the 1920s have since been much disparaged by historians as vulgar indulgences that did little to encourage either nationalism or revolution or elevate audiences' tastes. The

beginnings of the nationalistic May Fourth Movement in 1919 had seen the appearance of new approved literary works, and from this perspective, the cinema seemed backward. This dismissal of pre-1930s cinema manifests the established Confucian preference for art as education and dislike of popular culture that integrated well with the "modern" projects of both the Kuomintang nationalists and the Communists. They preferred the "progressive" or "left-wing" films that began to emerge in the 1930s.

However, holding up these leftist films in contrast to earlier productions erects a false barrier between them. Although the earlier films may not have directly encouraged political engagement, they did give agency to Chinese film-makers and represent recognizable contemporary conditions to Chinese audiences. The leftist films did not replace populist entertainments, but supplemented them, although this is often forgotten because the entertainment films have been written out of retrospectives of the period. Finally, the leftist films themselves shared more in common with pure entertainment films than is usually acknowledged, and they demonstrate that agitation and popular culture can be one and the same thing.

The impetus for the leftist cinema lay in the Japanese invasion of China. Beginning with the seizure of Manchuria in 1931, within a year the Japanese had bombed Shanghai and come near to taking the city. These events stimulated nationalism amongst audiences and film-makers alike. The Communist Party's front organization, the League of Left-Wing Writers, set up a film group in 1932, and this body infiltrated two of the best-established studios of the period, the Mingxing and the Lianhua. The Kuomintang government's appeasement policy limited direct expression of anti-Japanese sentiment. However, the leftist film-makers were aided in their efforts by the progressive political sentiments of at least some of the studio owners, and their coincident realization that the mood of the times made such productions profitable.

One of the earliest results of the leftist infiltration of the industry was Mingxing's adaptation of a Mao Dun short story, *Spring Silkworms*, released in 1933. The plot shows the inexorable destruction of a silk-farming family by fluctuations in international market prices and other machinations completely beyond their control. An almost documentary detailing of the back-breaking labour entailed in silk production makes the final tragedy all the more moving.

Sun Yu's *Big Road* (also known as *The Highway*), which came out at the beginning of 1935, is an excellent example of the merger of the pre-revolutionary and the post-colonial in one film. The plot involves a group of six unemployed workers who decide to join a road-gang building a strategic highway for the army. Censorship reasons made it impossible directly to name the Japanese as the enemy being fought, but the reference could hardly have been lost on any contemporary viewer. To this patriotism, the film adds class politics, with the inclusion of an evil

landlord who sells out to the Japanese. What makes this film effective, however, is its adoption and deployment of the very vulgar entertainment elements so disliked by later critics. Two of the workers form a comedic pairing that is at once modelled on Laurel and Hardy and the cross-talk, stand-up comedy teams of Chinese variety shows. The film has sound effects and music but no dialogue. In scenes where the pair indulge in slapstick, percussion enlivens their performance, and in another scene where the landlord's agent gets whirled around on one of the workmen's shoulders, a little animated aeroplane and dizziness stars buzz around his head. The workmen also encounter two women, one of whom sings for them in the little roadside restaurant they repair to when the day's work is done. Perched on a table, and given the soft-focus treatment employed for the alluring starlets of the period, she attracts the men's attention, but the song she sings is of the woes of China, beset by flood, famine, and war. Their desiring gaze upon her is not answered by shots of her, but by documentary footage of tanks, explosions, and refugees.

Other leftist films of the period also deployed comedy, song, and other elements of populist entertainment to similar ends. Notable titles include *The Goddess*, *Plunder of Peach and Plum*, *Crossroads*, *Street Angel*, *Little Toys*, *A Bible for Women*, *March of Youth*, *The Lianhua Symphony*, *Song of the Fishermen*, and many others. Made in 1937 just before the outbreak of full-scale war with Japan which brought this brief period of remarkable production to a close, *Street Angel* even adds references to Eisenstein to its post-colonial pastiche.

In the face of the Japanese take-over of all of Shanghai except for the foreign concessions, the Chinese film industry and its personnel fragmented. Some remained on the "orphan island" of the concessions until they too were taken over in 1941. Others fled to Hong Kong, adding Mandarin-language film-making to the established Cantonese industry, until the Japanese take-over in late 1941 brought film production to an end there too. Still others fled with the Kuomintang into the interior, first to Wuhan and then further inland to Chongqing. Shortages of film stock in the war diverted most of them into other activities, such as the patriotic drama troupes that toured during the war years.

Other more leftist artists made an effort to join the Communist Party in its wartime base at Yen'an in Shaanxi province. Among them was the ex-starlet Lan Ping, soon to enjoy a come-back as Mao's third wife, Jiang Qing. Also among them were the director Yuan Muzhi and his actress wife Chen Bo'er, who became Communist China's first Film Bureau head and Minister of Culture respectively in 1949. Film production only commenced at Yen'an in 1939 when Joris Ivens brought the gift of a camera, but even then, shortages of film stock limited production to a small number of documentaries.

While free Chinese film-making came to a halt during the war, a thriving local industry continued under the Japanese occupation. For whatever reasons, the

Japanese had encouraged local film production from their invasion of Manchuria, and after 1937 they added a Shanghai-based industry to their propaganda machine. Unsurprisingly, Chinese historians have preferred to draw a veil over this period, but recent studies indicate that the Japanese in Shanghai ruled the film industry with less brutality than they used elsewhere, and that films with patriotic subtexts, such as the 1939 *Huang Mulan Joins the Army*, based on a traditional legend, still got through the Japanese censors.

The Mingxing Company had collapsed with the coming of the Japanese, but the Lianhua Company re-established itself in Shanghai at the end of the war and once again became the base for the activities of leftist and progressive filmmakers. The films of this period document the corruption and spiralling inflation that characterized the period of the civil war with the Communists that broke out immediately. Proclaimed as "social realist" films as opposed to the Socialist Realism that soon took over with the establishment of the People's Republic in 1949, the productions of these three short years are considered the second "golden age" of Chinese film production.

Where the films of the first "golden age" were exuberantly disjunctive and hybrid mixes of entertainment and exhortation, the films of the later 1940s were smoother melodramas with more seamless plots and unity of tone. Perhaps the best-known example is *A Spring River Flows East*, a two-part epic, made by Lianhua in association with the Kunlun studio, and released in 1947 and 1948. Known as China's *Gone with the Wind*, the film can still provoke floods of tears from older Chinese audiences when shown today. The film opens with an ideal couple and their son. However, they are separated by the war when the husband retreats with the Kuomintang to the interior. There he is gradually corrupted and becomes the lover of a rich society woman. His faithful wife suffers through the war in Shanghai, waiting patiently for his return, but he comes back as a Kuomintang carpet-bagger, and the film climaxes when his wife discovers that he is the husband of the woman for whom she is working as a maid. He disowns her and she drowns herself in the Yangtze.

Disillusion with the Kuomintang and their hangers-on is even more pronounced in the films that depict post-war conditions. Films like *Myriads of Lights*, *Crows and Sparrows*, and *San Mao* (adapted from a newspaper cartoon about an orphan) were all enjoyable and humorous, but none attempted to hide the appalling social contradictions of these years and the resentment those who had suffered in Shanghai felt towards their compatriots who had managed to profit from the war. Stylistically, these films featured more subtle ensemble playing from actors seasoned by many years of stage work. Although less obviously pastiched than the films of the 1930s, they too represent post-colonial appropriation for pre-revolutionary ends, but this time drawing on the western spoken stage drama and

《黄土地》

its cinematic equivalents, rather than popular culture.

The second "golden age" ended China's pre-1949 cinematic history on a fitting high note. In retrospect, it is remarkable that five years of film-making in the 1930s (1932-1937) and three years in the 1940s (1946-1949) should stand out so strongly in a total film-making history of forty years (1909-1949). However, it would be wrong to suggest that these two "golden ages" appeared out of the blue. Rather, they represented windows of opportunity when talent that had been long developing was able to make itself visible. Some would argue that such an opportunity was not to present itself again for another forty-five years, until *One and Eight* and *Yellow Earth* (both 1984) heralded the arrival of another golden age of Chinese cinema.

第三章

转型时期

1945—1967

第一节　意大利新现实主义电影

意大利电影在 1914 年崛起，笃信电影影响力的独裁者墨索里尼分别在 1935 年和 1937 年先后建立意大利国立电影学院"罗马电影实验中心"（Centro Sperimentale di Cinematografia，培养过安东尼奥尼和桑提斯等）和大型制片厂"罗马电影城"（Cinecittà，后摄制过《甜蜜的生活》和《宾虚》等名片），但意大利有声电影基本上只剩下法西斯宣传片和逃避现实的"白色电话片"（庸俗喜剧片、古装大片和浪漫歌舞片）。而第二次世界大战的胜利和意大利的解放，彻底改变了意大利电影的面貌。

意大利新现实主义（neorealism）是 20 世纪 40、50 年代产生于意大利的电影艺术革命运动，与战后满目疮痍的社会现实和悲观沮丧的精神状态相契合。以《罗马，不设防的城市》《偷自行车的人》和《大地在波动》为代表的新现实主义影片关注普通人日常生活问题、强调自然光源的实景拍摄、启用非职业演员、倡导片断性叙事传达生活状态并弱化镜头和剪辑的技巧，用以实现最大限度再现现实生活、发掘生存内涵的目标。新现实主义的理论和实践受到以巴赞为代表的写实主义美学热烈赞扬，并对其后的法国"新浪潮"和世界电影产生重大影响。

Neorealism

An Italian film movement that was primarily a response to the artistic limitations of the Italian film industry under the fascist government and to the

social conditions of Italy during and immediately after the Second World War. Visconti's *Ossessione* (1942), based on James M. Cain's *The Postman Always Rings Twice*, is generally thought to foreshadow the neorealist film, with its realistic rural landscape and social environment, though the film was only released in a butchered version by censors during the war years and later had limited distribution because of its copyright infringement. Antonio Pietrangeli, who wrote the script for *Ossessione*, first used the term"neorealism"when discussing the film in a 1943 issue of the Italian journal Cinema. The movement, though, actually began with Roberto Rossellini's 1945 film, *Open City*, filming for which took place shortly after the Germans left Rome. Rossellini's film established all the elements that were to be central to the movement: realistic, authentic settings; ordinary people played by both professional and nonprofessional performers; everyday social problems; episodic plots which convey the rhythm of every day life; and unobtrusive camera and editing techniques. Rossellini's realism was aided by the film stock he had to use, which gave his images a grainy, unembellished, and documentary quality. To get on film the immediacy of actual locations, Rossellini had to forego the synchronic recording of sound and resort to postdubbing, a practice that became permanent in the Italian film industry. *Open City* was a great international success and was followed in 1946 by Rossellini's *Paisan*, which presented six episodes concerning the Allied forces' advance in Italy, and the less successful *Germany, Year Zero* (1947), the story of a nazified and corrupt Berlin youth.

In 1946, the first of Vittorio De Sica's three neorealist masterpieces appeared, *Shoeshine*, which told in uncompromising terms the tragic story of two impoverished boys in postwar Italy. *Shoeshine* won an Academy Award in this country as the best foreign film of the year and was followed in 1948 by *The Bicycle Thief*, a moving and beautiful film that tells, with authentic realism, the story of a poor man's struggle for survival in the harsh postwar years of Italy by focusing on both the theft of his bicycle, necessary for his work, and his moving relationship with his son. De Sica released what is considered the last of these neorealist films, *Umberto D*, in 1952, which relates in episodic fashion the plights of an impoverished old man and movingly dramatizes his tender affection for his dog. For all three films, as well as for *Miracle in Milan*, a neorealistic film with a strong comic vein that was released in 1951, De Sica's screenplays were written by Cesare Zavattini, a leading spokesman for the neorealist movement.

Two other significant films that belong to this group, both released in 1948, are Visconti's impressive *The Earth Trembles*, which relates the downfall of a family of Sicilian fishing people in a somewhat more dramatic fashion than the films already mentioned; and Giuseppi De Santis's *Bitter Rice* (1949), a film about female workers in the rice fields of Italy with a distracting erotic emphasis on Silvano Mangano. The neorealist movement ended in the early 1950s because of

improving social conditions, the government's crackdown on unpatriotic films, the financial difficulties of these films (most of them were not successful in Italy and their novelty was rapidly dissipating in foreign markets), and their directors' desire to move on to other types of film. But neorealism was to have an influence on future films: in Italy, on the works of Ermanno Olmi directly and on works by Antonioni, Fellini, Pasolini, and Petri to a lesser degree; in the United States, in a general manner, on film-noir works; and in India specifically on Satyajit Ray's *Apu trilogy* (1955-57) and other films.

1. 罗西里尼和《罗马，不设防的城市》

罗贝托·罗西里尼（Roberto Rossellini）执导的《罗马，不设防的城市》因真实描写"二战"结束前夕罗马的战乱惨状，塑造出左派游击队、天主教教士和普通民众等生动人物形象，成为新现实主义电影的开山之作。其后，罗西里尼还拍摄过《游击队》和《德意志零年》等新现实主义佳作，并与好莱坞女星英格丽·褒曼合作《火山边缘之恋》而闹出婚恋丑闻。

Roberto Rossellini

Even as the Nazis were evacuating Rome, Roberto Rossellini began to work on *Open City* (*Roma, città aperta*, 1945). An "open city" is one that is immune from attack because it has been declared demilitarized, as Rome was. Rossellini made the film under the most difficult conditions, closely resembling the early production problems of the Soviets: Raw film stock was scarce, money for constructing sets was even scarcer, actors were difficult to find, slickness and polish were impossible without the controlled lighting of studio filming. Rossellini turned defects into virtues. He willingly sacrificed polish for authenticity, sets for real locations, fiction for life. Rossellini often preferred laborers and peasants to actors (a parallel with Eisenstein and Pudovkin). He and cinematographer Ubaldo Arata carried their camera all over and fleetingly shot the real city on the run.

Open City (written by Sergio Amidei, Rossellini, and Fellini) contrasts the humane, committed, unified struggle of the Italian people for freedom—the unity of priests, workers, intellectuals, adults, children—with the brutality of the Nazi invaders, who used the most loathsome methods (torture, bribery, addiction) to enslave the weakest Italians or to force them to betray their fellows. The two

《罗马，不设防的城市》

styles of the film—the natural, open, realistic, crisply lit texture of the scenes with the Resistance figures and the cramped, artificial, shadowy texture of the scenes with the Nazis—support the film's thematic contrast.

At the end of the film a single member of the Resistance, a committed priest (Don Pietro, played by Aldo Fabrizi), is executed by the Nazi oppressors for his service to the people. This priest is a notable political exception (the Italian. clergy generally supported Mussolini's Fascist government), and his alliance with the Resistance is also an alliance with the Communists who led it. As the partisan priest dies, Rossellini's camera captures the activities of the children of Rome and a far shot of the city itself, for from the death of this one man will come a solidarity that was to be the hope of the new Rome. *Open City* became the unofficial cornerstone of a new movement in Italian cinema—Neorealism, a "new realism" characterized by the use of nonprofessional actors and realistic dialogue, an emphasis on the everyday struggles of common people and the unvarnished look of nonstudio reality, and the determination to present the characters in relation to their real social enviromnents and political and economic conditions.

Rossellini's next film, *Paisan* (1946), further defined his commitments. A collection of separate vignettes, each of the film's slx sequences moves progressively north with the Allied invasion and Nazi retreat. Despite its documentary structure, mirroring the movement of the campaign, Rossellini concentrates on the human texture within each of the vignettes—some lighter and some more brutal, some dominated by the imagery of battle-scarred cities

and some by the apparent placidity of the countryside. As is usual for Rossellini, he neither makes simple judgments nor takes simple positions, he is neither for nor against the insensitivities of the invading liberators and neither for nor against the Italians, themselves terribly divided by the struggle. Rossellini's camera, managed by Otello Martelli, records the luminous countryside in which the struggle takes place, seemingly unaffected by the brutal battle within it. The counterpoint between human action and the landscape that contains it would remain Rossellim's dominant visual technique and personal theme.

Rossellini completed this "War Trilogy" with *Germany Year Zero* (1947), in which he examined the rubble, hunger, and unemployment of postwar Berlin. Edmund (played by Edmund Meschke), a resourceful 12-year-old, is the sole support of his family, struggling to survive in the bombed-out city where civilization is as ruined as the buildings. By the end of the film, the boy has killed himself by jumping off a gutted building, an emblem of the world that looks as if it could never be reconstructed and whose children are at a dead end. This bleak and scrupulously realistic tale, shot on location in Berlin in 1947, is related in an objective tone, but it reveals in the opening voice-over its compassionate hope that German children will "relearn to love life".

Rossellini then tracked inward from cross-sectional surveys of an entire society to close studies of personal moralities and internal sensations. The best of these studies—*Stromboli* (1949) and *Viaggio in Italia* (*Voyage to Italy*, 1953)—featured Ingrid Bergman, the great star who defied Hollywood propriety and world opinion by abandoning her husband to remain with Rossellini in Italy.

Rossellini's ability to render the moral, emotional, architectural, philosophical, and poetic power of sights and systems would make him a major influence on a new generation of directors in both Italy and France.

2. 德·西卡与柴伐蒂尼和《偷自行车的人》

演员出身的维托里奥·德·西卡（Vittorio De Sica）以其作品《擦鞋童》《偷自行车的人》《米兰奇迹》和《风烛泪》成为新现实主义电影的中流砥柱，《偷自行车的人》更以对贫困现实的精确描写和对父子关系的细腻刻画而被称为新现实主义的扛鼎之作。德·西卡的成就离不开他的长期搭档、著名编剧西塞·柴伐蒂尼（Cesare Zavattini），他撰写过多部新现实主义电影剧本（包括上述四部以及另一部新现实主义名片《罗马十一时》）。与此同时，柴伐蒂尼还对新现实主义进行了一系列理论阐述，被公认为意大利新现实主义的美学代言人。

德·西卡《偷自行车的人》

De Sica and Zavattini

Cesare Zavattini, who wrote virtually all of Vittorio De Sica's Neorealist films, defined the principles of the movement: to show things as they are, not as they seem, nor as the bourgeois would prefer them to appear; to write fictions about the human side of representative social, political, and economic conditions; to shoot on location wherever possible; to use untrained actors in the majority of roles; to capture and reflect reality with little or no compromise; to depict common people rather than overdressed heroes and fantasy role models; to reveal the everyday rather than the exceptional; and to show a person's relationship to the real social environment rather than to his or her romantic dreams. As can be seen from the last of these tenets, the movement was as opposed to Expressionism as it was to Hollywood. The Neorealist film developed the influence of the social environment on basic human needs: the need for food, shelter, work, love, family, sex honor. In the tradition of Marxist thought (yet another parallel with the classic Soviet films), the Neorealist films repeatedly show that unjust and perverted social structures threaten to pervert or destroy essential human values.

Vittorio De Sica became the most popular Italian Neorealist with American audiences, probably because his melodramas effectively combined the political, the sentimental, and the traditional story—as opposed to the detached ironies, paradoxical observations, conceptual flaming, and elliptical narratives of Rossellini. De Sica, a popular stage and film actor in the 1930s and director of escapist fluff films in the early 1940s, directed the Neorealist *Shoeshine* in 1946

(script by Zavattini), a brutally poignant study of the destruction of a pair of Roman boys by both the gangsters and the police who are using them. *The Bicycle Thief* (1948, Zavattini's most important script) is another study of degradation and pain. Its literal title, *Bicycle Thieves* (*Ladri di biciclette*), is more appropriate than the accepted American translation because there are two thieves in the film: the mail who steals the protagonist's bike and the protagonist himself (Antonio, played by Lamberto Maggiorani), who eventually becomes a bicycle thief out of necessity.

From the film's opening shots De Sica and Zavattini begin their relentless development of the kind of social environment that turns men into bicycle thieves: There are many men without work; there are very few jobs; the men have wives and children to support; the man with a bicycle is one of the lucky working few. To get his bicycle out of the pawn shop, Antonio's wife takes her wedding sheets to pawn in exchange for the bike. The poignancy of her sacrifice is underscored by De Sica's long shot of piles of pawned bridal sheets—others have been forced to make the same sacrifice. De Sica's camera emphasizes the quantities of people and things that are embraced by this stow rather than implying that this is a tale of the exceptional few.

The film's powerfully simple narrative premise is Antonio's desperate need to find his stolen bicycle. Without the bicycle he has no job; without a job his family starves. The man and his young son, Brtmo (Enzo Staiola), roam the streets, catching an occasional glimpse of the bike or the figure who stole it. Throughout the film the boy's relationship with his father serves as barometer of the effects of the agonizing search on the man's soul. Father and son drift lhrther apart; the man even strikes the boy. When Antonio finally comers the thief, the thief's mother and neighbors protect him, and neither the police nor the local Mafia are any help, since Antonio has no evidence.

Realizing the impossibility of ever getting his own bicycle back, Antonio is tempted by the sight of the many unattended bikes around him. In desperation, he steals a bicycle himself, is swiftly caught, and then is beaten and abused by the angry citizens. Bruno sees his father's ultimate degradation. When the father tries to hurry away from the boy in shame, Bruno catches up with him and slips his hand inside his father's. Despite the terrible social humiliation, the humanity and affection of father and son have been restored. Then they disappear into a crowd of people who, the film implies, are struggling with analogous problems; this tragedy, made from such unglamorous materials, is one among thousands.

De Sica claims that an American producer offered him millions to make *Bicycle Thieves* with Caw Grant as Antonio. De Sica rejected both the money and the star. Instead, he cast a metal worker, a nonactor, as the desperate father.

De Sica's preference reveals many of the principles of Neorealism: authenticity rather than pretense, earthiness rather than sparkle, the common man rather than the idol. Instead of Hollywood's bright sets and stylish clothes, these films showed primitive kitchens, squalid living rooms, peeling walls, torn clothing, streets that almost stank of urine and garbage. Instead of the Hollywood love goddess, the Neorealist heroine incarnate was Anna Magnani: coarse, flew, indefatigable, sexual, strong, sweaty. Zavattini claimed that the Neorealist film was as attached to the present as sweat was to skin.

It is worth noting that *The Bicycle Thief* and *Open City* were edited by the same man. One of the most versatile editors in film history, Eraldo Da Roma edited the major films of Rossellini, De Sica, and Antonioni.

The essential theme of the Neoreatist film was the conflict between the contemporary common man and the immense social, economic, and political forces that determined his existence: first the war, after it the means of making a living and the struggle to keep a home and family together. In the late 1940s, many Italian directors developed their own variations on this theme.

But by 1950 Neorealism had either run or begun to change its course. The films became increasingly psychological and less sociological. The Italian film for the international market, while still valuing the realist actor and the realist milieu, had begun to use more polished scripts, more carefully constructed sets, more conventional ftctional structures and themes, and professional actors. Even the original Neorealist directors wandered away from earlier styles and themes.

3. 维斯康蒂和《大地在波动》

拥有贵族头衔的卢奇诺·维斯康蒂（Luchino Visconti）在 1943 年根据詹姆斯·凯恩小说《邮差总按两次铃》改编的《沉沦》就被认为是意大利新现实主义的先驱。他的《大地在波动》和《罗科和他的兄弟》具备新现实主义的典型特质，而后来的《豹》和《魂断威尼斯》则是维斯康蒂回归古典电影艺术的上乘之作。

Luchino Visconti

Born in Milan to a family that was both aristocratic (on his father's side) and very rich (on his mother's), Luchino Visconti was drawn to the cinema and to an

《豹》

involvement with left-wing politics when fashion designer Coco Chanel introduced him to Jean Renoir in 1935. After a short while working with Renoir in the France of the Popular Front, he returned to Fascist Italy and made an extraordinary first film, *Ossessione* (1942), which was a direct challenge to the official culture of the period and was widely hailed, on its release after the war, as a precursor of neo-realism. In 1948 he made the mammoth *La terra trema*, an epic about a Sicilian fishing family, loosely inspired by Giovanni Verga's classic novel *I Malavoglia*.

If *Ossessione* was a precocious forerunner of neo-realism, *La terra trema* equally surely outran it. Shot on location, with non-professional actors speaking their own lines in incomprehensible dialect, *La terra trema* emerged, paradoxically, as closer in style to grand opera than to the documentary realism it originally aspired to. With *Senso* (1954), his first film in Technicolor, Visconti was given the brief of making a film that would be "a spectacle, but [*sic*] of high artistic value". Set in the Risorgimento, Senso tells a complex story of betrayal and counter-betrayal, in which personal and political are closely but ambiguously intertwined.

The historical process recounted in *Senso* is one of passive revolution and of muted change achieved by accommodations and compromise. The same process also figures in *The Leopard* (*Il gattopardo*, 1962), an adaptation of Giuseppe Tomasidi Lampedusa's novel. In both these Risorgimento films the mechanism of the plot works through betrayal, whether sexual or political, while the underlying thematic concern is with the survival or otherwise of class and family groupings in the context of historical change. In *Rocco and his Brothers* (*Rocco e i suoi fratelli*, 1960) the same mechanisms are returned to a modern setting-the life of a family of

southern immigrants in Milan during the "economic miracle". The peasant family is torn apart under the pressure of urban life and its destruction is seen as the tragic but necessary price to be paid if the individuals composing it are to survive. In *Vaghe stelle dell'Orsa* (US: *Sandra*, 1964) a family is also destroyed, but the forces motivating its collapse are more internal. The story of *Vaghe stelle* is that of the *Oresteia*, and in particular of Electra, the daughter dedicated to avenging her father's death at the hands of her mother and step-father. Daughter Sandra suspects her mother of having betrayed her father, a Jewish scientist, to the Nazis, resulting in his death in Auschwitz. Sandra in turns plays on her brother's (incestuous) love for her and betrays himi leading to his suicide. Sandra however survives and there is a sense at the end of the film that a future exists not only for her but for other survivors as well. History continues despite or even because of the family's destruction.

In his later films, however, Visconti shows himself more and more skeptical about history as a progressive development. In *The Damned* (*La caduta degli Dei*, 1969),the story of a German capitalist family destroyed by Nazism, there are no survivors, Nor are there in *Ludwig* (1972), where the mad king is incarcerated by his ministers, leaving nothing behind him. Both these films are set in a recognizable history, whose development is cataclysmically blocked. In *Death in Venice* (*Morte a Venezia*, 1971)and *The Intruder* (*L'innocente*, 1976) on the other hand, there is no history at all. The films are set in their own present, which is our past. They have neither a future of their own nor any connection forward, even implicit, to our present. This cutting off of the past from the present goes along with an increasing in terest in deviant sexuality. The protagonists of thee late films are painfully aware of being the lass of their line. Significantly, few children are procreated, and none survive. This contrasts sharply with the world of *Rocco or La terra trema*, where the breakup of the family leaves behind children who are free to grow and develop. As Laurence Schifano (1990) has noted, this involution of Visconti's concerns connects with ambivalent feelings about his own homosexuality and with fears of his approaching death (during the making of *Ludwig* he had a severe stroke from which he never fully recovered). He died in 1976. In spite of his increasing pessimism and his fascination with decadence, he never abandoned the Marxist convictions he had formed in his youth.

Deeply immersed in all aspects of European culture, Visconti was also an accomplished musician and a renowned stage director. He directed operas in Paris and London as well as at La Scala in Milan and in other Italian opera houses. Among his finest productions wee Verdi's *La Traviata* and *Don Carlo* for Covent Garden. For the theatre he directed Shakespeare, Goldoni, Beaumarchais and Chekhov as well as contemporary plays. He had a great sense of scenic design and was a superb director of actors for both stage and screen.

第二节 意大利电影第二次复兴及其后

意大利新现实主义电影运动的热潮在20世纪50年代后期逐渐退去,但意大利电影的新现实主义精神却被很好地承继下来。在新现实主义电影中浸染学艺的费里尼和安东尼奥尼就在这一时期联手创造了意大利电影的第二次复兴。

1. 费里尼

费德里科·费里尼(Federico Fellini)曾经担任过《罗马,不设防的城市》和《游击队》的联合编剧,算是意大利新现实主义的正宗传人。他获得国际声誉的《大路》和《卡比利亚之夜》等早期作品也具有显著的新现实主义倾向。

20世纪60年代,如日中天的费里尼以呈现罗马上流社会浮华、空虚、堕落的《甜蜜的生活》和刻画艺术人生纷乱、迷失、升华的《八部半》成为意大利电影和国际艺术电影大师级的导演。而《八部半》更以其对于梦幻心理的意识流描摹,被奉为现代电影艺术教科书式的顶级经典。

后期的费里尼继续将奢华浓烈的笔法融入自己怀旧的幻想之中,创作出《罗马风情画》和《我记得》等杰作。电影艺术大师费里尼一生佳作不断且获奖无数,为世界电影艺术带来了巨大的影响,他还与伯格曼和塔尔科夫斯基一起被并称为欧洲艺术电影的"圣三位一体"。

《八部半》

Federico Fellini

Although Federico Fellini's apprenticeship was to Rossellini and Amidei on the screenplays for *Open City, Paisan,* and *The Miracle,* Fellini's own films reveal tile flamboyant romantic. He preferred the places of mystery, magic, and make-believe—the circus, the variety theatre, the nightclub, the opera house—to the squalid slums of reality. His characters search for happiness, for love, for meaning, not for social security. If Anna Magnani or Ingrid Bergman is the soul of Rossellini's Neorealism, Giulietta Masina is the soul of Fellini, his wife offscreen—she survived him by only a few months—and the central figure of many of his films, including *La strada* (*The Road,* 1954) and *Nights of Cabiria* (1956), two of his greatest. Giulietta Masina, with the glowing eyes, the smirking mouth, the deep dimpies, wildly joyful, wildly sad, is to Anna Magnani as a sunbeam is to a lion. In both *La strada* and *Cabiria* Masina plays a pure spirit of love, a being of the heart.

Fellini's greatest international success was *La dolce vita* (*The Sweet Life,* 1960; U.S. release 1961). In this wide-screen epic of the superficiality of modern life, with its unforgettable score by Nino Rota and stellar performance by Marcello Mastroianni, Fellini deserted Neorealism forever.

The contrast between sensuality and spirituality dominates *La dolce vita* from its first sequence, in which a helicopter pilot, towing a statue of Christ, looks down and waves at three Women in bikinis, sunning themselves on a Roman roof. The film's themes are already clear: Christ has been petrified; he is a tool of the

modern World (the helicopter); people have lost faith without finding an adequate substitute. Showing the effects of this moral superficiality, Fellini continues for three hours, contrasting sensual things—nightclubs, orgiastic parties—with the corruption of spiritual things—an intellectual commits suicide, children pretend to see a miraculous vision. But excess is part of his point, even this numbing excess of schematic examples. There is too much of everything in this film—everything but what the characters really need: some fulfilling kind of peace, simple beauty, self-knowledge. The hedonistic, narcissistic, highly publicized "sweet life" is an existential vacuum.

What characterizes and energizes Fellini's work is a romantic rebelliousness and an ambivalent reaction to the grotesque. A consistent Fellini target is the Roman Catholic Church. For Fellini, the Church is a hypocritical and empty show that bilks its public by playing on its insecurities and fears. The Church is the archsensualist masquerading as a spiritualist, hiding its confusion behind a mask of dogma and ritual. In *La Strada*, Fellini photographs a solemn Church procession with a neon sign reading "Bar" in the foreground; in *Nights of Cabiria*, a society of human unfortunates takes a desperate outing to a religious festival, where they are greeted by canned prayers on loudspeakers and greedy vendors hawking sacred candles and secular candies. In $8\frac{1}{2}$ (1963), the Church offers the main character not spiritual guidance but a ritualistic structure of nostalgia and guilt. *Fellini Roma* (1972) includes a monstrously funny clerical fashion show.

Whereas Fellini treats organized religion with grotesque bitterness and comical contempt, he treats the glamorous world of the rich with a stylish grotesqueness that reveals both its emptiness and its fascination. The society party in *La dolce vita*, the patrons of the health spa in $8\frac{1}{2}$, the first-class passengers in *And the Ship Sails On* (1983) are all examples of the grotesque—in costume, make-up, gestures, features, shapes, sizes—that Fellini finds hauntingly attractive.

Fellini's greatest film, his most impressive synthesis of dramatic power, personal vision, and cinematic control, may well be $8\frac{1}{2}$. Perhaps the quintessential postwar Modernist feature, the subject of $8\frac{1}{2}$ is simply itself. It is not merely about filmmaking; it is about the making of a film very much like this one: a film the director finds impossible to make. The protagonist of $8\frac{1}{2}$ (Guido, played by Marcello Mastroianni) is a director himself. Because of his nervousness and tension, he is relaxing, preparing for his next film, at a fashionable health spa. Preparing for the project, the director is flooded with images out of his film and memories out of his life. The director's emotional problem in the film—and undoubtedly Guido represents Fellini here—is wondering whether he is successftfi at either life or art.. His memories and fantasies not only intrude on the action but become it; the filmmaker's mindscreens and his moviemaking project unfold together, in a brilliantly integrated construct of stress and desire, analysis and

nostalgia.

$8\frac{1}{2}$ begins with Guido's nightmare: He feels trapped inside a hot, smoky automobile during a mammoth traffic jam. He longs to escape from the car, to fly high above the earth. The remainder of the film works on the man's anxiety and longing, his desire to break free of the bonds of his life, his desire to soar in life and art. He searches throughout for an actress to portray a pure lady in white, an illusory panacea that will make sense of both his personal relationships and his artistic purpose. By the end, Guido appears to renounce the search. He attends a gala party for his film. Unable to resolve his personal conflicts or to fmish the film, he imagines crawling under a table and shooting himself. The party becomes a gigantic circus comprising all the characters of his memories and his film. Fellini's camera swirls in an excited circle as the parade of Guido's creatures dances about a circus ring, that familiar Fellini setting. Guido stares at the dancing creatures; he then steps into their circle and joins the dance. The film that could not be made has been abandoned, but $8\frac{1}{2}$ has been completed. Whatever Guido's (and Fellini's) deficiencies as a human being, he is a maker of films. That is his act in the big circus.

2. 安东尼奥尼

米开朗基罗·安东尼奥尼（Michelangelo Antonioni）曾为法国导演卡尔内和罗西里尼工作过，早期电影也与意大利新现实主义电影一脉相承。但1959年安东尼奥尼却执导了体现人情冷暖、孤独隔绝的《奇遇》，以其非完形的现代叙事震惊国际影坛，并将人与人之间冷漠、疑虑、绝望和不可沟通的存在主题贯穿到此后的《夜》和《蚀》当中，而这三部影片也就构成了安东尼奥尼著名的"爱情（疏离）三部曲"。

安东尼奥尼在《红色沙漠》创造性的运用色彩展示孤独和隔绝，在《放大》等英语片中则对视觉呈现本身、物欲精神和人性身份发出质疑，具备相当深度的哲理性反思色彩。1972年，左倾的安东尼奥尼还受邀来华拍摄过纪录片《中国》，为世界影坛留下了弥足珍贵的中国影像。

Michelangelo Antonioni

Like Fellini's, Michelangelo Antonioni's roots were in Neorealism. While Rossellini and De Sica were malting their documentary-style features, Antonioni

《奇遇》女主角莫尼卡·维蒂

was making documentary shorts about the lives of street cleaners and farmers. But Antonioni soon deserted the documentary for the highly polished and understated drama of perceptions, emotions, epiphanies, moods—eventually to return to documentary filmmaking for the 1972 *Chung Kuo Cina*, shot in the People's Republic of China. Antonioni is as much an Abstract Expressionist painter as a documentary photographer. His series of 184 paintings, "Montagne Encantate" (Enchanted Mountain), reveals some of his visual values. These are colorful representations of living rocks, vaguely sensuous landscapes dominated by clashes of color and contrasts of forms. Such enigmatic shapes, charged with ambiguous significance, would dominate Antonioni's films as well, their evocative land scapes closer to Rossellini's disciplined psychological imagery (and, in France, Robert Bresson's pure, severe, unsentimental, understated intensity) than to Fellini's flamboyance or Zavattini's Neorealism. Whereas that Neorealism used the external social environment to define a human being, Antonioni found a way to present landscape and character as an integrated mystery—a subtle Expressionism in the service of psychological, sociological, and philosophical insight.

After making seven short documentaries (1943-1950) and directing his first features, Antonioni achieved complete mastery over his method with *L'avventura* (*The Adventure*, 1960), the first film of a trilogy that includes *La notte* (*The Night*, 1960) and *L'eclisse* (*Eclipse*, 1962). In declaring a new Italian cinema, this trilogy was at least as significant as *La dolce* vita and $8\frac{1}{2}$, partly because the two filmmakers were so stylistically assured and such opposites. If Fellini's films are

fast, fiambbyant, grotesque, and richly emotional, Antonioni's are slow, spare, unwilling to draw pointed conclusions, and often about characters who are unable to feel deeply—or to be sure what it is they feel.

Antonioni's method concentrates as much on the scenic environment as on the people in the environment. The emotional resonances of the environment convey the internal states of the people within it. Antonioni's favorite photographic subjects include both nature—for example, the sea and rocks in *L'avventura*— and the slick, hard-surfaced materials of modem architecture: glass, aluminum, terrazzo. The beginnings of Antonioni films consistently use the scenic environment to define both the film's social milieu and its emotional climate. The ending of *Eclipse* may be unique in film history: It presents the location where the main characters have *not* shown up and spends in a study of the sounds and details of the meeting place the screen time they would have spent together.

A cliché of Antonioni criticism is that all his characters live lives that are boring and empty, meaningless and sterile and that his films are accordingly boring, sterile, and abstract. But *La notte* has a deep emotional power that sneaks up on you, and *Blowup* (1966) does not deny meaning but complicates our view of its nature. Most of the central Antonioni figures find some value that helps them live. And what they learn most often is how to live with ambiguity. Like the characters, the films struggle to communicate things that are almost impossible to put into words or express in actions and images. With great effort, Antonioni's movies communicate emotional and moral states that can never be entirely clear or resolved.

The real subject of the Antonioni films is education. In the course of their journeys, his characters learn the pervasiveness of emptiness and the possible if temporary ways of combating it. For such a theme, Antonioni's visual images are the only means of rendering each emotional stage of the journey convincingly and sensitively. These outer landscapes become inner ones.

L'avventura may be Antonioni's most completely realized film. It is at once rewarding and frustrating, stunning and boring, uplifting and depressing. When a group of friends go on an adventure to an uninhabited island, Anna (Lea Massari) disappears; her lover, Sandro (Gabriele Ferzetti), and her best friend, Claudia (Monica Vitti), try to find her. Sandro and Claudia eventually become lovers— and never do find Anna. Despite the impression that the plot wanders, it travels steadily toward its final, ambiguous moment of reconciliation and compassion in which Claudia can feel sympathy for the weakness of Sandro and in which Sandro can feel the terrible pathos of his need to betray Claudia. The plot is a series of betrayals. Anna betrays Claudia by making her wait downstairs while she viciously devours Sandro in an afternoon of casual lovemaking. Sandro has betrayed his talent as an architect by selling out to the pressures of finance.

Antonioni shows Sandro's bitterness as the former architect deliberately spills ink on a young architectural student's careful line drawing of the town's cathedral. Sandro's betrayals are also sexual. He betrays Anna by lusting after Claudia before Anna disappears. And even after the touching, fulfilling moments with Claudia, he callously flirts with he tasteless American publicity seeker in the vew hotel where Claudia waits in bed for his retnrn.

But if Sandro's education is to discover the human wealmess that makes betrayal so inevitable, Claudia's education is to discover that betrayal is a fact of human life. "Human" and "fallible" are unfortunately synonymous; any meaningful human relationship must start from that definition. *L'avventura* is a journey and adventure that bring Sandro and Claudia to that potential starting point, but their relationship may be over. The ending of the film is'both open and final; *L'awentura* leaves many questions unanswered—What happened to. Anna? What will happen to Sandro and Claudia?—and is complete. It offers figures in a landscape that is often more interesting than they are, and it has no interest in genre or formula. For all its emotional complexity, it is beyond the characters that *L'avventura*, like other Antonioni films, finds a coherence that can be expressed only by the camera.

3. 意大利电影第三代：奥米、罗西、帕索里尼、贝托鲁奇和莱昂内

皮尔·保罗·帕索里尼（Pier Paolo Pasolini）既是诗人和作家、又是电影导演和电影理论家，他因激进的政治立场和特立独行的个人生活而饱受争议。帕索里尼诠释传统经典的影片《马太福音》《俄狄浦斯王》《定理》和《美狄亚》无不充盈着强烈的政治和性意味，而《索多玛的120天》更将这些倾向推向不忍卒看的极致。帕索里尼也为自己的信仰和理想付出了生命的代价，成为电影史上唯一遭到暗杀的导演。

贝纳尔多·贝托鲁奇（Bernardo Bertolucci）出身浓郁的文学背景并同样具备强烈的政治倾向，他根据文学名著改编的《蜘蛛策略》和《随波逐流的人》等展现了信仰与激情、理想与幻灭的激烈冲突，《巴黎最后的探戈》因对绝望人性的直面描述而成为艺术电影的经典。而他受到广泛赞誉的《末代皇帝》则是对中国末代皇帝溥仪跌宕一生精彩的演绎。

20世纪60年代出现的意大利电影第三代中，埃曼诺·奥米（Ermanno Olmi）以其《工作》《米兰心事》和后来的《木屐树》忠实地继承了新现实主义直面现实、关注生活的传统。而弗朗西斯科·罗西（Francesco Rosi）则以

《控制城市的黑手》和《马蒂事件》成为意大利政坛腐败、黑手党横行"政治电影"的代表人物。此外，丽娜·维尔特米勒（Lina Wertmüller）、塔维亚尼兄弟（Vittorio & Paolo Taviani）和马可·贝洛奇奥（Marco Bellocchio）也是第三代的代表人物。

在美国西部片式微的20世纪60年代，"意大利西部片"（spaghetti Western）却以变异和解构的姿态异军突起，获得广泛的肯定。意大利导演赛尔乔·莱昂内（Sergio Leone）成为意大利西部片的代表人物，其《荒野大镖客》《好坏丑》和《西部往事》被公认为意大利西部片的杰作。而意大利西部片明星克林特·伊斯特伍德（Clint Eastwood）也由此走上演而优则导的辉煌道路。

Other Directors and Subsequent Films

Following Visconti, Fellini, and Antonioni, and building on their foundation to greater or lesser extent and in various ways, there appeared a cluster of powerfully talented younger Italian film makers. The first two to be dealt with here, rather than paralleling the then current concerns of the three veterans, returned to some of the earlier neorealist impulses. One had had extensive documentary experience before turning to fiction; the other began his film career as assistant director on a neorealist feature.

Ermanno Olmi's first features contain socially significant themes, were shot on location, and use nonactors as in the earlier tradition. But instead of unemployment and poverty, he deals with jobs that offer little satisfaction and the difficulties of achieving fulfilling lives and relationships within the conformist demands of an industrialized society. What Olmi provides is a subtle and absorbing attention to the individual among the working classes. *Il Posto* (1961) is about a teen-age boy from a small village on his first job as messenger for a large firm in Milan. The tenderness and gentle humor with which the director regards the boy's tentative relationship with a girl, his loneliness at a dreary office party, and his feelings when he first sits at a clerk's desk are uniquely Olmi's own. *The Fiancés* (1963) concentrates on a worker who goes from the North to a new plant in Sicily. The slender story deals largely with his efforts to come to a better understanding of the fiancée he has had to leave behind and of their relationship. In later films, *One Fine Day* (1968) and *The Circumstance* (1974) for example, Olmi moved to the middle and upper classes, from workers to bosses, and fragmented his narrative, the present and recollected past sometimes intermingled with Resnais-like complexity. In *The Tree of Wooden Clogs* (1979), about the life of a peasant community in Lombardy at the close of the nineteenth century, Olmi returned to

《西部往事》开场对峙

his earlier lyrical and unadorned style. But in *Long Live the Lady!* (1987) he mixes his special comedy of behavior, in this case that of ordinary kids, with a fantastic banquet hosted by the incredibly ancient lady of the title.

Francesco Rosi, little known in the U.S., is much admired in Italy and in Europe generally. His first considerable achievement was *Salvatore Giuliano* (1962), shot entirely on location in Sicily with an almost exclusively nonprofessional cast. It concerns an actual Mafia leader whose banditry and guerrilla activities are seen as aimed towards achieving Sicilian independence. *Hands Over the City* (1963), in many ways similar in method and ultimate intent, examines the exploitation of capitalist power and political corruption by an unscrupulous housing developer in Naples. *The Mattel Affair* (1972) retains its basis in actuality but extends to a national, even internationl, scale. Enrico Mattei was an industrial manager who created a state-controlled oil company which loomed large in Italian political-economic affairs and competed against the other national and multinational oil interests in the world market. *Christ Stopped at Eboli* (1979) is Rosi's version of the Carlo Levi book about the condition of rural Southern Italy in the 1930s. *Three Brothers* (1981) traces the fortunes of three sons of a farmer in the Puglia region whose lives mirror the development of post-World War II Italy. It is a meditation on the conflicting values of the South and the North, the rural and the urban, and on the political violence and social fragmentation prevalent in modern Italy. The enigma of power, the pervasiveness of political influence, and the factual source remain characteristic of Rosi's finest work. Of the neo-neorealist directors, perhaps it is Rosi who has made most fully manifest the ideology implicit in the original movement.

His most recent films depart from that main line, however. Both are adaptations of masterpieces, one an opera the other a novel. Rosi's version of

Bizet's *Carmen* (1984) was his first substantial success in this country, partly due to the excellent interpretation and performance and most especially to the compelling sensuality of Julia Migenes Johnson in the title role. It was followed by his version of Gabriel García Mátrquez's *Chronicle of a Death Foretold* (1987). Though both films follow the neorealist tenet of shooting on location—*Carmen* in the Andalusian region of Spain and *Chronicle* in Colombia—in other respects they are closer to the later Visconti. (Rosi began in film as assistant director on *La Terra Trema*.)

In the work of other directors emerging in the 1960s who were close to the earlier neorealists we can see signs of the changing times. Rather than either Olmi or Rosi, perhaps another two Italian film makers, clearly influenced by the French New Wave, are more representative of the generation which followed Visconti, Fellini, and Antonioni.

Piero Paolo Pasolini and Bernardo Bertolucci had many things in common. Bertolucci even counted Pasolini as a "father" and was considerably influenced by his films and theoretical writings. Both were strongly committed to the political left, but the new rather than the old, Italian intellectual rather than doctrinaire Marxist. Both used their films as means of exploring the structure of society. Even when the surfaces or foregrounds seem devoted solely to the relationships among individuals, the attitudes of their characters and the kinds of dilemmas they find themselves in have political dimensions. While in France there is an active political consciousness at work among certain film makers and critics, in Italy this sort of concern is almost endemic among those involved with the cinema. Much of the critical discussion of a film there—from both right and left—will be devoted to its ideological significance and likely effects on social attitudes.

Pasolini, a novelist, poet, linguist, and film theorist before he directed his first feature, *Accattone!*, in 1961, consistently dealt with the "subproletariat"—beggars and outcasts. Even *The Gospel According to St. Matthew* (1964), his best-known film, conforms to that generalization. In it Christ is portrayed as a revolutionary orator-leader from the masses, of a sort common in the history of the Middle-Eastern peoples. Shot as if it were reportage rather than re-creation, hand-held camera and nonactors give the Biblical story a feeling of contemporary actuality and urgency. *The Hawks and the Sparrows* (1966), an allegorical comedy, reveals and examines the interdependency between Christianity and Marxism, between religion, ideology, and existence. *Teorema* (1968) and *Pigpen* (1969) include strange mythic evocations of transcendental states, perverse sexuality, and cannibalism in their attacks on capitalist society. Pasolini's ability as a writer and translator led him to attempt new interpretations of classic literary works. Following *Oedipus Rex* (1967) were *Medea* (1970), *The Decameron* (1971), *The Canterbury Tales* (1972), and *The Arabian Nights* (1974). His last film, *Salò—The 120 Days of Sodom*,

suggested by a work of the Marquis de Sade and full of violence, was completed just before his own violent death in 1975. Brilliant and multitalented, at the same time idiosyncratic and unpredictable, Pasolini occupied a position of leadership among the new Italians.

Bertolucci, who worked as assistant director on *Accatone!*, achieved a prodigious international success with *Before the Revolution* (1964), which he completed at the age of twenty-four. (His first feature, *The Grim Reaper*, based on a rough draft by Pasolini, had been made two years earlier.) Of the post-Visconti-Fellini-Antonioni generation, Bertolucci has made least use of the neorealist inheritance. His films more nearly resemble those of the later Visconti, in their sorting through of intertwined personal relationships and political attitudes, and in their bold painterly style: *The Conformist* and *The Spider's Stratagem*, both 1970, for example. Arguably his most exceptional work to date, *Last Tango in Paris* (1972), also bears some resemblance to Antonioni thematically and aroused something of the same exitement as *L'Avventura in* suggesting a new sort of film language, or personal idiom at least. In Bertolucci's case his contributions to cinematic expressiveness may lie soley in the style which is the man. Dense and unanalyzable in many respects, it is hard to know just what makes *Last Tango* work so powerfully. If it is too early to tell whether it is an enduring masterpiece, there is no question about its initial impact, the force with which Bertolucci was able to speak to his contemporaries. It was followed by the vast panorama of *1900* (1976), covering some seventy years of life and social conflict in the Emilia region of Italy; *Luna* (1979), the intimate study of an incestuous relationship between mother and son which occasioned controversy at least equal to that caused by *Last Tango*; and *Tragedy of a Ridiculous Man* (1981), involving a father-son relationship, kidnapping, and terrorism in present-day Italy.

The last three films had mixed critical receptions and weak box office performances. His next, *The Last Emperor* (1987), was a triumph on all counts. A huge multinational production, it tells the story of Pu Yi, the last emperor of China. The film can be seen in several ways. It is a sumptuous visual feast of elegance and display on a colossal scale. As cultural and political history it is less satisfactory; too much is crammed into too little time, with large events hinted at or dealt with obliquely. Perhaps it can best be understood as the story of a person whose emotional life becomes constricted and empty as a result of early traumas. He is torn from his mother and then from his wet nurse: ritual obeisance is substituted for love and nurturing. He is told he is the most powerful person in the world who can do anything he wants, when in fact he is someone who experiences one loss after another. In a sense he is a prisoner throughout his life. This aspect of the film is consistent with Bertolucci's persistent fascination with psychological tensions that lead to loneliness and aberrant behavior. He has suggested that his method

of film making and each of his films is part of his own psychoanalysis. In any event, the gamble at high stakes paid off handsomely. *The Last Emperor* attracted a great amount of critical attention, won eight Academy Awards, and became an international financial success.

Among the films of the newer Italian film makers especially popular in the U.S. have been those by Lina Wertmüller and the Taviani brothers, Paolo and Vittorio. Wertmüller's initial film work was as assistant director to Fellini on $8\frac{1}{2}$. Her first big success was *The Seduction of Mimi* (1972), followed by *Love and Anarchy* (1973) and *Swept Away* (1974). The most ambitious and important of her films to date is *Seven Beauties* (1976). All of them are comedies, though the latter, set in a Nazi concentration camp, contains horror and pathos. Giancarlo Giannini, who stars in them all, has developed a comic persona of the little man whose behavior is determined by the requirements of survival. The films mingle sex and politics, dominance and dependence, in what seems a puzzling ideological mix.

The Tavianis became known in this country chiefly for *Padre Padrone* (1977), an adaptation of a best-selling account of the progress of an ignorant Sardinian from shepherd to university professor, The *Night of the Shooting Stars* (1982), shot in their native Tuscany, was based on their own experiences as young boys and on oral accounts of fellow Tuscans. It concerns a group of villagers who in 1944 left their town in defiance of the retreating Germans and resident Fascists to search for the advancing Americans. It was followed by *Chaos* (1984), adaptations of four Luigi Pirandello stories shot in Sicily with a cast that included many nonprofessional actors. Like Bertrand Tavernier, whose success in France led him to *Round Midnight*, an American-financed English-language film aimed at the international market, the Tavianis were drawn to Hollywood. In fact, their first American film was about Hollywood, though shot mostly in Italy and Spain. *Good Morning, Babylon* (1987) concerns two Italian artisan brothers' involvement in the construction of the massive Babylon sets for D. W. Griffith's *Intolerance* and sundry subsequent adventures. Though a charming fable, the best of the Taviani films return to the emotional territory of neorealism, or at least have their roots in the history and traditional culture of the Italian people.

Many of the major contemporary Italian film makers appear to be stretching themselves, to be trying out new subjects and new forms. Films have resulted that don't always make full use of the special talents demonstrated in their earlier work. Yet, seen as a whole, the Italian film from 1960 onward represents a range and maturity of statement that has earned wide admiration. Artistic innovation has been tempered by continuing awareness of the role of film in society. A common sense of national identity among the film makers has strengthened individual efforts. In spite of obvious personal and generational differences, contemporary Italian directors share many aesthetic and political as well as cultural assumptions. That

cohesiveness permitted artists of the stature of Visconti and Fellini and Antonioni to have long productive careers. It has also provided a background from which newcomers have emerged to command worldwide attention. The term "Italian New Wave", bandied about at the time of the 1960 Venice Festival, wasn't really appropriate. What was being revealed in the three remarkable films shown there was merely the beginning of another evolutionary stage in an ongoing tradition that has existed in Italy at least since the end of World War II.

On the other side of what Winston Churchill perceived as an Iron Curtain, film history has been characterized more often than not by a resistance to change, especially in the dominant state, the Soviet Union. Recently that situation has begun to alter, and the Russian film appears to be returning to a more active relationship with that of the West.

Pier Paolo Pasolini

Pier Paolo Pasolini was a poet, novelist, film-maker, essayist, and controversialist, Born in Bologna, where he later went to university, he spent most of his childhood in Friuli in the far north-east of Italy. His early years were marred by the death of his brother, killed in internecine fighting between the Partisans in 1945, and by the frequent rows between his mother and his increasingly drunken ex-Fascist father. As a young man he joined the Communist Party, but was expelled from it in 1949 because of a scandal involving alleged sexual activities with adolescent boys. He seems to have regretted, rather than resented, his expulsion from the Communist Party, and proudly regarded himself as a Communist to the end of his life, in spite of his many public disagreements with the Party and with the rest of the left.

In 1950, Pier Paolo set out for Rome, taking his mother with him. There he soon established a reputation with two volmnes of poetry, *Le ceneri di Gramsci* (1957) and *La religione del mio tempo* (1961), and two novels malting creative use of Roman dialect and slang, *Ragazzi di vita* (1955) and *Una vita violenta* (1959). His skill with vernacular dialogue brought him work in the film industry, notably on the script of Fellini's *Le notti di Cabiria* (1957).

His first two films as director—*Accattone* (1961) and *Mamma Roma* (1962) —had Roman low-life themes, but were distinguished by a strong utopian current, hanced by the use of music by Bach and Vivaldi on sound-track, A short film, *La ricotta* ('Curd-chees episode of the 1962 compilation film *RoGoPaG*) featu Orson Welles acting as a (dubbed) mouthpiece for solini, and a parody of the Deposition from the Cross which led to charges of blasphemy. By contrast *Il vangelo secondo Matteo* (1964) was a stark and sober retelling of the Gospel according to Matthew,

which earned him the inaccurate label of Catholic-Marxist.

Pasolini's attitude to religion was in fact highly ambivalent. He was interested in all aspects of what he called "the sacred" (*sacrale*), but increasingly he came to locate this qualityin primitive religion and myth. In *Oedipus Rex* (*Edipo re*, 1967), *Porcile* ("*Pigsty*", 1969), and *Medea* (1970), he explored mythic notions of the transition from primitivism to civilization—to the implied disadvantage of the latter. In general he placed his own utopias as far away as possible from the modern, capitalist, bourgeois world of which he felt himself a member and a victim, moving downwards (to the peasantry and sub-proletariat), outwards (to southern Italy and then to Africa, the Arab world, and India), and backwards in time (to the Middle Ages and pre-classical Greece), in his desperate search for a mythic home.

In the 1960s his long-standing interest in language drew him in the direction of semiotics, and he attempted to theorize his approach to cinema in two essays, "The Written Language of Reality" and "A Cinema of Poetry" (reprinted in Heretical Empiricism 1988). Here he argued for a natural basis of film language in realtty itself, which is endowed with meaning when the film-maker turns it into signs. His own film work is far from naturalistic. Eschewing narrative continuity, Pasolini concentrates on the production of single, powerful images whose expressivity seems at first sight independent of any relationship to "reality" as ordinarily conceived. What underlies them, however, is an almost desperate search for a kind of pre-symbolic truth, an emotional reality which modern man can no longer grasp.

After his brutal dissection of the bourgeois family in *Theorem* (*Teorema*, 1968) and in the "modern" section of *Porcile*, Pasolini set all his films in the historic or pre-historic past. In 1970 he embarked on a series of films based on medieval collections of tales—*The Decameron* (1970), *The Canterbury Tales* (1971), and *The Arabian Nights* (*Il fior delle mille e una nolte*, 1974). Though all three have their darker side, these films—the so-called "trilogy of life"—were seen as a celebration or a lost world of joyful and innocent sexuality. But if this had been Pasolini's intention, he promptly repudiated it. Increasingly convinced that "sexual liberation" (including gay liberation) was a sham, he turned in his journalism to a fierce denunciation of contemporaw sexual mores. Having courted unpopularity on the left for his criticisms of the radical students of 1968, he compounded it with his opposition to the liberalization of Italy's archaic abortion law, and was forced to bear a muddled and hasty retreat. Then in 1975 he made *Salò* (*Salò o le centoventi giornate di Sodoma*), setting De Sade's novel in the last years of the Fascist regime in Italy, and explicitly linking Fascism and sadism, and sexual licence and oppression. Apart from the unfinished novel *Petrolio*, posthumously published in 1992, this terrifying document was to be his last work.

On the morning of 2 November 1975, his battered body was discovered on a piece of waste ground near the seaside re sort of Oslia, outside Rome.

Bernardo Bertolucci

With *The Last Emperor* (1987), Bernardo Bertolucci , son of Attilio, one of the greatest Italian poets of the century, and brother of Giuseppe, another respected film director, reached a peak of success, winning praise from both a world-wide audience and the vast majority of critics, as well as the 4,747 members of the Academy, who awarded the film nine nolminations and then nine Oscars.

This apotheosis was a far cry from his start in 1962, when the 21-year-old from Parma, who had published a slim volume of poetry (*In cerca del mistero*), which won the Viareggio Prize for a first work, and who had been Pasolini's assistant on *Accattone* (1961), directed his almost unnoticed first film, *La commare secca* ("The grim reaper"). He attracted more attention with his next film, *Before the Revolution (Prima della rivoluzione*, 1964), an autobiographical *Bildung* caught between passion and ideology. Several years of enforced inactivity followed, interrupted only by a long television documentary, *La via del petrolio*; a short film *Agonia* ("*Agony*") with Julian Beck and the Living Theatre; and a strange, experimental, Godardesque film, inspired by Dostoevsky, *Partner* (1968).

In 1970 came two films which were to put him on the path to international critical and popular success, *The Spider's Stratagem* (*Strategia del ragno*) and *The Conformist* (*Il conformista*-from the novel by Moravia). Set in Fascist Italy, both films explored the bourgeois roots of Fascism and centred on the theme of the father. Both also inaugurated important collaborations: *The Spider's Stratagem* that with director of photography Vittorio Storaro, and *The Conformist* the equally valuable ones with art director Ferdinando Scarfiotti and editor Kim Arcalli. With these films Bertoiucci's films begin to acquire their characteristic pacing and "look", with diffuse lighting, warm colours, and a relaxed rhythm interrupted by explosions of violent intensity,

His international status was consolidated by the *success de scandale* of *Last Tango in Paris* (1973), Aided by an extraordinary performance by Marion Brando, *Last Tango* earned $16 million in America, and the highest ever boxoffice in the history of Italian cinema, despite a magistrate's order for its seizure and destruction.

The film *1900* (1976) followed the parallel lives of two characters, a peasant and a landowner, born on the same day in 1900 on a central Italian farm estate. Its two parts, lasting 320 minutes (later cut to 240), make it a work of scope and ambition built around a dialectic of opposites: a film on the Class Struggle in Italy,

《巴黎最后的探戈》拍摄现场

it was nevertheless funded by American dollars, had an international cast, and attempted to merge Hollywood melodrama of the *Gone with the Wind* variety with socialist realism, and with a final scene worthy of Chinese ballet-film. It emerges as a political melodrama, half Marx and half Freud, with a nod in the direction of Verdi.

Like *Last Tango*, *1900* was an international co-production. Technically European, its making and release were heavily constrained by the marketing needs of the American companies who had backed it and acquired worldwide distribution rights. Difficulties with the distributors (not dissimilar to those experienced by Visconti on *The Leopard* in the early 1960s) led Bertolucci to seek production arrangements which would be less constricting. His next two films were Italian productions, while for his return to international production with *The Last Emperor* he teamed up with British-based producer Jeremy Thomas, who remained his producer for *The Sheltering Sky* (*Il tè nel deserto*, 1990) and *Little Buddha* (1993).

La luna ("*The moon*", 1979) was, like *1900*, at heart a melodrama, on a mother-son relationship and on the incestuous impulse which lies, more or less inlagined, at its ccntre. With *The Tragedy of a Ridiculous Man* (*La tragedia di un uomo ridicolo*, 1981), Bertolucci attempted to come to terms with the difficult, confused, and violent state of Italy in the 1970s, narrated for the first time from the point of view of the father. *The Sheltering Sky* (from the novel by Paul Bowles)

escapes the world of Oeclipal nab rative (except for a sub-plot involving a mother-son relationship) and is a love story, but one in which love is entwined with pain, death, and self-destruction. *Little Buddha*, by contrast, is an unexpectedly serene film, from which class struggle and tortured sexuality have been (at least temporarily) banished.

Sergio Leone

Sergio Leone was the man most responsible for the vogue of Italian "spaghetti westerns" in the 1960s. The son of a film industry pioneer, Vincenzo Leone, and screen diva Francesca Bertini, he entered Italian films at 18 and for many years worked as an assistant to various Italian directors (Gallone, Comenicini, Soldati, Camerini, among others) as well as American directors filming in Italy, including Mervyn LeRoy, Robert Wise, William Wyler, Raoul Walsh, and Fred Zinnemann. Among other American films, he served as an assistant on Quo Vadis, Helen of Troy, and Ben-Hur. He appeared in a bit as a priest in De Sica's *The Bicycle thief* and from time to time played small roles in films. He also worked as a second-unit director on a number of sumptuous productions and collaborated as a screenwriter on such costume adventure films as Nel Segno di Roma/Sign of the *Gladiator* (1958) and *Gli Ultimi Giorni di Pompei/The Last Days of Pompii* (1959). He took over the direction of the latter film from an ailing Mario Bonnard but received no screen credit for his effort. He also figured prominently in the production of Robert Aldrich's *Sodom and Gomorrah* (1961) on which he was billed as the second-unit director. He made his own official debut as a director with a pseudohistorical epic, *Il Colosso di Rodi/The Colossus of Rhodes* (1961) and scored a string of box-office hits several years later with a series of brutal but stylish made-in-Italy "Westerns", which he launched with the enormously popular *Per un Pugno di Dollari/A Fistful of Dollars* (1964). A remake of Kurosawa's Yojimbo, the film, noted for its explicit brutality, flamboyant visual style, and abundant use of extreme closeups, gave an enormous boost to the then-stagnant career of Clint Eastwood, perfectly cast as the laconic "Man With No Name". So influenced was Eastwood by Leone's filmmaking style that Eastwood's Academy Award-winning Western *Unforgiven* (1992) was in part dedicated to him.

Leone improved on his formula in the sequel *For a Few Dollars More* (1965) and scored another huge international hit with *The Good, the Bad, and the Ugly* (1966), the last of the man With No Name trilogy. The success of these films spawned a virtual avalanche of imitation Spaghetti Westerns which helped provide employment for several fading American stars and character players. Now backed with a hefty budget from Paramount, Leone proceeded to make *Once Upon a Time*

in the West (1968), an operatic-scale Western epic many consider his masterpiece. It was, however, a commercial failure, both in its original release version, running 165 minutes, and its mangled 140-minute studio cut. Disheartened, Leone functioned thereafter mostly as a producer. But in 1984 he returned to directing with his most ambitious film, the Hollywood financed *Once Upon a Time in America* (1984), a gangster saga starring Robert De Niro, set mostly in New York and running nearly four hours. The much abbreviated ("butchered", according to Leone) American release version fared poorly at the box office and only modestly with the critics, but viewers of the full original cut admired many aspects of the production. At the time of his sudden death of a heart attack, Leone was planning an even more ambitious project, a $70-million Soviet-Italian co-production, again starring De Niro, about the WW II German siege of Leningrad.

第三节　美国电影的转型

1. 大制片厂衰落与电视的出现

战后1946年，美国电影的票房收入达到创纪录的17亿美元，却在1962年骤降至9亿美元，原因包括"派拉蒙裁决"导致大制片厂的衰落、战后观众审美取向的变化、美国人口由城市向郊区的迁移、休闲生活的多元化、特别是电视出现产生的巨大吸引力。

心急如焚的好莱坞采用一系列技术革新措施挽回颓势，标准银幕演变成宽银幕（CinemaScope）、全息电影（Cinerama）和立体电影（3-D），70毫米胶片加立体声音响等效果风靡一时。《一个明星的诞生》《俄克拉荷马》《宾虚》《斯巴达克斯》和《埃及艳后》等宽银幕、大预算和全明星阵容大片成为好莱坞对抗电视小屏幕的法宝。而跟联美公司接近和B级电影相关的一些独立电影公司及其制作的小成本影片也在努力填补大制片式微留出的电影空间。

The 1950s: Widescreen and Stereo

The creation of a habitual movie-going audience in the 1930s effectively terminated technological experimentation. There was little or no demand on the part of audiences for technological innovation and costconscious exhibitors saw no reason to invest in the new projection equipment which 3-D, widescreen, and other exhibition technologies would require. However, the falling off of this habitual

《宾虚》中壮观惊险的战车竞赛

audience in the post-war years prompted a search for novel forms of presentation and led to the reintroduction of many of these earlier technologies.

In 1948 the average weekly attendance at motion pictures in the United States stood at 90 million—an all-time high. By 1952 this had dropped to 51 million, largely as a result of the demographic shift of a large percentage of the US population from the cities, where the major movie theatres were located, to the suburbs. At the same time, the return to a forty-hour work week, the institution of one and two-week paid vacations, and an increase in disposable personal income resulted in the creation of new patterns in leisure-time entertainment. Consumers abandoned passive entertainment, such as film-going, in favour of active participation in forms of recreation such as gardening, hunting, fishing, boating, golfing, and travel. These activities filled greater and greater blocks of the leisure time available to post-war audiences, while television satisfied their need for short-term, passive entertainment.

The American motion picture industry responded to these new patterns by providing more participatory forms of entertainment, which were modelled, in part, on concepts of presence associated with the legitimate theatre. New motion picture technologies involved spectators with the on-screen action in ways which provided them with an enhanced illusion of participation. Thus Cinerama, introduced in September 1952, informed its audiences that "you won't be gazing at a movie screen—you'll find yourself swept right into the picture, surrounded by sight and sound".

Advertisements for *Bwana Devil* (1952), which was filmed in 3-D, addressed audiences in similar ways, thrilling them with the promise of "a lion in your lap" and "a lover in your arms". Ads for Cinema Scope, which was introduced with the première of *The Robe* in September 1953, told potential spectators that CinemaScope "puts YOU in the picture". And ads for Todd-AO's *Oklahoma*! (1955)

declared that "you're in the show with Todd-AO". They celebrated the sense of presence created by the new, wide film format: "Suddenly you're there ... in the land that is grand, in the surrey, on the prairie! You live it, you're a part of it ... you're in Oklahoma!"

Cinerama, which was developed outside the film industry by a Long Island inventor, Fred Waller, achieved its remarkable sense of participation by filling the spectator's field of peripheral vision, encompassing an angle of view that was 146 degrees wide and 55 degrees tall. This was accomplished by filming with three interlocked 35 mm. cameras, which were equipped with wide-angle, 27 mm. lenses set at angles of 48 degrees to one another. The Cinerama camera ran at an accelerated speed of 26 frames per second to reduce ficker and exposed 35 mm. negative that was six perforations high rather than the standard four. In the theatre, three interlocked projectors in three different booths were used to project the three separate strips of film on to a huge, deeply curved screen.

Stereo sound was recorded magnetically with from five to six microphones and played back by a sound control engineer through seven speakers in the theatre; five speakers were located behind the screen, while the other two channels were used for surround sound. Magnetic sound recording had been introduced to the film industry via slightly modified German equipment which had been captured during the war. In 1935 the Germans had developed a magnetic recorder called the Magnetophon, which used plastic tape coated with powdered magnetic material: This equipment was brought to the United States in 1946. By 1949 Paramount had used the principles of the Magnetophon to develop equipment which enabled the studio to convert to magnetic sound for purposes of recording and editing, though it, like all the other studios, continued to release films with optical tracks in order to accommodate theatres, which were reluctant to install new sound reproduction equipment.

This Is Cinerama (1952), the first Cinerama feature, grossed over $32 million, though it played in only a handful of theatres, due to the complex requirements of the format's projection system. The first five Cinerama films were all travelogues, and it was not until 1962 that the format was used to film narrative features, such as *How the West Was Won*. Three-strip Cinerama lasted until 1963, when it was replaced by Ultra Panavision, a 70 mm. process which used a slight anamorphic compression to squeeze Cinerama's wide angle of view on to a single strip of film, thus duplicating Cinerama's original 2.77: 1 aspect ratio (the term "aspect ratio" refers to the relation of a projected image's width to its height).

The success of 3-D was even more short-lived than Cinerama, lasting for only about eighteen months, from late 1952 to the spring of 1954. In the 1950s 3-D relied upon polaroid filters rather than the anaglyphic format. An inexpensive technology for both producers and exhibitors, it became associated with

exploitation genres, such as the horror film (House of Wax, 1953; Creature from the Black Lagoon, 1954), science-fiction films (It Came from Outer Space, 1953), and Westerns (Hondo, 1953).

CinemaScope, which was introduced by 20th Century Fox, attempted to duplicate Cinerama, streamlining it for adoption by the film industry as a whole. The cornerstone of the CinemaScope system was an anamorphic lens, which had been developed back in 1927 by a French scientist, Henri Chrétien. This lens compressed a wide angle of view on to 35 mm film; a similar anamorphic lens on the projector in the theatre decompressed the image, producing, on a slightly curved, highly reflective screen, a panoramic view that had an aspect ratio of 2.55 : 1 (subsequently reduced to the current standard of 2.35: 1 when an optical sound-track was added to it in 1954). Unlike Cinerama, which required a separate strip of film to hold the tracks for its stereo magnetic sound, CinemaScope used magnetic oxide striping to place four tracks on the same strip of 35 mm. film which bore the image, thus eliminating the need for additional personnel in the theatre.

Fox engineers crammed all this information on to a single strip of 35 mm. film by redesigning the frame area as well as reducing the size of the perforations along both sides of the film. In doing this, Fox took advantage of the increased durability and stability of safety-based acetate film stock, which had been introduced in 1949 to replace the highly flammable nitrate film stock, which tended to shrink during processing.

CinemaScope also made use of the new Eastman Color film stock, which had been introduced in 1950. The old Technicolor three-strip camera was unable to accommodate a CinemaScope lens so Fox switched to single-strip Eastman Color negative, which could be used in any 35 mm. camera. This tri-pack film drew upon colour research conducted by the German company Agfa in 1939, which was subsequently marketed as Agfacolor. Like Agfacolor, Eastman's film featured three layers of emulsion, each sensitive to a different primary colour. During processing, dyes held within the film were released in response to the degree of exposure of the silver halides in each layer, thus reproducing the original colour. The advent of Eastman Color broke the grip which Technicolor had on production in colour, stimulating a dramatic increase in the number of films made in colour. In 1945, only 8 per cent of all Hollywood films were shot in colour; by 1955, that percentage had climbed to over 50.

CinemaScope quickly became an industry standard; by the end of 1954, every studio except for Paramount, which had developed its own widescreen process known as VistaVision, had adopted the CinemaScope format; and by 1957 85 per cent of all US and Canadian theatres had been equipped to show CinemaScope films. In Europe, the Soviet Union, and Japan, a number of CinemaScope clones emerged, including Dyaliscope and Franscope (France), Sovscope (USSR), and

Tohoscope (Japan). In 1958 Panavision developed a high-quality anamorphic lens, which it effectively marketed to the rest of the industry. And by 1967 Fox had retired CinemaScope in favour of Panavision for 35 mm. production and Todd-AO for wide film production.

Not all film-makers, however, were happy with the new widescreen format. Sidney Lumet noted that "the essence of any dramatic piece is people, and it is symptomatic that Hollywood finds a way of photographing people directly opposite to the way people are built. CinemaScope makes no sense until people are fatter than they are taller". Fritz Lang joked (in lines which he later repeated in Jean-Luc Godard's Franscope production of *Contempt* (*Le Mépris*, 1963)) that CinemaScope was a format ideally suited for filming snakes and funerals, but not human beings. But by the end of the decade, widescreen had become a new standard. And it gave expression to a new generation of artists-to directors such as Nicholas Ray and Otto Preminger, and to cinematographers such as Joseph LaShelle and Sam Leavitt.

Todd-AO also sought to duplicate the Cinerama experience, using extremely wide-angled lenses, wide 65/70 mm. film, a 30-frames-per-second film speed, a deeply curved screen, and six-track stereo magnetic sound. Todd-AO soon emerged as a premier format, reserved for big-budget blockbusters, which could be shown at top prices on a roadshow basis in the largest, most exclusive theatres. It led the way for other 65/70 mm. processes, such as MGM's Camera 65 (*Ben-Hur*, 1959), Ultra Panavision 70 (*Mutiny on the Bounty*, 1962), and Super Technirama 70 (*Spartacus*, 1960).

Although widescreen became a new standard, stereo magnetic sound quickly disappeared as a new technology. Movie palaces used it as an additional lure for audiences, but independent exhibitors refused to pay the added costs involved in equipping their theatres for stereo. At the same time, audiences accustomed to hearing dialogue emanate from a central theatre speaker resisted multitrack dialogue, which travelled from theatre speaker to theatre speaker. Five- and six-track sound, which accompanied large-format films, provided a more even distribution of dialogue, and continued to satisfy the needs of audiences for spectacle, but three- and four-track sound failed to catch on.

The various production and exhibition technologies introduced during the 1950s constituted a revolution of sorts in the nature of the movie-going experience. Audiences were initially overwhelmed by widescreen images in colour, which were projected on large, curved screens and accompanied by multi-track stereo magnetic sound. If the cinema can be said to have begun as a novelty with the peep-show Kinetoscope and with the projection of moving images on a large theatre screen for a mass audience, then the explosion of novel technologies in the 1950s almost amounts to a reinvention of the cinema. For the first time since

the transition-to-sound era, movies spectacularized the motion picture medium, thrilling audiences with displays of its power to move them. The revolution that took place in the 1950s may well represent the last chapter in the cinema's attempt, as a medium, to recapture, through the novelty of its mode of presentation, its original ability to excite spectators.

3-D, CinemaScope, Color, and the Tube

Television was not the sole cause of the film industry's commercial decay. The American demographic shift from the cities to the suburbs began just after the war. Movie theatres had always been concentrated in the city centers, and the multiplex cinemas of suburban shopping mails were two decades away. There were also many new ways to spend leisure time and the leisure dollar, including sports, travel, and music.

By 1952, Hollywood knew that television could not be throttled. If films and TV were to coexist, the movies would have to give the public what TV did not. The most obvious difference between movies and TV was the size of the screen. Television's visual thinldng was necessarily in inches, whereas movies could compose in feet and yards. Films also ebjoyed the advantage of over 50 years of technological research in color, properties of lenses, and special laboratory effects; the infant television art had not yet developed color or videotape. Hollywood's two primary weapons against television were to be size and technical gimmickry.

One of the industry's first sallies was 3-D, a three-dimensional, stereoscopic effect produced by shooting the action with two lenses simultaneously at a specified distance apart. TWo interlocked projectors then threw the two perspectives on a single screen simultaneously; the audience used cardboard or plastic glasses (with red and blue lenses for black-and-white films, polarized clear lenses for color films) to read the two overlapping, fiat images as a single three-dimensional one.

Despite the familiarity of the stereoscopic principle, to see it in a full-length, active feature film was a great novelty. The first 3-D feature was Harry K. Fairall's *The Power of love* (U.S., 1922); Russia released its first 3-D film, *Day Off in Moscow*, in 1940. Hollywood rushed into 3-D production in 1952 with Arch Oboler's *Bwana Devil*, which was followed by pictures like *House of Wax*, *It Came From Outer Space*, *Fort Ti*, *Kiss Me Kate*, and *I, the Jury* (all 1953); *Creature from the Black Lagoon*, *The French Line*, and *Gog* (all 1954); and finally, *Revenge of the Creature* (1955). Audiences eagerly left their TV sets to experience the gimmick that attacked them with knives, arrows, avalanches, stampedes, vats of chemicals, Ann Miller's tap shoes, and Jane Russell's bust; the thrill of 3-D was

that the formerly confined, fiat picture convincingly threatened to leap, fly, or flow out of its frame at the audience.

Some blame the death of 3-D on the headacheinducing glasses that it required, but the more obvious cause of death was that any pure novelty becomes boring when it is no longer novel. 3-D was pure novelty; the thrill of being run over by a train is visually identical to that of being run over by a herd of cattle. Further, because 3-D required the theatre owner to make costly additions and renovations (in order to perform changeovers, mere startup costs included four projectors— two for each reel), the exhibitors declared a war of neglect against the process and hastened its demise. Business for 3-D films fell off so quickly that Hitchcock, who had shot Dial *M for Murder* (1954) in the new process—taking full advantage of the opportunity to compose in depth—released it in the conventional two dimensions.

A second movie novelty also promised thrills. Cinerama, unlike 3-D, brought the audience into the picture, not the picture into the audience. Cinerama originally used three interlocked cameras and four interlocked projectors (the fourth for the soundtrack). The final prints were projected not on top of one another (superimposed, as in 3-D), but side by side—with barely visible vertical lines where the images met. The result was an immense wraparound image that was really three images. The wide, high, deeply curved screen and the relative positions of the three cameras worked on the eye's peripheral vision to make the mind believe that the body was actually in motion. The difference between a ride in an automobile and a conventionally filmed ride is that in an automobile the world also moves past on the sides, not just straight ahead. Cinerama's huge triple screen duplicated this impression of peripheral movement.

Like 3-D, the idea was not new. In 1927, Abel Gance had incorporated triple-screen effects, both panoramic and triptych, into his *Napoléon*. In 1938, Fred Waller, Cinerama's inventor, began research on the process. But when *This Is Cinerama* opened in 1952, audiences choked— quite literally—with a film novelty that sent them racing down a roller-coaster track and soaring over the Rocky Mountains. A magnificent sixtrack (in later Cinerama films, seven-track) stereophonic sound system accompanied the thrilling pictures; sounds could travel from left to right across the screen or jump from behind the screen to behind the audience's heads.

Cinerama remained commercially viable longer than 3-D because it was more carefully marketed. Because of the complex projection machinery, only a few theatres in major cities were eqmpped for the process. Seeing Cinerama became a special, exciting event; the film was sold as a "roadshow" attraction with reserved seats, noncontinuous performances, and high prices. Customers returned to Cinerama because they could see a Cinerama film so infrequently. (The second,

Cinerama Holiday, came out three years after *This Is Cinerama*.) And although Cinerama repeatedly offered its predictable postcard scenery and its obligatow rides and chases, the films were stunning travelogues.

Cinerama faced new troubles when it too tried to combine its gimmick with narrative: *The Wonderful World of the Brothers Grimm* (1962), *It's a Mad Mad Mad Mad World* (1963), *How the West Was Won* (1963). As with 3-D, what Aristotle called "Spectacle" (he found it the least important dramatic element) overwhelmed the more essential dramatic ingredients of plot, character, and ideas. In 1968, Stanley Kubrick's 2001: *A Space Odyssey* subordinated a modified Cinerama (shot with a single camera but projected on a Cinerama screen) to the film's sociological and metaphysical journey, letting the big screen and sound work for the story rather than letting the story work for the effects. Despite the artistic and commercial success of 2001, Cinerama was not the salvation that Hollywood thought.

A third gimmick of the early 1950s also took advantage of the size of the movie screen. The new format, christened CinemaScope, was the most durable and functional of them all, requiring no extra projectors, special film, or special glasses. It did, however, require theatre owners to invest in "scope" or anamorphic projection lenses; wide, curved screens; and, in most cases, stereophonic sound systems. The action was recorded by a conventional movie camera on conventional 35mm film. A special anamorphic lens squeezed the image horizontally to fit the width of the standard film. When projected with a corresponding anamorphic lens on the projector, the distortions disappeared and a huge, wide image stretched across the curved screen. The first CinemaScope feature, Henry Koster's *The Robe* (1953), convinced both Fox and the industry that the process was viable. The screen had been made wide with a minimum of trouble and expense. A parade of screen-widening "scopes" and "visions" followed Fox's CinemaScope, notably VistaVision, which print.ed the image sideways on the celluloid strip, and Todd-AO, which widened the film to 70nun. Tile first 70mm film of tile 1950s was *Oklahoma!* (1955), directed by Fred Zinnemann.

Ultimately it was size and grandeur that triumphed, not depth perception or motion effects. As early as 1930, Eisenstein advocated a flexible screen size, a principle he called the "dynamic square". He reasoned that the conventional screen, with its four-to-three ratio of width to height (an aspect ratio of 4:3, or 1.33:1), was too inflexible. The screen should be capable of becoming very wide for certain sequences, narrow and long for others, a perfect square for balanced compositions. But Eisenstein's principles were much closer to Griffith's use of masking or irising than to the wide screen's inflexible commitment to width .George Steven complained that CinemaScope was better for shooting a python than a person. How could a horizontal picture frame, with a five-to-two ratio of width to height, enclose a vertical subject?

Like sound in the early years, the new technological invention was a mixed blessing, adding some new film possibilities and destroying many of the old compositional virtues. What many critics of the wide screen did not perceive at the time was that just as deep focus permitted contrapuntal relationships between near and far within the frame (as in *Citizen Kane*), the wide screen permitted contrapuntal relationships among left, center, and right.

George Cukor's *A Star Is Born* (1954), a great remake of William Wellman's great 1937 melodrama, provides powerful proof of this potential. Two sequences demonstrate not only Cukor's mastery of the format, but also his awareness of its history and value. In one scene, Oliver Niles (Charles Bickford), the head of the studio, fires the aging matinee idol, Norman Maine (James Mason). Maine's popularity has been slipping and the studio itself has been slumping. The cause? Television. During this conversation, the men stand between two flickering black-and-white images on the far left and right edges of the frame. To the far left is a TV set; Niles has been watching the fights on TV (even a studio head cannot stay away from a TV screen). To the far right of the frame is a motion picture, projected in the next room for Maine's party guests. The discussion between Maine and Niles takes place precisely between a video image and a film image—a visual translation of the historical crossroads where all the studio heads and studio stars found themselves in 1954.

Cukor uses television again in the film's Academy Award ceremony. While Cukor shoots Vieky Lester's (Judy Garland) triumph with the CinemaScope lens in medium long shot, a TV monitor in the upper right-hand corner of the frame displays the moment in typical TV closeups. The shot is simultaneously a long shot and a close-up, a wide-screen color image and a smallscreen black-and-white TV image, a revelation of CinemaScope's visual power and television's cultural power, capable of bringing this moment, "live", into people's homes in close-ups.

The wide CinemaScope frame enabled Cukor to shoot whole scenes—even Garland's entire rendition of "The Man That Got Away"—in a continuous, complexly choreographed shot without a cut. (Of course, Welles and Toland had done that with the standard frame in *Citizen Kane*.) In the work of Cukor, Dorian, Ophüls, Preminger, and others, the 1950s saw an explosion of interest in the uses of the wide screen, an interest that remained evident in the 1960s and 70s works of such directors as Lean, Kurosawa, Leone, Peckinpah, and Godard. By the mid-1960s, the wide-screen revolution was as complete as the sound revolution of the late 1920s, and the wide new generation's film aesthetics.

The battle with television was partially responsible for another technical revolution in the 1950s—the almost total conversion to color. From the earliest days of moving pictures, inventors and filmmakers sought to combine color with recorded movement. The early Méliès films were hand-painted flame by frame.

Many silent films were bathed in color tints, adding a cast of pale blue for night sequences, sepia for interiors, and so on. As early as 1908, Charles Urban patented a high-quality color photographic process, Kinemacolor. But opposition from the then-powerful MPPC Trust kept Kinemacolor off American screens.

In 1917, the Technicolor Corporation was founded in the United States. Supported by all the major studios, Technicolor enjoyed monopolistic control over all color experimentation and shootlng in this country. Douglas Fairbanks's *The Black Pirote* (1926) and the musicals *Rio Rita* (1929) and *Whoopee!* (1930) used the early Technicolor process, which added a garish grandeur to the costumes and scenery. In the 1920s, Technicolor was, like Urban's Kinemacolor, a two-color process: two strips of film exposed by a single lens equipped with a beant-splitter prism, one strip recording the Mue-green colors of the spectrum, the other sensitive to the red-orange colors, then bonded together in the final processing. But by 1933 Technicolor had perfected a more accurate three-color process; three strips of black-and-white film, one exposed through a filter to red, the second to blue, the third to green, originally requiring a bulky three-prism camera—with a single lens—for the three rolls of film, copies of which were used to transfer red, blue, and green dyes to a print. The first two-strip Technicolor feature had been *The Toll of the Sea* (1922); the one that used color most creatively was *Doctor X* (1932). The first film made in the three-strip process was Disney's cartoon *Flowers and Trees* (1932). RKO's *La Cucaracha* (1934) was the first three-strip Technicolor live-action short, and Rouben Mamoulian's *Becky Sharp* (1935) the first three-strip Technicolor feature. Hollywood could have converted to color at almost the same time it converted to sound. But expenses and priorities dictated that most talkies use black-and-white film, which was itself becoming faster, subtler, more responsive to minimal light, easier to use under any conditions. Color was reserved for cartoons or for lavish spectacles that could afford the slowness and expense of color shooting (for example, Michael Curtiz and William Keighley's *The Adventures of Robin Hood*, 1938; Victor Fleming's *Gone With the Wind* and *The Wizard of Oz*, both 1939).

World War II, which demanded that the film industry keep up production while tightening its belt, generally excluded the luxury of color filming—unless the film had propaganda value and was likely to improve morale. England put up the money for Laurence Olivier's *Henry V* (1944), whose splendid and complex use of color intensified the film's propagandistic appeal.

After the war, Hollywood needed color to fight television, which—at least until the late 1950s—could offer audiences only black and white. Technicolor, formerly without competitors, had kept costs up and production down. Hollywood began encouraging a new, competing single-strip process, Eastmancolor. The new process was one of the spoils of war, a pirated copy of the German Agfacolor monopack. The monopack color film bonded three color-sensitive emulsions onto a single roll of film

stock. A color film could be shot with an ordinary movie camera. Color emulsions became progressively faster, more sensitive, more flexible. A series of new processes—DeLuxe, Metrocolor, Warnercolor—were all variations of Eastmancolor, which was less expensive and of lower quality than monopack Technicolor (introduced in 1942). What these monopack color processes gained over three-strip Technicolor in cheapness and flexibility they sacrificed in intensity and brilliance. (Technicolor's clean dyes were picked up and transferred directly onto the print by three strips or matrixes struck from the camera's three strips, but the Eastman dyes were *in* the stock and had to go through chemical processing in the lab.) So unstable and impermanent were their color dyes that Eastmancolor prints of the 1950s have already faded badly.

During the 1950s, black and white gradually became the exception and color, even for serious dramas, little comedies, short subjects, and low-budget westerns, became the rule. As the technology of color cinematography became more flexible, film artists learned, as they did with sound, that a new technique was not only a gimmick, but also a way to fulfill essential dramatic and thematic functions.

Sound quality improved drastically after World War II, thanks to the introduction of magnetic tape (another of the spoils of war, invented in Nazi Germany). Until 1949, optical film was used to record all film soundtracks.

Although the movies fought TV by offering audiences audiovisual treats that the tube lacked, Hollywood finally capitulated to TV by deciding to work with it rather than against it. If TV would not die, then it would need old movies and filmed installments of series to broadcast. Hollywood also lifted its ban against films and film stars appearing on TV. In 1954, RKO began to show its own movies on its own stations; as in a theatre, the "Million Dollar Movie" repeated the week's picture several times a day. In 1956, the other Hollywood studios first sold their films to TV, the sole provision being that the film had to have been produced before 1948. Since 1956, however, Hollywood has sold more and more recent films to the networks or cable stations. In a sense, TV has replaced the old fourth-and fifth-run neighborhood movie houses, most of which had disappeared by 1965—much as the rentable video has nearly wiped out the revival house.

By 1956, the war with TV was over, and although the armistice had clearly defined the ramses' future relationship with its living-room audiences, the future with its audiences in theatres was still uncertain.

2. 类型片的转型与科幻片的兴起

战后好莱坞类型电影业与时俱进发生着一系列变化。首先是类型大片的出现，如像罗伯特·怀斯的歌舞大片《西区故事》《音乐之声》、约翰·福特

和威廉·惠勒的西部大片《搜索者》和《锦绣大地》，以及《十诫》（1956年彩色版）、《宾虚》和《万世流芳》等历史大片；其次是类型片的深化，如西部片就演化成为《正午》（*High Noon*，1952）之类的"心理（成人）西部片"、《七侠荡寇志》之类的"职业西部片"和《双虎屠龙》之类的"反省西部片"等。而黑色电影也因冷战和好莱坞黑名单等背景而出现反共的意味；第三，科幻片的兴起和繁荣。

科幻片（science-fiction film）最早可以追溯到梅里爱1902年的《月球旅行记》，朗格1927年的《大都会》代表着科幻片的成形。而随着战后科技的发展、冷战的氛围和核武的威胁，20世纪50年代迎来了美国科幻电影的第一个黄金时代，代表作品包括《地球停转之日》《怪人》和《人体入侵者》等。

New Twists on Old Genres

With greater competition for the entertainment dollar, the major firms gave nearly all genres a higher gloss. And as studios cut back on the number of films produced, each movie had to be more distinctive. Executives enhanced production values with bigger stars, opulent sets and costumes, and the resources of color and widescreen technology. Even minor genres benefited from efforts to turn B scripts into A pictures.

The Western The postwar Western was set on the "big-picture" trail by David O. Selznick with *Duel in the Sun* (1945). King Vidor was fired from this passion drenched Technicolor saga before several other directors completed it. Roadshowed, it earned large grosses and set the pattern for *Red River* (1948), *Shane* (1953), *The Big Country* (1958), and other monumental Westerns.

More modest Westerns also benefited from enhanced production values, the maturity and range of the directors and stars, and a new narrative and thematic complexity. The genre helped John Wayne and James Stewart consolidate their postwar reputations. Color cinematography enhanced the majestic scenery of *The Naked Spur* (1953, Mann) and the rich costume design of Hawks's *Rio Bravo* (1959). At the same time, social and psychological tensions were incorporated. A Western might be liberal (*Broken Arrow*, 1950), patriarchal (*Red River*; *The Gunfighter*, 1950), youth-oriented (*The Left-Handed Gun*, 1958), or psychopathic (the Ranown cycle directed by Bud Boetticher; Sam Peckinpah's *The Deadly Companions*, 1961).

While the typical B film had run between 60 and 70 minutes, *Duel in the Sun* clocked in at 130 minutes, *Red River* at 133, and *Shane* at 118. Even less epic Westerns tended to run longer; *Rio Bravo's* charmingly rambling plot filled 141 minutes. Clearly such films were no longer designed to be the second half of a

《正午》中孤独的美国英雄

double feature—they were the sole attraction.

The Melodrama Enhanced production values also drove the melodrama to new heights. At Universal, producer Ross Hunter specialized in *women's pictures*, and central to his revamping of the genre was Douglas Sirk. Sirk was an émigré who had made anti-Nazi pictures and films noirs during the 1940s. Working with cinematographer Russell Metty, Sirk lit Universal's plush sets in a melancholy, sinister low key. Psychologically impotent men and gallantly suffering women (*Magnificent Obsession*, 1954; *All That Heaven Allows*, 1955; *Written on the Wind*, 1956; *Imitation of Life*, 1959) play out their dramas in expressionistic pools of color and before harshly revealing mirrors. Critics in later decades believed that Sirk's direction undercut the scripts' pop-psychology traumas and pat happy ending.

The Musical No genre benefited more from upgrading than the musical, believed to be Hollywood's most durable product. Every studio made musicals, but the postwar decade was ruled by MGM. The studio's three production units mounted everything from operatic biopics to Esther Williams aquatic extravaganzas. Backstage musicals like *The Barkleys of Broadway* (1949) were balanced by folk musicals like *Show Boat* (1951). Adaptations of Broadway hits (e.g., *Kiss Me Kate*, 1953) were matched by original scripts (e.g., *Seven Brides for Seven Brothers*, 1954). A film might be built around a set of career hits from a single lyricist-composer team. *The Band Wagon* (1953), for example, was based on the songs of Howard Dietz and Arthur Schwartz.

The most lauded musical unit at MGM was overseen by Arthur Freed, a top producer since *The Wizard of Oz*. The Freed unit showcased the best talents—

Judy Garland, Fred Astaire, Vera-Ellen, Ann Miller, and, above all, Gene Kelly, the wiry, wide-grinning dancer who added athletic modern choreography to the MGM product. *On the Town* (1949, codirected by Kelly and Stanley Donen), a frenetic tale of three sailors on a day pass in Manhattan, was not the first film to stage its numbers on location, but the choreography and the cutting gave the film a hectic urban energy. *In Brigadoon* (1954, Vincente Minnelli) and *It's Always Fair Weather* (1955, Kelly and Donen), Kelly made the musical a sour comment on masculine frustrations in postwar America.

More lighthearted was *Singin' in the Rain* (1952, Kelly and Donen), widely considered the finest musical of the period. Set during the transition to talkies, the film pokes fun at Hollywood pretension while satirizing the style of early musicals and creating gags with out-of-sync sound. The numbers include Donald O'Connor's calisthenic "Make 'Em Laugh"; Kelly's title number, blending swooping crane shots with agile choreography that exploits puddles and umbrellas; and the "Broadway Melody" number, an ebullient homage to MGM's early sound musicals.

Although MGM continued to turn out striking musicals after the mid-1950s, it was no longer the leader. Goldwyn's *Guys and Dolls* (1955), Paramount's *Funny Face* (1956), United Artists' *West Side Story* (1961), Columbia's *Bye Bye Birdie* (1963), and Disney's animated ventures all made the "big musical" a box-office stalwart. 20th Century-Fox based several roadshow musicals on Broadway hits— *The King and I* (1956), *Carousel* (1956), and *South Pacific* (1958), followed a few years later by the biggest blockbuster of all, *The Sound of Music* (1965). Warners contributed to the genre with George Cukor's *A Star Is Born* (1954) and Doris Day vehicles such as *The Pajama Game* (1957) before dominating the 1960s with *The Music Man* (1962), *My Fair Lady* (1964), and *Camelot* (1967).

Rock and roll brought new dynamism to the postwar musical. *Rock around the Clock* (1956) paved the way, and spon both Majors and independents went after teenage record buyers. After crooning rather than jittering in his debut, *Love Me Tender* (1956), Elvis Presley went on to present a fairly sanitized version of rock and roll in thirty musicals over the next dozen years. The genre was mocked in Frank Tashlin's *The Girl Can't Help It* (1956), which nonetheless managed to include "straight" numbers by popular bands.

Historical Epics Westerns, melodramas, and musicals had been major genres for several decades, but the inflation of production values and the speculating on big pictures brought another genre to prominence. The biblical spectacle had proved lucrative in the hands of Cecil B.DeMille in the 1920s and 1930s, but it had lain untouched until DeMille revived it in *Samson and Delilah*, the top-grossing film of 1949. When *Quo Vadis?* and *David and Bathsheba* (both 1951) also earned exceptional receipts, a cycle of historical pageants was launched. The genre's need

for crowds, colossal battles, and grandiose sets made it natural for widescreen processes, and so *The Robe*, its sequel *Demetrius and the Gladiators* (1954), and *Spartacus* (1960) all showcased widescreen technologies.

"Those who see this motion picture produced and directed by CECIL B. DEMILLE will make a pilgrimage over the very ground that Moses trod more than 3,000 years ago". Thus opens *The Ten Commandments* (1956), one of the most enduringly successful biblical epics. (Some observers noted that the credit gives Moses only second billing.) The film used 25,000 extras and cost over $ 13 million, a stupendous amount for the time. Despite ambitious special effects like the parting of the Red Sea, DeMille's staging often harked back to the horizontal blocking of his 1930s films. William Wyler's *Ben-Hur* (1959) proved an equally successful biblical blockbuster; it held the record for the most Oscars won (eleven) for decades, until another historical epic, *Titanic* (1997), tied with it.

Historical epics treated virtually every period. There were Egyptian pageants (*The Egyptian*, 1954; *Land of the Pharaohs*, 1955), chivalric adventures (*Ivanhoe*, 1952; *Knights of the Round Table*, 1953), and war sagas (*War and Peace*, 1956; *The Bridge on the River Kwai*, 1957; *Exodus*, 1960). Most of these attracted audiences, but because of budget overruns in production, some proved unprofitable in the long run.

Upscaling Genres Another genre was revived by the new commitment to big pictures. As the market in science-fiction writing expanded after the war, producer George Pal proved that the atomic age offered a market for science-fiction movies. The success of his *Destination Moon* (1950) gave him access to Paramount budgets for *When Worlds Collide* (1951) and two prestigious productions based on works by H. G. Wells, *The War of the Worlds* (1953) and *The Time Machine* (1960). Using color and sophisticated special effects, Pal's films helped lift science fiction to a new respectability. *Forbidden Planet* (1956), with CinemaScope, electronic music, an "Id-beast", and a plot based on *The Tempest*, was a somewhat more forced effort to dignify the genre. Disney's first CinemaScope feature, 20, 000 *Leagues under the Sea* (1954), and the precise stop-motion work of Ray Harryhausen (e.g., *The Seventh Voyage of Sinbad*, 1959) aided the rebirth of the fantasy film.

Less expensive science-fiction and horror films portrayed technology in a struggle with unknown nature. In *The Thing* (1951), scientists and military men discover a monstrous alien in the Arctic wastes. *In Invasion of the Body Snatchers* (1955), an average town is overrun by pods from outer space who clone the citizens and replace them with unfeeling replicas. Opposed to these paranoid fantasies were pacifist films, exemplified by *The Day the Earth Stood Still*, in which an alien urges earthlings to give up war. Special effects dominated films that portrayed eccentric science and misbegotten experiments, such as *The Fly*

(1958) and *The Incredible Shrinking Man* (1957). Such films were interpreted in immediate historical terms, often as commentaries on cold war politics or the nightmarish effect of nuclear radiation.

Low-budget movies, in order to compete with the new scale of expenditures, had to find their own selling points. The crime film, for instance, became more violent. Menacing films noirs like *Out of the Past* (1947) seemed subdued in comparison to the souped-up sadism of *The Big Heat* (1953) and *Kiss Me Deadly* (1955) and the brutality of a thug running down a little girl in *Underworld USA* (1961).

By the early 1960s, a genre film might be either a lavish blockbuster or a stark, seedy exercise. When the distinguished Hitchcock made a black-and-white thriller called *Psycho* (1960) without major stars and on a B-picture budget, he launched a cycle of grand guignol (e.g., *What Ever Happened to Baby Jane?*, 1962) that continued for decades. After fifteen years of dressing up genre formulas, leading filmmakers began to dirty them up.

3. 好莱坞黑名单

作为冷战在好莱坞的体现，麦卡锡主义的美国非美活动委员会（HUAC）在 1947 年和 1951 年两度召开听证会，要求好莱坞电影工作者作证说明共产党活动情况并指认共产党员，导致令人发指的出卖和背叛。该委员会将倾向左派共产党、同情苏俄和拒绝作证的十位好莱坞电影人（主要是编剧）列入黑名单而入狱失业，导致一向莺歌燕舞、欢乐祥和的好莱坞风声鹤唳、人人自危。"好莱坞黑名单或好莱坞十君子"（the Hollywood Ten and the Blacklist）为好莱坞留下历史污点，不但损害了电影的创作自由，也给相当一部分电影人造成难以愈合的心理创伤。

1960 年"好莱坞十君子"之一达尔顿·特朗勃（Dalton Trumbo）首次使用真名编剧《出埃及记》和《斯巴达克斯》，好莱坞黑名单的噩梦才宣告结束。

The HUAC Hearings and the Blacklist "Hollywood Ten"

These specific legal and commercial woes were accompanied by a general shift of American mood in the years following the war that also contributed

麦卡锡参议员与"好莱坞十君子"

to the ills of a troubled industry. The Cold War years of suspicion—dislike of foreign entanglements in general and the increasing fear of the "Red Menace" in particular—also produced a distrust of certain institutions within the United States. Because the film industry was so active in the war effort against the Nazis, because so many Hollywood producers and screenwriters were Jewish, because so many Jewish intellectuals seemed sympathetic to liberal political positions, and because the most extreme right-wing American opinion saw the entire war as a sacrifice of American lives to save the Jews in Europe and help the Soviets defend the Eastern front, it was not surprising that these rivers of reaction coalesced into an attack on the motion-picture industry as a whole. Whereas for four decades American suspicion had concentrated on Hollywood's sexual and moral excesses, in the decade following the war distrust shifted to Hollywood's political and social positions: to the subversive, pro-Communist propaganda allegedly woven—mainly by the writers—into Hollywood's entertainment films.

The first set of hearings of the House UnAmerican Activities Committee (or HUAC) in the fall of 1947, investigating Communist infitration of the motion-picture industry, produced the highly publicized national scandal of the "Holly wood Ten". Asked "Are you now or have you ever been" a Communist, the Ten—screenwriters Alvah Bessie, Lester Cole, Ring Lardner, Jr., John Howard Lawson, Albert Maltz, Samuel Ornitz, and Dalton Trumbo; director Edward Dmytryk; writer-producer Adrian Scott; and directorproducer Herbert J. Biberman'a—ccused the Committee of violating the Bill of Rights by its existence. When the Ten were

cited for contempt of Congress, the motion-picture industry reacted fearfully by instituting a blacklist—no known or suspected Communist or Communist sympathizer would be permitted to work in any capacity on a Hollywood film. Convicted, their appeals denied, the Ten began to serve one-year sentences in 1950. (When he got out, director Dmytryk named names and went back to work.)

The second set of congressional hearings (1951-52) gave witnesses two choices. If they admitted a previous membership in the Communist Party, they were obligated to name everyone else with whom they had been associated at that time or suffer a contempt of Congress sentence as had the Hollywood Ten. The other choice was to avoid answering any questions whatever on the basis of the Constitution's Fifth Amendment guarantee against self-incrimination. Although "taking the Fifth" kept the witness out of prison, it also kept the witness out of work—thanks to the industry's blacklist.

A number of the blacklisted writers found work under pseudonyms. Many left Hollywood, and some left the country. In 1953, an independent film called *Salt of the Earth* was shot in New Mexico by three blacklistees: writer Michael Wilson, director Herbert Biberman, and producer Paul Jarrico. Wilson's script, the true story of a mining strike that lasted more than a year, was critiqued by and rewritten to the satisfaction of the hundreds of people who had participated in the strike, many of whom played themselves in the movie. *Salt of the Earth* rigorously and dramatically analyzes a problem common to many political movements: that as the boss or tyrant treats the worker, so the male revolutionary often treats the female revolutionary. In this film the miners learn to stop treating their wives as underlings, and the newly unified commmnity wins its battles. Completed despite concered attacks, *Salt of the Earth* had practically no distribution in America, though it won acclaim abroad.

The result of the congressional hearings—and the controversial blacklist, the damaging publicity in the press, the threats of boycott against Hollywood films by the American Legion, the lists of suspected Conmmnists or Communist sympathizers in publications such as *Red Channels*—was an even greater weakening of the industry's crumbling commercial and social strength.

By the late 1950s, the star system and the studio system were as good as dead. A minor studio like Columbia, with very few stars under contract, a small lot, and no theatres, stayed healthier in those years of thinner profits. The big movie houses suffered with the big studios. On a weeknight, only a few hundred patrons scattered themselves about a house built for thousands. One by one the ornate palaces came down, to be replaced by supermarkets, shopping centers, and apartment buildings.

4. 转型期的导演们：斯蒂芬斯、怀尔德、津纳曼、卡赞、普莱明格、富勒、雷伊和西尔克及"方法学派"的青春偶像

转型时期好莱坞的电影导演们虽不如经典时期大师的万丈光芒，但同样是群星灿烂、五彩缤纷。

乔治·斯蒂芬斯（George Stevens）以手法细腻、画面精致、工于剧情和善用演员的"美国梦三部曲"著称，他的《郎心似铁》（根据德莱塞小说《美国悲剧》改编）和《巨人传》深刻揭示资本主义社会金钱和地位给人性带来的腐蚀和摧残，而他唯一的西部片《原野奇侠》则赋予了经典类型显著的反省性意味。

奥匈帝国犹太裔剧作家出身（曾担任刘别谦和霍克斯的编剧）的比利·怀尔德（Billy Wilder）是好莱坞不可多得的全才导演，擅长喜剧片、剧情片、黑色电影和战争片等多种类型和嘲讽、睿智和大胆的风格。他的《双重赔偿》是黑色电影的巅峰之作，《日落大道》是反省好莱坞的最佳剧情片，而《热情似火》则被公认为好莱坞喜剧片的执牛耳者。

与怀尔德的嬉笑怒骂皆成文章不同，同样出生于奥地利、曾跟随纪录片之父弗拉哈迪短暂学艺的弗雷德·津纳曼（Fred Zinnemann）则执著于写实派的传统和道德人性的研判。《正午》借用西部片的外壳表达麦卡锡主义时代难能可贵的正义和勇气，《乱世忠魂》涉及军队的人性和伦理冲突，而《四季之人》则全力塑造古代圣贤托马斯·莫尔正直和以身殉道的高尚品质。

伊利亚·卡赞（Elia Kazan）执导过田纳西·威廉斯舞台剧改编的《欲望号街车》、根据有关码头工会新闻报道撰写的《码头风云》和斯坦贝克原著改编的《伊甸园的东方》，对社会政治、现实生活和个人道德表达深切的关注。舞台出身的卡赞是斯坦尼斯拉夫斯基体系"方法学派"的忠实信徒（他联合创建了著名的"演员工作室"），而一度信仰共产主义的他又不得不用《码头风云》和自己的后半生来洗刷在非美活动委员会指认朋友同事的污点。

奥托·普莱明格（Otto Preminger）用自己的《蓝月亮》《金臂人》和《桃色杀机》对好莱坞的性、暴力和毒品戒律提出挑战，而萨缪尔·富勒（Samuel Fuller）则以低成本的《美国黑社会》《恐怖走廊》和《裸吻》直面美国社会普遍存在的暴力和变态。

孤独的反叛者尼古拉斯·雷伊（Nicholas Ray）被因其特立独行、游走于好莱坞体制之外而称为美国的"电影作者"（auteur），他最著名的作品《无因的反抗》既是年轻一代对家庭社会的反叛，也是雷伊自己对好莱坞和资本主义美国物欲泛滥、精神空虚的鞭挞。

此外，欧洲移民导演道格拉斯·西尔克（Douglas Sirk）在20世纪50年代拍摄了《地老天荒不了情》《此情可问天》和《春风秋雨》等一系列剧情片，对爱情、死亡和社会禁锢等进行具有一定深度的探讨，产生过广泛的社会影响。

"方法学派"（Method Acting）来自于俄罗斯戏剧大师康斯坦丁·斯坦尼斯拉夫斯基（Konstantin Stanislavski）的体验式表演方法，该方法构成了纽约"演员工作室"（the Actor's Studio，创建于1947年）的教学核心。该工作室在李·斯特拉斯伯格（Lee Strasberg）的领导下培养出詹姆斯·迪恩（《巨人传》《伊甸园的东方》和《无因的反抗》）、马龙·白兰度（《欲望号街车》和《码头风云》）和蒙哥马利·克利夫特（《红河》和《郎心似铁》）等一代青春偶像，而方法学派更通过玛丽莲·梦露、保罗·纽曼、简·方达、达斯廷·霍夫曼、罗伯特·德尼罗、艾尔·帕西诺和丹尼斯·霍普等明星传人对后来的美国电影产生巨大的影响。

随着战后美国社会的发展和思想的进步，以及好莱坞体制的分崩离析，经典时期建立的美国电影审查制度也受到空前的挑战。1952年美国电影发行商进口罗西里尼涉嫌亵渎宗教的影片《奇迹》遭到地方司法当局的禁映，但美国最高法院将电影定性为"出版发行"、享有言论自由（特别是小范围放映的"艺术电影"），此举严重冲击《海斯法典》的权威性。而普莱明格1953年的《蓝月亮》索性拒绝申请电影审查的批准印章，结果实施长达三十四年的《海斯法典》终于在1968年寿终正寝，让位于更加灵活和开放的电影分级制度（rating system）。

Stevens, Wilder, Zinnemann and Kazan

George Stevens, a native Californian, was in some ways even more firmly placed in the Hollywood aristocracy than George Cukor. Both of Stevens's parents were actors, and he made his debut on stage at the age of five, performing in his father's traveling company. He began work in the film industry in 1921, as an assistant cameraman; he became a cameraman and eventually a director of shorts. He directed his first feature in 1933.

Stevens's films of the thirties varied considerably in genre but were consistently well made. For example: *Alice Adams* (1935) offers some delightful small-town Americana; *Swing Time* (1936) is one of the best of the Astaire-Rogers musicals; *Gunga Din* (1939), based on a Kipling poem, commemorates the British in India. In the forties he made three engaging comedies in succession: *Woman of the Year* (1942), the first film costarring Hepburn and Tracy; *The Talk of the Town*

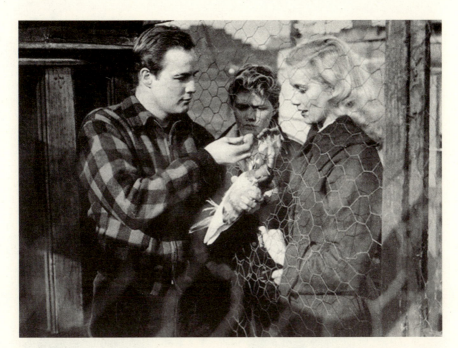

《码头风云》

《巨人》中的青春偶像詹姆斯·迪恩

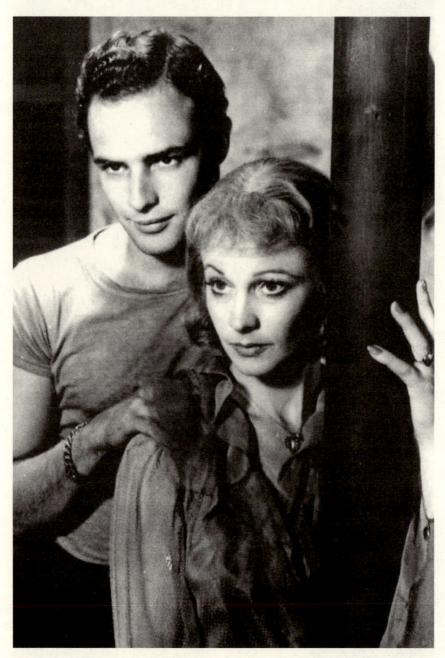

《欲望号街车》剧照

(1942), a distinguished jurist and his landlady joined by a suspected arsonist; *The More the Merrier* (1943), wartime housing shortage in Washington, D.C.

Then in the 1950s Stevens's work seemed to change direction and he made three of his finest films in succession: *A Place in the Sun* (1951), an updated and softened version of Theodore Dreiser's novel *The American Tragedy*; *Shane* (1953), a mythic tribute to the western genre (Stevens's only western); and *Giant* (1956), from the Edna Ferber novel, a celebration and castigation of Texas. These were more serious than his earlier films, with more substantial characterizations (and excellent performances), and a fuller, more exploratory use of cinematic technique.

A Place in the Sun is especially remarkable for its experimentation with sound in relation to sight. Its sound track, rich and detailed, complements the visuals to an unusual degree. A radio, unnoticed by the lonely and pregnant Alice (Shelley Winters), softly plays dance music, adding poignancy to a scene in which she waits in vain for George (Montgomery Clift), who is being drawn away from her by his attraction to the wealthy and glamorous Angela (Elizabeth Taylor). Or again, a portable radio on a deserted lakeside dock carries a newscast of the discovery of Alice's drowning, as George and Angela roar past in the near distance in a powerful speedboat. From time to time, sirens and barking dogs are heard, as they would be in life, contributing to a sense of uneasiness. A loon's cry just before Alice's death is a foreboding.

The film has a sad, romantic glow that sticks in the memory; for example, George and Angela dancing late at night, dreamily in love. In this scene the shots, many of them huge close-ups, are joined by slow dissolves rather than cuts, holding the delicate, unrecapturable moment before us. The loveliness of Angela, the hopelessness of George's longing for her, given their class differences and his obligation to Alice, are eloquently manifest. Stevens considered *A Place in the Sun* his best film.

Westerns tend to be more closely connected to genre conventions than to the historical or geographical West, but *Shane* seems to be about westerns. Its West, filmed mostly on location in Wyoming, is a lovely valley enclosed by snow-capped mountains seen in expansive panoramic shots (VistaVision and Technicolor). A drab clapboard settlement squats along a muddy street in the middle of it. The farmers settling the valley look real enough and seem to have real problems-with the land and with the ranchers who don't want them on it. Into this community rides the mysterious title character (played by Alan Ladd in white buckskin) at the time the homesteaders need someone to face up to the cattle baron's hired gun, the black-garbed Wilson (Jack Palance). The simple story is seen through the eyes of a boy (Brandon de Wilde) who idolizes Shane. Shane almost becomes part of the community, almost acknowledges the attraction he and the wife (Jean Arthur) of the farmer (Van Heflin) feel for each other. But the gunfight with Wilson is what

he has to do. After Wilson's death, Shane rides off into a mountain sunset. When asked where he's headed, he replies, "Someplace I've not been". When asked what it is he wants, he says, "Nothing".

Giant involves ranchers and conflict, too: the clash of landed cattle gentry, represented by Bick and Leslie Benedict (Rock Hudson and Elizabeth Taylor), and the coming technology of the oil and gas industry, represented by Jett Rink (James Dean, who died before the film was released). Its time extends from the 1920s to the 1950s; its scale is large enough to encompass the sprawling Ferber novel. A roundup, a barbecue, the excitement of an oil strike, and myriad details are closely observed and convincing; the huge Victorian mansion on the plain is extraordinary. Like the country, the characters seem bigger, more open, and flatter than life; courtesy and graciousness mingle with hardness and meanness. The awesome size and wealth that feed the legend and the legend itself are captured—*Giant* feels a lot like Texas.

Taken together, these three Stevens films make a large statement about the United States of America. Andrew Sarris labeled them the "American Dream Sun-Shane-Giant trilogy". Romantic and mythic they are. Stevens seemed to acknowledge that myths and legends are necessary parts of a culture. He re-stated them in ways that help us not so much to understand as to recognize values and behaviors that are indigenous, that must nourish us in someway.

As 1951 and *A Place in the Sun* marked a turning point in George Stevens's career, so it was with Billy Wilder and *Ace in the Hole* in the same year. This was Wilder's first film after the breakup of his fruitful scriptwriting collaboration with Charles Brackett, which had begun in 1938. Among their many successful scripts were *Ninotchka* (1939), directed by Ernst Lubitsch, and *Ball of Fire* (1941), directed by Howard Hawks. The first of their scripts to be directed by Wilder was *The Major and the Minor* (1942).

With the commercial failure of *Ace in the Hole* (it was rereleased as The Big Carnival in an effort to attract more customers), Wilder stopped making "films noir" (*Double Indemnity*, 1944; *The Lost Weekend*, 1945; *Sunset Boulevard*, 1950). Instead, he turned mostly to comedies in which dark touches and underlying cynicism were lightened or concealed by laughter.

The first of these, *Stalag 17* (1953), was based on a Broadway hit about American prisoners of war held by the Germans during World War II. (*Stalag 17* is the name of the camp.) Its center of interest is an opportunistic POW (played by William Holden) who seems devoted totally to self-interest, even to the point of collaborating with the Germans. Wilder's view of the characters is scathing; the laughter generated is not comfortable. Though it was popular with audiences, some reviewers complained of the film's nihilism and tastelessness.

Sabrina (1954), by contrast, is a Cinderella story that takes place on a lavish

Long Island estate. It is about a chauffeur's daughter (Audrey Hepburn) and her romances with the two wealthy brothers her father drives for, the playboy (William Holden) and the stuffy businessman (Humphrey Bogart). Elegant and charming, it is essentially a good-humored joke about class differences and romantic dreams in America. Social meaning could be read into it only with considerable, and serious effort.

The Seven Year Itch (1955), a stage-bound, quite amusing film of George Axelrod's play, chucks class differences altogether: Money is no object. The title refers to the sexual longings, fantasies, and guilts of a husband (Tom Ewell) of seven years, inspired by the luscious, kooky blonde (Marilyn Monroe) living in the Manhattan apartment directly above his.

In Love in the Afternoon (1957) much the same sort of material is moved to Paris, as a young woman (Audrey Hepburn) falls in love with an aging American playboy (Gary Cooper). This was Wilder's first film with the screenwriter who would become his second long-lasting collaborator, I.A.L. Diamond.

The above three romantic and/or sexual comedies are very Lubitsch-like, a comparison Wilder readily acknowledged. The next three comedies—*Some Like It Hot* (1959), *The Apartment* (1960), and *One, Two, Three* (1961)—are very Wilder-Diamond-like. In them there is a fusion of the acidic noir films with the joie de vivre of the Lubitsch comedies. Given this understanding of his work, *The Spirit of St. Louis* (1957), Charles Lindbergh's trans-Atlantic flight, and *Witness for the Prosecution* (1958), a courtroom melodrama, seem out of character, through the latter was expertly made and highly profitable.

Some Like It Hot combines elements of the gangster film (two musicians, Tony Curtis and Jack Lemmon, witness the St. Valentine's Day massacre), knockabout farce, fast-paced witty dialogue a la screwball comedy, and transvestism (to escape Spats Colombo, played by George Raft, the two male musicians become "girls" in an all-girl band that includes Marilyn Monroe). Perhaps it is also a critique of American capitalism (at least of organized crime and Florida retirement) and sex (whether hetero- or homo-, male or female, makes not much difference). Confused identities and sexual mismatches are forced to incredible limits. The closing line, delivered by lustful millionaire Osgood Fielding III (Joe E. Brown), is "Nobody's perfect".

The Apartment, its amalgam of sex and capitalism straightforward by comparison, adds a strong note of poignancy. An accountant for an insurance firm, C. C. "Bud" Baxter (Jack Lemmon), allows company executives to use his apartment for extramarital affairs. This arrangement presents only minor inconveniences, offset by the possibility for advancement, until Bud discovers that one of the users of his apartment, head of personnel (Fred MacMurray), is having an affair with the elevator operator, Fran Kubelik (Shirley MacLaine),

whom Baxter secretly cherishes. The evident lack of meaning in the business of the insurance business, the manipulation of people by other people within the bureaucratic hierarchy, the coldness and joylessness of the sexual games being played, cause every laugh to contain some discomfort. Unlike the characters in other Wilder films, Bud and Fran offer the possibility of decency against which the prevailing moral corruption can be measured. Wilder's comments on the way of the world are at least as misanthropic as usual, but the relationship between the principals is one of the tenderest in Wilder's films-one of a very few observed with tenderness.

Any satirical barbs not included in Wilder's work up to this point must be contained in *One, Two, Three* (1961). It is about corporate executives and sex again, and pleasing the boss, but it invades new territory: politics, on an international scale. The setting is Berlin at the time of the Cold War. (The wall between East and West Berlin was being erected during the shooting of the film; topical references abound.) The protagonist (James Cagney) runs the Berlin Coca-Cola bottling plant. Americans and Russians are ridiculed evenhandedly; capitalism is shown to be only slightly less obnoxious than communism. Everybody in the film seems to be self-centered and on the make. When the East German Comrade Piffl asks "Is everyone in this world corrupt?" the Russian Perpetchikoff replies "I don't know everyone". Though very funny, *One, Two, Three* is exceedingly dark.

It is interesting and no doubt significant that these dark comedies of Wilder's were commercial successes during the Eisenhower years, as film noir crime melodramas had been earlier. They allow a side of America to be seen, and a particular view of that side to be taken, that the films of George Cukor and George Stevens do not.

Fred Zinnemann was an immigrant like Wilder. Both were Viennese, Zinnemann a year younger. Both worked in film in Berlin before coming to America. In fact, they had worked together on an unusual and interesting semi-documentary feature, Menschen am Sontag (*People on Sunday*, 1929), Wilder on script and Zinnemann as assistant, along with Edgar Ulmer, to director Robert Siodmak. All four of those members of the crew subsequently came to Hollywood, Zinnemann arriving in 1929, Wilder in 1934. And there the similarities may end.

Wilder became a satirist, a parodist, a caricaturist; Zinnemann remained close to the documentary impulse of *People on Sunday*. An even more profound influence on his way of thinking about film making and about life in general, he has repeatedly acknowledged, came from his brief association with Robert Flaherty, American documentary pioneer, on an abortive project. In America, Zinnemann worked in various capacities on various sorts of films, such as codirector, with Paul Strand, of the documentary *The Wave* (1935), and director of shorts at MGM, and from 1942 on, of features.

The Search (1948)—a moving, authentic study of displaced and orphaned children in post-World War II Europe and of Americans in military and relief organizations trying to help them-was the first feature to establish his distinctive qualities. His realistic bent continued in *The Men* (1950), about paraplegic veterans of World War II, and *Teresa* (1951), about conflicts that arose when returning GIs brought home foreign wives, in this case Italian. Both films involved a good deal of location shooting-at a veterans hospital in the former, in Italy and New York City's Little Italy in the latter-and the use of non actors in supporting roles.

With High Noon (1952) Zinnemann achieved his first big box-office success. This western-produced by Stanley Kramer, photographed by Floyd Crosby, whose credits include most of the major documentaries of Pare Lorentz-is much more conventional than his three films just discussed. Even when directing non-documentary-like fiction, Zinnemann is consistently careful about the particularities of the physical settings, as well as of the psychological situations. *High Noon* is tightly scripted along generic lines and uses only professional actors. In allegorical fashion it deals with an ethical problem important to American society at the time, the political paranoia called McCarthyism. Only the sheriff (Gary Cooper) will stand up against the vengeful outlaw and his gang as other members of the community think of reasons why they cannot act. Its scriptwriter, Carl Foreman, was one of those blacklisted, following testimony before the House Un-American Activities Committee, and exiled himself in England.

From Here to Eternity (1953), from the best-selling novel by James Jones, was an even bigger box-office success than High Noon. It, too, examines the ethical expectations and behavior of Americans and the functioning of an institution, the peacetime army in Hawaii before the Japanese attack on Pearl Harbor. Though Zinnemann used well-known performers, he cast them against type: Montgomery Clift as a committed soldier, Deborah Kerr as the adulterous wife of the captain, Frank Sinatra, in his first straight dramatic role, as the doomed Maggio. Though the film reduces the novel's indictment of the army system to a matter of individual excess, it is about the army system and the hurt done to some men and women connected with it.

During the remainder of the period being discussed Zinnemann never succeeded in recapturing the critical and commercial success of *High Noon* and *From Here to Eternity*, but three films embodied some of the characteristic Zinnemann thematic and stylistic elements.

A Hatful of Rain (1957) is about a drug addict and the effects of his addiction not only on himself but on his family. It was the first film on the subject after the 1956 revision of the Production Code, referred to earlier, permitted it. The location shooting in New York City is noteworthy-the scene in a Lower East Side park in which a pusher is caught by the police, and the night scenes on the streets of the

city.

The Nun's Story (1959) concerns the spiritual struggles of a young Belgian nun (Audrey Hepburn) whose desire to nurse the sick and learn more about medicine conflicts with the strict discipline of her order. The first half takes place in the austere convent and deals with the training of the novitiates; the second half is set in the lush Congo jungle and involves an intense and troubling relationship with a surgeon (peter Pinch).

The Sundowners (1960) is a large and sprawling comedy-drama about an Australian family of sheep herders. The exteriors were shot in Australia, and careful attention is given to things Australian-sheep herding and shearing, for example, and a rural horse race.

Though Zinnemann's direction proved expert in various kinds of films (during this period he also directed film versions of Carson McCuller's novel/play The Member of the Wedding [1953] and the Rodgers and Hammerstein musical Oklahoma! [1955]), he seems at his best when his characters are involved in personal moral dilemmas that relate to a larger social dimension—cultural or institutional. His concerns and his style have been closer to the documentary impulse than have those of other Hollywood directors.

Eli Kazan used artistic heightening to make life on the screen appear to be that taking place outside the theater. His verisimilitude and dramatic power were achieved primarily through his work with actors. A principal practitioner of "the Method", as the acting style derived from Konstantin Stanislavsky was popularly called, he directed numerous important Broadway productions before and during his work in film (for example, Thornton Wilder's The Skin of Our Teeth and Arthur Miller's Death of a Salesman). Screen performances directed by Kazan are among the most valued in cinema.

A second striking aspect of Kazan's films is the ways in which they seem to have been connected with the national life, with the political life of the time. Of the six directors discussed in this chapter, Kazan best exemplifies certain of the shifting tendencies in American film generally over several decades. After A Tree Grows in Brooklyn (1945) and Sea of Grass (1947), both based on popular novels, Kazan directed a body of work that was at the center of the realistic/problem films of liberal sentiments and good causes. Boomerang (1947) and Panic in the Streets (1950) were taut crime melodramas which at the same time honored the courageous work of government officials on behalf of the individual and the public in the face of misunderstanding, resistance, and lack of appreciation. Gentleman's Agreement (1947) and Pinky (1949) were prominent in the race relations cycle. In 1951 he directed the film version of Tennessee Williams's play A Streetcar Named Desire, which he had also directed on the stage. Then, in 1952, Kazan was called before the House Un-American Activities Committee, confessed to his own

Communist Party membership between 1934 and 1936, and named those he had known as Party members. He placed an ad in *The New York Times* justifying his change of political attitude and calling upon others to join him in confessing past error and denouncing communism and communists.

Elements of self-justification can also be seen in Kazan's subsequent films. *Viva Zapata!* (1952, with a script by John Steinbeck) shows the seeds of corruption taking root within the Mexican revolutionary leader, Emiliano Zapata, and the ultimate failure of the revolution through the adoption of the same totalitarian measures as those of the dictatorial regime which had been overthrown. *Man on a Tightrope* (1953), based on a screenplay by Robert Sherwood, was one of the anticommunist films of the period that dramatized actual events of the Cold War. It recounted the escape of a Czech circus from behind the Iron Curtain.

On the Waterfront (1954), the most powerful and empathic of these social-political statements, is from a script by Budd Schulberg, who also had confessed past Party membership to the Un-American Activities Committee and named people he had known as communists. It deals with the matter of informing to a government crime commission. Longshoreman Terry Malloy (played by Marlon Brando, who had also played Zapata) comes to realize that in order to stand upright as a moral being he must expose the gangster forces controlling the waterfront labor unions and inform on his former associates. (Lee J. Cobb, who plays the union boss, and Leif Ericson, who plays one of the Waterfront Crime Commission investigators, were others involved in the production who had confessed and named names to HUAC.) The symbolism built around Terry's care and training of his flock of pigeons takes on a special significance when we remember that screenwriter John Howard Lawson, one of the "unfriendly witnesses", had charged that HUAC's "so-called 'evidence'" had come from a parade of "stool pigeons, neurotics, publicity-seeking clowns, Gestapo agents, paid informers and a few ignorant and frightened Hollywood artists".

With these three films Kazan seemed to release his need for broad ideological statement, though *A Face in the Crowd* (1957, script again by Schulberg) concerns a radio-television personality who comes to savor the enormous political power inherent in his mass popularity, and *Wild River* (1960) deals with the individual in conflict with big government in the Tennessee Valley of the 1930s. Instead, he confined himself to individual drama (*East of Eden*, 1955, the finest, starring James Dean; *Baby Doll*, 1956; *Splendor in the Grass*, 1961) which became increasingly personal and even autobiographical. In subsequent years his connection with the Hollywood film industry and with the movie going public became less frequent and less direct.

Preminger and Freedom of Speech

A landmark Supreme Court ruling, the so-called Miracle case of 1952 (formally, Burstyn v. Wilson), declared that movies were part of the nation's "press", entitled to Constitutional guarantees of freedom of speech.

The story of a simple-minded peasant woman, seduced by a stranger, who believes she has been impregnated by St. Joseph, Roberto Rossellini's *The Miracle* (1948) was condemned as sacrilegious by the archdiocese of New York and seized by New York's commissioner of police. After repeated losses in lower courts, Joseph Burstyn, the film's American distributor, took the case to the Supreme Court, which ruled that the term *sacrilegious* had no clear meaning and that films could no more be suppressed than any other forum for public debate. In addition to its liberating effect on film exhibition, this ruling undermined the legitimacy of the Production Code, even if the PCA was not a government office. That it took a foreign "art film" to effect this important change in American law foreshadowed many other changes that "art films" would effect within the decade. Produced outside America and shown in little theatres whose owners were not members of the Motion Picture Association, these "art films" were never subject to the industry's Code.

The war against the Code began officially in 1953 with Otto Preminger's decision to release *The Moon Is Blue* without the Code's seal of approval. Not only was Preminger's the first major American movie since 1934 (when the first was awarded) not to bear a seal, it also demonstrated the commercial and publicity value of not receiving a seal of moral approval. The war declared by Preminger would end in 1968 with the elimination of the 1930 Production Code (already modified in 1966) and the adoption of the more flexible system of rating the "maturity" of a film's content.

Otto Preminger, a Lubitsch protégé, had begun with ironic, unpretentious genre films at Twentieth Century-Fox (from *Laura* in 1944 to *River of No Return* in 1954) only to move toward more monumental, controversial, and socially conscious literary adaptations in the era of independent production. His *cause célèbre*, *The Moon Is Blue*, merely added a few "naughty" words (for example, *virgin* and *mistress*), leering eyebrows, and bedroom situations to a conventional comedy of manners. But his camerawork, his mastery of the crane and (beginning with *River of No Return*) the wide screen, never were conventional. Two of Preminger's steadily gripping adaptations, *The Man With the Golden* Arm (1955) and *Anatomy of a Murder* (1959), use quiet, understated acting and evocatively moody jazz scores (by Elmer Bernstein and Duke Ellington, respectively) to make the stories of drag addiction and rape more absorbing and the social commentary less obvious.

Preminger was instrumental in vanquishing the blacklist, as he had challenged the Code; he hired Dalton Trumbo, one of the Hollywood Ten, to write the script for *Exodus* (1960) under his own name. At approximately the same time, Kirk Douglas hired Trumbo to write *Spartacus* (1960), and the nearly simultaneous release of those two major spectacles broke the power of the blacklist.

Samuel Fuller

Beginning in 1949, Samuel Fuller directed, wrote, and often produced a series of inexpensive genre films that fell somewhere between A and B pictures in their budgets, styles, stars, and shooting schedules: westerns (*I Shot Jesse James*, 1949; *Run of the Arrow*, 1957), gangster films (*Pickup on South Street*, 1953, the most relevant to questions of subversion; *Underworld U.S.A.*, 1961), and disturbing melodramas (*Shock Corridor*, 1963; *The Naked Kiss*, 1964). Fuller's war films about the war in Korea (*The Steel Helmet* and *Fixed Bayonets*, both 1951) are shockingly violent and honest. For the subject at his last war film, *The Big Red One* (1980), he returned to World War II. In 1982, he made a film about racism, *White Dog*, that was judged too controversial to release. Some of his pictures, including *Shock Corridor* and *The Naked Kiss*, were restored and re-released before he died, still full of energy and tough charm, in 1997. Sometimes instead of yelling "action", he fired his 45 in the air.

Nicholas Ray

A loner and a rebel, Nicholas Ray began making films in 1948. Ray became a director on the fringes of the Hollywood establishment with films that be often wrote himself. Although he began in the theatre and came to Hollywood as Elia Kazan's assistant, Ray would feel more comfortable with Hollywood genres than with theatrical ones: westerns (*Johnny Guitar*), war films (*Flying Leathernecks*, 1951), the combination of *film noir* and wild youth (*They Live By Night*, 1948, released 1949; *Knock on Any Door*, 1949). But like *Johnny Guitar*, his pictures often leave their genres behind.

Rebel Without a Cause (1955) is one of Ray's most personal works. The rebellion in the film's title is the only detail Ray borrowed from Robert Lindner's bestselling 1944 case study of a young psychopathic criminal. The title is a smoke screen for the film's real issue—the attempt of three outsiders, strangers alike to the materialistic values of their weak but rigid parents and the desperately insecure values of their teenage contemporaries, to form an alternative community of

genuine human sympathy.

Jim Stark (James Dean) begins the film as a hopeless drunk because he sees no value in a future represented by the enslavement of his lather (Jim Backus—the voice of Mr. Magoo) to material possessions and a nagging wife. "Jimbo's" father is a man of no commitments or aspirations, except to keep the peace amongst the sterile bric-a-brac of his bourgeois home. Judy (Natalie Wood) also has problems with a father who spurns her confusedly provocative need for affection, sending her off in search of thrills and easy sensual power over boys her own age. Plato (Sal Mineo), the rich kid who never sees his divorced parents, is the most vulnerable and intellectual of the three, the most socially unskilled, and implicitly homosexual. Plato recognizes the fragility of human experience in a cold and awesome universe—suggested by the hypnotic planetarium show, a spectacle of sound and light analogous to movies. Plato, like Judy, searches for love and finds it in the same source—Jim.

Ray chronicles Jim's discovery of what it means to be a man and a responsible human being. The seeming alternative he sees to his father's emasculation is the world of his violent contemporaries, with their knife fights and chicken runs, car races that may be to the death. Jim, Judy, and Plato try to be good—and they are—but always seem to end up being called bad. Only love can unscramble their hearts, can give an uncontradictory message, can let them find themselves beyond the empty and unfulfilling hypocrisy of imposed social roles.

Rebel Without a Cause had great power for young audiences in the 1950s, urging them to abandon conformity to seek values that made personal sense. At the same time, it urged parents to face up to their own problems. The film's visual power—Ray's first in CinemaScope and color—contributed to its moral argument. The awesome horizontal sweep of the CinemaScope frame, as Ray used it, suggested a passion for openness that contrasted with the cramped and confined interiors of bourgeois homes. Ray described Dean's red jacket, in contrast with his black Mercury, as a danger sign, a personality about to explode. Ray consistently identified with oddballs and loners who saw themselves as different from everyone else.

Douglas Sirk

Douglas Sirk shrinks the world into a modern, bourgeois interior that has been arranged and ordered to death. Born in Denmark, Sirk moved to Germany, where he began making films in the 1930s. A leftist, he left Germany in 1937 and arrived in America in 1939 to direct anti-Nazi war films (*Hitler's Madman*, 1943), *films noirs* (*Sleep My Love*, 1948), and domestic comedies (*No Room for the Groom*,

1952). Sirk's major Work began in 1954 after his move to Universal, where he became a director of glossy melodramas (adult soap operas, at the time called weepies or women's pictures) under producer Ross Hunter.

The Sirk melodramas are odd mixtures of contradictory qualities. On the one hand, they seem slick depictions of the most tawdry values of materialistic, middle-class life. On the other hand, they seem brutally funny comments on this very tawdriness, on the values of bourgeois life that the characters automatically accept and on the values of movies and movie audiences that accept them just as automatically. To see a Sirk film, like *Imitation of Life*, in a 1959 movie theatre was a fractured experience: half the audience sobbing hysterically into wet handkerchiefs, the other half laughing hysterically in sheer disbelief. These same contradictory reactions have divided audiences of Sirk films ever since.

The reason is that Sirk films are powerful bourgeois melodramas and, at the same time, powerful comments on the assumptions of bourgeois melodrama. In *All That Heaven Allows* (1955, U.S. release 1956), an attractive, middle-aged widow (Jane Wyman) falls for a younger man (Rock Hudson), her own gardener, depicted as Thoreau's "man of nature". Her friends find the man unsuitable— not rich enough, not old enough, not a member of her own social class. The single attraction they see in him is physical—what they can see. She sees him as spiritually different. But if he is such a "natural spirit", why does nature play such a tame visual role in the film—embodied by one symbolic deer behind a plate-glass window in a sound-stage forest? "Nature" is a pitiful visual metaphor in many Sirk films; to say the least, we are not in Ford's Monument Valley. Why is almost every scene of nature in the supposedly Thoreauvian *All That Heaven Allows* so obviously an indoor imitation of the outdoors? Is it a mere studio convention, or is Sirk debunking the convention—along with the contrast between nature and artifice on which the film depends? This question is always at the center of a Sirk film. We are never quite sure who is kidding whom.

Sirk shoots his bourgeois world filtered through reminders of Hollywood's presence. Doorways, partitioning screens, windowpanes, mirrors, reflective surfaces (even the glass screens of television sets) dominate Sirk frames, calling attention to the fact that we look not at life but at a frame. Unnatural prismatic lighting effects in Sirk's color films raise questions about the source and purpose of this oddly colored light. Is the *mise-en-scène* merely decorative, an exercise in cold good taste, or is Sirk "deconstructing" the very images he constructs (pointing out their internal contradictions)? Is the using Brechtian distancing devices to separate the audience from the illusion of the work? Or is he, without irony—and with or without contempt—simply giving the audience what it wants: the slickly artificial and maudlin?

Imitation of Life (1959) is the ultimate Sirk film—both his last and his most

powerful at posing these questions. It is a story about race relations, one of the few serious social subjects that films could explore in the 1950s without fear of right-wing protests and boycotts. An unemployed white actress, Lora (Lana Turner), meets a black woman, Annie (Juanita Moore), early in the film while their daughters play together on a crowded beach. The actress rises to success, aided by the financial support and household service of Annie, who has moved in with her. Lora's daughter, Susie (Sandra Dee), enjoys a typical upper-middle-class adolescence (boarding school and college), while the black daughter, Sarah Jane (Susan Kohner), who looks white, suffers the pain of social exclusion. She tries to escape her black heritage, seeking sexual affairs with white boys, working as a showgirl in a white nightclub—but returns in the end for her mother's funeral to suffer orgiastic agonies of grief, accompanied by the sorrowful singing of Mahalia Jackson and the sobbing ecstasies of the film's audience.

In remaking this Fanny Hurst novel, Sirk and Hunter made a crucial change. While in the original (novel and film), Lora makes a public success of Annie's private recipe for pancake flour (a clear allusion to Aunt Jemima), the black woman in the 1959 film has no direct relation to the white woman's vocational success. The world of pancake mix has been abandoned for the glittering world of Broadway stardom. What happens to the black woman in this new world? Quite simply, she becomes Lora's maid.

There is no indication in the film of why this black woman—the social and financial equal of the white woman at its beginning—should automatically accept her "place" as the white woman's servant. Is this a plea for interracial respect and personal authenticity, or a sentimental exaltation of the problems of racism and role playing? Although the white woman and the black woman inhabit the same house, the same film, and the same frame, they don't inhabit the same universe. Class and race have nothing and everything to do with their friendship. Who's kidding whom here?

Whatever adjectives one might seek to describe these films by Fuller, Ray, and Sirk, escapist wouldn't be one of them. The moral, economic, social, psychological, and sexual ambiguities of such films suggest an America that was itself as genuinely confused as it was superficially assured about its purpose and direction.

Method Acting

Although most filmgoers readily form opinions about acting, the subject of performance is one of the least analyzed aspects of film aesthetics. What exactly do actors contribute to film artistry, and how do they do it? Lee Strasberg, a teacher

and theorist of acting and a leader of the Actors Studio, suggested that the most effective film performers were those who did not *act*. "They try not to act but to be themselves, to respond or react", he said.

This may be a debatable proposition in the sense that performers' images and roles are invariably constructed by such factors as studio publicity and genre codes, but it does relate to a central tenet of the Stanislavski method: actors were not to emote in the traditional manner of stage conventions, but to speak and gesture in a manner one would use in private life. Konstantin Stanislavski, who was a director at the Moscow Art Theatre, wrote a number of books on acting, the first of which, *An Actor Prepares*, was published in English translation in 1936. Before then, however, one of his students, Richard Boleslawsky, opened an acting school in New York and began teaching Stanislavskian principles (Boleslavsky went on to Hollywood and directed a number of films in the 1930s).

The first significant performance work drawing on Stanislavski's ideas was carried out by the Group Theatre, formed in New York in 1931. The Group's most famous production was a play expressing the militant radical spirit of the 1930s, *Waiting for Lefty* (1935), by *Clifford Odets* (1903-1963), who became a Hollywood scriptwriter and occasional director. The Group did not last beyond the 1930s, but its influence continued in Hollywood and through the formation of the Actors Studio.

After World War II, in the context of the Actors Studio, the Stanislavski method was shorn of its radical political connotations (the Group Theatre became a particular target of anticommunist investigators) and emphasized an individualized, psychological approach to acting. The "Method" required a performer to draw on his or her own self, on experiences, memories, and emotions that could inform a characterization and shape how a character might speak or move. Characters were thus shown to have an interior life; rather than being stereotyped figures representing a single concept (the villain, the heroine), they could become complex human beings with multiple and contradictory feelings and desires. It was the ability to convey the complexity—indeed the confusion—of inner feelings that made the Actors Studio-trained Marlon Brando, Montgomery Clift, and James Dean such emblematic figures for the postwar era.

第四节　法国"新浪潮"

1. "新浪潮"之前的法国经典大师：布列松、塔蒂、奥菲欧斯和麦尔维尔

法国战败、巴黎沦陷导致雷诺阿和克莱尔等黄金一代导演遭放逐，年轻的法国导演获得拍片机会，而他们真正的杰作却出现在战后，包括雷内·克莱门特（René Clément）的《禁忌的游戏》、雅克·贝克（Jacques Becker）的《金盔》和亨利-乔治·克鲁佐（Henri-Georges Clouzot）的《恐惧的代价》等。

编剧出身的罗伯特·布列松（Robert Bresson）起步于战前，算是依赖文学价值的法国电影质量传统的代表人物，但他以精准的简约风格、朴素的心理现实主义和古典主义的宗教哲学倾向，被巴赞称为最具默片艺术气质的当代"电影作者"。布列松的代表作品《乡村牧师日记》也因其在表演、对白和场面调度等方面展现的简朴特质而成为与德莱叶《圣女贞德》比肩的极简主义典范，对后世影响深远。此外，《死囚越狱》和《扒手》也是布列松获得广泛声誉的杰作。

身兼主演的雅克·塔蒂（Jacques Tati）创造出一种幽默嘲讽式的仪式化视听轻喜剧，取笑现代生活的刻板和异化，赢得广大观众的欢迎和电影评论家的欢心（他也因此获得"电影作者"的头衔）。《节日》《胡洛先生的假期》和《我的舅舅》都体现出塔蒂法式喜剧优雅含蓄中的睿智锋芒。

在好莱坞拍摄过《巫山云》的法籍德裔导演马克斯·奥菲欧斯（Max Ophüls）20世纪50年代回到法国拍片，《轮舞》《快乐》《伯爵夫人的耳坠》

《乡村牧师日记》

和《倾城倾国欲海花》以其回环往复的非线性叙事、流畅延续的镜头运动和花前月下的轻歌剧内涵,形成独特的电影视听风格,直接启发了后来的"新浪潮"电影。

20世纪50年代法国的另一位知名导演让-皮埃尔·梅尔维尔(Jean-Pierre Melville)以拍摄低成本巴黎实景电影见长,他的《赌徒鲍勃》等也对"新浪潮"产生影响,特吕弗和戈达尔甚至使用了梅尔维尔的御用摄影师拍摄自己的成名作。而一向以拍摄独行杀手和城市犯罪的麦尔维尔还执导过声誉卓著的《武士》等。

早在1943年,马塞尔·莱比尔(Marcel L'Herbier)创建并长期领导了法国巴黎"高等电影学院"(IDHEC, the Institut des Hautes Etudes Cinématographiques),学院教授包括著名电影史学家、《世界电影史》作者乔治·萨杜尔和著名电影理论家、《电影美学与心理学》作者让·米特里等,培养过阿兰·雷乃、路易·马勒、施隆多夫、文德斯和安哲罗普洛斯等电影大师。

The Occupation and Postwar Cinema

During the German Occupation of France, from 1940 to 1944—when Feyder, Renoir, Duvivier, and Clair were all in exile—a new generation of French directors emerged, most of whom had worked as scriptwriters or assistants under the major figures of poetic realism in the thirties. Perhaps the most important film event of the Occupation was the founding of the Institut des Hautes Études Cinématographiques (IDHEC) by Marcel L'Herbier in 1943. This government-

《武士》

subsidized film school today offers professional training in every aspect of film production as well as in history and aesthetics. It provides certification for persons wishing to enter the French film industry, and its high standards have attracted students from all over the world.

Claude Autant-Lara, who had worked as a designer for Marcel L'Herbier and as an assistant to Clair, directed a number of sophisticated period films during the Occupation, including Le Mariage de Chiffon (1942), Lettres d'amour (1942), and the satirical Douce (1943). Autant-Lara's critical reputation rests most firmly, however, upon a series of stylish literary adaptations written by Jean Aurenche and Pierre Bost that he made in the postwar era—especially Le Diable au corps (The Devil in the Flesh, 1947; from the Raymond Radiguet novel), L'Auberge rouge (The Red Inn, 1951; from Aurenche), Le Blé en herbe (The Ripening Seed, 1954; from Colette), Le Rouge et le noir (The Red and the Black, 1954; from Stendhal), and Le Joueur (The Gambler, 1958; from Dostoevsky). Writing as a team, Aurenche and Bost became specialists in tightly scripted films; they also worked closely with the director René Clément, whose first film had been a neorealistic account of the activities of the French Resistance, La Bataille du rail (The Battle of the Rails, 1946).

Clément also codirected La Belle et la bête (Beauty and the Beast, 1946) with playwright Jean Cocteau and made the suspenseful anti-Nazi thriller Les Maudits (The Damned, 1947). But his two greatest films of the postwar era, both written

by Aurenche and Bost, were the poetic antiwar drama *Jeux interdits* (*Forbidden Games*, 1952) and a strikingly evocative adaptation of Zola's *L'Assommoir* entitled *Gervaise* (1956). These films won multiple international awards, as did Clément's comic masterpiece *Monsieur Ripois* (*The Knave of Hearts*), shot in England in 1954. Afterward Clément turned to big-budget international coproductions like *Is Paris Burning*? (1966) and *Rider on the Rain* (1969), most of them distinctly mediocre.

Jean Grémillon, who had made important films in the silent era (*Un Tour au large*, 1927; *Maldone*, 1928), produced his greatest work during the Occupation—*Lumière d'été* (1943), a Renoiresque portrait of the decadent French ruling classes written by Jacques Prévert, and *Le Ciel est à vous* (English title: The *Woman Who Dared*, 1944), a beautiful film about a provincial woman who breaks the world record for long-distance flying with the help of her husband and the people of her town. After the war, Grémillon turned to the documentary but continued to exercise great influence upon French cinema as president of the Cinémathèque Frangaise.

Jean Cocteau (1889-1963), who had confined himself to writing scripts during the Occupation (for Jean Delannoy's modernized version of the Tristan and Isolde legend, *L'Éternel retour* [*The Eternal Return*, 1943]; for Robert Bresson's *Les Dames du Bois de Boulogne* [*The Ladies of the Bols de Boulogne*, 1945]), returned to filmmaking in the postwar years. Perhaps more than any other figure he incarnated the literary tendency of French cinema during this period. In 1946 he wrote and codirected (with Clément) an enchantingly beautiful version of the Flemish fairy tale *La Belle et la bête* (*Beauty and the Beast*) in a visual style based upon the paintings of Vermeer; it stands today as perhaps the greatest example of the cinema of the fantastic in the history of film. Next, Cocteau directed two film versions of his own plays, the satirical *Ruy Blas* (1947) and *Les Parents terribles* (English title: *The Storm Within*, 1948), a domestic tragicomedy set within the confines of a single room. With *Orphée* (1950), a modern version of the Orpheus legend, Cocteau returned to the surreal, psychomythic regions of *Le Sang d'un poète* (*Blood of a Poet*, 1930) to create his most brilliant film. He adapted his play *Les Enfants terribles* (*The Terrible Children*, directed by Jean-Pierre Melville) for the screen in 1950 and gave the cinema his final artistic statement in *Le Testament d'Orphée* (*The Testament of Orpheus*, 1959), a surrealistic fable that is replete with personal symbols and that attempts to suggest the relationships among poetry, myth, death, and the unconscious.

Jacques Becker (1906-1960) is another figure who emerged during the Occupation and came to prominence in the postwar years. As assistant to Renoir from 1931 to 1939, Becker tended to direct films that cut across the traditional class barriers of French society. *Goupi Mains-Rouge* (English title: *It Happened at the Inn*, 1943) is a realistic portrait of peasant life; *Falbalas* (English title: *Paris*

Frills, 1945) is a drama set in the Parisian fashion houses; *Antoine et Antoinette* (1947) is a tale of young love in a working-class milieu; *Rendez-vous de juillet* (1949) offers a sympathetic study of the attitudes and ambitions of postwar youth; and *Edouard et Caroline* (1951) examines young married life in high society. But Becker's masterpiece is unquestionably *Casque d'or* (*Golden Helmet/Golden Marie*, 1952), a visually sumptuous tale of doomed love set in turn-of-the-century Paris and written by Becker himself. Cast in the form of a period gangster film and based upon historical fact, *Casque d'or* is a work of great formal beauty whose visual texture evokes the films of Feuillade and engravings from *la belle époque*. *Touchez pas au grisbi* (English title: *Honor Among Thieves*, 1954), adapted from an Albert Simonin novel, is a sophisticated tale of rivalry between contemporary Montmartre gangs; it started the vogue for gangster films and thrillers that typified French cinema in the late fifties (for instance, the American émigré Jules Dassin's *Rififi*, 1955). After making three commissioned films of uneven quality, Becker directed his final masterpiece, *Le Trou* (*The Hole/The Night Watch*, 1960), shortly before his death in 1960. Like Bresson's *Un Condamné àmort s'est échappé* (*A Man Escaped*, 1956), this film, set entirely in a prison cell where five men plot an ill-fated escape, is a restrained exploration of loyalty, freedom, and human dignity.

Another important director whose career began during the Occupation was Henri-Georges Clouzot (1907-1977), a former scriptwriter for E. A. Dupont and Anatole Litvak at UFA. Clouzot's first feature was unremarkable, but his second, *Le Corbeau* (*The Raven*, 1943), established him as the chief progenitor of French *film noir*. This darkly pessimistic tale of a town destroyed by poison-pen letters is a masterpiece of psychological suspense, but because it was produced by the Nazi-owned Continental Corporation and seemed to be anti-French (although it was actually misanthropic), both Clouzot and his coscenarist, Louis Chavance, were accused of collaboration and briefly suspended from the French film industry after the Liberation. Clouzot, in fact, was apolitical, but his films typically dealt with the brutal, the sordid, and the neurotic, and his entire career was marked by an aura of scandal. His first postwar film, *Quai des orfèvres* (English title: *Jenny Lamour*, 1947) was a violent thriller that transcended its genre by creating Hitchcockian suspense. In *Manon* (1949), Clouzot modernized the Abbé Prévost's eighteenth-century classic, *Manon Lescaut*, setting it in the post-Liberation context of the Paris black market and the illegal emigration of Jews to Palestine. And with *Le Salaire de la peur* (*The Wages of Fear*, 1953), Clouzot achieved a masterpiece of unrelenting horror and alienation in a film about a group of down-and-out European expatriates trapped in a miserable South American town who are driven by despair and greed to undertake the suicidal mission of hauling nitroglycerine for an American oil firm.

Always a meticulous and professional craftsman in the French studio

tradition, Clouzot became increasingly erratic as the fifties progressed. The film that confirmed his international reputation, *Les Diaboliques* (*Diabolique*, 1955), is a brilliantly manipulative exercise in horrific suspense involving a complicated murder plot in a boarding school. Like Hitchcock's *Vertigo*, it was adapted from a novel by Pierre Boileau and Thomas Narcejac. Similarly, *Le Mystère Picasso* (*The Picasso Mystery*, 1956) is an ingenious seventy-five-minute study of Picasso at work shot in desaturated color and CinemaScope. But *Les Espions* (*The Spies*, 1957), set in a psychiatric clinic, is a failed attempt to combine the bitter naturalism of his earlier films with surrealistic fantasy. *La Vérité* (*The Truth*, 1960) is a professional but glib film cast in the form of a murder trial and narrated in flashbacks. A projected film on the destructive effects of jealousy, *L'Enfer* (1964), was scrapped because of Clouzot's ill health, and he was able to complete only a single feature before his death in 1977—the controversial and somewhat experimental *La Prisonnière* (*The Prisoner*, 1968), which returns to the perverse and pathological mode of *Le Corbeau* to examine the dynamics of sexual degradation.

Robert Bresson

Bresson's reputation rests upon a comparatively small body of work. After his first two significant films, *Les Anges du péché* (1943) and *Les Dames du Bois du Boulogne* (1945), he made only eleven films in forty years, most notably *Diary of a Country Priest* (1951), *A Man Escaped* (1956), *Pickpocket* (1959), *Au Hasard Balthasar* (*At Random Balthasar*, 1966), *Mouchette* (1967), *Four Nights of a Dreamer* (1972), *Lancelot du Lac* (*Lancelot of the lake*, 1974), and *L'Argent* (*Money*, 1983). Yet, from the early 1950s on, Robert Bresson (1907-1999) was one of the most respected directors in the world. Championed by the *Chiers* critics, praised by Sarris and the *Movie* group, his rigorous, demanding films display an internal consistency and a stubbornly individualistic vision of the world.

Bresson's reliance on literary texts gave him some credibility in the period when the Cinema of Quality reigned. His films are often structured around letters, diaries, historical records, and voice-over retellings of the action. Yet there is nothing particularly literary about the finished product. His work perfectly exemplifies Astruc's *caméra-stylo* aesthetic: he took literary works as pretexts, but he composed by purely filmic means. Bresson was fond of contrasting what he called "cinematography"—"writing through cinema"—with "cinema", or the ordinary filmmaking that is, he insisted, merely photographed theater.

Bresson concentrated on sensitive people struggling to survive in a hostile world. His two 1940s features weave vengeful intrigues around innocent victims.

With *Diary of a Country Priest* and on through the early 1960s, a long second phase emerged in his work. The films presented austere images and subdued acting. In most of these works, suffering is redeemed to one degree or another: the country priest dies with the realization "All is grace"; in *A Man Escaped,* Fontaine breaks out of a Nazi prison by trusting in his cellmate; after a fascination with crime, the central character in *Pickpocket* learns to accept a woman's love. Bresson's interest in religious subjects struck a strong chord during the revival of Catholicism in postwar France. During this phase, he gained his international reputation as the great religious director of postwar cinema.

After the mid-1960s, his films became far more persimistic. Viewers who had identified Bresson as a "Catholic" director were puzzled by his turn to the secular, even sexual, problem of young people in modern society. Now his protagonists were led to despair and even suicide. In *Balthasar*, Marie dies after a juvenile gang has stripped and beaten her. *Mouchette* and the protagonists of *Une Femme douce (A Gentle Woman,* 1969) and *The Devil Probably* (1977) kill themselves. In *L'Argent,* an unjust accident hurls a young man in and out of prison and toward unreasoning murder. Now Christian values offer no solace: the quest the Grail in Lancelot du Lac fails; chivalry becomes a heap of bloodied armor.

However bleak they may be, Bresson's films radiate mystery. It is difficult to understand his characters because they are typically examined from the outside. The performers—Bresson called them his "models"—are often nonactors or amateurs. They are preternaturally still and quiet, breaking their silence with a clipped word or a brief gesture. In this cinema, a sudden raising of the eyes becomes a significant event: a shared look, a climax. The models are often filmed from behind, or in close-ups that fragment their bodies. In addition, Bresson's abrupt cutting, short scenes, abrupt track-ins or track-outs, and laconic sound tracks demand the viewer's utmost concentration. The reward is a markable balance between a penetration of the characters' experiences and a sense that their inner states remain elusive and mysterious, as in a scene from *Diary of a Country Priest,* when the protagonist discovers information about the author of a cruel anonymous letter to him.

After *Diary of a Country Priet,* Bresson began to avoid long shots. He typically created a scene's space by showing small portions of it and linking shots through characters' eyelines. At other times his tightly framed camera movements suggest action by concentrating on details. In one scene from *Mouchette,* for instance, by showing no faces, Bresson calls attention to Mouchette's discouraged gait and her shabby clothes.

Bresson also needs no long shot of Mouchette's school because he has evoked the setting through the sounds of the school bell and the students' chatter. "Every time that I can replace an image by a sound I do so". Against a background of

pervasive silence, every object in a Bresson film takes on a distinct acoustic flavor: the scrape of the bedstead in Fontaine's cell, the clank of the knights' armor in *Lancelot du Lac*, the rusty bray of the donkey Balthasar. Offscreen sound will establish a locale or will provide a motif that recalls other scenes. Bresson's intense concentration on physical details and isolated sounds often fills in for psychological analysis. The mystery and ambiguity of Bresson's style proved suited to his treatment of solitary individuals who struggle to survive a spiritual or physical ordeal.

These enigmatic gestures, textures, and details are presented in a highly sensuous way. Bresson's images may be severe, but they are never drab. *In Les Anges du péché*, the nuns' habits create an anglar geometry and lustrous range of tonalities. His color films achieve vivid effects by minute means: a knight's armor stands out slightly by its sheen; a mail basket in a prison office becomes a vibrant blue.

Bresson moved toward abbreviated, elliptical storytelling. From *Pickpocket* on, and especially in *Au Hasard Balthasar*, so much is left to the spectator's imagination that the very story events—"what happens"—become almost opaque. ("I never explain anything, as it is done in the theatre".) What gives the Bresson film a sense of ongoing structure are the subtly varied, almost ceremonial repetitions—daily routines, replayed confrontations, returns to the same locales. The spectator suspects, as the individuals involved do not, that the apparently random action is part of a vast cycle of events governed by God, fate, or some other unknown force.

Bresson never sought the commercial success enjoyed by Antonioni, Bergman, and Fellini. Yet he influnced filmmakers as varied as Jean-Marie Straub (who saw political implications in ascetic image and direct sound) and Paul Schrader (whose *American Gigolo* reworks *Pickpocket*). Although Bresson never made his long-cherished version of the biblical book of Genesis, he remains one of the most distinctive auteurs of the past fifty years.

Jacques Tati

With true auteurist fervor Truffaut once declared that "a film by Bresson or Tati is ecessarily a work of genius *a priori*, simply because a single, absolute authority has been imposed form the opening to 'The End'." The similarities between the two directors are enlightening. Both made tentative starts on their film careers during the 1930s, worked on films during the war, and became prominent in the early 1950s. Both spent years on each film; Tati's output, with only six features between 1949 and 1973, was even slimmer than Bresson's. Both directors

experimented with fragmented, elliptical narrative and unusual uses of sound.

Unlike Bresson, however, Jacques Tati (1908-1982) made some very popular films. Since he was a performer as well as a director, he also became an international celebrity. From this perspective, Tati resembled Buunel in pushing modernist tendencies toward accessible, mainstream tradition. At one level, Tati's films are satiric commentaries on the rituals of modern life—vacations, work, housing, travel. Declaring himself an anarchist, he believed in freedom, eccentricity, and playfuless. His films lack strong plots: things simply happen, one after the other, and nothing much is ever at stake. The film accumulates tiny, even trivial events—like the microactions of Italian Neorealism, only treated as gags.

Jour de fête (*Holiday*, 1949) set the patter for most of Tati's subsequent works. A small carnival comes to a village, the townsfolk enjoy a day off, and the carnival leaves the next day. In the midst of the celebration, the local postman, François, played by Tati, continues to deliver the mail and decides to adopt American methods of efficiency. The circumscribed time and place, the contrast between humdrum routine and bursts of zany amusement, the bumbling character who disrupts every-one else's life, and the recognition that only children and eccentrics know the secret of fun—all these elements would reappear throughout Tati's later work. The loose plot, built out of elaborately staged gags and motifs rather than a strong cause-and-effect chain, would become a Tati trademark.

Jour de fête also inaugurated Tati's characteristic style. The comedy is not verbal (very little is said, and that often in a mutter or mumble) but visual and acoustic. A stiff-legged beanpole capable of outrageously mechanical gestures, Tati was one of the cinema's great clowns. Like Keaton, he was also one of its most innovative directors, relying on long shots that spread elements across the frame or in depth. Changes in sound source or level shift our attention from one aspect of the shot to another. In *Jour de fête*, for example, a depth shot shows a farmer staring at François on the road, thrashing his arms about. As François moves on, we hear a buzzing noise and see the farmer begin flapping away at the invisible bee; then the buzzing fades, and, as the shot ends, François begins flapping his arms again.

An even bigger success was *Mr. Hulot's Holiday* (*Les Vacances de M. Hulot*, 1953). The scene is a seaside resort that various middle-class people visit; the action consumes the one week of their stay. The disruptive force is Mr. Hulot, who insists on making the most of his vacation. He shatters the routine meals, arranged outings, and quiet evenings playing cards. His splenetic car disturbs the guests, his outrageously unprofessional tennis game defeats all comers, and his antics on the beach bring woe to bystanders. Tati's performance captivated audiences around the world and was credited with single-handedly reviving the pantomime tradition of Chaplin and Keaton. Again, sound guides our eye and characterizes people and

objects, from the percussive chugging of Hulot's car to the musical thunk of the hotel restaurant's door to the harsh ricochet of a ping-pong ball as it invades the hotel parlor. Just as important, Tati the director had composed a film with a firm structure that owes little to traditional plotting. By alternating strong visual gags with empty moments that invite the spectator to see ordinary life as comic, Mr. Hulot's Holiday points forward to the more extreme experiments of Play Time.

Back in Paris, Hulot launches a hilarious attack on modern work and leisure on *Mon Oncle* (*My Uncle*, 1958). The windows of a modernistic house seem to spy on passersby; plastic tubing extruded from a plant becomes a giant serpent. Again, Tati's long shots show individuals at the mercy of the environment they have created. The result is a comic version of Antonioni's portrayal of urban alienation.

The international success of *Mon Oncle*, which won the Academy Award for best foreign film, encouraged Tati to undertake his most ambitious project. On the outskirts of Paris he built a false city, complete with paved roads, water and electricity, and traffic. He shot the film in 70mm, with five-track stereophonic sound.

The result was *Play Time* (1967), one of the most audacious films of the postwar era. Aware that audiences would watch for Hulot, Tati played down his presence. Knowing that viewers rely on close-ups and centered framings to guide their attention, Tati built the film almost completely out of long shots and scattered his gags to all corners of the frame. Sometimes, as in the lengthy sequence of the disintegration of the Royal Garden restaurant, he packs simultaneous gags into the frame, challenging the spectator to spot them all. Tati's satire of tourism and urban routine encourages us to see all of life as play time.

Since Tati initially insisted that *Play Time* be shown in 70mm, it did not get wide distribution and quickly failed. Tati went into bankruptcy, and his career never recovered. To the end of his life, he hoped to establish one theater somewhere in the world that would show *Play Time* every day, forever.

He made two more films. In *Traffic* (1971), Hulot helps a young woman deliver a recreational vehicle to an Amsterdam auto show. Simpler than *Play Time* or Mr. Hulot's Holiday, Traffic satirizes car culture. *Parade* (1973), shot for Swedish television, is a pseudodocumentary celebration of the circus and its audience. As usual, Tati blurs the boundary between performance and the comedy of everyday life.

Before his death, Tati was planning another Hulot film, *Confusion*, in which his hero would work in television and be killed on camera. But the debts of *Play Time* haunted him, and in 1974 his films were auctioned off at an absurdly low price. Over the next two decades, however, rereleases of all his films demonstrated to new audiences that Tati had left behind a rich body of work that invites the spectator to see ordinary life as an endless comedy.

Max Ophüls

Another major figure working in French cinema in the fifties, and one who had a profound influence on the New Wave generation that succeeded him, was Max Ophüls (Max Oppenheimer, 1902-1957). Ophüls was a German Jew who had directed films for UFA between 1930 and Hitler's rise to power in 1933 (*Die verkaufte Braut* [*The Bartered Bride*, 1932]; *Liebelei* [1933]). For the next seven years he made films in Italy, the Netherlands, and France, where he ultimately became a citizen in 1938. Ophüls was forced to flee to Hollywood when France fell to the Nazis in 1940, and after four years of anonymity, he was finally able to make a series of stylish melodramas for Paramount: *The Exile* (1947), *Letter from an Unknown Woman* (1948), *Caught* (1949), and *The Reckless Moment* (1949), which are among his very best films. Returning to France in 1949, Ophüls entered the period of his greatest creativity, making four elegant, masterful films in succession between 1950 and 1955—*La Ronde*, *Le Plaisir*, *Madame de ...*, and *Lola Montès*. Ophüls had always worked within the studio system, so that the subject matter of his films—often light and operetta-like—was never as important to him as visual style. And it is for their dazzling *mise-en-scène* that Ophüls' last four films, all photographed by the great French cameraman Christian Matras, are most remarkable.

La Ronde (1950) is an adaptation of an Arthur Schnitzler play set in turn-of-the-century Vienna. Its ten separate episodes posit that love is a perpetual roundabout in which one partner is regularly exchanged for another until the pattern comes full circle, like the movements of a waltz, only to begin again. This unbroken circle of affairs is presided over by a master of ceremonies who manipulates and comments on the behavior of the characters, becoming a surrogate for Ophüls himself. *Le Plaisir* (English title: *House of Pleasure*, 1952) is derived from three Maupassant stories, linked by a narrator; they illustrate the theme that pleasure may be easy to come by but happiness is not. Like all of Ophüs' work, the film is marked by meticulous attention to period detail and by an incessantly moving camera. In one famous sequence, the camera circles the exterior of a brothel time and time again, never entering the set but peering voyeuristically through windows at significant dramatic action taking place within. In *Madame de ...* (English title: *The Earrings of Madame de...*, 1953), also set at the turn of the century, Ophüls constructs yet another circular narrative that rotates around a central axis of vanity, frivolity, and lust. Here, the passage of a pair of earrings from a husband to his wife to the husband's mistress to the wife's lover and finally back to the husband again constitutes a single perfect revolution in the roundabout of infidelity. The characters are ultimately shallow, because everything in *Madame*

de... is subordinate to its aesthetic design. As if to mirror the movement of the waltzes on the soundtrack, the camera whirls and pirouettes continuously to follow the film's principals through its glittering period decor, suggesting that life is itself a kind of waltz in which all of us are caught up while the music plays.

Lola Montès (1955) is generally considered to be Ophüls' masterpiece, the consummation of his entire life's work. Conceived by its producers as a big-budget superspectacle in Eastmancolor and CinemaScope with an international cast of stars, it was based on the scandalous life of a mediocre nineteenth-century dancer who became the mistress of the composer Franz Liszt and, during the revolutions of 1848, of Ludwig I, deposed king of Bavaria. She finally ended as a circus performer selling kisses to earn her keep. Ophüls cared nothing for the subject, remarking of Lola herself, "Her role is roughly the same as that of our pair of ear-rings in *Madame de* ...".That is, he merely used her story to create a dazzling exercise in visual style, and *Lola Montès* became one of the most intricate, opulent, and elaborate films to appear on the French screen since Abel Gance's *Napoléon* (1927). Ironically, Ophüls was initially opposed to the use of Cinema Scope, but his sense of visual patterning was such that he turned *Lola Montès* into a stunning exhibition of composition for the widescreen frame. He frequently broke the horizontal space of the screen with vertical dominants and framed shots through arches, columns, and drapery. He learned to compose close-ups by balancing both sides of the frame, and at other times—as during the circus scenes—he would fill the entire CinemaScope frame with significant dramatic action. The film begins and ends within the circus tent, where the ringmaster introduces Lola's act by recalling the circumstances of her past life, which is then represented on the screen in a series of achronological flashbacks. Ophüls uses color nonnaturalistically throughout the film, especially in these flashback sequences, where each is tinted according to its prevailing emotional tone. Finally, the camera seems never to stop its circular tracking around some invisible axis, in or out of the tent, making the circularity of things seen on the screen a metaphor for life itself. As Andrew Sarris has remarked, "With Ophüls it is movement itself that is emphasized rather than its terminal points of rest".

As with *Intolerance* (1916) and *Citizen Kane* (1941), the narrative technique of *Lola Montès* was so unconventional that audiences stayed away from it. In response, its producers, the Gamma Company, first cut the film from 140 to 110 minutes, and finally re-edited the story in chronological sequence for release in a ninety-minute version. Still, the film's commercial failure was so complete that Gamma was eventually bankrupted by it, and it seems likely that Ophüls' death from a rheumatic heart condition ill 1957 was hastened by the mutilation of his masterpiece. In 1969, however, the original version was reconstructed and re-released, to great critical acclaim.

The key to Ophüls' style is his mastery of the long take and, especially, of the continuously moving camera. Ophüls was also a genius at composition within the frame, and the influence upon him of both German Expressionism and French pictorial Impressionism was profound. In his passion for decor and his obsession with the sensuous surfaces of reality, Ophüls most closely resembles von Sternberg. In his cynicism and worldly wit, he is close to Ernst Lubitsch. That his films are devoid of content—a charge frequently leveled against both von Sternberg and Lubitsch—is quite true, if we mean by the term *verbal* or *conceptual* substance. But as the New Wave generation was to argue and to demonstrate time and again, the substance of cinema is *audiovisual*, not verbal, and it exists on a level of discourse—like that of the circular tracking shots in *Lola Montès*—where perception and conceptualization become one.

Jean-Pierre Melville

Jean-Pierre Melville (1917-1973), who started his own small production company in 1946, shot his tough, methodical films on the streets of Paris, on available locations (real apartments and cafés, for example), and occasionally in a small studio. If the New Wave fiimmakers learned from the Neorealists the advantages of shooting in the streets and on location, working with a small budget and without big studio support, they learned from Melville how to make such films in Paris. An unsentimental writer and director, Melville often follows a central character through a process that is difficult and isolating: the last job planned by a lifelong gambler (*Bob le flambeur*, 1955), the activities of the French Resistance supervised by an efficient and dedicated organizer (*Army of Shadows*, 1969), the killings carried out by a cool, solitary hit man (*Le Samouraï*, 1967). Most of his films, from the rough-edged *Bob le flambeur* to the cold, elegant *Le Samourai*, were shot by Henri Decaë, whose low-budget, streetsmart look contributed so much to *The 400 Blows*, for Truffaut borrowed not only Melville's independent methods but also his cameraman.

2. 巴赞、《电影手册》、"电影作者论"和克拉考尔

著名的电影理论家和法国"新浪潮"电影教父安德列·巴赞（André Bazin）在40—50年代发表写实主义电影的经典著作《电影是什么》（*What Is Cinema*），强调电影是现实生活的渐近线，发现并阐释了意大利新现实主义

安德列·巴赞

的重要价值，创立对后世产生重大影响的长镜头理论，倡导场面调度和景深镜头完整呈现现实的写实主义意味。

巴赞在1951年创办《电影手册》(Cahiers du Cinéma)，与其得意门生特吕弗借用亚历山大·阿斯楚克（Alexander Astruc）的"作者"概念，创立切近生活丰富多义、注重个人艺术风格的"电影作者论"(la politique des auteurs)，并将好莱坞的希区柯克、福特、威尔斯、霍克斯和法国的冈斯、维果、雷诺阿、奥菲欧斯以及德国的朗格等人确定为"电影作者"，用以对抗以克莱尔、克莱门特和克鲁佐等为代表的所谓法国电影的"质量传统"(tradition of quality)，直接催生了法国"新浪潮"电影运动。

此外，德国著名的电影理论家齐格弗里德·克拉考尔（Siegfried Kracauer）也以专著《电影的本性：物质现实的复原》(Theory of Film: The Redemption of Physical Reality, 1960)，借用宗教"救赎"(Redemption)的概念，强调电影"记录"和"揭示"的本质属性，排斥电影人为设计的创造虚构，与巴赞的写实主义电影理论产生重要的呼应。而他早先的另一本著作《从卡里加里到希特勒》(From Caligari to Hitler, 1947)也曾经对表现主义时期的德国电影做出过鞭辟入里的社会心理学分析。

Theory: Astruc, Bazin, and Cahiers du Cinéma

The theoretical justification for the New Wave cinema came from another

source: the film critic Alexandre Astruc (1923-), who published a highly influential article in *L'Ecran française* in March 1948 on the concept of the *caméra-stylo*, which would permit the cinema "to become a means of expression as supple and subtle as that of written language" and would therefore accord filmmakers the status of authors, or *auteurs*. Astruc's notion was to break away from the tyranny of narrative in order to evolve a new form of audiovisual language. He wrote: "The fundamental problem of the cinema is how to express thought. The creation of this language has preoccupied all the theoreticians and writers in the history of cinema, from Eisenstein down to the scriptwriters and adaptors of the sound cinema". Like Bazin, Astruc questioned the values of classical montage and was an apostle of the long take, as exemplified in the work of Murnau. Astruc later became a professional director after apprenticing himself to Marc Allégret (1900-1973), but his own films (*Le Rideau cramoisi* [*The Crimson Curtain*; English title: *End of Desire*, 1952] and *Une Vie* [*A Life*, 1958]) do not attempt to realize the ideal of the *caméra-stylo*. Following the example of German Expressionism, Astruc's films tend to be highly stylized elaborations of visual imagery that make excessive use of mannered compositions and camera angles.

Astruc was succeeded as a theorist by the vastly influential journal *Cahiers du cinéma* (literally, "*cinema notebooks*"), founded in 1951 by André Bazin (1918-1958) and Jacques Doniol-Valcroze, which gathered about it a group of young critics—Françis Truffaut, Jean-Luc Godard, Claude Chabrol, Jacques Rivette, and Eric Rohmer—who were to become the major directors of the New Wave. These young men were *cinéphiles*, or "film-lovers". They had grown up in the postwar years watching great American films of the past and present decades (many available for the first time only when the German Occupation ended) as well as classical French films at the amazing Cinémathèque Française in Paris, the magnificent film archive and public theater founded in 1936 by Georges Franju and Henri Langlois to promote cinema study and cinema culture in France and throughout the world. During the Occupation, Langlois kept the enterprise in operation secretly at great personal risk, and afterward, through André Malraux, minister of culture, he obtained a large government subsidy for it. Today the Cinémathèque is the largest public film archive in the world, housing over fifty thousand films, three theaters, and a museum in the Palais de Chaillot devoted entirely to film history. It was Langlois who preserved the works of Griffith, Keaton, Gance, Vigo, and Renoir for the postwar generation of *cinéphiles* and introduced them to the then-unrecognized genius of directors like Ingmar Bergman and the great Japanese masters Akira Kurosawa and Yasujiro Ozu. Under Langlois's tutelage, these young men came to love film and desperately wanted to become filmmakers themselves, but they found the French commercial cinema inaccessible to them because of the powerful influence exerted by the trade unions.

Since they knew more about film than any other generation in history, based on the experience of actual viewing, they became critics and theorists instead.

The *Cahiers* critics had two basic principles. The first, deriving from Bazin, was a rejection of montage aesthetics in favor of *mise-en-scène*, the long take, and composition in depth. *Mise-en-scène*, the "placing-in-the-scene", is probably best defined as the creation of mood and ambience, though it more literally means the structuring of the film through camera placement and movement, blocking of action, direction of actors, etc.—in other words, everything that takes place on the set prior to the editing process. Integral to the concept of *mise-en-scène* is the notion that film should be not merely an intellectual or rational experience but an emotional and psychological one as well. The second tenet of the *Cahiers* critics, derived from Astruc, was the idea of personal authorship which Françis Truffaut expressed in a 1954 essay entitled "*Une certaine tendance du cinéma françis*" ("*A Certain Tendency in French Cinema*") as *la politique des auteurs*. This "*policy of authors*", christened "*the auteur theory*" by the American critic Andrew Sarris, states that film should ideally be a medium of personal artistic expression and that the best films are therefore those that most clearly bear their maker's "signature"— the stamp of his or her individual personality, controlling obsessions, and cardinal themes. The implicit assumption was that with each successive film an *auteur* grows increasingly proficient and mature of vision, an assumption that is not always borne out by fact.

Truffaut's essay, which appeared in *Cahiers du cinéma* for January 1954, began by attacking the postwar "tradition of quality", that is, the commercial scenarist tradition of Aurenche and Bost, Spaak, and directors such as Clair, Clément, Clouzot, Autant-Lara, Cayatte, and Yves Allégret, with its heavy emphasis on plot and dialogue. The key figure in this literary / theatrical cinema was the scriptwriter, the director being merely "the gentleman who added the pictures". To these "*littérateurs*" and their "*cinéma de papa*", Truffaut counterposed "*un cinéma d'auteurs*" in the work of such French writer-directors as Gance, Vigo, Renoir, Cocteau, Becker, Bresson, and Ophüls, and of numerous American directors—both major and minor—who had somehow managed to make personal statements despite the restrictions imposed upon them by the studio system. Some of the American choices—Welles, Hitchcock, Hawks, Lang, Ford, Nicholas Ray, and Anthony Mann, all masters of *mise-en-scène*—made perfect sense. Others—Jerry Lewis, Otto Preminger, Roger Corman—were based less on the quality of their films than on evidence of their personal directorial control. And the unquestioning allegiance which the *Cahiers* group gave to the figures in its pantheon made many skeptics wonder whether one form of iron-clad dogmatism had not simply been exchanged for another. But for all its deficiencies (and a proneness to fanaticism and cultism seems to be a major one), the *auteur* theory does

offer a valuable schematic model for interpreting the filmmaking process and goes some way toward solving a very basic methodological problem of film criticism: that is, to whom or what does one attribute cinematic creation? Furthermore, the *Cahiers* critics were able to partially vindicate the *auteur* theory by becoming filmmakers themselves and practicing it.

The New Wave's challenge to the "tradition of quality" was economic as well as aesthetic. Under the system that prevailed from 1953 to 1959, government aid was awarded to productions by the Centre National de la Cinématographie (CNC, founded 1946) on the basis of reputation, so potential directors needed an established record of success, and very few new people could hope to enter the industry. But in 1959, the laws relating to aid for film productions were changed to allow first films to be funded by the state on the basis of a submitted script alone, enabling hundreds of new filmmakers to become their own producers and creating the economic context for the New Wave. Moreover, the international commercial success of films like *Les Quatre-cents coups*, which was produced for seventy-five thousand dollars and brought five hundred thousand dollars for its American distribution rights alone, dramatically increased the number of private producers willing to finance new work. Thus, for a while at least, until the failures mounted, Truffaut's concept of *un cinéma d'auteurs* was realized in France by placing the control of the conception of a film in the same hands that controlled the actual production.

Kracauer

Siegfried Kracauer (1889-1966) was a film theoretician, sociologist, and historian. The holder of a Ph.D. from the Berlin University, he was on the editorial staff of the Frankfurter Zeitung from 1920 to 1933 and wrote a novel and several scholastic works. Immigrating to the US in 1941, he worked at New York's Museum of Modern Art for a couple of years, then was awarded a Guggenheim Foundation fellowship to write a history of the German film. The result was *From Caligari to Hitler* (1947), a critical study of the social and economic conditions and the psychological atmosphere that culminated in the rise of Hitler in Germany as they were reflected in German cinema between the World Wars. This thorough and often fascinating study has been criticized for a certain twisting and bending on the part of the author in postulating his premise.

Dr. Kracauer, who in the 50s was a senior member of the Bureau of Applied Social Research at Columbia University, wrote a second important cinema book, *Theory of Film*, in 1960. Stipulating that the one aim of cinema is the "redemption of physical reality", Kracauer proceeds to present a laborious and

systematic argument to support his theory. Although weakened by dogmatism and by subjective aesthetic preferences, and again by the tendency to twist and bend ideas to fit the author's a priori stipulations, the book remains one of the few comprehensive theoretical works in the field of film.

3. "新浪潮"

"新浪潮"（New Wave, *Nouvelle Vague*）是发生在20世纪50年代末60年代初的法国电影革新运动，特吕弗、戈达尔、夏布洛尔、侯麦和里维特这群在著名的法国电影资料馆（Cinémathèque Française，亨利·朗格洛瓦创建于1936年）自学成才的《电影手册》影评人成为"新浪潮"的主要成员，并在50年代后期相继投入电影创作实践、实现自己的理论主张。"新浪潮"导演虽然风格各异，但大都遵循巴赞写实主义的基本原则：包括反传统性多愁善感的真实人物、非戏剧性的松散叙事结构、自然光效的实景拍摄、强调电影媒介本身的反省性和导演创作的自我评论功能、以存在主义方式看待世界和人类行为等等。特吕弗的《四百下》、戈达尔的《精疲力尽》和雷乃的《广岛之恋》被公认为"新浪潮"最重要的代表作品，其中意大利新现实主义、美国经典电影和法国电影作者的影响不容小视。

New Wave, Nouvelle Vague

A movement in French cinema beginning in the late 1950's and peaking by 1962 that sought innovation in subject matter and technique. The movement itself, a response to the moribund French movie industry, received its major impetus from a small group of film enthusiasts who began their careers writing for the film journal *Cahiers du Cinéma* and who were especially influenced by the film criticism of one of the journal's founders, André Bazin. These critics, François Truffaut, Claude Chabrol, Jean-Luc Godard, Eric Rohmer, and Jacques Rivette, wrote against traditional and predictable film practices and argued for a more individual style of film making under the individual inspiration and vision of the director. The first of the New Wave films is considered Chabrol's *Le Beau Serge* (*Bitter Reunion*, 1958), though 1959 marked the true rise of the movement with Truffaut's unsentimental and honest autobiographical portrait of an alienated youth, *The 400 Blows*. Resnais's brilliant narration of a love affair between a Japanese man and French woman ravaged by memories of the Second World

War, *Hiroshima Mon Amour*, and Godard's irreverent, unsentimental, and comic homage to the American gangster film, *Breathless*. Because of the critical acclaim and international popularity of these films, the French movie industry in the next two years sponsored works by some sixty new directors, although only a small group of these filmmakers were financially successful enough to continue their careers.

Although the New Wave directors are marked by individual approaches and sensibilities, the following elements are considered central to the movement: (1) an irreverent, untraditional, and generally unsentimental treatment of character; (2) a loose, realistic, or innovative plot structure; (3) the use of light-weight, portable cameras and equipment that results in more spontaneous and realistic picture and sound; (4) much on-location and outdoor shooting; (5) elliptical cutting that draws attention to the relation between images as well as between image and sound and to the medium itself; (6) experimentation with filmic space and time; (7) allusions to earlier films to mark the continuity and discontinuity of tradition, to comment on the specific work's own self-reflexive quality as a movie, and also to pay homage to specific directors or films; and (8) a general existential attitude to an absurd universe and especially to human behavior and action. One must, of course, make distinctions between the more romantically inclined works of Truffaut, the political radicalism of Godard, the structural experimentation of Resnais, the moral sensibility of Rohmer, the theatricality of Rivette, and the eclecticism of Louis Malle.

Some other highly acclaimed films from this movement were Truffaut's *Shoot the Piano Piayer* (1960) and *Jules et Jim* (1961); Godard's *My Life to Live* (1962); and Resnais's *Last Year at Marienbad* (1961). Most of these directors went on to develop each in his own way; but there can be no question of the *Nouvelle Vague's* impact on international cinema, an impact which was to help free the cinema in the United States and Germany, for example, from conventionality and tradition and contribute to the movement toward *auteur* filmmaking in these nations.

4. 特吕弗和戈达尔及夏布洛尔、侯麦和里维特

弗朗索瓦·特吕弗（François Truffaut）1954年发表"新浪潮"电影宣言《法国电影的一种倾向》（*A Certain Tendency of the French Cinema*），并相继拍摄《四百下》《枪击钢琴师》和《茱尔与吉姆》等，奠定自己"新浪潮"主将的地位。特吕弗讲述反叛少年的自传体处女作《四百下》明显受到让·维果《零分操行》的影响，而由此延伸出的自传体影片系列则对青春、

《四百下》的不良少年

戈达尔《精疲力尽》

爱情、婚姻和人生等进行了浪漫而又严肃地探讨。特吕弗的代表作品还包括对电影媒介进行反省思考的《以日为夜》和反映地法国抵抗时期政治与爱情的《最后一班地铁》。

如果说特吕弗关注情感生活和艺术人生，那"新浪潮"另一位主将让 - 吕克·戈达尔（Jean-Luc Godard）则以强烈的政治倾向、极端的个性风格和执着的创新精神在世界影坛驰骋至今，《精疲力尽》《随心所欲》《轻蔑》《疯狂的彼埃罗》和《周末》等都是"新浪潮"的杰作。特别是由特吕弗构思故事、夏布洛尔担任技术顾问的《精疲力尽》一片可以算作"新浪潮"电影的梦幻组合，影片将对好莱坞经典黑帮片的模仿、法国小混混的悲剧性生存与巴黎街头的浪漫情仇融为一炉，表达出强烈的反叛和荒谬意味。激进左倾、崇尚维尔托夫的戈达尔虽然在1968年的法国"红五月"出尽风头，但晚年戈达尔的创作则偏重于人生哲学、视听语言和电影史论的探究。

此外，克洛德·夏布洛尔（Claude Chabrol）拍摄于1958的《漂亮的塞尔吉》被认为是"新浪潮"的先声，而他以后的影片也因精准地描绘两性激情与社会环境的张力而被誉为"希区柯克的法国传人"。埃里克·侯麦（Eric Rohmer）曾长期担任《电影手册》主编（1957—1963），作为最晚获得电影创作成功的"新浪潮"导演，他的《六个道德故事》及其《喜剧与箴言》系列电影都已道德和欲望、矜持与人性的主题获得观众的好评。而雅克·里维特（Jacques Rivette）就以其处女作《巴黎属于我们》，确定自己对于电影本体及其叙事方法（"新浪潮"电影的核心母题之一）的持续关注。

François Truffaut

The young François Truffaut (1932-1984), like the young Vigo and the young Renoir, built his early films on the central artistic idea of freedom, both in human relationships and in film technique. Truffaut's early protagonists are rebels, loners, or misfits who feel stifled by the conventional social definitions. Antoine Doinel (Jean-Pierre Léaud), the 13-year-old protagonist of *The 400 Blows* (*Les Quatre cents coups*: to raise hell or make mischief), must endure a prison-like school and a school-like prison, sentenced to both by hypocritical, unsympathetic, unperceptive adults. Charlie Kohler (Charles Aznavour) of Truffaut's *Shoot the Piano Player* (1960) has deliberately cut himself free of the ropes of fame and fortune as a concert pianist, preferring his job in a small, smoky bar, where he thinks he can remain—uncommitted, unburdened, unknown. Catherine (Jeanne Moreau) of *Jules and Jim* (1961, released 1962) feels so uncomfortable with all definitions—wife, mistress, mother, friend, woman—that she commits suicide. Truffaut's early

cinematic style was as anxious to break free as his characters were. The early films are dazzlingly elliptical, omitting huge transitional sections of time and emotional development. These narrative leaps—and a camera that moved unpredictably but always effectively, as if possessed by a vision of cinema and its renewed possibilities—gave the Truffant films an intensity, a spontaneity, a freshness that other films lacked.

The Truffaut filmography splits into two unequal halves—a group of early films in black and white (which earned him his initial respect and reputation) and two decades of films in color (which, despite their craft and subtlety, have never achieved the critical recognition of his first three films). The two recurrent themes of Truffaut's later films are education and art, both of which grow out of his earliest work. After several transitional pieces in a variety of styles—the realistic love triangle of *The Soft Skin* (1964), a repressive, antiliterate world of the future in *Fahrenheit 451* (1966, based on the novel by Ray Bradbury), and a Hitchcock dissertation in *The Bride Wore Black* (1968, based on the novel by Cornell Woolrich, and made after he published his book-length interview with Hitchcock)—the more commercial, less experimental half of Truffaut's career begins with the return to Antoine Doinel in *Stolen Kisses* (1968).

Antoine Doinel is Truffaut's alter ego; his adventures on film parallel Truffaut's own personal experiences as a child and young man; the maturing of the actor who plays Doinel, Jean-Pierre Léaud, parallels the maturing of the film director behind the camera who discovered the young boy and nurtured his early career. Léaud is Truffaut's spiritual son, much as Truffaut claimed André Bazin as his own spiritual father.

In *Stolen Kisses*, young Doinel blunders at both love and work, clumsily groping toward self-fulfillment in both. In *Bed and Board* (1970) Antoine is married, with a child of his own as well as a mistress; he is still a half-committed blunderer, the consistent trait of his adult life. And in *Love on the Run* (1979), Antoine gets divorced, but his novel has finally been published—a novel that is really an autobiographical exploration of his own experiences with women, transmuted into art.

The Wild Child (1969, released 1970), Truffaut's only black-and-white film after *The Soft Skin*, is also devoted to education. A late 18th-century scientist succeeds in taming a wild boy—a child who had spent his entire early life in the forest—and introduces him to the luxuries of civilization: speech, clothes, shelter, discipline, and love—which make him unfit for life in the wild. That the film is much closer to the Doinel cycle than it might seem from its case-history surface can be seen in Truffaut's dedication of the film to Jean-Pierre Léaud and in Truffaut's playing Dr. Jean Itard, the scientist who taught the boy. Just as both the boy and the scientist are changed as the result of the

educational process in The Wild Child, both Truffaut and Léaud, themselves outlaws and outcasts, grew in the process of creating works of art, the ultimate product of civilization.

The central Truffaut theme had evolved into one that was quite close to Renoir's: the relationship of art to nature and the ability of art to contain nature and to become its own nature.

This tension between art and nature propels *Day for Night* (1973), whose subject is the process of filmmaking. The film develops the con fiict and resultant synthesis of art and nature, for the commercial filmmaking process is one of converting the arranged and the artificial into the seemingly natural. A studio film produces candle effects with electric lights, rain and fire with valves and hoses, snow with suds of foam. The term that gives the film its title, *day-for-night* (in French, *la nuit américaine*—"American Night"), is itself a contradiction and an artifice that transforms nature, the term that Hollywood coined in the era when the movies produced the effect of nighttime by shooting during the day with a filter or with the lens opening reduced. Art and nature approach a synthesis in the twist—reminiscent of late Renoir—that the dedication to art becomes natural for people who define themselves as being artists.

Truffaut was never a committed political filmmaker. Like Renoir, he was too much the sympathetic but detached observer and ironist who saw the validity of competing ideological positions. And like Ophüls, he was too much the romantic and formalist in his quest for emotional satisfaction and artistic perfection. Truffaut faced his evasions directly in *The Last Metro* (1980), his most political film. In that film, the director of a Parisian acting ensemble during the Nazi Occupation (Catherine Deneuve) insists on continuing business as usual, performing the escapist plays the public and the authorities expect of her, refusing to take a stand against the anti-Semitic regulations that devastate her own acting company. Although her detachment angers the new leading man of the troupe (Gérard Depardieu), he discovers that her apolitical stance is a ruse to protect her own husband, the company's former director and leading man, who is hunted by the Occupation authorities and hiding in the basement of the theatre.

Here Truffaut made two points about his own apolitical films—in response to the activism of his colleague and contemporary, Jean-Luc Godard, who took quite the opposite path. First, the genuine political effects of art are frequently unknowable on the surface; second, the business of artists is to make art. The artist who rejects his *métier* for explicit political and rhetorical programs might produce bad art.

Jean-Luc Godard

Jean-Luc Godard (1930-) took the idea for his first feature film, *Breathless* (*A bout de souffle*, shot in 1959 and released early in 1960), from Truffaut. Michel Poiccard, the gangster-lover-hero of the film, is very much a Truffaut figure, a synthesis of Charlie, Catherine, and Antoine Doinel. Except for the fact that the cinema was both directors' ultimate subject, Breathless was as close as Godard's films ever came to Truffaut's. Whereas Truffaut's films are consistent in both theme and technique, the Godard films are consistent in their inconsistency, their eclecticism, their mixing of many different kinds of ideas and cinematic principles.

Godard, paradoxically, supports several contradictory ideas and filmic methods at the same time. He finds human experience irrational and inexplicable: Many of his films end in sudden, almost arbitrary deaths. But we do not cry over these deaths, from which we are distanced by the director's unsentimental treatment. Godard embraces Brechtian devices and politics, and Brecht's premise was that both art and human problems must be viewed as strictly rational and hence solvable.

Like Truffaut's, Godard's film career breaks into two parts—the works preceding and following 1968. But Godard's films never evolve toward Truffaut's synthesis of life and art; instead, Godard's films progressively reflect a fear that the familiar solutions of art are precisely antithetical to the necessary solutions for life, particularly political life. Bourgeois films cannot solve bourgeois problems, let alone Marxist and Maoist ones; such films cannot even ask the right questions. One cannot think with these films. The old forms provide their own oversimplified answers. And so Godard's films become not more whole and dramatic but more fragmented and questioning, in search of "new forms for new contents". Rather than resolving his contradictions, Godard's evolving work seeks to explore and analyze them. To the extent that he characteristically presents a dialectic rather than its resolution and that he thinks so deeply about the cinema as a language, Godard may well be considered the filmmaker who picked up where Eisenstein left off.

Breathless remains the strongest narrative of the Godard films. Godard examines the life of Michel Poiccard (Jean-Panl Belmondo), alias Laszlo Kovacs. Poiccard is indeed a petty crook in the B-picture tradition, a casual car thief who kills a policeman virtually by chance, gets emotionally entangled with his girl (Jean Seberg), whom he wants to run away with him, and is eventually gunned down by the police after the girl tips them off. The remarkable thing about the film is not just its simple story and the choppy, exciting, refreshing way it is told, but its Bogartesque character: brazen, charming, free, refusing to warp emotions into

words or conduct into laws.

To like Godard for *Breathless* is perhaps to wish he were another Truffaut. But even in *Breathless* the unique Godard devices—the logical assault against logic, the sudden and abrupt event, the Brechtian detachment of the viewer from the illusion of the film—control the work. As Michel drives the stolen car, his monologue on life and the countryside is addressed directly to us, an artifice that Godard emphasizes with his jump cutting, which destroys—or excitingly charges—the visual continuity of time and space.

The primary strength of Godard's early films is his ability to catch flashing, elusive moments of passion, joy, or pain with the most surprising and unconventional narrative techniques. *Vivre sa vie* (1962) is a cold and moving, compelling and detached study of a woman (Nana, played by Godard's first wife, Anna Karina), who drifts into prostitution (a consistent Godard metaphor for the relationships of people under capitalism) and is shot to death when one pimp tries to sell her to another (in an understated, realistic scene of almost arbitrary violence—as far from a big "Hollywood ending" as possible).

If Godard's overall career reveals a consistent pattern, it is that he began by using bizarre devices of cinematic perception as a means to tell rather conventional narratives—the means to bring his characters to life—and he became progressively more concerned with a critique of cinematic perception as an end in itself.

Three of Godard's pre-1968 films are most clearly committed to a study of image making. *Contempt* (1963) is a film explicitly about the making of film images (with Fritz Lang in the role of a director and Brigitte Bardot as a sex-object star); *A Married Woman* (1964) is an analysis of the commodification of women, marriage, "beauty," and "romance" in modern society. *2 or 3 Things I Know About Her* (1967) is a return to the milieu of prostitution of *Vivre sa vie* but with the emphasis on the milieu (cafés, cars, city streets, architecture) and the cultural, political, and economic system of which prostitution is an integral part and for which it is a valid symbol. It is also about the problem of knowing, defining, and filming anything—a major investigation of the phenomenology and epistemology of the filmed world. As his films moved toward 1968, Godard became increasingly convinced that one cannot make movies—or any other kind of artwork—without first understanding how one is making them and why.

The Paris riots of May-June 1968 intensified Godard's political commitments, leading him to organize a political cell (he and co-founder Jean Pierre Gorin called it the Dziga Vertov film collective, after the Soviet innovator of Kinó—Pravda) for making films, in opposition to the Apollonian, bourgeois model of the individual artist-creator. The character played by Yves Montand in *Tout va bien* (1972) is, like Godard, a flint director who explains that he could no longer continue making auteurist films after the events of 1968. But Montand's choice becomes a cynical

one; he decides to shoot the most vapid and exploitative television commercials exclusively. Unlike this character, Godard has decided to become the analyst rather than the manipulator of modern cultural packaging.

The investigation of language is an aspect of every Godard film, but it reaches its philosophical peak in *2 or 3 Things* and its political apex in *Wind from the East* (1969). Beginning in 1968, Godard also made films for TV about language (*Le Gai savoir*, released 1969); with Anne-Marie Miéville, he made two important series for TV, the 1976 *Communication* (*Six fois deux/Sur et sous la communication* [*Six Times Two*]) and the 1978 *France/ Tour/ Détour/ Deux/ Enfants*. After *Sauve qui peut*, Godard made a number of richly theatrical films that investigated art, religion, and genres (*Detective*, 1985; *Passion*, 1982; *First Name: Carmen*, 1983; *Hail Mary*, 1985). In *Notre musique* (*Our Music*, 2004), a meditation on violence on film and in the world, Godard argued that the cinema is built on the "shot and countershot" of the imaginary and the real: "Imaginary: certainty. Reality: uncertainty. The principle of cinema: go toward the light and shine it on our night. Our music".

Extending the investigation of self, divination, and spirit begun in *Passion* and *Hail Mary*, and facilitating the leap from *Germany Nine Zero* (1991) to *For Ever Mozart* (1996), *Hélas pour moi* (*Alas for Me*, or *Woe is Me*, 1992, released 1993) is a meditation on mortality and disappointment. If Wittgenstein was the philosopher most important to *2 or 3 Things*, *Hélas pour moi* extrapolates the work of Jacques Derrida—seeking the traces of a god in a legend and in the ordinary contemporary world, while knowing that the traces can lead to no final knowledge and that there can be no absolute universal center or foundation of knowledge. Nevertheless, Godard meditates from a kind of center (which he calls *ici-bas*, or "here as over there", a pun *là-bas*) in which he finds that things are "absent—but nowhere else". As in *2 or 3 Things*, Godard is still investigating objects and trying to construct a basis for the cinema; he is also still doing a lot of quoting. Even if, as he admits, parts of the world and his subject refuse to be told, Godard's mature understanding of distance allows him to continue to probe the nature of engagement.

Chabrol, Rohmer, and Rivette

Many important directors—though not of the stature of Godard and Truffaut—also contributed to the reputation of the French film in the 1960s. Claude Chabrol (1930-2010) was the first of the *Cahiers* critics to make a feature film (*Le Beau Serge*, 1958). In films such as *Les Cousins* (1959), *Les Bonnes femmes* (1960), *Les Biches* (1968), *Le Boucher* (1970), and *Violette* (1978), Chabrol reveals—rather like Hitchcock, whom he often emulates—a superb contrapuntal tension between

the sexual passions of his characters and the carefully detailed social environment.

Eric Rohmer (1920-2010) began making his "Six Moral Tales" in 1962 and found a worldwide audience with the fourth one, *My Night at Maud's* (1969), a tale of love and religion and serious conversation. The mental battle over desire was joined again, almost as memorably, in the last two films in the series, *Claire's Knee* (1970) and *Chloe in the Afternoon* (1972). In 1976 he turned his anstere eye to literature, adapting Heinrich van Kleist's *The Marquise of O...*, and in 1978 he retold Chrétien de Troyes's 12th-century version of the legend of the grail-seeking Parsifal according to the conventions and in the imagery of medieval art (*Perceval*).

Of the five *Cahiers* critics-turned-filmmakers, Jacques Rivette (1928-) has had the least commercial success, but his long, labyrinthine explorations of the nature of film and the paradoxes of narration are central to the New Wave's spirited reinvention of the cinema, His first feature was Paris nous appartient (*Paris Belongs to Us*, released in 1961); produced by Truffaut, it's the picture the family goes to see in *The 400 Blows*. Using both narrative and antinarrative methods, Rivette dramatized and analyzed narration itself in *L'Amour fou* (1968), *Out one* (1971, nearly 13 hours), *Out one: Spectre* (1974, a different film made from the footage of *Out one*), and especially the mysterious, intricate, and playful *Céline and Julie Go Boating* (1974).

5. 左岸的阿兰·雷乃等人

"左岸派"（Left Bank, Rive Gauche）可以算作"新浪潮"同盟军或组成部分，塞纳河的左岸是巴黎著名的文化区，"左岸派"导演具备精英知识分子意识、强烈的文学、哲学和美学倾向、纪实电影风格并接受过电影专业训练。而阿兰·雷乃（Alain Resnais）就是"左岸派"最典型的代表人物，他将一生电影创作聚焦在"时间与记忆"的主题上，早期纪录片《夜与雾》在流逝的时间中对纳粹大屠杀进行哲学沉思，著名的《广岛之恋》对日本广岛和法国内韦尔两个时空的爱情进行交织体验，而《去年在马里昂巴德》则对生命时间的暧昧宿命做出精彩的电影化阐释。

早在1953年雷乃就与克里斯·马凯（Chris Marker）联合执导了纪录片《雕像也会死去》，而次年女导演艾格尼丝·瓦尔达（Agnes Varda）推出的《短角岬》（雷乃担任剪辑）更被认为是"左岸派"电影的先驱。"左岸派"的代表作品还包括马凯的《防波堤》、瓦尔达的《五点到七点的克莱奥》、瓦尔达丈夫雅克·德米（Jacques Demy）的《罗拉》《天使湾》和《瑟堡的雨伞》以及雷乃剪辑师亨利·科尔比（Henri Colpi）的《长别离》等。而著名女作

家、《广岛之恋》和《长别离》的编剧玛格丽特·杜拉斯（Marguerite Duras）和法国"新小说派"大师、《去年在马里昂巴德》的编剧阿兰·罗伯-格里耶（Alain Robbe-Grillet）也相继开始执导影片。

此外，路易·马勒（Louis Malle）被认为是独立于《电影手册》和"左岸派"之外又兼收并蓄的"新浪潮"导演，他的惊悚爱情片《通往绞刑架的电梯》（*Elevator to the Gallows or Frantic*，1957）被认为是"新浪潮"早期的杰作，具有很高的视听和叙事价值。

New Cinema: The Left Bank

The late 1950s brought to prominence another loosely affiliated group of filmmakers—since known as the *Rive Gauche*, or "Left Bank", group. Mostly older and less movie-mad than the *Cahiers* crew, they tended to see cinema as akin to other arts, particularly literature. Some of these directors—Alain Resnais, Agnès Varda, and Georges Franju—were already known for their unusual short documentaries. Like New Wave filmmakers, however, they practiced cinematic modernism, and their emergence in the late 1950s bendfited from the youthful public's interest in experimentation.

Two works of the mid-1950s were significant precursors. Alexandre Astruc, whose caméra-stylo manifesto had been an important spur to the auteur theory, made *Les Mauvaises rencontres* (*Bad Meetings*, 1955), which uses flashbacks and a voice-over narration to explain the past of a woman brought to a police station in connection with an abortionist. More important is Agnès Varda's short feature *La Pointe courte* (1955). Much of the film consists of a couple's random walks. But the nonactors and real locales conflict with the couple's archly stylized voice-over dialogue. The film's elliptical editing was with-out parallel in the cinema of day.

The prototypical Left Bank film was *Hiroshima mon amour*, directed by Alain Resnais from a script by Marguerite Duras. Appearing in 1959, it shared the limelight with *Les Cousins* and *The 400 Blows*, offering more evidence that the French cinema was renewing itself. But *Hiroshima* differs greatly from the works of Chabrol and Truffaut. At once highly intellectual and viscerally shocking, it juxtaposes the present and the past in disturbing ways.

A French actress comes to Hiroshima to perform in an antiwar film. She is attracted to a Japanese man. Over two nights and days they make love, talk, quarrel, and gain an obscure understanding. At the same time, memories of the German soldier she loved during the Occupation well up unexpectedly. She struggles to connect her own torment during World War II with the ghastly

suffering inflicted in the 1945 atomic destruction of Hiroshima. The film closes with the couple's apparent reconciliation, suggesting that the difficulty of fully knowing any historical truth resembles that of understanding another human being.

Duras builds her script as a duet, with male and female voices intertwining over the images. Often the viewer does not know if the sound track carries real conversatins, imaginary dialogues, or commentary spoken by the characters. The film leaps from current story action to documentary footage, usually of Hiroshima, or to shots of the actress's youth in France. While audiences had seen flashback constructions throughout the 1940s and 1950s, Resnais made such temporal switches sudden and fragmentary. In many cases they remain ambiguously poised between memory and fantasy.

In *Hiroshima's* second part, the Japanese man pursues the French woman through the city over a single night. Now her inner voice takes the place of flashbacks, commenting on what is happening in the present. If the film's first half is so rapidly paced as to disorient the spectator, the second art daringly slows to the tempo of their walking, her nervous avoidance, his patient waiting. The rhythm, which forces us to observe nuances of their behavior, anticipates that of Antonioni's *L'Avventura*.

Hiroshima mon amour was shown out of competition at Cannes in 1959 and awarded an Internatinal Critics' Prize. It caused a sensation, both for its scenes of sexual intimacy and for its storytelling techniques. Its ambiguous mixture of documentary realism, subjective evocation, and authorial commentary represented a land-mark in the development of the international art cinema.

Hiroshima lifted Resnais to international renown. His next work, *Last Year at Marienbad*, pushed modernist ambiguity to new extremes. This tale of three people encountering each other in a luxurious hotel mixes fantasy, dream—and reality, if there is any to be discovered. Resnais's next film *Muriel*, uses no flashbacks, but the past remains visible in a young man's amateur movies of his traumatic tour of duty in Algeria. Even more explicitly than *Hiroshima*, the film takes up political questions; the Muriel of the title, never seen, is an Algerian tortured by French occupiers. Resnais emphasizes the anxiety of the present through a jolting editing far more precise tham the rough jump cuts of the New Wave.

The success or *Hiroshima mon amour* helped launch features by other Left Bank filmmakers. Georges Franju's *Eyes without a Face* and *Judex* offered cerebral, slightly surrealist reworkings of classic genres and paid homage to directors like Fritz Lang and Louis Feuillade. Resnais's editor Henri Colpi was able to make *Une Aussi longue absence* (1960), a tale of a café keeper who believes that a tramp is her returning husband. With its fragmentary scenes and unexpected cuts, it anticipates *Muriel*. Marguerite Duras, who wrote Colpi's film

as well as Resnais's, was eventually drawn to filmmaking.

The fame of Resnais's work enabled another literary figure to move into directing. After scripting *Last Year at Marienbad*, the novelist Alain Robbe-Grillet debuted as a director with *L'Immortelle*. It continues *Marienbad*'s rendition of "impossible" times and spaces. Robbe-Grillet's second film, *Trans-Europe Express*, is self-consciously about storytelling, as three writers settle down in a train to write about international drug smuggling. The film shows us their plot enacted, with all the variants and revisions that emerge from the discussion.

The *Hiroshima* breakthrough also helped Agnès Varda make a full-length feature, *Cléo from 5 to 7*. Despite its title, the film covers ninety-five minutes in the life of an actress awaiting the results of a critical medical test. Varda distances us from this tense situation by breaking the film into thirteen "chapters" and by including various digressions. The film's exuberance, in surprising contrast to its morbid subject, puts it close to the New Wave tone, but its experiment in manipulating story duration has an intellectual flavor typical of the Left Bank group.

Varda's films after Cléo include the controversial *Le Bonheur*, which disturbed viewers by suggesting that one woman can easily take the place of another. In a typically modernist attack on traditional morality, Varda quotes Renoir's *Picnic on the Grass*, in which a character remarks, "Hapiness may consist in submitting to the order of Nature".

Alain Resnais

The tension between formal experiment and political commitment is also central to the work of Alain Resnais (1922-2014). Although Resnals has been consistently linked with both Truffaut and Godard, he is a completely different kind of filmmaker. Ten years older than Truffaut and Godard, Resnais began his career in films not as *cinéaste* and critic but as film editor and documentary filmmaker. His most important early films were documentaries that studied the works of artists (Van Gogh, Gauguin, Picasso's *Guernica*) or examined the horrors of the Nazi concentration camps (*Night and Fog*, 1955). But as with Truffaut, 1959 was the year of Resnais's first feature, *Hiroshima mon amour*, and critics considered his work part of the same "wave" despite the differences in his films.

Resnais begins with a far more literary premise than Truffaut or Godard. His films are neither improvised nor spontaneous. Like Bresson and Renoir, Resnais begins with detailed, literate, highly polished scripts. Although

Resnais does not adapt novels into films, he asks novelists to write his original scripts: Marguerite Duras, Alain Robbe-Grillet, Jean Cayrol. Resnals respects literateness, complex construction, and poetic speech. His films are thoughtful, astonishing, tightly controlled, and operatic in comparison with the breezy, erratic, makeshift feeling of the early Truffaut and Godard films. Because one of the key Resnais themes is the effect of time, the interrelation of past, present, and future, of memory and event, his narratives are frequently elliptical, cutting in time and space even more freely than Truffaut's or Godard's.

In *Hiroshima mon amour* (1959), written by Marguerite Duras, a French woman and a Japanese man try to build something more between them than a single night in bed. She is an actress who has come to Hiroshima to make a peace film; he is an architect trying to build the ruined city up from its ashes. But they are separated by more than cultural distance. Between them is the past. For him, there is Hiroshima, the burned-out home of his youth; for her, Nevers, the little French town where she loved a German soldier in the occupation army whom the villagers murdered when the Nazis evacuated. Both have burned-out pasts.

To show the intrusion of these pasts into the present, Resnais, the sensitive editor, cuts shots of Nevers and the Hiroshima carnage into the shots of the present. At the film's opening, the two embracing lovers' arms seem to be covered with radioactive dust. As they make love, Resnais's camera tracks through the Hiroshima war museum, showing the burnt buildings and mutilated bodies. When the woman (Emmanuelle Riva) glances at the twitching hand of her sleeping lover (Eiji Okada), Resnais cuts to a short, sudden flash of her experience in Nevers: the moment she held her Geman lover and saw his hand twitch as he died. The result of this assault of the past on the present is an emotional gulf between them that can never be bridged.

In *Last Year at Marienbad* (1961), every event is ambiguous. A man (X, played by Giorgio Albertazzi) meets a woman (A, played by Delphine Seyrig) at what may or may not be an elegant resort near the town of Marienbad; he may or may not have met her there or at a different resort one year before. He relentlessly implores her to leave the resort with him, to flee the man (M, played by Sacha Pitoeff) who may or may not be her husband. At the end of the film, she may or may not remember having met him (X may have convinced her of a lie), and they may or may not leave the chateau together.

In this maze of time and faces, several dominant themes are quite clear. One is time itself. The man claims to have met the woman last year, but what exactly is a year? She has photographs in her room, clear mementos of the past, but the pictures seem to be of her in the present. At one point in the film a man bumps into a woman and spills her drink. Some 45 minutes of film time

continue from this point. Then Resnais returns to the spilled-drink sequence, with the characters in exactly the same positions as when the drink was spilled. Has Resnais equated 45 minutes of screen time with an instantaneons flash of thought and feeling in a character's mind? And if it is a subjective flash, whose is it? Although the film's structure resembles the stream-of-consciousness narration of modern fiction, it is difficult to determine whose consciousness is streaming in the film—the man's, the woman's, the director's, the writer's, or that of the film itself.

Resnais followed *Marienbad* with *Muriel* or *The Time of a Return* (1963), his first feature in color. *Muriel* sticks to the present as its characters attempt to deal with the past. Even as the characters remember and talk about the past, and figures from the past show up (some with lies and some with the hidden truth), forcing all of them to deal with old political atrocities and romantic betrayals, *Muriel* shows how they and the city in which the action is set (Boulogne—like *Hiroshima*, reconstructed after World War II) are part of a system. As cold and intellectual as some people find such systematic, formally perfect films, they are deeply romantic and intensely political in addition to being philosophically profound. Like Godard and Chris Marker, Resnais is someone who thinks with film.

After returning to black and white to make a relatively accessible story of love and politics in the context of the long-lost Spanish Civil War, *La Guerre est finie* (*The War is Over*, 1966), Resnais concentrated on formal color style pieces. Many of Resnais's later films, including *Providence* (1977), *Mon oncle d'Amérique* (1980), *La Vie est un roman* (*Life is a Novel*, 1983), and *Smoking/No Smoking* (1993), continue his experiments with narrative, contributing to the library of world cinema some of the most vigorously crafted, intellectually provocative movies ever made.

第五节 苏俄"解冻"电影

1. 繁荣的电影春天

1953年赫鲁晓夫主导的"非斯大林化"迎来了苏俄电影的"解冻时期"（Thaw），一大批超越苏俄僵化社会主义现实主义意识形态、倡导人性艺术和普世价值观的电影如雨后春笋般涌现出来，迅速赢得国际电影界的关注和世界观众的好评。卡拉托佐夫的《雁南飞》荣获戛纳电影节"金棕榈奖"，丘赫莱依的《第四十一》和《士兵之歌》、邦达尔丘克的《一个人的遭遇》和格拉西莫夫的《静静的顿河》都是苏俄解冻电影的代表作品。

"解冻"电影同样带来苏俄民族电影的发展，格鲁吉亚导演谢尔盖·帕拉杰诺夫（Sergei Paradjanov）就以《被遗忘祖先的影子》和《石榴的颜色》风格化的民间故事、神话传说、音乐舞蹈和生活习俗，展示出独具特色的乌克兰、格鲁吉亚和亚美尼亚文化价值，成为世界电影界的一株奇葩。

Cinema during the Khrushchev Thaw

Stalin's death on March 5, 1953, caused an immediate loosening of ideological criteria, and 1954 witnessed the production of forty Soviet features. But it was not until Nikita Khrushchev became first secretary of the Central Committee and denounced Stalin's brutal despotism in his famous "secret speech" before the Twentieth Party Congress in February 1956 that the de-Stalinization process began in earnest. Khrushchev's charges against his former boss ranged

《雁南飞》

from self-glorification to political mass murder, and he roundly indicted Stalin's promulgation of a "cult of personality" through the film. More striking still, perhaps, was his assertion that Stalin had lost touch with the reality of his country as he rose to power and that he eventually knew it only through the pseudorealistic film images mandated by his own cultural bureaucracy which, when he did not like the images, he caused to be ruthlessly purged. In fact, Khrushchev declared that Stalin had not set foot in a village since 1928, adding: "He knew the country and agriculture only from films. And these films had dressed up and beautified the existing situation Many films so pictured *kolkhoz* life that the tables were bending from the weight of turkeys and geese. Evidently, Stalin thought it was actually so".

It is important to understand, however, that although Stalin was officially discredited, Zhdanov was not, and socialist realism as a doctrine was not then and never was officially rescinded (although it was unanimously rejected by a vote of the Filmmakers Union in June 1990, shortly before the collapse of the Soviet state). It was simply interpreted with greater moderation than previously.

The Khrushchev regime's more flexible attitude toward the arts (initially, at least) produced a thaw in the Soviet film industry that started dramatically in 1956. In that year new films began to appear from recent graduates of the VGIK for the first time since the thirties, many of which had contemporary themes. Among them were Grigori Chukhrai's (b. 1921) *The Forty-first* (*Sorok pervyi*), Stanislav Rostotski's (b. 1921) *The Land and the People* (*Zemlia i liudi*), Samson

Samsonov's (b. 1921) *The Grasshopper* (*Poprygunia*—from a Chekhov story), the Georgian director Marlen Khutsiev (b. 1925) and Felix Mironer's (b. 1927) *Spring on Zarechnaia Street* (*Vesna na Zarechnoi ulitse*), Eldar Riazanov's (b. 1927) musical comedy *Carnival Night* (*Karnavalnaia noch'*), Vasili Ordynski's (b. 1925) *A Man Is Born* (*Chelovek rodilsia*), Alexander Alov (b. 1928) and Vladimir Naumov's (b. 1927) *Pavel Korchagin* (based on Nikolai Ostrovski's *How Steel Was Tempered*), Lev Kulijanov (b. 1924) and Iakov Segel's (b. 1923) *This Is How It Began* (*Eto nachinalos' tak*), and the first non-Russian postwar film, Magdana's *Little Donkey* (*Lurdzha Magdany*), by the Georgian directors Tengis Abuladze (b. 1924) and Revaz Chkheidze (b. 1926). Veteran directors were also productive in the early thaw—-Sergei Iutkevich with *Othello* (1956), the first Soviet Shakespearean adaptation, and *Stories about Lenin* (*Rasskazy o Lenine*, 1957); Mark Donskoi with a remake of Pudovkin's *Mother* (*Mat*, 1956); Alexander Ptushko (b. 1900) with the first Soviet widescreen film, the puppet-animation fairy tale *Ilia Muromets* (1957); and, most prominently, Mikhail Kalatozov with *The Cranes Are Flying* (*Letiat zhuravli*, 1957).

When the latter won the Grand Prix at Cannes in 1958, it announced to the world that some sort of revival was taking place within the Soviet cinema. Just over a year before, however, Soviet tanks had brutally crushed the Hungarian revolution, and this had produced a chilling effect on domestic culture. For a while, the safest subjects for films became literary adaptations, and the late fifties witnessed a glut of them, especially among directors of an older generation—for example, Sergei Gerasimov's (1907-1985) three-part version of Mikhail Sholokhov's And Quiet Flows the Don (Tikhii Don, 1957); Ivan Pyriev's adaptations of Dostoevsky's The Idiot (idiot, 1958) and White Nights (Belye nochi, 1959); Donskoi's Gorki adaptation, Foma Gordeev (1959); Vladimir Petrov's version of Turgenev's On the Eve (Nakanune, 1959); the actor Alexei Batalov's adaptation of Gogol's The Overcoat (Shinel, 1959—actually a remake of the Kozintsev and Trauberg 1926 version, but this time done in the Moscow Art Theater's naturalistic style); and losif Heifitz' adaptations from Chekhov, The Lady with the Little Dog (Dama s sobachkoi, 1960) and In the Town of S (V gorode "S", 1966). Also notable in this category are the actor-director Sergei Bondarchuk's (1920-1994) version of Fate of a Man (Sud, ba cheloveka, 1959), adapted from Mikhail Sholokhov, and the four-part epic War and Peace (Voina i mir, 1965-67), adapted from Tolstoi; and Kozintsev's distinguished adaptations of Don Quixote (1956), Hamlet (1964), and King Lear (Korol' Lir, 1972).

Yet Khrushchev was not Stalin, and advances in the industry continued to be made under his regime: by 1958 the annual output had reached 115 features, of which one-third were in color (introduced to the Soviets in 1950); in 1959 the Moscow International Film Festival was inaugurated on a regular biennial

basis; and, most significant perhaps, production was either renewed or begun on a full-time basis in all of the non-Russian republics in the period 1955-1965. Furthermore, the bolder Soviet filmmakers continued to test the waters of social comment during this time with such works as Kulijanov and Segel's *The House I Live In* (*Dom v kotorom ia zhivu*, 1957); Chkheidze's *Our Courtyard* (*Nash dvor*, 1957) and *Father of a Soldier* (*Otets soldata*, 1964); Chukrai's internationally acclaimed *Ballad of a Soldier* (*Ballada o soldate*, 1958)—a prize-winner at Cannes and San Francisco—and *Clear Skies* (*Chistoe nebo*,1961); Kalatozov and Sergei Urusevski's *The Letter That Wasn't Sent* (*Neopravlennoe pismo*, 1960) and *I Am Cuba* (*la Kuba*, 1964), a fantastic two-and-one-half hour propaganda epic scripted by Yevtushenko that was released in the United States in 1995; Iuli Raizman's *If This Is Love* (*A esli eto liubov*, 1961); Mikhail Romm's philosophical feature *Nine Days in a Year* (*Deviat' dnei odnogo goda*, 1962) and remarkable compilation documentary *Ordinary Fascism* (*Obykno-vennyi fashizm*, 1965); Elem Klimov's first feature, *Welcome, But Unauthorized Persons Not Allowed* (*Dobro požalovat', li postoronnim vhod vosprěščën*, 1964), all antiauthoritarian satire in the guise of a youth film; and, most strikingly, Marlen Khutsiev's *Lenin's Guard* (also known as *Ilich Square* [*Zastva Ilicha*], produced 1962), which provoked a storm of official outrage and had to be reshot as *I'm Twenty* (*Mne dvadsat'let*, released 1964) over the next eighteen months.

In December 1962, Khrushchev announced that liberalism in the arts had gone too far, and he issued a stinging indictment of Soviet modernist painting on the occasion of the exhibition "Thirty Years of Pictorial Art" in Moscow. This was followed by party-line attacks on *Nine Days in a Year* and *The Letter That Wasn't Sent*, making it clear that the basic tenets of socialist realism hadn't changed a bit. Caution immediately became the industry watchword, although remarkable debuts continued to be made—for example, by the Georgian directors Georgi Danelia (b. 1930; *I Walk About Moscow* [*la shagaiu po Moskve*, 1963]) and Eldar Shengelaia (b. 1933; *White Caravan* [*Belyi karavan*, 1963]) and by the actor-director Vasili Shukshin (1929-74; *There Was a Lad* [*Zhivet takoi paren*, 1964]).

In October 1964, Khrushchev was removed from office by a conspiracy among his deputies, and a diumvirate was installed consisting of Leohid Brezhnev and Alexei N. Kosygin as first secretary of the Central Committee and chairman of the Council of Ministers, respectively. (Brezhnev became general secretary in 1966, and ultimately he superseded all of his comrades to become supreme leader of the country, a position he held until his death.) There followed a period of uncertainty and indecision for the arts that ended abruptly with the Warsaw Pact occupation of Czechoslovakia in August 1968 and a renewed domestic campaign against the liberalization of Soviet culture in 1969. Appropriately, however, the brief period of the Khrushchev thaw ended with the production of one of the

most extraordinary and beautiful films ever made: Sergei Parajanov's *Shadows of Forgotten Ancestors* (*Teni zabytykh predkov*, 1964).

Paradjanov

Sergei Paradjanov (1924-1990) was born in Georgia, was tutored by Dovzhenko, made most of his films in Ukraine (some in Georgia and Armenia), and died in Armenia in 1990. A musician, painter, and connoisseur of folktales, Paradjanov became world famous with the Ukrainian *Shadows of Forgotten Ancestors* (1964), a lyrical explosion disguised as a movie. Set in the Carpathian mountains among a tribe "forgotten by God and men", *Shadows* episodically relates a folktale of undying love. Its combination of realism and mythology evokes what is at once a vivid natural world and a magical realm brimming with the power of characters who are both simple and bigger than life (as in the folk legend and myth) and with psychological and supernatural forces that erupt into the wild daylight. Its "prosaic days are for work, holidays for magic". But this world that has been so carefully re-created, both in its look and in its worldview, is observed by an utterly up-to-date camera that rushes to frame the action or follows it fluidly, or circles within or around the action. From its swish pans to its slow motion, from its constantly changing music to its abrupt shifts in narrative tone, from its rough realities to its brilliant dreams, *Shadows of Forgotten Ancestors* was the most important Soviet film since *Ivan the Terrible, Part II*. Though Paradjanov was hailed as a new Dovzhenko, he ran into trouble when the film was accused of formalism—the demon of the old Stalinist censors—and of promoting Ukrainian nationalism. In 1968 he made a controversial film—*Sayat Nova*, also known as *The Color of Pomegranates*—that evoked the poems and the inner life of an 18th-century Armenian monk through a series of stunning images; when he refused to revise the film to suit authorities, it was recut by someone else and shelved. While he was serving four years at hard labor in the Gulag, an early, unfinished (1971) version of *Sayat Nova* was seen by filmmakers and shown at festivals outside the country; Paradjanov completed the film in 1978, when he got out of prison. His last major works were *The Legend of the Suram Fortress* (1984, co-directed by Dodo Abashidze) and *Ashik Kerib* (1988).

2. 塔尔科夫斯基

安德烈·塔尔科夫斯基（Andrei Tarkovsky）1962 年的处女作《伊万的童年》赢得威尼斯电影节"金狮奖"，但具有浓郁欧洲艺术背景并执著于宗教哲

学主题的塔尔科夫斯基一直与苏俄意识形态龃龉不断,最终于 1984 年自我放逐到欧洲。塔尔科夫斯基通过其电影结构和电影风格体现出来的强烈个性特征和深沉的艺术韵味,使他成为与费里尼和伯格曼比肩的欧洲艺术电影大师("圣三位一体")。

塔尔科夫斯基的《安德烈·鲁勃廖夫》通过宗教画家的执著展现精神世界的坚贞,《镜子》表现诗意化的情感和记忆。 流放欧洲期间的《乡愁》是对俄罗斯故土最深沉的怀念,而绝笔之作《牺牲》则是对于人类宿命作出《圣经》启示录式的预言。

Andrei Tarkovsky

Andrei Tarkovsky was born in the Russian countryside near the town of Yuryevets. His father, the poet Arseny Tarkovsky, whose works are frequently quoted in his son's films, separated from his mother when Andrei was 4; the largely autobiographical *Mirror* (1975) reflects this childhood trauma, and the themes of an absent father and a close but tense relationship with a mother who is loved but resented are particularly prominent in Tarkovsley's early films.

Tarkovsky achieved international recognition with his first feature film, *Ivan's Childhood* (1962), the tragic story of a young war scout, which won the Golden Lion at the 1962 Venice Film Festival. *Andrei Roublev*, loosely based on the life of a famous medieval Russian icon painter, was completed in 1966, but not released in the Soviet Union till 1971—largely because of its portrayal of the conflict between the artist and the political power structure. Despite increasing tensions with the cultural bureaucracy, Tarkovsky was allowed to continue working, producing *Solaris* (1972), based on a science-fiction novel by Stanislaw Lem; *Mirror*; and another ostensibly futuristic work, *Stalker* (1979), from a novella by Boris and Arkady Strugatsky. During this period, his problems with the authorities derived less from political unorthodoxy-he constantly refused to label himself as a "dissident"-than from the intensely personal nature of his films, their intellectual "difficulty", and their total disregard of the still starving canons of Socialist Realism in both them style. His refusal to compromise with anything that might damage the artistic integrity of his work harmed and benefited him, causing hostility and objection but also gaining him grudging respect even from opponents (supported by his growing international reputation).

After being allowed to film the Soviet-Italian co-production *Nostalghia* (1983) in Italy, Tarkovsky announced in July 1984 that he intended to continue living abroad, citing personal harassment by the Soviet authorities and their frustration of many of his most cherished film projects. After completing *The Sacrifice* (1986)

《安德烈·鲁勃廖夫》

in Sweden, he was diagnosed as suffering from lung cancer and died in Paris in December 1986.

Tarkovsky's films are distinguished by an intense moral seriousness matched by only a handful of other film-makers-most notably two of his own favourites, Robert Bresson and Ingmar Bergman. As his book *Sculpting in Time* makes clear, he wanted film to be an art, not of entertainment, but of moral and spiritual examination, and he was prepared to make extreme demands, both of himself and of his audience, to achieve this. Despite the move from Russia to the west, his films display a continuity and development of theme and style that transcend differing political systems. They explore what he saw as eternal themes of faith, love, responsibility, loyalty, and personal and artistic integrity. In his last three films in particular this is combined with an increasingly strident attack on the soulless materialism of both "east" and "west", their reliance on technology as a solution to human problems, and the dehumanization and destruction of the natural environment that result. These themes are expressed through a complex system of imagery and a challenging narrative structure that remain essentially constant and yet develop throughout his career. Tarkovsky always insisted that audiences should "experience" his films before attempting to "understand" them, and he objected to criticism that attempted to explain his work in terms of its supposed symbolism. Beginning on a relatively simple scale with *Ivan's Childhood*, his narratives block and frustrate conventional methods of analysis, forcing an essentially personal

reaction to their meaning; an understanding created through response to patterns of sound and imagery, to rhythm, movement, and the handling of space and time, rather than through dialogue and accepted notions of character conflict and analysis. His increasing reliance on the long take, with several shots lasting six minutes and longer in his last three films, is intended to fuse the experience of both character and spectator and to 'free' the spectator from the predetermined and manipulated control associated with the editing techniques of directors such as Eisenstein.

The most characteristic element of Tarkovsky's films, however, is the creation of a filmic world that has the power, mystery, ambiguity, and essential reality of a dream. In *Ivan's Childhood* the dreams, though vivid and moving, are clearly distinguished from the everyday world. In *Solaris* and *Mirror*, however, certain scenes take on a hallucinatory quality that speaks directly to the subconscious of the viewer, and by *Stalker*, *Nostalghia*, and, especially The *Sacrifice*, this aspect has permeated the structure of the whole film, eliminating the possibility of one single interpretation of its meaning or even of what actually 'happens' within it. In this way Tarkovsky bypasses the rational, scientific analysis that he so much distrusted, and is able to speak directly to the receptive viewer by means of images whose beauty and suggestive power resonate with a forcefulness unmatched by almost any other film-maker.

第六节　战后各国电影的兴盛

1. 欧洲艺术电影的"圣三位一体"：瑞典的伯格曼

　　欧洲本来就是艺术电影的发源地和大本营，而"新浪潮"电影的"作者电影"观念又进一步推动了 20 世纪 50、60 年代艺术电影的发展。布纽埃尔、伯格曼、费里尼、安东尼奥尼、布列松、塔蒂和塔尔科夫斯基等艺术片导演，选取独特的主题和鲜明的风格，形成色彩斑斓、一以贯之的电影艺术个性，对后世的艺术电影产生巨大的影响。其中的伯格曼、费里尼和塔尔科夫斯基更借用基督教"圣父、圣子和圣灵"的概念被冠以"圣三位一体"的称号，足见他们在艺术电影界地位的崇高。

　　英格玛·伯格曼，从 50 年代到 70 年代一直是艺术电影的标志性人物，这位牧师的儿子毕生游走于电影和舞台之间，执著于人与人之间、人与沉默或缺席的上帝之间的纠结关系，在情感和哲学方面兼具复杂和沉郁的特色。1957 年，伯格曼以《第七封印》和《野草莓》一举奠定自己国际艺术电影大师地位，前者通过人与上帝及死神的关系探讨生命的价值，后者则通过梦境和回忆的拼贴成为现代意识流电影的杰作。《假面》被公认为伯格曼最复杂也最具反省性的极品，对人性残忍冷漠和人格分裂转换进行了深入直观的探讨。后期的伯格曼在《呼喊与细语》继续关注困难的亲情关系，而收山之作《芬妮与亚历山大》则用对童年的回忆为伯格曼自己多彩又跌宕的一生作结。

《假面》的两个女人

Authorship and the Growth of the Art Cinema

Such ideas of authorship meshed smoothly with the growing art cinema of the 1950s and 1960s. Most of the prestigious directors of the period wrote their own scripts; all pursued distinctive themes and stylistic choices in film after film. Film festivals tended to honor the director as the central creator. In a commercial context, Tati, Michelangelo Antonioni, and others became "brand names," differentiating their products from the mass of "ordinary" cinema. Such name recognition could carry a film into foreign markets.

During the 1950s and 1960s, auteurist critics tended to focus on filmmakers who developed the cinematic modernism. Auteurism sensitized viewers to narrative experiments that expressed a director's vision of life. It also prepared viewers to interpret stylistic patterns as the filmmaker's personal comment on the action. Auteur critics were especially alert for ambiguities that could be interpreted as the director's reflection on a subject or a theme.

Luis Buñuel, Ingmar Bergman, Akira Kurosawa, Federico Fellini, Michelangelo Antonioni, Robert Bresson, Jacques Tati, and Satyajit Ray are not the only auteurs in the history of cinema, of course, but they were considered among the giants by critics promoting the theory of authorship during these decades.

Although each of these directors was significant within his own country's cinema, none was wholly typical of the national trends and movements in filmmaking that came and went during his long career. All remained resolutely individualistic, and most have been influential on later generations.

These directors also typify broader tendencies in world film production. All

made breakthrough films in the 1950s. All triumphed at film festivals and won international distribution, even gaining some foothold in the inhospitable American market. The institutions of film culture helped them to frame, and these directors' successes in turn strengthened the authority of coproductions, national subsidy programs, festivals, and film journals. Some, such as Antonioni and Bergman, made films outside their own country, and several more enjoyed the benefits of international funding. Their careers thereby highlight important trends in the postwar cinema.

In addition, these directors became the most celebrated exponents of 1950s and 1960s modernist filmmaking. Critics considered that each director had enriched film technique while als expressing an idiosyncratic vision of life. The directors' work exercised wide influence on other filmmakers. Since these directors all considered themselves serious artists, they shared auteurist assumptions with audiences and critics. Fellini echoed Astruc: "One could make a film with the same personal, direct intimacy with which a writer writes".

During the 1960s and 1970s, auteurism helped create film studies as an academic discipline. Students and fans soon made the idea of authorship a commonplace in the culture at large. Journalistic reviewers now usually assume that a film's primary maker is its director. Many ordinary moviegoers use a simple version of auteurism as criterion of taste, not only for art-film directors but also for Hollywood filmmakers such as Steven Spielberg, Brian De Palma, James Cameron, and Oliver Stone.

During the late 1960s and the 1970s, not all of our exemplary auteurs sustained their reputations. Most suffered critical and commercial setbacks (often resulting from their incompatibility with post-1968 political cinema). To a considerable extent, however, these directors regained critical acclaim after the mid-1970s, and in the intervening decades their work has continued to command attention.

Ingmar Bergman

From the late 1950s through the 1970s, no single filmmaker was as respected, worldwide, as Ingmar Bergman. His complex films were dense and disturbing, both emotionally and philosophically. Audiences began to follow his films as links in an argument about the nature of life. Some theatres showed his pictures in 24-hour marathons. Every new film was an advance on what had become Bergman's central concerns: our often painful relations with each other and with a silent or perhaps absent God. Audiences came to know Bergman's mind and to await his next film. He may have been the first writer-director to demonstrate that movies

could be central to intellectual and cultural life, that they could be profound, essential, necessary. Further, many audiences learned first through Bergman that there were certain statements and kinds of drama that could be reached only with film. Those who found it urgent to discuss "the new Bergman" with their friends evolved into those who were discussing the latest New Wave picture or trying to figure out *Blowup*; they became the core of a new filmgoing generation that looked to the art: theatres and revival houses rather than to the first-run Hollywood *the atres* for stimulating, important movies. They were ready to accept the *auteur* theory because Bergman had shown them how a single person could express his preoccupations through the collaborative art of cinema.

Bergman directed his first film, *Crisis*, in 1945. For ten years Bergman and his first cinematographer, Gunnar Fischer, felt their way together within the film form, discovering how to synthesize the theatre (Bergman's first love) with the visual image, building a stock company of actors sensitive to one another and to the director: Max von Sydow, Gunnar Björnstrand, Eva Dahlbeck, Ingrid Thulin, Harriet Andersson, Bibi Andersson, Gunnel Lindblom. Later regulars would include Liv Ullmann and Erland Josephson. *Smiles of a Summer Night* (1955) was probably Bergman's first fully mature work.

But it was *The Seventh Seal* (1956, released 1957) that first conquered audiences throughout the world, and soon Bergman had released two more films, *Wild Strawberries* (1957) and *The Magician* (*The Face*, 1958), to cement his reputation. These three films are a central unit in the Bergman canon, a pool of ideas and images from which all his later work seems to be drawn.

The Seventh Seal is the stow of a medieval knight who returns home from the crusades only to encounter Death waiting for him on a desolate, rocky, beach. The knight (Antonius Blok, played by Max van Sydow) challenges Death (Bengt Ekerot) to a game of chess, knowing the inevitable result but playing for time. He wants the time for one reason: to discover the value of living. Everywhere around him he sees death: from the crusades, from the plague, from flagellation and superstition.

At the end of the film, the knight loses the chess game, and Death overtakes him and his party. But as the knight himself says, the delay has been most significant, for he has found some good people and learned, partly through them, to value life and hope, and he has helped a young family escape Death. This innocent, happy family of father (named Joseph), mother (named Mary), and infant becomes the film's trinity of life. At the end of the film, they stand in the sunlight as Joseph watches Death lead the knight and his party across a hilltop in shadow.

The film's central contrast is the opposition of the ways of life and the forces of death. The Church—organized, dogmatic religion— becomes emblematic of superstition and death. In fact, the knight mistakes the figure of Death for a priest

when he makes confession.

Opposed to the film's dark moments are its moments of life, clarity, and light. The scenes between Joseph (Nils Poppe) and Mary (Bibi Andersson)—the two strolling players—are brilliantly bathed in light. The scene in which the knight partakes of their happiness, when the group sits in the sunshine to eat wild strawberries, is natural, peaceful, and bright. The real religion, the real humanity in the film stems from the sincere, unselfish feelings of the characters for one another.

Wild Strawberries puts the same theme in modern dress. The film begins with a vision of death, the old man's dream in which he sees a hearse roll down a desolate street, in which he sees himself inside the hearse's coffin. Bergman increases the dream's impression of bleakness and desolation by overexposing the whole vision. Then the old doctor wakes up. Since he perceives the closeness of death, he is haunted by questions about the value of the life he has lived. Ironically, this doctor, Isak Borg (played by Sjöstrom), aged 78, is about to be honored by society for the value of his life's work; a university is to award him an honorary degree. Despite the university's assessment of his life's worth, the doctor is not so certain about it. The rest of the film shows him groping for an answer, through his memories and through the events of the day (as well as a final dream).

When Borg examines his present relationships, he sees nothing but empty sterility. Borg's great legacy to his son has been to transfer his nihilism, his contempt for life. So successfully has Borg passed on this dowry that the son and daughter-in-law are in danger of separating. The son hates life so bitterly that he refuses to bring children into it.

The two groups that Borg encounters on the road are diametric opposites. The young hikers are shining, vital, energetic; they devour life with a callous yet honest robustness (Ibsen called it the Viking Spirit), unfettered by social convention, disillusionment, and failure. The middle-aged couple are tied to each other by habit, by argument, and by the need to share futility. Both encounters trigger Borg's visions. The pair with blasted lives evokes Borg's bitterest dream, in which he attends a hell-like school (the scene echoes the school scene in Strindberg's *A Dream Play*) and fails an examination administered by the husband. Uncompassionate and guilty, he must learn to ask forgiveness.

But the hikers, particularly the young woman (Bibi Andersson), stimulate Borg to dream of his childhood, his summers at the family summer house, where he felt both disappointment in romance and the happiness of youth. Bergman shoots these scenes with a clarity and a whiteness that echo the scenes between Mary and Joseph in *The Seventh Seal*. Summer and sunshine—not overexposure, which he saves for nightmares—are consistent metaphors for moments of happiness in *Smiles of a Summer Night*, *Monika*, and *Summer Interlude* (1950, released 1951).

Like the knight of *The Seventh Seal*, Isak Borg translates his vision into action, primarily by offering to ease his pressure on his son and, in effect, reconciling son and daughter-in-law to each other. By the film's end, Borg has taken a journey toward life and finally helped his son do the same.

In *The Magician* (literally, *The Face*), Bergman turns from the relationship of death to life to examine the relationship of art to life. A 19th-century magic lanternist (who is also a "mesmerist", or hypnotist) and his assistants travel by coach to a town where they are stopped by the local authorities. These bureaucratic devotees of reason are anxious to see the lanternist display his wares, to see whether his illusion is powerful enough to unsettle their conventional understanding of reality. The magician's art is indeed powerful enough to drive one spectator to hang himself and another to the point of madness. And yet the bureaucrats judge the man's performance a failure. In the midst of his dejection, word comes to the illusionist that his presence is desired at court. In an unexpected mood of triumph and sunshine, the magician's coach sets out for the court.

The great power of *The Magician* is that it operates on two levels simultaneously. There are two magicians: Vogler, the lanternist (played by Max von Sydow), and Bergman, the filmmaker. Both Vogler and Bergman work on the principle that the trick, the mask (a false face), the illusion can seize the mind more powerfully than the expected reality. Vogler's life is a web of lies and tricks. He is not mute as he pretends to be; his assistant is not a boy but his wife. Everything about the man is false—a game of mirrors and deceptive appearances like his lantern show. But Bergman plays tricks on his audience just as Vogler plays them on his: by making us think a character has died, by switching from gloom to sunshine as if switching on the lights in a theatre. His ultimate trick on us is also the magician's ultimate trick on the bureaucrat: Vogler lures the official to an attic, locks him in, and then reduces him to absolute terror with thumping sounds, invisible attacks, and the vision of a detached eyeball swimming in an inkwell. Bergman scares us too; the sequence is inexplicable, evocative of the powers of the unknown, tensely controlled in its rhythm of sounds and cutting. The irrational, the weapon of the artist (certainly of Bergman and Vogler), has an undeniable power; its appearances can capture not reason but feelings and the imagination. Loving and imagining, as both *The Seventh Seal* and *Wild Strawberries* assert, are the essential human functions, and the cinema is, like the title of Bergman's favorite Strindberg work, a dream play.

The later Bergman films return often to the same ground as these central three. The films that Bergman designated as his trilogy—*Through a Glass Darkly* (1961), *Winter Light* (*The Communicants*, 1962), and *The Silence* (1963)—all seek meaningful, sometimes spiritual values in a world in which life has no absolute purpose and there are many barriers to communication. *Cries and Whispers* (1972)

shows how the awareness of an impending death defines the values of living. And *Persona* (1965, released 1966) combines the self-conscious cinematic tricks of *The Magician* with a psychoanalytic and metaphysical study of a person who, like Isak Borg, views the experience of living as a bleak and terrible lie.

But despite the similarities of these to the earlier films, the Bergman cinematic style had altered radically, becoming less theatrical and more elliptical. Bergman's stylistic shift was partly the result of his switching to a more experimental cinematographer, Sven Nykvist, who replaced Gunnar Fischer in the 1960s. The late Bergman films are increasingly concerned with psychology—the fears, anguish, and even mental diseases of individuals—and painful relationships. The characters are caught in institutions through which they can fulfill or destroy themselves but which they can never fully understand: the church, the theatre, marriage.

Persona is Bergman's masterpiece, his most complex and reflexive film, and his truest display of technical virtuosity. On its surface, the film is the story of a cure, a psychological case study of Elisabeth Vogler (Liv Ullmann), an actress who went blank onstage during a performance of *Electra* and has refused to speak since. Her refusal to conmmnicate is symptomatic of her feeling that human existence is merely a collection of lies. For Elisabeth, to speak is to lie. She is treated in a mental hospital by a young, energetic, and dedicated nurse, Alma (Bibi Andersson), and later in the seaside home of the hospital's head psychiatrist. At that seaside retreat, where the nurse does all the talking, the two women share moments of intimacy and hatred. The end of this process is the actress's apparent return to communication, to her life on the stage and with her family, and Nurse Alma's return to her job, shaken by the experience but continuing on her way.

What complicates the case study is Bergman's elliptical and nonlinear way of telling this story, which gives rise to several motifs that extend far beyond a simple examination of a neurotic artist. Bergman presents *Persona* not as a record of events but (1) as a film and (2) as a kind of mental movie screen on which the "events" appear. The film repeatedly refers to itself—at one point appearing to stop, rip, and burn in the projection gate.

Bergman calls attention to the film as a film because he wants to emphasize that what follows is a fiction, an illusion—a sequence of light and shadow on a flat screen. The audience has entered the world of art and chimera—of magic and theatre, not of nature and reality. But Bergman's film then gives this clear dichotomy another twist, for is the world of nature—or personal identity itself—any more solid, any more real than the one of artistic illusion?

Persona was followed by the grim, powerful, nightmarish trilogy of *Hour of the Wolf* (1966, released 1968), *Shame* (1967, released 1968), and *The Passion of Anna* (1969), all of which starred Liv Ullmann and Max von Sydow. After several

more emotionally painful works—notably *Cries and Whispers* and *Scenes from a Marriage* (1974, condensed from the 1972 TV version)—Bergman returned to the sustaining vision of theatricality. Most of his later films reaffirm his faith in illusion, in the imagination, in art, and in magic. The three-part structure of *Fanny and Alexander*, fashioned from a longer version made for Swedish TV, seems Bergman, s own spiritual autobiography. It begins happily, surrounded by family, in the theatre—the place where Bergman began, the place of joyous illusion, of smiles and light. It then plunges into a middle section of dark despair, dominated by Calvinist severity and mortification—which parallels Bergman's despairing black-and-white films of the 1960s. But it escapes once again into the light, back to the celebration of magic and theatre—and the performance of Strindberg's *A Dream Play*.

After *Fanny and Alexander*, Bergman officially retired from filmmaking, but he continued to work in television and theatre, and he wrote movie scripts for others to direct (*The Best Intentions*, by Bille August, and *Sunday's Children*, by his son Daniel Bergman, both 1992; *Faithless*, by Liv Ullmann, 2000). In 2003 he wrote and directed the film he announced was his very last: *Saraband*. A sequel to *Scenes from a Marriage*, again starring Liv Ullmann as Marianne and Erland Josephson as Johan, it is emotionally grueling and ultimately enlightening.

2. 英国电影：英国自由电影运动和社会现实主义电影

因为语言文化同宗同源的关系，英国电影经常被好莱坞电影的光芒所遮蔽。但英国电影仍然顽强地体现着英国式的严谨优雅、对社会现实一以贯之的强烈关注，成为英语电影的重要力量。英国电影包括古典名著改编、当代家庭情节剧、讽刺性轻喜剧和奇观性史诗片等类型，而战后英国电影的三位大师利恩、鲍威尔和里德在这些片种中颇有建树。

大卫·利恩（David Lean）既有反映"发乎情，止乎礼"式婚外情的《相见恨晚》，也有狄更斯小说改编的《孤星血泪》和《雾都孤儿》，而史诗大片《桂河桥》和《阿拉伯的劳伦斯》更为他赢得崇高的声誉。迈克尔·鲍威尔（Michael Powell）的豪华爱情片《红菱艳》赢得广大观众的赞誉，《偷窥狂》以其独特的反省性视点备受电影行家的追捧。而卡洛尔·里德（Carol Reed）的《第三个人》则将黑色、惊悚、悬疑与爱恨情仇完美地结合在一起。

英国自由电影运动（Free Cinema）出现在50、60年代，反对保守的电影创作观念，倡导艺术家的社会责任感，关注劳动阶层和日常生活题材，并强调艺术创作的个性。其代表作品有林赛·安德森（Lindsay Anderson）的《体

《阿拉伯的劳伦斯》

育生涯》、托尼·理查森（Tony Richardson）的《愤怒的回顾》、杰克·克莱顿（Jack Clayton）的《楼顶屋》和卡洛尔·雷兹（Karel Reisz）的《浪子春潮》等。

英国"新电影"（New Cinema）又称社会现实主义电影（Social Realism）可以看作是自由电影运动一脉相承的发展和延伸，涌现出约翰·施莱辛格（John Schlesinger，《一夕风流恨事多》和《午夜牛郎》）、约瑟夫·洛赛（Joseph Losey，《仆人》和《送信人》）和彼得·沃特金斯（Peter Watkins，《战争游戏》）等一系列具备社会良知的杰出导演。

England and Its Postwar Masters

With certain notable exceptions, the British film never quite recovered the experimental uniqueness of the era of Hepworth, Smith, and Williamson. The common language made England—the center of filmmaking activity in the British Isles—such a Hollywood colony that in 1927 the British government passed quota laws to protect the native cinema. A British theatre owner was obliged to show a certain quota of British-made films. These quotas produced a flood of cheapies—called "quota quickies"—that served as second features (sometimes screened at 10 A.M.) for the American films that everyone came to see.

If a British film did score an international success in the 1930s—such as Alexander Korda's *The Private Life of Henry VIII* (1933) or Hitchcock's *The 39 Steps*—its director or star almost immediately departed for Hollywood. Cary Grant (born Archibald Leach in Bristol), Laurence Olivier, John Gielgud, Ralph

Richardson, Jack Hawkins, Start Laurel, Charles Chaplin, Boris Karloff, and Leslie Howard were as much a part of the Hollywood of the past as Richard Burton, Sean Connery, Maggie Smith, Julie Andrews, Anthony Hopkins, Richard Attenborough, Peter O'Toole, Ben Kingsley, Daniel Day-Lewis, Kate Winslet, Judi Dench, and Emma Thompson have been of the "Hollywood" of the recent past.

David Lean's (1908-1991) first great film was the restrained, deeply moving romantic drama *Brief Encounter* (1945); he followed it with two of the most highly regarded of all Dickens adaptations, *Great Expectations* (1946) and *Oliver Twist* (1948). He then began directing a series of spectacles, literate and long, that were overwhelmingly pictorial, organized around complex characters, and designed to explore moral questions under pressure. The best of these were *The Bridge on the River Kwai* (1957) and *Lawrence of Arabia* (1962, shot by Frederick A. Young), followed by *Doctor Zhivago* (1965) and *A Passage to India* (1984).

Carol Reed (1906-1976) made his mark with economical, precisely observed films as diverse as *The Stars Look Down* (1939) and *Outcast of the Islands* (1951). He did his very best work in two tightly constructed, haunting thrillers: *Odd Man Out* (1947) and *The Third Man* (1949).

For the 15 years after World War II, British film seemed synonymous with four kinds of movies, all carefully crafted. London was—and still is—the world capital of a style of English theatre and literature that has evolved over many centuries. These literate, well-spoken films displayed taste, style, grace, and intelligence.

First, there were the polished, fluently acted adaptations of literary classics: Lean's films of Dickens, Anthony Asquith's adaptations of Rattigan (*The Winslow Boy*, 1948; *The Browning Version*, 1951) and Wilde (*The Importance of Being Earnest*, 1952), and Olivier's later adaptations of Shakespeare (*Hamlet*, 1948; *Richard III*, 1955). Olivier's *Henry V* (1944) had created much of the momentum for this genre: More than an effective wartime propaganda film, it showed how cinematically original a literary adaptation could be.

Second, there were the tightly edited, intelligently written contemporary dramas, many of which adopted the terms of familiar genres. Some of these concerned themselves with wartime military assignments or postwar political cabals, but the majority were romances (*Brief Encounter*), thrillers (*Odd Man Out*), mysteries (Sidney Gilliat's *Green For Danger*, 1946), and horror films (*Dead of Night*, 1945).

Third, there were the biting, richly dry and satiric "little" comedies made at the Ealing Studios by Robert Hamer (*Kind Hearts* and *Coronets*, 1949), Alexander Mackendrick (*The Ladykillers*, 1955), Charles Crichton (*The Lavender Hill Mob*, 1951), and Anthony Kimmins (*The Captain's Paradise*, 1953). Many of these masterpieces of comic construction, irony, and understatement—including some

not made at Ealing, such as Ronald Neame's *The Horse's Mouth* (1958) featured the protean performances of Alec Guinness, who could transform himself into any kind of comic character—fuddy-duddy scientist, bohemian painter, old lady.

And fourth, there were the elegant Technicolor spectacles produced by the Archers, an independent company formed by Michael Powell (1905-1990), who directed the films, and Emeric Pressburger, who wrote them. The Archers were best known for their intense use of color, their spectacular fantasies, and their social and psychological boldness. Their key works include *The Life and Death of Colonel Blimp* (1943, an epic satire), *A Matter of Life and Death* (1946, a fantasy released in the U.S. as *Stairway to Heaven*), *Black Narcissus* (1947), and *The Red Shoes* (1948). *The Red Shoes* was no fairy-tale backstage musical, but a beautiful, disciplined, adult film made with absolute artistic control. Like the ballet danced within it—"The Red Shoes", based on Hans Christian Andersen's story—*The Red Shoes* tells of a woman (Moira Shearer) who puts on the red shoes, cannot take them off, and dancer to her death. She is torn between two men, the impresario who offers her the great career she wants and deserves, and the young composer who wants her to quit dancing and love him. Neither of these men will give her a break, and the conflict they represent is, in any case, between the lover and artist in herself; the choice proves impossible, and she is destroyed—in a moment that intricately represents the triumph of artifice. Powell and Pressburger collaborated from 1938 to 1957; Powell went on to direct the savage, brilliant *Peeping Tom* (1960). *Peeping Tom*, released earlier in the same year as Hitchcock's *Psycho*, is, like *Psycho*, a forerunner of the slasher film, a disciplined masterpiece, and an ironic mixture of voyeurism and murder—reflexively linked by the making of images literally taken from life.

The general traits of all four of these British categories were a subtle understatement, expert acting, detailed decor, and a firm control of taut narrative construction.

Among the most distinctive and significant work in the British film between the era of Charles Urban and 1959 was the documentary film movement of the 1930s and 1940s. Sponsored by the government and directed by filmmakers like John Grierson, Paul Rotha, Basil Wright, Harry Watt, Edgar Anstey, and Humphrey Jennings, the British documentaries developed the craft of capturing the surfaces of reality to illuminate the essences beneath them. The realist texture that seemed to distinguish British fictional films from Hollywood's was especially obvious in the purely realist documentary films. To some extent, the new British film of 1959 which found a ready international market as part of the generalized new wave of European cinema-began with a similar premise. This new British film was the product of several influences: of the British documentary tradition; of the new class-conscious British novels and plays by authors like John Osborne, Alan

Sillitoe, and Alun Owen; of the Italian Neorealist films; and of the new spirit of free cinema that was emerging in France at the same time. The result of these many influences was a series of films that were radically different from the polished, elegant films of Asquith and Reed.

The Free Cinema Movement

In practice, Free Cinema meant the production of short, low-budget documentaries like Anderson's *O Dreamland* (1954), a satirical assault on the spiritual emptiness of working-class life, set in an amusement park, and Reisz's and Tony Richardson's *Momma Don't Allow* (1956), a study of postwar youth in the environment of a London jazz club. Between February 1956 and March 1959, the Free Cinema movement presented a series of six programs at the National Film Theater that featured most prominently *O Dreamland*; *Momma Don't Allow*; *Every Day Except Christmas* (1959), Anderson's study of Covent Garden flower and vegetable vendors; *We Are the Lambeth Boys* (1958), Reisz's portrait of a South London youth club; and a number of recent Continental films: Georges Franju's *Le Sang des bêtes* (1949); Alain Tanner and Claude Goretta's *Nice Time* (1957, shot in Piccadilly Circus); François Truffaut's *Les Mistons* (1957); Roman Polański's *Two Men and a Wardrobe* (*Dwaj ludzie z szafç*, 1958); and Claude Chabrol's *Le Beau Serge* (1958).

At the time that the Free Cinema movement emerged, a revolution was under way in British theater and literature in which liberal working-class values emanating from the East End of London and the provinces were overturning the established bourgeois tradition of the preceding decades. John Osborne's antiestablishment diatribe *Look Back in Anger* rocked the world of traditional culture when it was staged at the Royal Court Theatre in May 1956 by calling into question the whole class structure of British society and assailing the moral bankruptcy of the welfare state. The following years witnessed the appearance of a new group of young, antiestablishment, working-class novelists, such as David Storey, John Braine, Alan Sillitoe, and Shelagh Delaney, who treated similar themes in a style that can be accurately characterized as "social realism". By 1959—significantly, the year that the French New Wave won a great number of the prizes at Cannes—the time was ripe for the overthrow of the class-bound British feature cinema in favor of working-class social realism.

In that year, the industry itself produced two films that announced the revolution: Jack Clayton's adaptation of John Braine's novel *Room at the Top* and Tony Richardson's adaptation of *Look Back in Anger*, scripted by the author. Both films were big-budget commercial productions with well-know stars that

nevertheless dealt seriously with the disillusionment and frustration of the British working classes, and both were international hits. *Look Back in Anger* was so successful, in fact, that Tony Richardson and Osborne were able to form, with the financial backing of producer Harry Saltzman (later responsible for the slick James Bond series), their own production company, the short-lived but influential Woodfall Films. In Woodfall's first feature, coproduced with Holly Films, Richardson collaborated with Osborne again to adapt his second play, *The Entertainer* (1960). It starred Laurence Olivier as the seedy music-hall comedian Archie Rice and was partially shot on location in Blackpool. Woodfall's first completely independent production, Karel Reisz's *Saturday Night and Sunday Morning* (1960), a version of the Alan Sillitoe novel, was shot on location in Nottingham with unknown actors for a budget of under three hundred thousand dollars, or less than one-third of the standard feature allocation. But it recovered this figure in the first two weeks of its London run alone and went on to become the biggest international success the British film industry had known since the thirties.

British "New Cinema", or Social Realism

Saturday Night and Sunday Morning became the prototype for what may be fairly labeled British "New Cinema", a social-realist film movement whose themes were borrowed from Italian neorealism and whose techniques were modeled upon the Free Cinema documentary of the late fifties and the films of the French New Wave. The New Cinema movement's films were generally set in the industrial Midlands and shot on location in black and white against the gloomiest backgrounds their makers could find. The films featured unknown young actors, and their protagonists were typically rebellious working-class youths like Richardson / Osborne's Jimmy Porter or Reisz / Sillitoe's Arthur Seaton— youths who were contemptuous of the spiritual torpor that had been induced in their parents and friends by the welfare state and by mass communications, as exemplified by the BBC. The films' heroes spend a good deal of their time in pubs, drinking and brawling, and use a tough vernacular speech until then unheard in British cinema. Major New Cinema productions include Tony Richardson's *A Taste of Honey* (Woodfall, 1961; script by Shelagh Delaney) and *The Loneliness of the Long Distance Runner* (Woodfall, t962; adapted from a Sillitoe novel); John Schlesinger's *A Kind of Loving* (1962) and *Billy Liar* (1963); Lindsay Anderson's *This Sporting Life* (produced by Reisz, 1963); Canadian-born Sidney J. Furie's *The Leather Boys* (1963); and Karel Reisz's *Morgan: ASuitable Case for Treatment* (1966).

Like the French New Wave, British New Cinema reached its peak around 1963 and then rapidly declined as a movement while its directors went their separate ways. During the mid-sixties, in fact, a reaction to the bleakness of social realism set in, and the depressing images of the industrial Midlands were replaced by those of "swinging London" in big-budget widescreen color productions like *Alfie* (Lewis Gilbert, 1966), *Smashing Time* (Desmond Davis, 1967), and *Joanna* (Michael Same, 1968), all of which, however, did have working-class protagonists. Nevertheless, Lindsay Anderson (1923-1994) continued to pursue antiestablishment themes in *If...* (1968), a brilliant film about the nature of individualism and authority cast in the form of a surrealist satire on the British public school system. One of the sixties' most important films, *If...* can be favorably compared with Vigo's *Zéro de conduite* (1933), to which it contains several explicit allusions; it established Anderson as the most influential figure to emerge from the New Cinema movement. In Anderson's powerful *O Lucky Man!* (1973), whose mock-poetic title refers back to his first film, *O Dreamland*, the protagonist of *If..* continues his education through the various levels of corruption in London society, only to be totally corrupted himself at the end of the process—by being "discovered" by the director Lindsay Anderson to star in a motion picture entitled *O Lucky Man!* The film *Britannia Hospital* (1982) continued Anderson's dissection of the contemporary British psyche in an unsparing absurdist satire on labor strikes, racial tensions, and the misuse of the National Health Service by doctors and patients alike. More recently, he directed *The Whales of August* (1987), a delicate mood piece adapted by David Berry from his own 1981 play, about two elderly sisters (played in the film by Bette Davis and Lillian Gish) living out their last years in a family home on the coast of Maine.

After an impressive start in *Saturday Night and Sunday Morning*, the work of Karel Reisz (1926-2002) generally declined during the sixties (e.g., *Isadora*, 1968), with the exception of *Morgan* (1966; also known *as Morgan: ASuitable Case for Treatment*), a subtle and painfully funny film about mental breakdown. But Reisz's intelligent, American-made *The Gambler* (1975) signaled renewed vigor. His second American feature, *Who'll Stop the Rain?* (1978), a corrosive adaptation of Robert Stone's best-selling allegorical thriller *Dog Soldiers*, about heroin smuggling during the Vietnam war, marked his return to prominence. His version of John Fowles' complex "Victorian" novel *The French Lieutenant's Woman* (1981), scripted by Harold Pinter and strikingly photographed by Freddie Francis, was a triumph of the filmmaker's art. More recently, Reisz has directed *Sweet Dreams* (1985), an intelligent biography of country singer Patsy Cline, who was killed in a plane crash at the height of her success, and *Everybody Wins* (1990), from an original screenplay by Arthur Miller (his first since *The Misfits* in 1961). Wherever Reisz's far-ranging aesthetic sensibilities lead him next, it should be noted that his

important book, *The Technique of Film Editing*, has greatly influenced such major film artists as Alain Resnais.

The same general falling-off was seen in the work of Tony Richardson, who, after a series of three excellent working-class films and the flamboyant period comedy *Tom Jones* (1963; adapted from Henry Fielding's novel), abandoned social commitment for big-time commercial cinema. Since then, most of his films, like the American-made *The Loved One* (1965), have been failures. But a filmmaker of substantial verve is still perceptible in *The Charge of the Light Brigade* (1968), *Ned Kelly* (1970), and *Joseph Andrews* (1977), another Fielding adaptation. Later, Richardson worked in the United States to produce *The Border* (1981), a tale of passion and intrigue on the Mexican-American border, and *The Hotel New Hampshire* (1984), an adaptation of John Irving's rambling chronicle of an eccentric American family. He was directing telefilms when he died of AIDS in 1991.

John Schlesinger, who began his career as a BBC documentarist, has been much more successful artistically than either Reisz or Richardson. He made his first feature, *A Kind of Loving*, in 1962. After *Billy Liar* (1963), he achieved great commercial success with *Darling* (1965), a modish examination of upper-class decadence filmed *à la nouvelle vague*, which brought Julie Christie to stardom. Schlesinger's best fihn of the decade, however, was *Far From the Madding Crowd* (1967), shot on location in Dorset and Wiltshire by Nicolas Roeg with exceptional painterly skill. This big-budget (four million dollars) adaptation of a novel first published by Thomas Hardy ill 1876 is astonishingly faithful both to the artistic vision of its source and the cinematic spirit of its times. With *Midnight Cowboy* (1969) and throughout the seventies, Schlesinger continued to specialize in stylish and intelligent films—*Sunday, Bloody Sunday* (1971), *The Day of the Locust* (1975; from the novel by Nathanael West), *Marathon Man* (1976), and *Yanks* (1979). After a failed attempt at social satire in *Honky-Tonk Freeway* (1980), he redeemed himself with the BBC telefilm *An Englishman Abroad* (1983), based on an incident from the life of Cold War defector and spy Guy Burgess, and the American-produced real-life espionage film *The Falcon and the Snowman* (1984), both of which ponder the moral implications of treason. Many critics felt that Schlesinger's violent voodoo-cult thriller *The Believers* (1986) was an exercise in needless mystification, but *Madame Sousatzka* (1988), a leisurely narrative focused on a middle-aged piano teacher and her circle, was much admired, as were the ambiguous American thriller *Pacific Heights* (1990) and the British espionage films *A Question of Attribution* (1991) and *The Innocent* (1993).

British cinema was further enhanced in the sixties and seventies by the presence of two American expatriates, Joseph Losey and Richard Lester. Joseph Losey (1909-1984), who became a British citizen after being hounded out of

Hollywood during the McCarthy era, produced some of the most significant British films of the decade in collaboration with absurdist playwright Harold Pinter. These included *The Servant* (1963); *Accident* (1967); and *The Go-Between* (1971), adapted from the novel by L. P. Hartley. A subtle stylist whose major themes are the destructiveness of the erotic impulse and the corrupting nature of technocracy, Losey has also produced important films from his own scripts, notably *Eve* (1962), totally mutilated in its commercial version, and the remarkable antiwar drama *King and Country* (1964). Losey's films of the seventies were *The Assassination of Trotsky* (1972); a version of Henrik Ibsen's *A Doll's House* (1973); *The Romantic Englishwoman* (1975), an elegant and witty film about modern marriage scripted by the playwright Tom Stoppard; *M. Klein* (1976), a study of anti-Semitism in occupied France; a version of Mozart's opera *Don Giovanni* (1979), shot on location in northern Italy; and *Les Routes du sud* (*Roads of the South*, 1979), an intimate portrait of a father-son relationship set in rural France that contains autobiographical elements. The director's final work was the visually riveting *La Truite* (*The Trout*, 1982), based on an existential novel by Roger Vailland, and *Steaming* (1985), an adaptation of Nell Dunn's ebulliently feminist stage play.

Richard Lester directed several award-winning shorts, notably *The Running, Jumping, and Standing Still Film* (1960) and *The Mouse on the Moon* (1963; a sequel to Jack Arnold's *The Mouse That Roared*, 1959), before he came to fame and fortune through his two Beatles films, *A Hard Day's Night* (1964) and *Help!* (1965), which employ the full cinematic arsenal of the New Wave—telephoto zooms and swoops, flashbacks, jump cuts, and every conceivable device of narrative displacement to create a dazzling new kind of audiovisual comedy. His subsequent films—*The Knack* (1965), *How I Won the War* (1967), *Petulia* (1968), and *The Bed-Sitting Room* (1969) use the same techniques to more serious dramatic purpose, often with less success, though *Petulia's* disjointed narrative style works perfectly to embody the psychological disintegration of its principal characters. During the seventies, Lester directed the highly successful swashbucklers *The Three Musketeers* (1973), *The Four Musketeers* (1975), and *Royal Flash* (1975); the historical romance *Robin and Marian* (1976); an adaptation of the Broadway comedy *The Ritz* (1977); the comic Western "prequel" *Butch and Sundance: The Early Days* (1979); and *Cuba* (1979), a political thriller set in the last days of the Batista regime. His films in the eighties included two entries in the *Superman* cycle, *Superman II* (1980) and *Superman III* (1983), the caper farce *Finders Keepers* (1984), and the final installment of his Musketeers trilogy, *The Return of the Musketeers* (1989), which combines the casts of the two earlier films. *Get Back* (1991) was a fairly straightforward documentary on Paul McCartney's world-wide tour of that year.

3. 日本电影崛起中的黑泽明、战后第二代、"新浪潮"和大岛渚

50年代，日本电影《罗生门》《活下去》和《七武士》等相继荣获各项国际大奖，执导这些影片的黑泽明（Akira Kurosawa）因其日本文化内涵与西方叙事观念的完美结合，而成为最具国际影响的日本电影大师。加之《雨月物语》和《地狱门》等影片获得的国际赞誉，战后复兴的日本电影迅速成为世界影坛一股不容忽视的力量，而早在50年代就蜚声日本影坛的沟口健二和小津安二郎等第一代日本电影人终于被世界影坛重新"发现"。

黑泽明的《罗生门》多种叙述的现代叙事手法和《七武士》富于韵律感的视觉表现手段，为世界电影带来浓重的东方文化气息。而后来的《蜘蛛巢城》《用心棒》《影子武士》和《乱》也续写着自己和日本电影在国际影坛的辉煌。

此后，市川崑（Kon Ichikawa）的《缅甸竖琴》、新藤兼人（Kaneto Shindo）的《裸岛》和小林正树（Massaki Kobayashi）的《切腹》等又相继在国际电影节获奖，成为日本战后第二代电影的主力军。

60年代，今村昌平（Shohei Imamura,《日本昆虫记》和《楢山节考》）、敕使河原宏（Hiroshi Teshigahara,《沙之女》）、筱田正浩（Masahiro Shinoda）和吉田喜重（Yoshishige Yoshida）等第三代日本电影人发起了日本新浪潮运动，而新浪潮运动的主将则非大岛渚（Nagisa Oshima）莫属。"太阳族"的反叛青春、激进左派的意识形态、惊世骇俗的性爱、与欧洲文化的密切关联以及革新的现代电影语汇构成了大岛渚电影的基本元素。《青春残酷物语》《新宿小偷日记》和《官能王国》就是典型代表。

Rashomon, Kurosawa, and the Postwar Renaissance

Rashomon, based on two short stories by Ryunosuke Akutagawa, is a film about the relativity of truth in which four conflicting versions of the same event are offered by four equally credible (or equally incredible) narrators. In twelfth-century Japan, three men take cover from a rainstorm under the crumbling Rashomon gate of the ancient capital, Kyoto. Two of them, a woodcutter and a priest, have just come from police headquarters, and they tell the third a strange tale which becomes the main portion of the film in flashback. The woodcutter explains how he had found the body of a nobleman in the woods; the man had been stabbed to death, but the weapon was missing. The priest says that he had encountered this same nobleman

《罗生门》

traveling with his wife on the road shortly before the murder.

While the woodcutter and the priest were at police headquarters, where both had come to give evidence, the police captured a bandit (played by Toshiro Mifune—a brilliant actor and Kurosawa's constant collaborator) who confessed to killing the man and who gave the following account: The bandit was asleep in the woods when the nobleman passed by with his beautiful wife. Consumed with desire for her, he tricked the husband, tied him to a tree, and raped the wife. Afterward the woman forced the two men into a duel in which the husband was killed. Next, the wife was brought to police headquarters, where she gave her version of the truth. As she told the story, the bandit had left after the rape, and her husband then spurned her for being so easily dishonored. She had fainted from grief and awakened to find a dagger in her husband's breast. The priest and the woodcutter then inform the stranger that a third version was offered by the spirit of the dead husband, speaking through the lips of a medium. He testified that after the rape his wife had begged the bandit to kill her husband and carry her away. The bandit refused; the wife ran off into the woods; and her husband committed suicide with the dagger, which he felt someone remove from his body after his death. Finally, the woodcutter admits to the priest and the stranger that he had actually witnessed the whole sequence of events from a hiding place in the forest: "There was no dagger in that man's breast," he says. "He was killed by a sword thrust." The woodcutter's story is that both men were cowards and had to be goaded into the duel by the shrewish woman. In the event, he says, the bandit killed the husband almost by accident, and the woman ran off into the woods. But this "objective" account of things is called into question when the stranger accuses the woodcutter of having stolen the missing dagger.

Thus all four versions of the truth are shown to be relative to the perspectives and self-serving intentions of the individual participants. Even the woodcutter's detached account suggests the possibility of distortion. Kurosawa implies that reality or truth does not exist independent of human consciousness, identity, and perception. It is small wonder, then, that Alain Resnais claimed *Rashomon* as the inspiration for his own film about the enigmatic nature of reality, *L'Annde dernière à Marienbad* (1961).

Cinematically, *Rashomon* is a masterpiece, and its release marked the emergence of Akira Kurosawa (1910-1998) as a major international figure. Each of the four tales has a unique style appropriate to the character of its teller, but the film as a whole is characterized by the many complicated tracking shots executed by cinematographer Kazuo Miyagawa, superbly paced editing, and thematically significant composition of the frame in depth. The camera seems to be almost constantly in motion, much of it violent, and Kurosawa uses many subjective shots to represent "reality" from the perspective of the individual narrators. Ironically, the Japanese had been somewhat reluctant to enter *Rashomon* in the Venice Festival, thinking that foreigners would misunderstand it. They were as amazed as they were pleased when the film won the Golden Lion, but their industry was quick to capitalize on its success. From 1951 through the present, the Japanese have consistently submitted entries to international film festivals, and they have achieved recognition and respect for their cinema all over the world. Between 1951 and 1965, as vast new export markets opened in the West and as Japanese films won prizes in festival after festival, Japanese cinema experienced a renaissance unprecedented in the history of any national cinema. Established figures like Mizoguchi and Ozu produced their greatest work during this period, and relatively new figures like Kurosawa, Shindo, Ichikawa, and Kobayashi all made films that stand among the classics of the international cinema.

Kurosawa became the most famous Japanese director in the West, perhaps because his films are more Western in construction than those of his peers. He followed *Rashomon* with an adaptation of Dostoevsky's *The Idiot* (*Hakuchi*, 1951) and the brilliant *shomin-geki Ikiru* (*Living/ To Live,* 1952), a fatalistic yet ultimately affirmative account of the last months of a minor bureaucrat dying of cancer. In 1954 Kurosawa produced the epic *jidai-geki*, *Seven Samurai* (*Shichinin no samurai*), which many critics regard as his greatest work. Over eighteen months in production, this spectacular and deeply humanistic film tells the story of a small village that hires seven unemployed *samurai* to defend it against bandit raids in sixteenth-century Japan, an era in which the *samurai* as a class were rapidly dying out (in fact, the bandits are themselves unemployed *samurai*). As an epic, *Seven Samurai* clearly ranks with the greatest films of Griffith and Eisenstein, and cinematically it is a stunning achievement. As several critics have

pointed out, the entire film is a tapes-try of motion. Complicated tracking shots compete with equally elaborate and fast-paced editing to create a prevailing tempo which is like that of war punctuated by ever shorter intervals of peace. For the battle between bandits and *samurai* that concludes the film, Kurosawa created a montage sequence that rivals the massacre on the Odessa steps in *Potemkin* ill its combination of rapid tracking shots and telephoto close-ups of the action at various decelerated camera speeds. *Seven Samurai* was honored on a global scale, received the *Kinema Jumpo* award in Japan, the Silver Lion at Venice, and the Academy Award for Best Foreign Film in the United States. It was remade by John Sturges as *The Magnificent Seven* (1960), with its setting transposed to the American West, and it stands firmly behind the theme and style of Sam Peckinpah's classic anti-Western *The Wild Bunch* (1969).

Kurosawa's other masterpiece of the fifties was a brilliant adaptation of Shakespeare's *Macbeth* as a *jidai-geki* set in medieval Japan. Despite the cultural transposition, *Throne of Blood/Cobweb Castle* (*Kumonosujo*, 1957) is perhaps the greatest version of Shakespeare on film. The supernatural element of the drama was enhanced by the sparing use of ritualized conventions from classical *noh* plays and by the exteriors shot in the misty forests around Mount Fuji. Like *Seven Samurai*, *Throne of Blood* concludes with an elaborate montage sequence in which the Macbeth figure, Lord Washizu (Toshiro Mifune), is immolated by a hail of arrows.

In *Seven Samurai* and *Throne of Blood*, Kurosawa succeeded in elevating the *jidai-geki* from a simple action genre to an art form. After another literary adaptation, of Maxim Gorki's play *The Lower Depths* (*Donzoko*, 1957), he made three superb *chanbara*—*The Hidden Fortress* (*Kakushi toride no san-akunin*, 1958), *Yojimbo (The Bodyguard*, 1961), and *Sanjuro* (*Tsubaki sanjuro*, 1962). Though these films lack the thematic depth of his earlier *jidai-geki*, they are masterworks of widescreen composition and rival their predecessors in visual richness.

In 1960, Kurosawa was put in charge of his own production unit at Toho and given complete control of it. Kurosawa Productions' first effort was *The Bad Sleep Well* (*Warui yatsu hodo yoku nemuru*, 1960), a film about corporate versus social responsibility in the form of a murder mystery. It was followed by *Yojimbo*; *Sanjuro*; *High and Low* (*Tengoku to jigoku*, 1963), a strikingly formalized film of kidnapping and detection, loosely based on a novel by Ed McBain, which contains some of the most thematically complex widescreen framings of Kurosawa's career; and *Red Beard* (*Aka hige*, 1965), the story of a young doctor's education in late-Tokugawa Japan. Although *Red Beard* was one of his most successful films financially, it was five years before Kurosawa produced another. In the interim, he wrote the screenplay for *Runaway Train*, based on *a Life* magazine article about an actual train accident in upstate New York, and contracted with 20th Century-Fox to shoot it in Rochester as his first color film. But bad weather on location forced

cancellation of the project (it was eventually realized by Russian émigré director Andrei Mikhalkov-Konchalovski for Cannon Films in 1985). Kurosawa was then invited by Fox to shoot the Japanese sequences of the Pearl Harbor battle epic *Tora! Tora! Tora!* (1970), an experience that ended bitterly for both parties when the director's footage was rejected.

Returning to Japan, Kurosawa finally made his first color film, the low-budget (albeit in Eastmancolor), independently produced *Dodes'kaden* (*Dodesukaden*, 1970), an unstructured narrative about the lives of the very poor in a Tokyo slum. This film failed at the box office, the first of Kurosawa's ever to do so, and in December 1971 the director, despondent over the state of his career, attempted suicide (a logical and culturally acceptable act for a Japanese who perceives the possibilities of his or her life to be exhausted). Fortunately he survived, and in 1976, after six years of silence, Kurosawa gave the cinema another masterpiece— *Dersu Uzala*, a Soviet-Japanese coproduction shot in 70mm with six-track sound. Set in the forests of eastern Siberia at the turn of the century, it is a portrait of the friendship between an aging hunter of the Goldi tribe and a young Russian surveyor. By 1977 the film had won the Grand Prize at the Moscow Festival and an Academy Award in America. In 1980 Kurosawa completed *Kagemusha* (*Shadow Warrior*), a tragic *jidai-geki* set during the sixteenth century civil wars; this film was cowinner of the Grand Prix at Cannes in the year of its release, but, as great as it was, *Kagemusha* was in many ways simply a test run for Kurosawa's masterpiece, *Ran* (literally, "*Chaos*"), in 1985. This ten-million-dollar Japanese-French coproduction—the most expensive film ever made in Japan—was the culmination of a life's work: a stylized, epic version of *King Lear* set in the context of the same clan wars as those portrayed in *Kagemusha*. *Ran* was internationally recognized as the director's most brilliant, profound, and magisterial film. In 1987 Kurosawa announced his intention to retire from directing, as if after *Ran* there was little left to say, but in 1990 he produced the eight-part fantasy anthology *Dreams* and in 1991 the contemplative *Rhapsody in August*, a rumination on the atomic bombing of Nagasaki at the end of World War II. For his thirtieth feature, Kurosawa directed *Not Yet* (*Madadayo*, 1993), a rambling account of the writer Hyakken Uchida and his protégés.

Kurosawa is unquestionably a giant of the international cinema. Like Bergman and Antonioni, he is the true *auteur* of his films—he sets up his own shots, does his own editing, and writes his own scripts. He is probably more conscious of Western styles of filmmaking than any of his Japanese peers and has always claimed a great stylistic debt to John Ford (American cinema's recent debt to Kurosawa has been noted; in 1991 he received an Academy Award for lifetime achievement). Kurosawa was a professional student of Western painting before he entered the cinema, but it would be a mistake to assume that the Western "look"

of his films betokens Western values. Sometimes mistakenly identified by Western critics as a humanist, he is, in fact, a fatalist, or at least an existentialist, in subtle but thoroughly Japanese terms. His vision of human experience is firmly rooted in the value system of feudal Japan. Zen Buddhism, the *samurai* code of *bushido* ("the way of the warrior"—loyalty and self-sacrifice), and the master-pupil relationship are all-important ethical components of his films. Because of his great universality of spirit, we can recognize ourselves in Kurosawa, but we would do well to remember that Kurosawa also shares many sympathies with Yukio Mishima, the famous anti-intellectual novelist and right-wing militant who staged a raid on the Tokyo headquarters of the nation's "peacekeeping" forces on November 25, 1970, and committed a spectacular act of *seppuku*, or *hari-kari*, there to protest the decadence of contemporary Japan and the declining role of feudalism in its culture.

The Second Postwar Generation

The second generation of the postwar renaissance came to prominence in the fifties and sixties and comprised primarily Masaki Kobayashi, Kon Ichikawa, and Kaneto Shindo. The works of Kobayashi and Ichikawa are probably better known in the West than those of Shindo. Masaki Kobayashi (1916-1996) was trained in philosophy at Waseda University, and his early films dealt mainly with social and political problems in a realistic vein. His first masterpiece was *The Human Condition* (*Ningen no joken*, 1959-1961), a nine-and-one-half-hour antiwar epic depicting Japan's occupation and rape of Manchuria, 1943-1945. Released in three parts, this humanistic but grimly realistic widescreen film tells the story of a young pacifist forced into the war and ultimately destroyed by it.Kobayashi's next important films were graphically violent *jidai-geki*—*Hara kiri* (*Seppuku*, 1962) and *Rebellion* (*Joi-uchi*, 1967)—both of which used the situation of an individual's doomed revolt against the authoritarian social system of tile Tokugawa period to make serious comments on the survival of feudalism in modern technological Japan. In the uncharacteristic but strikingly beautiful film *Kwaidan* (*Kaidan*, 1964), Kobayashi made carefully controlled use of the widescreen format and expressive color to tell four haunting ghost stories adapted from the writings of Lafcadio Hearn, an American author who became a Japanese citizen. One of the tales, "Hoichi the Earless" ("Mini-machi Hoichi") draws heavily on elements of the *noh* play. Among Kobayashi's seventies works are the period gangster film *Inn of Evil* (*Ino-chi bo ni furo*, 1971) and the thirteen-part television series, *Kaseki* (1975), a sensitive account of an elderly business executive who discovers that he is dying of cancer and must reassess his life. More recently, he has directed the intensely tactile erotic melodrama *Glowing Autumn* (*Moeru aki*, 1981), the

Ozu-like domestic tragedy *Fate of a Family* (*Shokutaku no nai ie*, 1985), and the two-part, 265-minute documentary *The Tokyo Trial* (*Tokyo saiban*, 1985), an extraordinary account of the war crimes trials held by the Allies from 1946 to 1948 of twenty-eight top Japanese officials charged with conspiracy and aggression in World War II.

Kon Ichikawa is widely acknowledged in the West as one of the Japanese cinema's most brilliant stylists. He began his career as an animator, but his first important film was *The Burmese Harp* (*Biruma no tategoto*, 1956), a lyrical epic about a Japanese soldier whose guilt at his complicity in the collective horrors of war drives him to become a saintly Buddhist monk; like all of his major work through 1965, this was scripted by his wife Wada Natto. Ichikawa's other great pacifist film, *Fires on the Plain* (*Nobi*, 1959), is set during the last days of the Japanese occupation of the Philippines, when the remnants of the decimated Japanese army turned to murder and cannibalism in order to survive and face their final battle with "honor". The film offers a nightmarish vision of an inferno that goes far beyond its implicit social criticism of the feudal code of *bushido*. *Conflagration* (*Enjo*, 1958), adapted from a novel by Yukio Mishima, is a richly textured widescreen film that tells the true story of a young Buddhist novitiate who burns down the Temple of the Golden Pavilion at Kyoto in disgust at the worldly corruption that surrounds him. Other Ichikawa films admired in the West include *Odd Obsession / The Key* (*Kagi*, 1959), a disturbing tale of an elderly man's sexual perversion; *Alone in the Pacific* (*Taiheiyo hitoribochi*, 1963), based on the true story of a young man who sailed the Pacific from Osaka to San Francisco in three months; and the monumental documentary *Tokyo Olympiad* (1965), which compares favorably with Leni Riefenstahl's *Olympia* (1936). Less well known are Ichikawa's ambiguous critiques of Japanese family life, *Bonchi* (1960), *Younger Brother* (*Ototo*, 1960), and *Ten Dark Women* (*Kuroi junin no onna*, 1961), and the remarkable *An Actor's Revenge* (*Yukiniojo henge*, 1963), the third screen version of Otokichi Mikami's story of an *onnagata* who sets out to avenge his father's death in 1836 Edo, which Donald Richie called one of the most visually ravishing films ever to come from Japan. In 1973, Ichikawa produced *The Wanderers* (*Matatabi*), generically a nineteenth-century *chanbara*, which many critics saw as the consummation of his career to date in its combination of savage irony, technical mastery, and lush compositional beauty. After directing a series of overplotted potboilers for producer Haruki Kadokawa (e.g., *The Inugami Family* [*Inugami-ke no ichizoku*, 1976]; *The Devil's Bouncing Ball Song* [*Akuma no temariuta*, 1977]; *Island of Horror* [*Gokumonto*, 1977]; *Queen Bee* [*Jobachi*, 1978]; *House of Hanging* [*Byoinzaka no kubikukuri no ie*, 1979]), Ichikawa returned to his former high standards. *Lonely Hearts* (*Kofuku*, 1982) is an adaptation of an Ed McBain crime thriller, shot by Ichikawa's regular cinematographer Kazuo Hasegawa in a

filtering process midway between black-and-white and color, while *The Makioka Sisters* (*Sasame yuki*, 1983) is a poignant family epic set in the twenties, based on the classic novel by Junichiro Tanizaki and arguably the director's most important film since the sixties. *Ohan* (1984), an old-fashioned domestic melodrama set in the same era, is, like all of Ichikawa's best work, notable for its rhapsodic use of color and widescreen. Equally resplendent in visual terms is *Princess from the Moon* (*Taketori monogatari*, 1987), based on a ninth-century legend about a magical moon woman who is temporarily stranded on earth, and *Actress* (*Eiga joyu*, 1987), a fascinating biography of Japan's great female movie star *Kinuyo Tanaka*, whose career spanned most of Japanese film history. In 1985, Ichikawa remade *The Burmese Harp* in color and CinemaScope, and it quite properly became a domestic box-office hit in the year of the fortieth anniversary of the Hiroshima-Nagasaki holocaust.

Kaneto Shindo (1912-) began as a scriptwriter for Kurosawa, Ichikawa, and others. His status as a film artist is less secure than that of either Kobayashi or Ichikawa, but he has made a number of important films since the war. Shindo worked as an assistant to Mizoguchi on *The Life of Oharu* and *Ugetsu*, and in 1952 he made his first major film, *Children of Hiroshima* (*Genbaku no ko*), a stylized semidocumentary about the atomic holocaust and its effects upon the Japanese people. Shindo's reputation in the West rests on the international success of another semidocumentary, *The Island* (*Hadaka no shima*, 1960), which concerns the struggle of a peasant farming family to survive on a barren Pacific atoll. The film is poetic in the manner of Robert Flaherty's work—some consider it self-consciously beautiful—but it has obvious authenticity as a representation of human experience, which stems from the fact that it is largely autobiographical. Another Shindo film that is known outside of Japan is the folkloristic *jidai-geki Onibaba* (1964), which concerns a mother and daughter who survive the civil wars of the sixteenth century by killing wounded *samurai* and selling their armor for rice. This strange and brutal film blends gorgeous widescreen photography with sickening violence and graphic sex, and it never achieves the poetic quality Shindo apparently sought for it. *Kuroneko* (1968), a horrific ghost story, forms a pendant with *Onibaba*, and Shindo produced a final *jidai-geki* in *The Solitary Travels of Chikuzan* (*Chikuzan hitori tabi*, 1977), a film about the life of a wandering blind *shamisen* musician. Although some of his work has tended toward the sensational and melodramatic, Shindo is a prolific scriptwriter and remains a figure of importance in his nation's cinema. A recent notable Shindo film is *The Horizon* (*Chiheisen*, 1984), a chronicle of a Japanese woman who is fashioned after his own sister. She comes to San Francisco as the purchased bride of a Japanese farmer in 1920, raises a family, undergoes internment in an American concentration camp during World War II, and is ultimately reassimilated into American society after the war.

The Japanese New Wave

The third postwar generation of Japanese fiimmakers emerged during the late sixties and the seventies to form a kind of radical New Wave (*nuberu bagu*). Many of them worked initially for the studios (Shinoda, Yoshida, and Oshima, for example, worked for Shochiku) and for this reason did much of their early work in some form of CinemaScope, to which the studios had converted wholesale by 1960 in order to combat the threat of television. But ultimately, most of them moved away from the studios to form their own independent production companies. Some characteristic directors are Hiroshi Teshigahara, Masashiro Shinoda, Yasuzo Masumura, Yoshishige Yoshida, Seijun Suzuki, Koji Wakamatsu, Shohei Imamura, and Nagisa Oshima.

Hiroshi Teshigahara (1927-2001) is an avant-garde abstractionist whose international reputation rests upon a single film, *Woman in the Dunes* (*Suna no onna*, 1964), adapted by Kobo Abé from his own novel and produced for less than a hundred thousand dollars. Among the premier works of the Japanese New Wave, this film—which won the Cannes Special Jury Prize for the year of its release—is a complex allegory in which a young scientist becomes trapped in an isolated sand pit through the mysterious powers of a woman who apparently is condemned to shovel away the sand interminably by hand.

Masashiro Shinoda (1931-) is a New Wave director similarly committed to the younger generation's struggle against society, but unlike Hani, he is a supreme stylist whose sense of pictorial composition compares favorably with that of the "classical" directors of the fifties (and, in fact, he had worked as Ozu's assistant on *Tokyo Twilight*, 1957). He has made films on every major aspect of his country's history, as well as on contemporary life. Like the films of his peers, Shinoda's tend to be violent and nihilistic, but they are also ethically committed and formally precise. His most significant films of the New Wave and post-New Wave eras are *Pale Flower* (*Kawaiba hana*, 1963), *Assassination/The Assassin* (*Ansatsu*, 1964), *Punishment Island* (*Shokei no shima*, 1966), *Double Suicide/The Love Suicide at Amijima* (*Shinju ten no amijima*, 1969), *The Scandalous Adventures of Buraikan* (*Buraikan*, 1970), *Banished Orin* (*Hanare goze Orin*, 1977), and *Demon Pond* (*Yashagaike*, 1979).

In the eighties, Shinoda produced two major mainstream works, both beautifully photographed by Kazuo Miyagawa, the foremost cinematographer in Japan (*Rashomon*, *Ugetsu*, etc.). *MacArthur's Children* (*Setouchi shonen yakudan*, 1984) treats the trauma of Japan's defeat in World War II and its seven-year occupation by the American army as experienced in the microcosm of a rural island. *Gonza the Spearman* (*Yari no gonza*, 1986), a classical, if bloody, adaptation of an early-eighteenth-century play by Chikamatsu in the *bunraku*

puppet theater tradition," tells the story of a *samurai* trapped in the coils of his own implacable code of honor; it won the Silver Bear at Berlin in the year of its release. Both of these films starred the popular Japanese rock singer Hiromi Go, for whom Shinoda filmed the phenomenally successful forty-five-minute music video *Allusion* in 1985. More recently, Shinoda swept the Japanese Academy Awards with *The Boyhood* (*Shonen jidai*, 1991), a film about the deep cultural conflict between private emotion and public duty.

Another New Wave director of note is Yasuzo Masumura (1924-1986)—The *Hoodlum Soldier* (*Heitai yakuza*, 1965); *Red Angel* (*Akai tenshi*, 1966); and the highly stylized *The Love Suicides at Sonezaki* (*Sonezaki shinju*, 1977), adapted from a Chikamatsu *bunraku* puppet play. Even more significant, however, is Yoshishige Yoshida (1933-)—*Farewell to Summer Light* (*Saraba natsu no hikari*, 1968), and the important avant-garde trilogy about twentieth-century radicalism *Eros plus Massacre* (*Eros purasu gyakusatsu*, 1969), which focuses on both the Taishō-era anarchist Osugi Sakae and his female lovers (who were murdered by the military police [*kempei-tai*] in the aftermath of the 1923 Kanto earthquake) and their contemporary student counterparts. Yoshida's films of tbe seventies include Heroic *Purgatory* (*Rengoku eroica*, 1970), a densely symbolic analysis of student activism during the fifties; and *Martial Law* (*Kaigenrei*, 1973), an elliptical biography of Kita Ikki, whose writings inspired the abortive coup d'état of February 26, 1936, in which fourteen hundred young right-wing off, cers and troops briefly seized control of Tokyo and murdered a number of prominent civilian officials (and were in turn, along with Kita, executed by the military police when the rebellion was suppressed three days later). Yoshida did not make another feature for thirteen years, when *The Promise* (*Niguen no yakusoku*, 1986), a film that seems to plead for euthanasia, appeared at Cannes.

Seijun Suzuki (1923-), a comedy and action film director for Nikkatsu, produced a number of youth films (*seishun-eiga*), such as *Kanto Wanderer* (*Kanto mushuku*, 1963), *Our Blood Won't Allow* It (*Oretachi no chi ga yuru sanai*, 1964), and *Tokyo Drifter* (*Tokyo nagaremono*, 1966), that contained New Wave themes, but his major contribution to the movement was *Elegy to Violence/The Born Fighter* (*Kenka ereiji*, 1966), scripted by Kaneto Shindo, about a fighting youth from the provinces who becomes ensnared in the politics of the 1936 attempted coup d'état; after this, Suzuki became a prolific director of "pink" films, although his two beautifully decadent ghost films *Zigeunerweisen* (1980) and *Heat Shimmer Theater* (*Kageroza*, 1981), both independently produced, were critically acclaimed in the early eighties.

At the same time the former Nikkatsu contract director Koji Wakamatsu (1936-) made a successful bid to raise the pink film to the level of New Wave abstraction with his *Secret Act Inside Walls (Kabe no naka himegoto*, 1965), for

which he was fired from Nikkatsu, and his low-budget, independendy produced *The Embryo Hunts in Secret* (*Taiji ga mitsuryo suru toki*, 1966) and *Violated Angels / Violated Women in White* (*Okasareta byakuri*, 1967), which was inspired by the mass murder of nine nurses in Chicago in 1964. Wakamatsu also produced the bizarre *Go, Go You Who Are a Virgin for the Second Time* (*Yuke, yuke nidome no shojo*, 1969)—whose point of reference is the Tate-LaBianca murders committed by the Manson gang in the same year—and the revolutionary fantasy *Angelic Orgasm* (*Tenshi no kokotsu*, 1970).

Another outstanding director of the New Wave is Shohei Imamura (1926)— *Pigs and Battleships* (*Buta to gunkan*, 1961); *Intentions of Murder/ Unholy Desire* (*Akai satsui*, 1964); *The Insect Woman* (*Nippon konchuki,* 1964); *The Pornographer* (*Jinruigaku nyumon*, 1966); *A Man Vanishes* (*Ningen johatsu*, 1967); *The Profound Desire of the Gods/ Kuragejima: Tales from a Southern Island* (*Kamkgami no fukaki yok ubo*, 1968); *History of Postwar Japan as Told by a Bar Hostess* (*Nippon sengo-shi: Madamu Omboro no seikatsu*, 1970). The first four films, all photographed in high-contrast black and white by Shinsaku Himeda, deal, respectively, with the *yakuza* subculture living off the detritus of the American fleet in the Japanese port city of Yokusuka circa 1960; a housewife who becomes the willing victim and finally the accomplice of a rapist; a poor woman who achieves enormous success through prostitution in postwar Japan (her corruption clearly symbolizes that of her country during the same era); and a mild-mannered businessman who produces pornographic films to support his middle-class and classically Oedipal family. Characterized by a mixture of fiction and the documentarylike incrementation of sociological detail, and by a boldly experimental use of the anamorphic widescreen frame, Imamura's New Wave films have about them a kind of anthropological precision that prepared audiences for such essays in classical anthropology as *A Man Vanishes* and *The Profound Desire of the Gods*, the latter a narrative analysis of an incestuous family on a primitive southern island (the mythic origin of the story is an incestuous relationship between brother and sister gods).

A former assistant to Ozu, Imamura worked mainly in documentary television during the seventies (e.g., *History of Postwar Japan as Told by a Bar Hostess* [1970]; *The Making of a Prostitute* [*Karayuki-san*, 1975]), but emerged at the end of the decade as a truly major figure with *Vengeance Is Mine* (*Fukushu suru wa are ni ari*, 1979). A relentless, semidocumentary account of an actual seventy-eight-day murder spree, the film refuses to judge either society, the criminal, or his victims. *Eijanaika* (1980) is a drama about the culture shock involved in the opening of Japan to the West after two hundred years of self-imposed isolation (the title—*Why Not?* or *What the Hell?*—derives from the rallying cry of the bloody anarchist riots of 1867, which explode at the film's conclusion). Imamura's *The*

Ballad of Narayama (*Narayamabushi-ko*, 1983), based on a story by Shichiro Fukazawa about a people in a remote section of Japan who traditionally take their aged to a high mountaintop to die, won the Golden Palm at Cannes in the year of its release (a 1958 version by Keisuke Kinoshita had adapted the narrative as if it were a *kabuki* play). And his work *The Pimp* (*Zegen*, 1987), which links the rising fortunes of a pimp with the success of Japan's military adventures in creating the Greater Southeast Asia Coprosperity Sphere prior to World War II, was also critically acclaimed. Imamura's own production company also helped to make Japan's most controversial film since the New Wave—*The Emperor's Naked Army Marches On* (*Hara Yuki yukite shingun* [*Kazuo Hara*, 1987]), a two-hour documentary portrait of Kenzo Okuzaki, an aging veteran who demands that Emperor Hirohito apologize publicly to the Japanese people for causing the horrors of World War II. More recently, Imamura has produced a restrained adaptation of Masuji Ibuse's novel on the atomic bombing of Hiroshima, *Black Rain* (*Kuroi ame*, 1989), which won the Technical Prize at Cannes.

Nagisa Oshima

But by far the most influential filmmaker of the Japanese New Wave is Nagisa Oshima, a militantly radical intellectual who was trained at Kyoto University in political history and law. He joined the Shochiku studios as a scriptwriter in 1955 and began directing there in 1959. Among his earliest work is *Cruel Story of Youth* (*Seishun zankoku monogatari*, 1960), a virtual paradigm of the New Wave in its expressive use of color and widescreen composition to embody youthful rebellion through sex and violence. When one of Oshima's Shochiku films, *Night and Fog in Japan* (*Nihon no yoru to kiri*, 1960), was withdrawn for political reasons, he left the studio to form his own production company, Sozosha (Creation), which is still in operation. Much of his early work was in the genre of the *yakuza*-eiga, or contemporary gangster film. It tended to be violent, sexually explicit, and politically radical, in that Oshima's criminals were figures in open revolt against modern Japanese society. The malaise of this society was to become Oshima's overriding theme, making him the first major postwar director to concentrate solely on the problems of being Japanese in the present. Appropriately, Oshima rejected his culture's cinematic past as well as its historical one, so that even his earliest films reveal the influence of the French New Wave rather than that of his great Japanese predecessors. The use of hand-held cameras, *cinéma-vérité* shooting techniques, and on-location sound recording is typical of Oshima's early work, although all of his films since 1960 have been made in widescreen and color. By the late sixties Oshima has moved away from narrative, and the influence of

Godard and the Yugoslav avant-gardist Dušan Makevejev became apparent in his blending of fantasy and reality and in his use of printed chapter titles, voice-over narration, extreme long shots, and audience-alienation effects. As the Japanese critic Hideo Osabe puts it, the films of Oshima have become "provocations directed at the spectators". Like Godard's, Oshima's films are audiovisual polemics designed to generate in the audience indignation and rebellion at the state of contemporary society.

Japanese society, like our own, is one in which massive industrialization, urbanization, and technocratization have accelerated social change and caused the disintegration of traditional (and, in Japan's case, centuries-old) values without offering anything in their place. As Oshima sees it in films like *Death by Hanging* (*Koshikei*, 1969), *The Diary of a Shinjuku Thief* (*Shinjuku dorobo nikki*, 1969), *Boy* (*Shonen*, 1969), *The Man Who Left His Will on Film* (*Tokyo senso sengo hiwa*, 1970), and *The Ceremony* (*Gishiki*, 1972), the Japanese family structure so dear to Ozu has degenerated into a series of empty rituals; the giant corporations have destroyed the physical and psychological environment of the entire country; Japan's cities are sinks of pollution, overcrowding, and violent crime. In response, the Japanese state has become feudal once more—authoritarian, imperialistic, racist, and politically repressive. For Oshima, then, Japan is in the midst of a nightmare of social disorder that increasingly courts a rebirth of fascism. His films are works of aggressive, often violent, social protest. Frequently, the graphic, even pornographic, depiction of sex becomes a vehicle for his radical indictment of modern, technocratized Japan, as vividly demonstrated in his films of the late seventies, *Empire of the Senses/In the Realm of the Senses* (*Ai no corrida*, 1976) and *Empire of Passion / The Phantom of Love* (*Al no borei*, 1978). Ultimately, ideas are more important to Oshima than visual surfaces, and he is frequently accused of having no consistent style. But critics often confuse inconsistency with versatility, and there can be no question that Oshima the social critic is also a great film artist and one of the foremost innovators of the international cinema today—a reputation confirmed in the eighties by *Merry Christmas, Mr. Lawrence* (1983), depicting the tragic results of cultural ambivalence between East and West in a Japanese prisoner-of-war camp on Java during World War II, and *Max, mon amour* (*Max, My Love,* 1986), a Buñuelian satire shot in Paris by Raoul Coutard about a British diplomat's wife who has an affair with a chimpanzee.

4. 印度电影和雷伊

人口众多、种族语言复杂、当权者的审查和干涉、业者的投机牟利、明

星魅力及其必不可少的载歌载舞，构成了印度电影重量轻质的"宝莱坞式"总体印象。从传统意义上讲，印度电影主要分为"社会现实片（socials）"和"神话歌舞片"（mythologicals）两大类，而作为社会现实片代表人物、印度电影大师萨伊吉特·雷伊（Satyajit Ray）的《阿普三部曲》在国际上获得空前的成功，才使印度电影受到世界影坛的瞩目。

雷伊继承法国诗意现实主义和意大利新现实主义贴近生活、关注生命的传统，运用极具民族特色的手法呈现印度文化对于人性、苦难、宿命和超越的体验。《音乐室》《大都会》和《棋手》都体现着雷伊电影的特质。而雷伊同辈的李维克·哈吉塔克（Ritwik Ghatak）和"印度新电影"（the New Cinema）左派主将姆里纳尔·森（Mrinal Sen）则从不同的侧面丰富着印度电影的母题，进而成为印度电影的标志性人物。

India Cinema and Satyajit Ray

The West discovered the Indian cinema much as it did the Japanese. Satyajit Ray's *Pather Panchali* (*Song of the Little Road*, 1955) won a prize at the 1956 Cannes Film Festival, and his next film, *Aparajito* (*The Unranquished*, 1956) won the Golden Lion Award at Venice the following year. *Apur Sansar* (*The World of Apu*, 1959) completed the trilogy. Unlike the Japanese cinema, Indian cinema offered no rich unknown cache of artistry. Not that the Indian film industry was not prolific: India produced some 300 feature films in 1958, second only to Japan in the quantity of feature production. In the 1970s, India became the world leader in the number of feature films produced each year. In the 1980s and 1990s, India remained the world's top producer, releasing an average of two films a day (one fifth of all the features made worldwide). But several causes—unique both to Indian society and to its film industry—keep quantity up and quality down. It should be noted, however, that some of the most formulaic, massmarket Indian films are exported to more than 100 nations—primarily in the Third World—where they have long proved extremely popular.

First, India is a vast nation of over 900 million people, and movies remain the only form of popular entertainment accessible to the masses, although the video industry is very much on the rise. The pressure on the studios to provide film after entertaining film for a huge, uneducated audience has led to a consistent mediocrity, a devotion to formula and convention, and a fear of experimentation. The dominant narrative formula calls for a lengthy love story, many problems standing in the way of the lovers' happiness (he might be from the wrong caste, she might be kidnapped by gangsters), endless musical numbers, a great deal of violence, a happy ending in which all problems are resolved, and three hours of footage.

《阿普三部曲》

Second, and even more difficult for the film industry, India is a nation without a common language. There are over a dozen Indian languages, not counting dialects every one of them a mystery to the speakers of the others—the most common of which are Hindi, Urdu, Bengali, Telegu, Marathi, and Tamil. This language barrier caused little difficulty in the Silent Era. The Indian silent film industry, effectively established in 1913 by the magical, mythological films of Dadasaheb Phalke and developed by pioneers such as Dhiren Ganguly, Debaki Bose, and Chandulal Shah, may well have been more artistically advanced than the silent Japanese cinema. But the coming of sound, which liberated the Japanese cinema from the *benshi*, imprisoned the Indian cinema in the Tower of Babel.

Most films for the all-India market are now made in Hindi in the commercial film capital, Bombay. Adopting in the mid-1990s a term coined by a non-Indian journalist, Bombay's commercial cinema has taken the name Bollywood. (The term has stuck even though Bombay has been Mumbai since 1995.) In Madras and elsewhere, many films—some more mainstream than others—are made in regional languages for regional and, in some cases, international distribution. The art film, or "alternative cinema", has flourished in Bombay and Calcutta and runs parallel to the commercial film establishment, never touching it. This New Indian Cinema produces work of considerably greater interest than the Hindi popular melodramas, finds little distribution in India, and acknowledges the inspiring example of Ray

(most of whose films were shot in Bengali, adopted a lyrical realist aesthetic, and found a worldwide audience).

Third, the Indian cinema has been subject to ruthless government intervention and censorship. Under the British, themes of independence were forbidden; under the government of free India, "decadent" Western influences were forbidden. Kissing scenes first appeared in the 1970s. In addition to limiting its artistic freedom, the Indian government taxes the film industry heavily; its huge audiences provide handsome revenues, even with the low ticket prices. Further, the government has levied severe import quotas that restrict the supply of raw film stock. Even more ironic, an Indian print that has been shown abroad is subject to duty as an "imported" film upon returning home. If the government restricted the movement of commercial films, it encouraged alternative production by financing personal ffiins. Satyajit Ray's first films—as well as those of Mrinal Sen, Shyam Benegal, and Aparna Sen—were supported by the Indian government.

Fourth, the Indian film industry itself is a victim of corrupt profiteering practices. Independent producers who want to make a quick killing, rather than established film compatries, are the rule. In the 1930s, however, India's studios were more solid organizations; the most famous of them, Bombay Talkies, was a cooperative familial studio—modeled on Germany's Ufa, where Bombay Talkies' married owners, Himansu Rai and Devika Rani, had worked. But the independent speculator, who usually did not have enough money to complete a film once it was started and therefore needed to beg, borrow, deal, and swindle more as the shooting went along, came to dominate the industry in the 1940s.

The speculator could get that money only because, fifth, the Indian film industry has been totally dominated by the star system since the familial studios collapsed in the 1940s. And it has been a star system with a vengeance, making the power of the Hollywood luminaries look puny. Because only a producer with a major star could get the money to finish a film, stars became so popular and enjoyed such power—even political clout—that they commanded immense salaries (at least half of it paid under the table in untaxable "black money") and might work on as many as two dozen films at once, dropping in periodically on each of the production units as the star's schedule and inclinations permitted. Music was the supporting "star" of an Indian film (the music director is the second highest paid position in the Indian film industry); for decades, of the hundreds of films shot each year in India, there was *not one* without singing and dancing. The Indian film became so conventional that its foremost historians (Barnouw and Krishnaswamy) described the formula succinctly as "a star, six songs, and three dances". These formulaic Hindi films are called *masala* films; "masala" means a mixture of spices, and the sense of the term is that these films consist of a number of standard ingredients in combinations that vary only slightly from film to film— as if one were adding a little more garlic to a successful recipe or substituting

turmeric (pirates) for fenugreek (gangsters).

To Such assumptions and conventions Satyajit Ray (1921-1992) was, and remained, a stranger. His father was a friend of Rabindranath Tagore, the greatest Indian poet of the 20th century. Well read in Indian literature and philosophy, Ray studied painting after receiving a degree in economics. But Ray was also a *cinéaste*; with Chidananda Das Gupta, Ray was co-founder of the first film society in India, the Calcutta Film Society, in 1947. So one might see Ray as uniting the traditions of Indian literature, painting, and music with those of Western cinema. The meeting of Western and Indian values is one of his recurring subjects. The influence of European films is unmistakable in Ray's films, particularly Italian Neorealism and the French cinema of the 1930s—though when he was a young man, he preferred Hollywood movies. Ray was particularly influenced by observing Jean Renoir make *The River* in Calcutta in 1949-1950, when he spoke frequently with the classical French director. Although Ray, who died in 1992, was a Bengali, his outlook was always international.

In the Indian cinematic tradition, the two dominant genres are "socials" and "mythologicals". The mythologicals, as the name suggests, use the cinema to bring to life the traditional tales and settings of Indian folklore, ancient literature, and myth. The socials, or contemporary melodramas, address social problems but use them primarily as plot complications. In the most general sense, Ray's films could be classified as socials. Though he was not hostile to the mythologicals and once hoped to make one, he did poke gentle fun at the genre in the film-within-a-film sequence of *The World of Apu*, which parodies a mythological but also shows the audience's intense devotion to the movie. *Pather Panchali*, which he was inspired to begin after seeing *Bicycle Thieves in* London, had no star (in the manner of the Soviets and Italians, Ray even used some nonprofessional actors), no songs and dances (although there was an instrumental score by Ravi Shankar), and a cinematographer who had never shot a motion picture before (the still photographer Subrata Mitra). Furtermore, it was shot on location. Ray's film wanted to have as much to do with reality as possible.

Ray's Apu trilogy (*Pather Panchali*; *Aparajito*; and *Apur Sansar*, commonly referred to as *The World of Apu*), adapted from two mammoth novels by Bibhutibhusan Banerjee (*Pather Panchali*, which covers the first film, and *Aparajito*, which covers the last two), employs a complex, careful structure that is apparent in the unity of the individual films as well as in the overall conception of the trilogy. The subject of the trilogy is the growth of a young Indian boy (Apu) front his peasant, rural youth to a mature and educated adulthood in the city—an Indian *Bildungsroman*. The three films devote themselves to childhood, adolescence, and adulthood, respectively.

At the end of *Pather Panchali*, the remaining family members leave their village to try to live better in the city (Benares). At the end of *Aparajito*, Apu pulls

himself together after the death of his mother and takes the path back to the city (Calcutta) and the university. At the end of *The World of Apu*, Apu is back on the road, returning to Calcutta again, his son on his back.

Perhaps Ray's essential theme may be found in his ultimate commitment to life, to human exertion, and to the cycles of nature of which man is a small and uncomprehending part. Ray's films acutely show that life is often painful, that people can be petty, that sorrow is inescapable and death inevitable, and that nature is an everpresent mystery.

Ray's other films are equally interesting in their careful views of Indian life and are often quite as effective. In *The Music Room* (1958) Ray examines the collapse of the old India—its traditions and its art—and the rise of the new bourgeoisie. *Devi* (*The Goddess*, 1960) is also a clash of old and new, a study of the old religious prejudices and fanaticism that can destroy happiness. *Mahanagar* (*The Big City*, 1963) examines family life in the new Calcutta, particularly the new status of women. *The Chess Players* (1977), Ray's first film in Urdu rather than Bengali, is the chilling-amusing story of two men who concentrate so much on the chess games they play with each other that they do not notice-or pretend to be above—how the political world is playing games with them. All of these films, and others not mentioned, are memorable for their careful and sensitive development of human relationships, their social analysis, their understated camerawork, and their subtle philosophical psychology.

Ray's are not the only nonmainstream films made in India. One of his most significant contemporaries, in many ways his opposite (loud sound effects, jarring editing, a ruthless vision of the interconnected evils of the world), was Ritwik Ghatak (1925-1976), whose masterpiece is *Meghe Dhaka Tara* (*The Cloud-Capped Star*, 1960); he followed that with *Komal Gandhar* (*E Flat*, 1961), *Subarnarekha* (1962), and *Jukti Takko ar Gappo* (*Reason, Debate, and a Tale*, 1974), then drank himself to death. Ray's other great contemporary, Mrinal Sen (1923-), is a Marxist whose denunciations of the exploitation of the poor (*Akaler Sandhaney/In Search of Famine*, 1980) and of women (*Ek Din Pratidin/And Quiet Rolls the Day*, 1979) and whose attacks on middle-class hypocrisy (*Khandhar/ The Ruins*, 1983) have found an international audience.

5. 戛纳、威尼斯和柏林国际电影节

战后相继创建的国际电影节是各国优秀电影进行竞争、交流和交易的核心舞台，为世界电影的发展和推广立下汗马功劳。而1932年在意大利独裁者墨索里尼支持创立的威尼斯电影节就被誉为"国际电影节之父"，"二战"后

建立的戛纳、威尼斯和柏林电影节是公认的世界三大国际电影节。

戛纳国际电影节（Cannes International Film Festival）原定于1939年创始，目的就是对抗法西斯倾向的威尼斯电影节。但由于"二战"的爆发，直到1946年才在法国地中海滨的戛纳举行首届电影节。戛纳电影节以强调电影的标新立异和艺术质量著称，像《罗马，不设防的城市》《雁南飞》《甜蜜的生活》《豹》《瑟堡的雨伞》《放大》《出租汽车司机》《现代启示录》《锡鼓》《影子武士》《低俗小说》《霸王别姬》《樱桃的滋味》《黑暗中的舞者》和《华氏911》等伟大作品都曾夺得戛纳电影节的最高荣誉"金棕榈奖（Palme d'Or）"。

威尼斯国际电影节（Venice International Film Festival）也在1946年以全新面目恢复举行（原电影节1943年在墨索里尼倒台后停办），并用威尼斯城徽"圣马克金狮奖"（Golden Lion）取代原先的"墨索尼里奖"。威尼斯电影节坚持评审的独立精神并大力支持多元电影文化，像《罗生门》《阿普三部曲》《去年在马里昂巴德》《伊万的童年》《红色沙漠》《白日美人》《芳名卡门》《再见吧，孩子们》《悲情城市》和《暴雨将至》等因为荣获"金狮奖"（Leone d'Oro）而青史留名。

柏林国际电影节（Berlin International Film Festival）1951年创建是称为"西柏林电影节"，1990年东西德统一改为现名。柏林电影节在"和平友爱"的口号下倡导东西方文化的交融、对政治意识形态导向的电影情有独钟。《恐惧的代价》《十二怒汉》《野草莓》《薇罗尼卡·福斯的渴望》《红高粱》和《中央车站》都曾因荣获柏林"金熊奖"（Golden Bear）而蜚声世界影坛。

此外，转型期还涌现了瑞士诺迦诺、捷克卡罗维发利（1946）、英国爱丁堡（1947）、澳大利亚墨尔本（1952）、西班牙塞巴斯蒂安、澳大利亚悉尼（1954）、美国旧金山、英国伦敦（1957）、苏联莫斯科和西班牙巴塞罗那（1959）等电影节。

Film Festivals

An international initiative of the postwar era was the film festival. It was, most evidently, a competition among productions for prizes awarded by panels of experts. Thus films shown "in competition" would be high-quality representatives of a nation's film culture. The prototype was the Venice festival, run under Benito Mussolini's patronage between 1932 and 1940. In the postwar era, film festivals helped define the public's conception of advanced European cinema. Festivals also showcased films that might attract foreign distributors. Winning a prize gave a film an economic advantage; and the directors, producer, and stars gained fame (and

（上）戛纳金棕榈奖、（左下）威尼斯金狮奖、（右下）柏林金熊奖

perhaps investment for their next ventures). At the same time, many films would be shown "out of competition"— screened for the press, the public, and interested producers, distributors, and exhibitors.

The Venice Film Festival was revived in 1946. Festivals in Cannes, Locarno, and Karlovy Vary began in the same year. The postwar years saw a steady increase in festivals worldwide: Edinburgh (beginning in 1947), Berlin (1951), Melbourne (1952), San Sebastian and Sydney (1954), San Francisco and London (1957), Moscow and Barcelona (1959). These were festivals of short films, animation, horror films, science-fiction films, and experimental films. These also appeared an enormous number of "festivals of festivals", usually noncompetitive events that showcased outstanding works from the major festivals. In North America, festivals began in New York, Los Angeles (Known as Filmex), Denver, Telluride, and Montreal. By the early 1960s, a film devotee could attend festivals year-round. In recent decades, festivals have multiplied, forming a distribution and exhibition circuit parallel to commercial theatrical showings.

第七节　新纪录电影

1. 法国真实电影：让·鲁什

法国真实电影（*Cinéma vérité*）源自维尔托夫"真理电影"的理念，倡导用并置的影像揭示被掩盖的真相，强调制作者对声画内容的积极介入。让·鲁什（Jean Rouch）的《夏日纪事》追问巴黎街头和法国南部人们的生活态度，克里斯·马凯的《美好的五月》探究着阿尔及利亚战争的真相，而马塞尔·奥菲欧斯（Marcel Ophüls）的《悲哀与怜悯》则执著于法国维希时代合作与抵抗迷局。

真实电影的创始人让·鲁什曾经是位人种学家，他的《美洲豹》《我是一个黑人》和《人类金字塔》等都与人种学有关。而他的《夏日纪事》则以其开创性的纪录电影观念和互动反省性的拍摄手法，成为法国真实电影的扛鼎之作。

France: *Cinéma Vérité* and Provocation

In France, Direct Cinema emerged not out of television but out of Jean Rouch's ethnographic inquiries. The key film, and the most influential work of Direct Cinema in any country, was *Chronique d'un été* (*Chronicle of a Summer,* 1961), which Rouch made in collaboration with the sociologist Edgar Morin. Out of their collaboration came yet another model of Direct Cinema—one in which the filmmakers did not simply observe or sympathize but rather prodded and provoked.

《夏日纪事》

After a prologue in which Rouch and Morin interview Marcelline, a market researcher, *Chronique d'un été* shows her asking people on the street, "Are you happy?" In the clichéd and defensive responses of the passersby, the sequence reveals the superficiality of casual poll taking. The rest of the film scrutinizes the opinions and memories of a group of Parisians. Students and working people discuss their lives with Morin, who presses them to explain themselves. Gradually the interviewees come to know one another, a process that the film documents.

In an extension of Rouch's technique in *Mi un noir*, the last portion of *Chronique d'un été* shows the subjects discussing the film that Rouch and Morin have made. Their comments — the footage is said to be boring, truthful, embarrassing, even indecent — become part of the film. In an epilogue, Rouch and Morin appraise the success of their enterprise and anticipate the reaction of the public.

Chronique lacks the suspenseful drama of the Drew films. The film centers on ordinary people explaining their lives, while Morin's insistent questioning makes Direct Cinema a provocative force. Rouch and Morin did not accept Leacock's demand that the camera efface itself. Viewers of *Chronique* are given occasional shots of equipment or technicians. For Rouch, the camera was not a brake on the

action but an accelerator: "You push these people to confess themselves.... It's a very strange kind of confession in front of the camera, where the camera is, let's say, a mirror, and also a window open to the outside". An inquiry into personal history and psychology, *Chronique* encourages its subjects to define themselves through performances for the camera.

Chronique's prologue calls the film "a new experiment in cinema-truth (*cinema vérité*)". The important word is new, since Morin believed that the emerging technology and the willingness to explore everyday life permitted filmmakers to go beyond Vertov's *Kino-Pravda* ("film-truth"). But the label got applied to far more than *Chronique*, and even American filmmakers began to call their work *cinéma vérité*. A 1963 conference of filmmakers found it too biased a term, but up to the present, *cinéma vérité* remains a synonym for Direct Cinema.

A more hybrid version of Direct Cinema was explored in two films by Mario Ruspoli, shot by Michel Brault (cameraman on several French Canadian films as well as *Chronique*). *Les Inconnus de la terre* (*The Unknown Ones of the Land*, 1961) studies the poor peasants of the Lozère region, observing peasants discussing their problems. *Regard sur la folie* (*A Look at Madness*, 1962) visits an asylum in the same area.

Ruspoli's films lie midway between the American "observational" method and the Rouch-Morin "prevocational" one. At times, the camera style is discreet, even surreptitious. Yet, even more than Rouch, Ruspoli flaunts the act of recording, showing his crew and ending *Regard sur la folie* with the camera turning from a conversation between doctors to advance toward us. We are continually aware of the filmmaker's presence even if the subjects are not.

A direct criticism of Rouch and Morin's method is to be found in Chris Marker's *Le Joli mai* (*The Pretty May*, 1963). Marker could not embrace the Direct Cinema trend, preferring always to retain the voice of a narrator who reflects on the images before us. *Le Joli mai* absorbs Direct Cinema techniques into a larger meditation on freedom and political awareness.

The first part of the film inquires into the state of happiness in Paris in May 1962, the moment when the Algerian war ended. Marker's aggressive questioning of smug or oblivious people pushes the confrontational camera to the point of rudeness. He also criticizes the limited, apolitical notion of happiness from which *Chronique* began. (Marker ironically dedicates his film "To the happy many".) A clothes salesman says that his goal in life is to make as much money as possible; a couple in love are indifferent to social issues. Part two, opening with mysterious evocations of terrorism and right-wing reprisals, consists of interviews with people who seek political solutions to contemporary problems.

Harsh and acerbic, shot through with Marker's quirky huimor and poetic digressions, *Le Joli mai* asks *cinéma vérité* to recognize the complexity of life

and the political forces goverming French society at a historical turning point. Yet Marker's meditation has its base in Direct Cinema; his evidence consists partly of his lipsync interviews. "Truth is not the destination", he conceded, "but perhaps it is the path".

Jean Rouch

Among the totemic ancestors of the factual film three figures, all of whom may be labelled "Jean Rouch", can be discerned. These figures have certain characteristics in common—a background in the French administrative and intellectual class, an education at the Haute École des Ponts et Chaussées, and a subsequent career in anthropology primarily working with the Songhay people of West Africa.

The first Jean Rouch (1917-2004) is an ethnographer with a particular interest in possession cults. Rouch extended participation-observation techniques to embrace a willingness to join, rather than just observe, the activities of his informants. It is, then, reasonable that this ethnographer of possession should come to describe such major works as *Les Magiciens de Wanzerbe* (*The magicians of Wanzerbe*, 1948-9) and *Les Mâitres fous* (*The mad masters*, 1953-4) *as ciné-transe*.

Rouch is more generally important because he is one of the few leading anthropologists to use film as his primary ethnographic tool. Indeed since the completion of his Doctorat d'État on Songhay religion and magic in 1960 he has produced no long texts or monographs, only the occasional article; but he has filmed more than seventy-five titles.

Despite his enormous empathy for traditional life, Rouch has been accused (by Sembene Ousmane, among others) of observing Africans "like insects". *Les Mâitres fous*, in particular, has been controversial, and for much of his career Rouch has been embroiled in such seemingly inevitable anthropological rows.

The second Rouch is a cineaste and documentarist, one of the Cinématheque Française circle in Paris during the Second World War and a film-maker intimately involved in the revival, since the 1960s, of the 1920s Russian debate as to the nature of documentary film authenticity. Rouch, by using the term *cinéma-vérité*, brought back into vogue Vertov's reflexive documentary practice (as in *The Man with a Movie Camera*, 1929). For instance, Rouch forced French and African teenagers at an Ivory Coast high school to interact with each other—and showed his audience that he was doing this—for *La Pyramide humaine* (*The human pyramid*, 1958-9). Returning to France to film 'the strange tribe that lives in Paris' the following year, Rouch and the sociologist Edgar Morin elaborated a similar "sort of cinema truth" in the seminal *Chronique d'un été* (1960). Here the subject of

the documentary becomes the making of the documentary itself, with Rouch and Morin prominent among the filmed participants. This sort of reflexivity then began to influence Rouch's more traditional ethnographic films, such as *La Chasse an lion a l'arc* (*Lion hunt with bow and arrow'*, 1957-64), where even the telegrams summoning the crew to the hunt are featured. While this honesty is attractive it has been criticized for being both glib and limiting.

Rouch's ethnography owes much to a French tradition which, for instance, concentrates on cosmologies rather than kinship patterns, and his documentary practice comes from a French style of personal film (as in the work of Chris Marker). Nevertheless Rouch is an original. This can be seen most clearly in the work of a more elusive third Rouch, the creator of "ethno-fictions". Already in *Jaguar* (1954-67), a reconstructed film about the traditional migration of young Songhay men to the Guinea coast to find work, Rouch was ready to allow his informants to suggest the very idea for the film. Rouch went a step beyond reconstructing what had or could happen, as Flaherty had done, and moved to reconstructing what could not be filmed—namely the interior life of his informants. This can be seen in *Moi, un noir* (*I, a black man*, 1957), in which a group of urban Africans are imdted to live our their weekend fantasies, in Rouch's words: "a sort of mythic Eldorado, based on boxing, the cinema, love, and money."

Rouch has said that "fiction is the only way to penetrate reality". In the long term, given the problematic status of the documentary image as evidence in a world of post-modern theory and digital manipulation, this willingness to abandon the strait-jacket of objectivity could be his most important legacy for documentary practice.

2. 美国直接电影：怀斯曼

美国的直接电影（direct cinema）秉持与法国真实电影相似的主旨，却坚持客观中立的旁观立场，绝少使用旁白与字幕。直接电影的基本班底出自20世纪60年代初期的"德鲁小组"（Drew Associates），罗伯特·德鲁（Robert Drew）、理查德·利亚科克（Richard Leacock）和D. A. 彭尼贝克（D. A. Pennebaker）联合拍摄的《初选》《童目睽睽》和《电椅》，以及梅索斯兄弟（Albert and David Maysles）后来的《圣经推销员》都是典型的直接电影作品。

直接电影的代表人物弗雷德里克·怀斯曼（Frederick Wiseman）本是法律学者，但从1967年开始陆续拍摄了《疯人院》《高中》《法律与秩序》和《医院》等一系列反映社会机构冷漠控制的纪录片，以马赛克似的段落拼贴和纯客观的直面观察体现直接电影的精髓。

《疯人院》

Direct Cinema

Between 1958 and 1963, documentary filmmaking was transformed. Documentarists began to utilize lighter and more mobile equipment, to work in smaller crews, and to reject traditional conceptions of script and structure. The new documentary sought to study individuals, to reveal the moment-by-moment development of a situation, to search for instants of drama or psychological revelation. Instead of staged scenes dominated by a voice-over narration, the new documentary would let the action unfold naturally and permit people to speak for themselves.

Called *candid cinema, uncontrolled cinema, observational cinema*, and *cinéma vérité* ("*cinema truth*"), this trend was most generally known as Direct Cinema. The name suggests that the new technologies recorded events with an unprecedented immediacy and that the filmmaker avoided the more indirect documentation—restaging, narrational commentary — of earlier documentarists.

Several factors influenced the new approach. Most generally, Italian Neorealism had intensified documentarists' urge to capture everyday life. Technological in novations, such as the growth of 16mm production and the emergence of sound-on-tape, provided a new flexibility. Moreover, television

needed motion pictures to fill airtime, and network news organizatins sought a fresh approach to audiovisual journalism. In the United States, Canada, and France, documentarists affected by these conditions forged distinct versions of Direct Cinema.

The United States: Drew and Associates In the United States, Direct Cinema emerged under the auspices of the photojournalist Robert Drew. Drew wanted to bring to television reporting te dramatic realism he found in *Life* magazine's candid photography. In 1954, he met Richard Leacock, who had worked on *Native Land* and had been cinematographer for Flaherty's *Louisiana Story*. With the backing of Time, Inc., Drew hired Leacock, Don Pennebaker, David and Albert Maysles, and several other filmmkers.

Drew produced a series of short films aimed at television broadcast, including the ground-breaking *Primary* (1960), a report on the Wisconsin primary contest between John Kennedy and Hubert Humphrey. Leacock, Pennebaker, the Maysleses, and Terence Macartney-Filgate all worked as cinematographers. Although the film contained some lip-sync sound, its visual authenticity attracted more attention. The camera followed the politicians working the streets, riding from town to town, and nervously relaxing in hotel rooms. *Primary's* drama was heightened by crossculting between the two candidates and by voice-over news reports, which largely replaced explanatory commentary.

Shortly afterward, Drew ahnd Leacock were commissioned to make several films for ABC television, notably *Yanki, No!*(1960),an examination of anti-U. S. feelings in Latin America, and *The Children Were Watching* (1960), a study of school integration. Between 1961 and 1963,Drew Associates made twelve more films, including *Eddie* (1961), *Jane* (1962) and *The Chair* (1962). Ten of these films became known as the *"Living Camera"* series. By now they fully exploited direct sound.

Drew, who exercised editorial control over most of the films made by the company, saw documentary as a way of telling dramatic stories. "In each of the stories there is a time when man comes against moments of tension, and pressure, and revelation, and decision. It's these moments that interest us most". For Drew, Direct Cinema gripped audiences through what came to be called its *crisis structure*. Most Drew-unit films center on a high-stakes situation to be resolved in a few days or hours. The film arouses the viewer's emotion by showing conflict, suspense, and a decisive outcome. *Primary* exploits the crisis structure, as dose *The Chair*, which shows lawyers' struggles to save a rehabilitated convict from execution. The crisis puts the participants under stress and reveals their personalities. Often as in *Eddie* or *Jane*, the protagonist fails to achieve the goal, and the film ends with a scrutiny of his or her emotional reaction.

Soon Drew's filmmakers left the unit to from their own companies. The

Maysles brothers departed to make *Showman* (1962), a study of film producer Joseph E. Levine, and *What's Happening! The Beatles in New York* (1964). Far more episodic than the Drew films, the Maysleses' projects avoided the crisis structure and offered casual, sketchy portraits of show-business celebrities. *What's Happening!*, the first Direct Cinema film in the United States to omit voice-over narration entirely, was simply a diary of the Beatles' tour, rousing one professional television producer to complain, "As most documentary filmmakers understand the film, it was hardly a film at all".

Don Pennebaker and Richard Leacock also left Drew Associates, forming their own firm. Penebaker made a study of handicapped twins (*Elizabeth and Mary*, 1965) and specialized in films documenting American popular music (*Don't Look Back,* 1966; *Monterey Pop*, 1968; *Keep on Rockin'*, 1970). Leacock went on to make *Happy Mother's Day* (1963), showing how the birth of quintuplets disrupts a small town; *A Stravinsky Portrait* (1964); and *Ku Klux Klan—The Invisible Empire* (1965).

Leacock, the most proselytizing of U.S. Direct Cinema filmmakers, advocated what he called "uncontrolled cinema". The filmmaker would not interfere with the event; the filmmaker simply observed, as discreetly and responsibly as possible. Leacock believed that a self-effacing crew could become so integrated into a situation that people would forget they were being filmed.

The purpose of uncontrolled cinema, Leacock claimed, is "to find out some important aspect of our society, by *watching how things really happen* as opposed to the social image that people hold about the way things are *supposed* to happen". Leacock's concern for Direct Cinema's power to reveal social institutions through face-to-face interactions was to prove significant for a generation of filmmakers.

Frederick Wiseman and the Tradition of Direct Cinema

In the spring of 1966, a middle-aged lawyer produced and directed a film about conditions at a Massachusetts hospital for the mentally ill. He filmed everyday activities as well as a show put on by the patients. The result, titled *Titicut Follies* after the patients' name for their show, was released in 1967 and set off a storm of protest. Since that directorial debut, controversy has pursued Wiseman through over thirty-five feature-length documentaries. In the process, his work has become emblematic of Direct Cinema.

Whereas the Drew unit concentrated upon situations of high drama and the Rouch-Morin approach to *cinéma vérité* emphasized interpersonal relations, Wiseman pursued another path, focusing on the mundane affairs of social

institutions. His titles are indicative: *Hospital* (1970), *Juvenile Court* (1972), *Welfare* (1975), *Racetrack* (1985), *Zoo* (1993), and *Public Housing* (1997). *Law and Order* (1969) records police routine, while *The Store* (1983) moves behind the scenes of a Dallas department store.

Wiseman typically does not follow individuals facing a crisis or solving a problem. He assembles a film out of slices of day-to-day life in a business or government agency. Each sequence is usually a short encounter that plays out a struggle or expresses the participants' emotional state. Then Wiseman moves to another situation and other participants. He has called this a "mosaic" structure, the result of assembling tiny pieces into a picture of an institution. Using no narrator, Wiseman creates implications by making shrewd juxtapositions between sequences and by repeating motifs across the film. The meaning, he insists, is in the whole.

His first films reflect a conception of institutions as machines for social control. He declared himself interested in "the relationship between ideology and practice and the way power is exercised and decisions rationalized". Wiseman records the frustrations of ordinary people facing a bureaucracy, and he captures the insular complacency of those exercising power. In his most famous film, *High School* (1968), secondary education becomes a confrontation between bewildered students and oppressive or obtuse teachers: schooling as control and conformity.

In his later work, Wiseman claimed to take a more flexible and open-minded approach reminiscent of Richard Leacock's "uncontrolled cinema".

"You start off with a little bromide or stereotype about how prison guards are supposed to behave or what cops are really like. You find that they don't match up to that image, that they're a lot more complicated. And the point of each film is to make that discovery".

This concern for complexity, plus decades of support form the Public Broadcasting System (PBS), led Wiseman to expand his mosaics to vast proportions, shown as miniseries. *Canal Zone* (1977) runs almost three hours, the pair *Deaf* and *Blind* (both 1988) total eight hours, and *Belfast, Maine* (1999), a portrait of a community, lasts about six hours. It is as if his search for comprehensiveness and nuance forced Wiseman to amass more and more evidence, searching for all sides of the story. In later decades, Wiseman expanded his subject matter beyond micropolitical struggles for survival, investigating instead artistic creation in *Ballet* (1995; on the New York City Ballet) and *La Comédie-Française* (1996). Despite Wiseman's reliance on television, his films are also shown in museums and in marathon retrospectives at film festivals.

Wiseman carries on the Leacock tradition of fly-on-the-wall observation. The cameraman and the recordist (Wiseman) efface themselves. The filmmakers ask no questions and hope that the subjects never look into the lens. Wiseman creates classical continuity through eyeline matches, cutaways, and sound overlaps. We

seem to be on the scene, invisible observers of social rituals of authority and humiliation.

Surprisingly, Wiseman insisted that his documentaries were subjective creations, "reality fictions" expressing highly personal judgments. Yet many critics and filmmakers believed that he did not signal his point of view strongly enough and that his films fostered a belief that documentary yielded hard nuggets of fact. Wiseman's consummate use of Direct Cinema became a target for filmmakers who saw documentary as creating an illusory knowledge of reality.

3. 事实、真相与态度

20世纪70年代纪录片对越南战争倾注了大量的热情,《心灵与智慧》就是突出的例证。而进入20世纪80年代后期,迈克尔·摩尔(Michael Moore)和埃罗尔·莫里斯(Errol Morris)成为纪录电影领域的领军人物。

迈克尔·摩尔坚持自己的草根立场,对商业公司、利益集团和政治体制进行无情的抨击,《罗杰与我》《科伦拜恩的保龄》和《华氏911》获得叫好又叫座的巨大影响力。

而主修历史、科学和哲学出身的埃罗尔·莫里斯则在题材的选择上相当的广泛,《蓝色警戒线》探讨司法的公正性,《时间简史》是对霍金理论的视听诠释,而《战争迷雾》则通过对前国防部长麦克拉玛拉的贴近深入采访再次揭开越南战争难以愈合的伤疤。

Facts, Truth, and Attitude: Michael Moore and Errol Morris

Michael Moore and Errol Morris came to prominence at nearly the same time: Morris's *Thin Blue Line* was released in 1988, Moore's *Roger & Me* in 1989. Both men reaped the benefits of growing support for independent cinema, and their idiosyncratic films fitted the new demands for personal visions. Both were interested in ideas, but they also saw that to reach large audiences a documentary needed a dramatic narrative driven by clearly defined characters. Instead of filming gray-bearded experts pontificating in front of bookshelves, they sought out extreme situations and eccentric or sinister individuals. The differences in their approach to this format defined two poles of U.S. documentary in the 1990s and 2000s.

Michael Moore became famous for his attacks on American corporations and

迈克尔·摩尔《科伦拜恩的保龄》

political policies, but he would not have attracted so much attention if he had not made himself his protagonist. In sneakers, baseball cap, and thick glasses, Moore looked like a stereotypical Midwesterner. Each of his films becomes his personal quest for truth, showing irreverent humor and a dogged refusal to take no for an answer. *Roger & Me* chronicles his efforts to ask Roger Smith, the CEO of General Motors, why the Flint, Michigan, plant was shut down. For *The Big One* (1997) Moore manages to meet a Nike executive and question him about manufacturing policies in developing countries. A notorious school massacre in Colorado led Moore to investigate Americans' attitude toward guns in *Bowling for Columbine* (2002). *Sicko* (2007) pursues a comparison between health-care practices in the U.S. and in other countries. Moore claimed that his films weren't neutral reportage, but something like newspaper editorials—strong opinions backed up with evidence.

Moore's biggest success was *Fahrenheit 9/11* (2004). Although Moore takes center stage in some sections, President George W. Bush becomes the film's central figure. Moore portrays him as lazy, slow-witted, and devoted to serving corporations and rich Saudis. According to Moore, the President exploited the nation's grief after the 2001 Trade Tower attacks in order to launch a tragic war. Moore widens his attack in the final sections of the film. Borrowing confrontational tactics from Direct Cinema, he ambushes Senators on the street to ask if their children will enlist in the armed forces. Moore's earlier films had been accused of

distorting evidence, so for *Fahrenheit 9/11* he detailed all his sources in a book and on his website.

The films make their points with bluntness and gonzo humor. A bank gives out rifles when you open an account. President Reagan visits a town suffering from plant closures and, during his speech at a restaurant, the cash register is stolen. Moore sends right-to-life presidential candidate Pat Buchanan a check from "Abortionists for Buchanan"; Buchanan takes the money. Moore scores montage sequences to sardonic melodies, as when "It's a Wonderful World" plays behind scenes of American military aggression, or "Cocaine" is heard overfootage referring to Bush's military service. *Fahrenheit 9/11* makes scathing use of behind-the-scenes footage. Perhaps the most famous sequence in all of Moore's work is the one showing President Bush in a schoolroom learning that the U.S. has been attacked. On the soundtrack, Moore offers possible thoughts: "Was he wondering if maybe he should have shown up to work more often?".

Moore's aggressive, opinionated films and bestselling books made him one of the most prominent figures on the U.S. political left. He was incessantly attacked in print, in the blogosphere, and in films such as *Michael Moore Hates America* (2004), *Celsius 41.11* (2004), and *Michael & Me* (2004). *In Manufacturing Dissent* (2007), former admirers review his career skeptically and, borrowing his first-person approach, record his efforts to evade an interview with them. The very fact that a filmmaker could inspire other films aiming to rebut his work indicates the importance of Moore and the new status of theatrical documentary.

Errol Morris did not receive the same sort of scrutiny. He did not put himself at the center of his movies, and he tackled his subjects from a more cerebral angle. Before *The Thin Blue Line*, Morris had made documentaries about a pet cemetery (*Gates of Heaven*, 1981) and an eerie town (*Vernon, Florida*,1981). These established his willingness to lace apparently neutral documentaries with mordant humor. While *The Thin Blue Line* also has its light moments, it concentrates on the difficulty of recovering a past event. Instead of giving up the search for truth, however, Morris shows that with effort, a film can present a plausible version of reality.

Morris moved toward a string of portrait documentaries. Some explored the nature of genius and talent: a study of physicist Steven Hawking (*A Brief History of Time*, 1991) and a subtle examination of three gifted eccentrics (*Fast, Cheap, and Out of Control*, 1997). These films give sway to Morris's love of the grotesque, with a spinning chicken in *Brief History* and celebrations of oddity in *Fast, Cheap*. In less playful films Morris showed how intelligent, apparently rational people could pursue lethal courses of action. *Mr. Death: The Rise and Fall of Fred A. Leuchter, Jr.* (1999) studies a man bent on improving execution equipment and convincing the world that, on engineering grounds, the Holocaust could not have

occurred. In *The Fog of War: Eleven Lessons from the Life of Roberts McNamara* (2003), Morris portrays the architect of America's involvement in the Vietnam War. The brilliant McNamara, who formulates ten "lessons" about global conflict, reveals himself as oddly short-sighted, inclined, like Fred Leuchter, to treat individuals as data sets and design constraints. These conclusions are allowed to accrete slowly, not pounded home by voice-over commentary in the manner of Moore.

Moore puts himself center stage, but Morris remains offscreen. He devised what he called the "interrotron", an arrangement of cameras and mirrors that allowed his interviewees to look directly at him while seeming to look at the camera. The result gives talking heads a disconcerting intimacy.

Morris's analytical approach dominates *Standard Operating Procedure* (2008), which scrutinizes the activities of U.S. soldiers at Abu Ghraib prison in Iraq. Morris interviews the guards involved in "breaking" prisoners and photographing them in humiliating poses. But *Standard Operating Procedure* goes beyond reportage to pose the problem of arriving at truth on the basis of images. In a book and a *New York Times* blog, Morris asked how a photograph, a moment lifted from the fabric of life, can ever represent the truth of the situation. "When you see a picture", one soldier comments, "you never see outside the frame".

Morris argued: "There's always an imposition of point of view in anything. There's this crazy thinking that style guarantees truth. You go out with a hand-held camera, use available light, and somehow the truth emerges...I call attention to the fact that I have a point of view." Moore would have agreed. Both filmmakers sought to go beyond Direct Cinema recording by acknowledging their own concerns and commitments. Yet they also sought to expose a reality that went beyond mere opinion. Granted, Moore used a machete while Morris used a scalpel. But both sought to show that the detachment of Direct Cinema was not the only way that a documentary could offer something approximating truth.